PIMLICO

205

CENTURIES OF CHILDHOOD

Philippe Ariès was born in Blois in 1914. He studied at the Sorbonne and later became an expert on tropical agriculture. This he found only modestly absorbing and consequently took up historical research, describing his experiences in this area, in his autobiography, *Un historien du dimanche*.

His first interest was in demography, the starting point for this book, *Centuries of Childhood*, and for an earlier work *Histoire des populations françaises*. His later and more controversial works, focusing on the subject of death, include *Western Attitudes Towards Death* and *The Hour of Our Death*.

All Ariès's books are outstanding examples of the discoveries which historians can make when they decide to concentrate on what Balzac claimed should be the province of the novel: that of writing the history of manners and of man's perception of himself. Philippe Ariès died in February 1984.

Adam Phillips was formerly principal child psychotherapist at Charing Cross Hospital in London. He is the author of *Terrors and Experts*, *On Kissing, Tickling and Being Bored*, *On Flirtation* and *Winnicott*.

Contents

Introduction to the Pimlico Edition
by Adam Phillips

Until well into the nineteenth century most Western peoples' relationship to God would have seemed infinitely more important — more necessary to their future — than their relationships with their parents or their children. Even Darwin's discovery of Natural Selection made monkeys, in a sense, far more influential in people's lives than their immediate family. It is only very recently that our personal pasts — both what we can remember and what we can find out — have begun to seem the key to who we are, and who we might become. The modern science of genetics has confirmed our sense that now we are, to all intents and purposes, our pasts; and perhaps particularly — or at least, most meaningfully — our childhoods. Our sense of the sacred has returned in the kind of significance we give to childhood. For us — or rather, for the non-religious — it is the only source that makes sense.

We are so accustomed now to thinking of childhood as essential to any notion of our own personal history, and identity, it is difficult to remember that childhood itself — as both an ordinary preoccupation, and an academic subject worthy of study — has a history. Our childhood is not simply something we remember or forget, but a subject we have inherited as something worth thinking about. We have learned that childhood matters: we have learned stories about how it works. It was the virtual revelation of Ariès's book when it was first translated over thirty years ago — and like all secular revelations it seems entirely obvious in retrospect — that childhood had been, in a way he was very careful to specify, invented. Before the seventeenth century people had been children; but before the seventeenth century there was no such thing as childhood. And what he meant by this still startling paradox was that before the seventeenth century childhood experience was not deemed worthy of representation; it was not, what Ariès calls, a concept. As though people had felt no real need to think about it; that is, describe it in its manifold varieties, attend to it as something of moment. At a certain point in history, Ariès shows with his wonderfully informative, buoyant scholarship, children became visible. So if this is a book — indeed, *the* book — about the history of childhood it is also a book about how things, like

childhood, or the family, come to seem important: worth talking about, or writing about, or painting. It is a book about what might make people's preoccupations change. History shows us that our needs are always fashionable. Ariès describes the very beginnings of our modern obsession with childhood; something we cannot, as yet, imagine losing interest in.

As the original French title of Ariès's book intimates — *L'Enfant et la vie familiale sous l'ancien règime* — his book is essentially about a revolution; one both complicit with the ideals of the French revolution, and of a piece with their disappointment. The liberation of the child, in Ariès's account, became a confinement. On the one hand, he describes a minor revolution in iconography. In the seventeenth century, for the very first time, painters begin to paint children as subjects in their own right, with their own clothes and distinctive mannerisms. They are no longer merely adults in miniature. The franchise of representation is extended to childhood. There is, as it were, a new democratisation of the stages of life. Children begin to have their say. There begin to be more words to describe them — to differentiate their life stages — but also, and perhaps more significantly, there is a special interest in what they actually say. No longer verbally incompetent adults, children begin to seem the kind of inspired oracles that they will become for the poets of romanticism, the tellers of difficult truths that they have become in contemporary child abuse cases. The child takes on the burden of privilege. In other words, in Ariès's powerfully documented account we see that curious reversal taking place in which children continually aspire to become adults, but adults begin to aspire to become like children; to be in touch with the fresh language and sexuality of the child; to acquire the child's visionary frankness. Ariès's book might make us wonder, among many other things, what has to happen to adulthood that would make us idealise the child. After all, nothing in nature is closer to nature than anything else.

Perhaps for good reason — there is a wry scepticism in this book that is averse to modish speculation — Ariès never makes too much of something that, from a contemporary point of view, seems all too obvious: that Ariès is describing, among many other things, a gradual eroticisation of the child. Referring, for example, to the quite new 'coddling' of very young children that seems to have begun in the sixteenth century, Ariès quotes Montaigne complaining — or rather, as he puts it, bristling — 'I cannot abide that passion for caressing new-born children, which have neither mental activities nor recognisable bodily shape by which to make themselves lovable.' This coddling of the very young that seems so natural, so obvious to us, was such a novelty, as Ariès points out, that it could provoke this kind of critical reaction. Montaigne could not abide this

new-fangled notion of loving children for their 'frolicking, games and in-fantile nonsense'. It is perhaps possible that as infant mortality improved, as diet and hygiene and the advances of science improved life expectancy, that people began to feel that they could afford to indulge their passionate feelings for the very young. (It is, of course, literally incredible to modern, affluent westerners how people could have borne the loss of so many of their children in the past.) But whatever the reasons — and they must, as Ariès implies, be at least complicated — children became, in Europe in the seventeenth century, new objects of pleasure; worth won-dering about, and therefore a new source of imagery. 'A new concept of childhood had appeared,' Ariès writes, 'in which the child, on account of his sweetness, simplicity and drollery, became a source of amusement and relaxation for the adult.' The child became, one might say, something be-tween a commodity and an object of sexual desire: a 'toy' to use one of the words in Ariès's book. And this toy is the forerunner of our contemporary psychological child, in need of so much understanding and training.

But if childhood was, as it were, the least aristocratic of virtues — everyone, after all, has one — Ariès also shows how, on the other hand, this new-found attentiveness to children and to childhood was part of a more dispiriting story about modernity. That as the child became an object of pleasure he or she also became an object of discipline: a creature in need of education; someone who needed watching. That with the in-vention of schooling came our modern sense of the long childhood. Whereas once, in what is loosely described here as the medieval period, the child would slip, usually no older than seven, into the hard rough and tumble of the adult world; now there would be added, by what Ariès calls 'moralists', an institutionalised third intermediate stage. Children would begin to be schooled for adulthood. The adult world became something one needed elaborate formal training for. It was no longer something you could just pick up.

Ariès, of course, does not idealise de-schooled medieval society; and yet there is a nostalgia — or perhaps, an idealism — in this book for a kind of multi-generational hurly-burly society; for a world before the mass retreat into institutions and families; for a world of freer association, which modern theorists refer to as carnival. So Ariès's book is also a new chapter in the long story of medievalism: that cult of the medieval that has been the only viable alternative to classicism. Ariès is keen to describe a world before the family, as he puts it, which 'imposed itself tyrannically on people's consciousness'. Not until the eighteenth century, he writes rue-fully, did the family begin to 'destroy the old sociability'. It is perhaps only with hindsight we can see that — or rather, to what extent — *Centuries*

of Childhood was a book of its time. First published in France in 1960, symbolic in itself, it was a necessary precursor, part of the spirit of the times that produced ideas about the death of the family and deschooling society — ideas that were to be too quickly neglected. 'The whole evolution of our contemporary manners', Ariès writes by way of conclusion, 'is unintelligible if one neglects this astonishing growth of the concept of the family. It is not individualism that has triumphed, but the family.' It is this parallel and entangled evolution of the school and the family that rouses Ariès's passion; that makes the stridency of his conclusion so exhilarating.

If the seventeenth century brought the new concept of childhood, then hot on its heels the eighteenth century brought the new concept of the family. Once you invent the child you need something — like a school or a family — to contain it (the child as Frankenstein's monster). Ariès's account is not as schematic as this suggests — his is a history of detail, and therefore of process — but this is his radical assertion. And so in its own distinctively understated, scholarly way *Centuries of Childhood* is also one of the great elegaic histories. It is a story of the losses entailed by our gaining of childhood. 'Life in the past', Ariès writes, 'until the seventeenth century, was lived in public . . . Privacy scarcely ever existed.' If this is contentious — and it surely must be, if only from the perspective of class distinctions — it is nevertheless true that with the modern obsession with childhood comes the invention of a new kind of person with a private inner world. To invent the concept of childhood is to radically redescribe what a person is, and what a life might be. And above all, perhaps, it embroils people in their privacy.

Ariés's great book, in a very real sense, instigated the history of childhood. It has now become an irresistible part of the history it invented. Childhood memories, and our descriptions of childhood, it suggests, are always genre pieces; they have conventions and histories. So without histories of childhood — and there are many histories in this book — one's own childhood does not make sense. *Centuries of Childhood* shows us, in vivid and dramatic detail, why the past is never finished — that we can never get over it because it is never over.

Introduction

This book on the family under the ancien regime is not the work of a specialist in that period, but of a demographic historian who, struck by the original characteristics of the modern family, felt the need to go back into a more distant past to discover the limits of this originality. I must make it clear from the start that there is no question here of a gratuitous examination of society under the ancien regime. I have explained elsewhere (Aries, 1954), how difficult it was for me clearly to distinguish the characteristics of our living present, except by means of the differences which separate them from the related but never identical aspects of the past. Similarly I can tell the particular nature of a period in the past from the degree to which it fails to resemble our present. This dialectic of past and present can be fairly safely neglected by historians of 'short periods', (Braudel, 1958), but it must be used in the study of manners and feelings whose variations extend over a 'long period'. This is the case with the family, with day-long relations between parents and between parents and children.

But have we any right to talk of a history of the family? Is the family a phenomenon any more subject to history than instinct is? It is possible to argue that it is not, and to maintain that the family partakes of the immobility of the species. It is no doubt true that since the beginning of the human race men have built homes and begot children, and it can be argued that within the great family types, monogamous and polygamous, historical differences are of little importance in comparison with the huge mass of what remains unchanged.

On the other hand, the great demographic revolution in the West, from the eighteenth to the twentieth century, has revealed to us considerable possibilities of change in structures hitherto believed to be invariable because they were biological. The adoption of contraceptive measures has brought about both quantitative and qualitative changes in the family. However it is not so much the family as a reality that is our subject here as the family as an idea. True, men and women will always go on loving one another, will always go on having children, whether they limit their numbers or give free rein to instinct, and will always go on guiding the first

steps of those children. That is not the question at issue. The point is that the idea entertained about these relations may be dissimilar at moments separated by lengthy periods of time. It is the history of the idea of the family which concerns us here, not the description of manners or the nature of law.

In what direction is this idea evolving?

For a long time it was believed that the family constituted the ancient basis of our society, and that, starting in the eighteenth century, the progress of liberal individualism had shaken and weakened it. The history of the family in the nineteenth and twentieth centuries was supposed to be that of a decadence: the frequency of divorces and the weakening of marital and paternal authority were seen as so many signs of its decline. The study of modern demographic phenomena led me to a completely contrary conclusion. It seemed to me (and qualified observers have come to share my conclusions). It seemed to me (and qualified observers have come to share my conclusions) (Prigent, 1954) that on the contrary the family occupied a tremendous place in our industrial societies, and that it had perhaps never before exercised so much influence over the human condition. The legal weakening proved only that the idea (and the reality) did not follow the same curve as the institution. Is not this disparity between living ideas and legal structures one of the characteristics of our civilization? The idea of the family appeared to be one of the great forces of our time. I then went on to wonder, not whether it was on the decline, but whether it had ever been as strong before, and even whether it had been in existence for a long time. I accordingly looked back into our past, to find out whether the idea of the family had not been born comparatively recently, at a time when the family had freed iself from both biology and law to become a value, a theme of expression, on occasion of emotion. The aim of this book is to reply to this question on the modernity of the idea of the family.

But how was I to discover, in the documents of the past, references to things which were too ordinary, too commonplace, too far removed from the memorable incident for contemporary writers to mention them? Our experience of the modern demographic revolution has revealed to us the importance of the child's role in this silent history. We know that there is a connection between the idea of childhood and the idea of the family. We were entitled to suppose that this connection also existed in a more distant past, and to estimate one with the help of the other. That is why we are going to study them together.

In the tenth century, artists were unable to depict a child except as a man on a smaller scale. How did we come from that ignorance of childhood to the centring of the family around the child in the nineteenth

century? How far does this evolution correspond to a parallel evolution of the concept people have of the family, the feeling they entertain towards it, the value they attribute to it? It will be no surprise to the reader if these questions take us to the very heart of the great problems of civilization, for we are standing on those frontiers of biology and sociology from which mankind derives its hidden strength.

Part One: **The Idea of Childhood**
Chapter 1: **The Ages of Life**

A man of the sixteenth or the seventeenth century would be astonished at the exigencies with regard to civil status to which we submit quite naturally. As soon as our children start to talk, we teach them their name, their age and their parents' name. We are extremely proud when little Paul, asked how old he is, replies correctly that he is two and a qalf. We feel in fact that it is a matter of importance that little Paul should get this right: what would become of him if he forgot his age? In the African bush, age is still quite an obscure notion, something which is not so important that one cannot forget it. But in our technical civilization, how could anyone forget the exact date of his birth, when he has to remember it for almost every application he makes, every document he signs, every form he fills in — and heaven knows there are enough of those and there will be more in the future. Little Paul will give his age at school; he will soon become Paul — of Form — and when he starts his first job he will be given, together with his Social Security card, a registration number which will double his own name. At the same time as being Paul — and indeed rather than being Paul — he will be a number, which will begin with his sex, the year of his birth, and the month of that year. A day will come when every citizen will have his registration number. Our civic personality is already more precisely expressed by the coordinates of our birth than by our surname. In time the latter might well not disappear but be reserved for private life, while a registration number in which the date of birth would be one of the elements would take its place for civic purposes. In the Middle Ages the Christian name had been considered too imprecise a description, and it had been found necessary to complete it with a sur-name, a place name in many cases. And now it has become advisable to add a further detail, the numerical character, the age. The Christian name belongs to the world of fancy, the surname to that of tradition. The age, a quantity legally measurable to within a few hours, comes from another world, that of precise figures. In our day our registration practices partake at the same time of all worlds.

There are, however, some acts which commit us to a serious degree, which we draw up ourselves, and which do not call for the inscription of

our date of birth. Belonging to very different species, some are commercial documents, bills of exchange or cheques, and the others are wills. But they were all devised in ancient times, before the rigour of modern identification had been introduced into our way of life. The recording of births in parish registers was imposed on the priests of France by François I, but to be respected, this order, which had already been prescribed by the authority of the councils, had to be accepted by people who for a long time remained hostile to the rigour of abstract accounting. It is generally agreed that it was only in the eighteenth century that the parish priests began keeping their registers with the exactness, or the attempted exactness, which a modern state requires of its registrars. The personal importance of the idea of age must have grown in proportion as religious and civic reformers imposed it in documentary form, beginning with the more educated social strata, that is to say, in the sixteenth century, those who had a college education.

In the fifteenth- and sixteenth-century memoirs which I have consulted in order to collect a few examples of the status of scholars,[1] it is not uncommon to find at the beginning of the story the author's age or his date and place of birth. Sometimes indeed the age becomes an object of special attention. It is inscribed on portraits as an additional sign of individualization, exactness and authenticity. On many sixteenth-century portraits one may find inscriptions like *Ætatis suae 29* – in his twenty-ninth year – with the date of the painting ANDNI *1551* (portrait by Pourbus of Jan Fernaguut, Bruges). On the portraits of famous people, court portraits, this reference is rarely to be found; but it exists either on the canvas or on the old frame of family portraits, linked with family symbols. One of the oldest examples is the admirable portrait of Margaretha Van Eyck. At the top: *co(n)iux m(eu)s Joha(nn)es me c(om)plevit an(n)o 1439, 17 Junii* – what meticulous accuracy: my husband painted me on 17 June 1439; and at the bottom: *Ætas mea triginta trium an(n)orum* – aged thirty-three. Very often these sixteenth-century portraits go in pairs; one for the wife, the other for the husband. Each portrait bears the same date, which is accordingly given twice over together with the age of both husband and wife: thus the two pictures by Pourbus of Jan Fernaguut and his wife Adrienne de Buc bear the same indication: *Anno domini 1551*, with *Ætatis suae 29* in the man's case and *19* in the woman's. It sometimes happens too that the portraits of husband and wife are painted together on the same canvas, like the Van Gindertaelens attributed to Pourbus, depicted with their two little children. The husband has one hand on his hip and is resting the other on his wife's shoulder. The two children are playing at their feet.

1. Chapter 9.

The date is 1559. On the husband's side is his coat of arms with the inscription *aetas an. 27*, and on the wife's side, the coat of arms of her family and the inscription *Ætatis mec. 20*. These particulars sometimes take on the appearance of a real epigraphic formula, as on the portrait by Martin de Voos dated 1572, which depicts Antoon Anselme, an Antwerp magistrate, his wife and their two children. The husband and wife are sitting on opposite sides of a table, one holding the boy and the other the girl. Between their heads, at the top and in the middle of the canvas, there is a fine scroll, carefully ornamented, bearing the following inscription: *concordi ae antonii anselmi et johannae Hooftmans feliciq: progagini, Martino de Vos pictore, DD natus est ille ann MDXXXVI die IX febr uxor ann MDLV D XVI decembr liberi ä Ægidius ann MDLXXV XXI Augusti Johanna ann MDLXVI XXVI septembr.*[2]

These dated family portraits were documents of family history, as photograph albums were to be three or four centuries later. The same spirit governed the family record books, in which, apart from the household accounts, domestic events were noted down, births and deaths. Here a regard for accuracy and the idea of the family came together. It was not so much a question of the individual's coordinates as of those of the members of the family: people felt a need to give family life a history by dating it. This curious passion for dating appeared not only in portraits but also in personal belongings and furniture. In the seventeenth century it became a common habit to carve or paint a date on beds, coffers, chests, cupboards, spoons and ceremonial glasses. The date corresponded to a solemn moment in the family's history, generally a marriage. In certain regions – Alsace, Switzerland, Austria and Central Europe – furniture from the seventeenth to the nineteenth century, and particularly painted furniture, was dated and also frequently inscribed with the names of its joint owners. In Thun Museum I have noticed this inscription on a chest: 'Hans Bischof – 1709 – Elizabeth Misler'. Sometimes only the initials of husband and wife were inscribed on either side of the date, the date of the marriage. This custom became very common in France, and disappeared only at the end of the nineteenth century: thus an official of the Musée des Arts et Traditions Populaires found a piece of furniture in the Upper Loire bearing the inscription: 1873 LT JV.[3] The inscription of ages or of a date on a portrait or an object helped to answer the desire to give the family greater historical consistency.

The taste for chronological inscription, while lasting into the middle of

2. The four pictures just described all appeared at an exhibition at the Orangerie, Paris, 1952.

3. Musée des Arts et Traditions Populaires, Exhibition no. 778.

the nineteenth century at least among people in average circumstances, rapidly disappeared in town and court, where it was obviously considered early on to be naive and provincial. From the middle of the seventeenth century, inscriptions tended to disappear from pictures (there were still a few to be found, but only on the pictures of painters working in or for the provinces). Fine period furniture was signed; or, if it was dated, it was dated very discreetly.

In spite of the importance which age had acquired in family epigraphy in the sixteenth century, there remained in everyday custom and usage some curious survivals of an age when it was an uncommon and difficult thing to remember one's age exactly. I pointed out earlier that our little Paul knows his age as soon as he begins to talk. Sancho Panza did not know exactly how old his own daughter was, for all that he was extremely fond of her: 'She may be fifteen, or two years older or younger, yet she is as tall as a lance and as fresh as an April morning . . .' (Cervantes, 1605). This is a case of a man of the people. In the sixteenth century, even in the educated classes where habits of modern precision were observed at an earlier date, children doubtless knew their age; but an extremely curious custom forbade them in the name of good manners from openly revealing it and obliged them to answer questions about it with a certain reserve. When the Valais humanist and pedagogue Thomas Platter tells the story of his life, he states with great precision when and where he was born, yet considers himself obliged to wrap up the fact in a prudent paraphrase: 'To begin with, there is nothing I can vouch for with less assurance than the exact date of my birth. When it occurred to me to ask for the date of my birth, I was told that I had come into the world in 1499, on Quinquagesima Sunday, just as the bells were ringing for Mass.' A curious mixture of uncertainty and precision. This reserve is an habitual reserve, a souvenir of a time when nobody ever knew a date for certain. What is surprising is that it should have become a part of good manners, for this was how one was supposed to give one's age in response to any inquiry. In Cordier's dialogues, two boys at school question each other during the play-hour: 'How old are you?' 'Thirteen, *so I have heard my mother say.*' (Cordier, 1586.) Even when the habits of personal chronology became part of our way of life, they did not succeed in imposing themselves as a positive attainment, and did not immediately dispel the old obscurity of age, and the custom of obscuring one's age lingered on for some time in the observance of good manners.

The 'ages of life' occupy a considerable place in the pseudo-scientific treatises of the Middle Ages. Their authors use a terminology which

strikes us as purely verbal: childhood, puerility, adolescence, youth, senility, old age – each word signifying a different period of life. Since then we have borrowed some of these words to denote abstract ideas such as puerility or senility, but these meanings were not contained in the first acceptations. The 'ages', 'ages of life', or 'ages of man' corresponded in our ancestors' minds to positive concepts, so well known, so often repeated and so commonplace that they passed from the realm of science to that of everyday experience. It is hard for us today to appreciate the importance which the concept of the 'ages' had in ancient representations of the world. A man's 'age' was a scientific category of the same order as weight or speed for our contemporaries; it formed part of a system of physical description and explanation which went back to the Ionian philosophers of the sixth century BC, which medieval compilers revived in the writings of the Byzantine Empire and which was still inspiring the first printed books of scientific vulgarization in the sixteenth century. We have no intention of trying to determine its exact formulation and its place in the history of science: all that matters here is that we should realize to what extent this science had become common property, how far its concepts had entered into mental habits and what it represented in everyday life.

We shall understand the problem better if we glance through the 1556 edition of *Le Grand Propriétaire de toutes choses*. This was a thirteenth-century Latin compilation which itself repeated all the data of the writers of the Byzantine Empire. It was thought fit to translate it into French and to give it a greater circulation by means of printing. *Le Grand Propriétaire de toutes choses* is an encyclopedia, a sort of Encyclopedia Britannica, but which is not analytical in concept and which attempts to render the essential unity of Nature and God. A treatise on physics, metaphysics, natural history, human physiology and anatomy, medicine and hygiene, and astronomy, at the same time as theology. Twenty books deal with God, the angels, the elements, man and his body, diseases, the sky, the weather, matter, air, water, fire, birds, and so on. The last book is devoted to numbers and measures. Certain practical recipes could also be found in this book. A general idea emerged from it, a scientific idea which had become extremely commonplace, the idea of the fundamental unity of Nature, of the solidarity which exists between all the phenomena of Nature, phenomena which could not be distinguished from supernatural manifestations. The idea that there was no opposition between the natural and the supernatural derived both from popular beliefs inherited from paganism and from a science that was physical as well as theological. I am inclined to think that this rigorous concept of the unity of Nature must be held responsible for the delay in scientific development, much more than

the authority of tradition, the ancients or the Scriptures. We cannot exert any influence on an element of Nature unless we are agreed that it can be adequately isolated. Given a certain degree of solidarity between the phenomena of Nature, as *Le Grand Propriétaire* postulates, it is impossible to intervene without setting off a chain reaction, without upsetting the order of the world: none of the categories of the cosmos possesses a sufficient autonomy, and nothing can be done in the face of universal determinism. Knowledge of Nature is limited to the study of the relations governing phenomena by means of a single causality – a knowledge which can foresee but cannot modify. There is no escape from this causality except through magic or miracles. A single rigorous law governs at one and the same time the movement of the planets, the vegetative cycle of the seasons, the connections between the elements, the human body and its humours, and the destiny of a man, with the result that astrology makes it possible to discover the personal effects of this universal determinism. As late as the middle of the seventeenth century, the practice of astrology was sufficiently widespread for the sceptical Molière to choose it as a butt for his raillery in *Les Amants magnifiques.*

The correspondence of numbers seemed to be one of the keys to this profound solidarity; the symbolism of numbers was a commonplace theme in religious speculations, in descriptions of physics and natural history, and in magic practices. For example, there was a correspondence between the number of the elements, the number of man's temperaments, and the number of the seasons: the figure 4. We find it difficult today to imagine this tremendous concept of a massive world in which nothing could be distinguished but a few correspondences. Science had made it possible to formulate the latter and to define the categories which they linked together; over the centuries these correspondences had slipped from the realm of science into that of popular mythology. The concepts born in sixth-century Ionia had gradually been adopted by the ordinary mentality; the categories of antiquo-medieval science had become commonplaces: the elements, the temperaments, the planets and their astrological significance, and the symbolism of numbers.

The concept of the ages of life was also one of the common ways of understanding human biology, in accord with the universal system of correspondences. This concept, which was destined to become extremely popular, did not go back to the great period of ancient science, however. It originated in the Byzantine Empire in the sixth century (Comparetti). Fulgentius found it hidden in the *Aeneid*: he saw in Aeneas's shipwreck the symbol of man's birth in the midst of the storms of existence. He interpreted Cantos 2 and 3 as the image of childhood hungering for fabu-

lous tales, and so on. An Arabian fresco of the eighth century, Kuseir Amra, already represented the ages of life.

There are countless medieval texts on this theme. *Le Grand Propriétaire de toutes choses* deals with the ages in its sixth book. Here the ages correspond to the planets, and there are seven of them:

The first age is childhood when the teeth are planted, and this age begins when the child is born and lasts until seven, and in this age that which is born is called an infant, which is as good as saying not talking, because in this age it cannot talk well or form its words perfectly, for its teeth are not yet well arranged or firmly implanted, as Isidore says and Constantine. After infancy comes the second age . . . it is called *pueritia* and is given this name because in this age the person is still like the pupil in the eye, as Isidore says, and this age lasts till fourteen.

Afterwards follows the third age, which is called adolescence, which ends according to Constantine in his viaticum in the twenty-first year, but according to Isidore it lasts till twenty-eight . . . and it can go on till thirty or thirty-five. This age is called adolescence because the person is big enough to beget children, says Isidore. In this age the limbs are soft and able to grow and receive strength and vigour from natural heat. And because the person grows in this age to the size allotted to him by Nature. (Yet growth is over before thirty or thirty-five, even before twenty-eight. And it was probably even less tardy at a time when work at a tender age mobilized the resources of the constitution earlier on).

Afterwards follows youth, which occupies the central position among the ages, although the person in this age is in his greatest strength, and this age lasts until forty-five according to Isidore, or until fifty according to others. This age is called youth because of the strength in the person to help himself and others, according to Aristotle. Afterwards follows senectitude, according to Isidore, which is half-way between youth and old age, and Isidore calls it gravity, because the person is grave in his habits and bearing; and in this age the person is not old, but he has passed his youth, as Isidore says. After this age follows old age, which according to some lasts until seventy and according to others has no end until death . . . old people have not such good sense as they had, and talk nonsense in their old age . . . The last part of old age is called *senies* in Latin, but in French there is no separate word for it . . . The old man is always coughing and spitting and dirtying (we are a long way yet from the noble old man of Greuze and Romanticism) until he returns to the ashes and dust from which he was taken.

Nowadays we may consider this jargon empty and verbose, but it had a meaning for those who read it, a meaning akin to that of astrology: it called to mind the link which joined the destiny of man to that of the planets. The same sort of sidereal correspondence had inspired another division into periods connected with the twelve signs of the zodiac, thus

linking the ages of life with one of the most popular and moving themes of the Middle Ages: the scenes of the calendar. A fourteenth-century poem, reprinted several times in the fifteenth and sixteenth centuries, expounds this calendar of the ages:

The first six years of life on earth
We to January would compare,
For in that month strength is as rare
As in a child six years from birth.

(from Morawski, 1926)

Or witness this thirteenth-century poem:

Of all the months the first behold,
January two-faced and cold.[4]
Because its eyes two ways are cast,
To face the future and the past.
Thus the child six summers old
Is not worth much when all is told.
But one must take every care
To see that he is fed good fare,
For he who does not start life well
Will finish badly, one can tell ...
When October winds do blow,
Then a man his wheat must sow
To feed the other men on earth;
Thus must act a man of worth
Who has arrived at sixty years:
He must sow in young folk's ears
Wisdom all their hearts to fill,
And give them charity if he will.

(from Morawski, 1926)

Of the same nature is the correspondence established between the ages of life and the other 'fours': *consensus quatuor elementorum, quatuor humorum* (the temperaments), *quatuor anni temporum et quatuor vitae aetatum.* About 1265, Philippe de Novare spoke of the 'four times of man's age' (Langlois, 1908), namely four periods of twenty years each. And these speculations went on recurring in text up to the sixteenth century.[5]

We must try to grasp the fact that this terminology, which seems so futile to us now, expressed ideas which were scientific at the time and also corresponded to a popular and commonplace idea of life. Here again, we come up against great difficulties of interpretation, because today we

4. Depicted in the calendars as *Janus bifrons.*
5. 1568.

no longer have this idea of life: we see life chiefly as a biological phenomenon, as a situation in society. Yet we say 'Such is life!' to express at once our resignation and our conviction that there is, outside biology and sociology, something which has no name, but which stirs us, which we look for in the news items of the papers, or about which we say: 'That's lifelike'. Life in this case is a drama, which rescues us from everyday boredom. For the man of old, on the contrary, it was the inevitable, cyclical, sometimes amusing and sometimes sad continuity of the ages of life; a continuity inscribed in the general and abstract order of things rather than in real experience, for in those periods of heavy mortality few men were privileged to live through all these ages.

The popularity of the 'ages of life' made the theme one of the most common in profane iconography. They are to be found for instance on some illuminated twelfth-century capitals in the baptistry at Parma (Didron). The sculptor has tried to represent at one and the same time the parable of the master of the vineyard and the labourers of the eleventh hour, and the symbol of the ages of life. In the first scene one can see the master of the vineyard laying his hand on a child's head, and underneath an inscription points out the allegory of the child: *prima aetas saeculi; primum humane; infancia.* Further on, *hora tertia; puericia secunda aetas* – the master of the vineyard can be seen putting his hand on the shoulder of a young man who is holding an animal and a bill-hook. The last of the labourers is resting beside his mattock: *senectus, sexta aetas.*

But it was above all in the fourteenth century that the essential characteristics of this iconography became fixed and remained virtually unchanged until the eighteenth century; they can be recognized on capitals in the Palace of the Doges (Didron) no less than in a fresco of the Eremitani at Padua (Venturi, 1914). First of all the age of toys: children playing with a hobby-horse, a doll, a windmill, or birds on leashes. Then the age of school. The boys learn to read or carry book and pen-tray, the girls learn to spin. Next the ages of love or of courtly and knightly sports: feasting, boys and girls walking together, a court of love, and the Maytime wedding festivities or hunt of the calendars. Next the ages of war and chivalry: a man bearing arms. Finally, the sedentary ages: those of the men of law, science or learning – the old bearded scholar dressed in old-fashioned clothes, sitting at his desk by the fire. The ages of life did not correspond simply to biological phases but also to social functions; we know that there were some very young lawyers, but in popular imagery learning is an old man's trade.

These attributes of fourteenth-century art are to be found in almost identical form in prints of a more popular, more commonplace type, which

lasted with very few changes from the sixteenth century to the beginning
of the nineteenth century. They were called the 'steps of the ages', because
they depicted a row of figures representing the various ages from birth to
death, and often standing on steps going up on the left and going down on
the right. In the centre of this double staircase, as under the arch of a
bridge, stood the skeleton of Death, armed with his scythe. Here the theme
of the ages merged with that of death, and it is probably no accident that
these two themes were among the most popular: prints depicting the
steps of the ages and the dances of death went on recapitulating until the
beginning of the nineteenth century an iconography established in the
fourteenth and fifteenth centuries. But unlike the dances of death, in which
the costumes never changed and remained those of the fifteenth and
sixteenth centuries even when the print was produced in the nineteenth,
the steps of the ages dressed their characters after the fashion of the day.
In the last of the nineteenth-century prints, First Communion costumes
can be seen making their appearance. The enduring quality of the symbols
is all the more remarkable for that: the child is still there riding his
hobby-horse, the schoolboy carrying book and pen-tray, the handsome
couple, with the young man sometimes holding a may-bush in one hand
as a sign of the feasts of adolescence and spring, and the man at arms, now
an officer wearing the sash of command or carrying a banner; on the
downward slope, the costumes have stopped being in fashion or have re-
mained true to the fashions of old, the men of law are still equipped with
their procedure-bags, the scholars with their books or their astrolabes, and
the churchgoers – the most curious of all these figures – with their rosaries.[6]

The repetition of these pictures, pinned to the wall next to the calendar
and in the midst of everyday objects, fostered the idea of a life cut into
clearly defined sections corresponding to certain modes of activity, physical
types, social functions and styles of dress. The division of life into periods
had the same fixity as the cycle of Nature or the organization of society.
In spite of the constant evocation of old age and death, the ages of life
remained good-natured, picturesque sketches, character silhouettes of a
rather whimsical kind.

Antiquo-medieval speculation had bequeathed to posterity a copious
terminology relating to the ages of life. In the sixteenth century, when it
was proposed to translate the terminology into French, it was found that
the French language, and consequently French usage, had not as many
words at its disposal as had Latin or at least learned Latin. The 1556 trans-

6. The 'steps of the ages' was not a theme in popular prints only. It is also to be found
in painting and sculpture: in Titian and Van Dyck and on the *fronton* of the Versailles
of Louis XIV.

lator of *Le Grand Propriétaire de toutes choses* makes no bones about recognizing the difficulty: 'It is more difficult in French than in Latin, for in Latin there are seven ages referred to by various names, of which there are only three in French: to wit, childhood, youth and old age.'

It will be noted that since youth signifies the prime of life, there is no room for adolescence. Until the eighteenth century, adolescence was confused with childhood. In school Latin the word *puer* and the word *adolescens* were used indiscriminately. Preserved in the Bibliothèque Nationale are the catalogues of the Jesuit College at Caen, a list of the pupils' names accompanied by comments.[7] A boy of fifteen is described in these catalogues as *bonus puer*, while his young schoolmate of thirteen is called *optimus adolescens*. Baillet, in a book on infant prodigies, admitted that there were no terms in French to distinguish between *pueri* and *adolescentes*. There was virtually only one word in use: *enfant*.

At the end of the Middle Ages, the meaning of this word was particulary extensive. It could be applied to both the *putto* (in the sixteenth century the *putti* room, the bedchamber decorated with frescoes depicting naked children, was referred to as 'the children's room') and the adolescent, the big lad who was sometimes also a bad lad. The word *enfant* ('child')* in the *Miracles de Notre-Dame* was used in the fourteenth and fifteenth centuries as a synonym of other words such as *valets, valeton, garçon, fils* ('valet', 'varlet', 'lad', 'son'): 'he was a *valeton*' would be translated today as 'he was a good-looking lad', but the same word could be used of both a young man ('a handsome *valeton*') and a child ('he was a *valeton*, so they loved him dearly . . . *li valez* grew up'). Only one word has kept this very ancient ambiguity down to our times, and that is the word *gars* ('lad'), which has passed straight from Old French into the popular modern idiom in which it is preserved. A strange child, this bad lad who was 'so perverse and wicked that he would not learn a trade or behave as was fitting in childhood . . . he kept company with greedy, idle folk who often started brawls in taverns and brothels, and he never came across a woman by herself without raping her'. Here is another child of fifteen: 'Although he was a fine, handsome son', he refused to go riding or to have anything to do with girls. His father thought that it was out of shyness: 'This is customary in children.' In fact, he was betrothed to the Virgin. His father forced him into marriage: 'The child became very angry and struck him hard.' He tried to make his escape and suffered mortal injuries

7. Bibliothèque Nationale, MSS Fond Latin, nos. 10990 and 10991.

* In the following discussion of terminology (pp. 23–6), wherever the word 'child' or 'children' is used, the original French source has 'enfant' or 'enfants' (translator's note).

by falling downstairs. The Virgin then came for him and said to him: 'Dear brother, behold your sweetheart.' And: 'At this the child heaved a sigh.' According to a sixteenth-century calendar of the ages, at twenty-four 'a child is strong and brave', and 'this is what becomes of children when they are eighteen.'

The same is true in the seventeenth century. The report of an episcopal inquiry of 1667 states that in one parish 'there is *un jeune enfans* ['a young child'] aged about fourteen who in the year or so he has been living in the aforementioned place has been teaching children of both sexes to read and write, by arrangement with the inhabitants of the aforementioned place' (Charmasse, 1878).

In the course of the seventeenth century a change took place by which the old usage was maintained in the more dependent classes of society, while a different usage appeared in the middle class, where the word 'child' was restricted to its modern meaning. The long duration of childhood as it appeared in the common idiom was due to the indifference with which strictly biological phenomena were regarded at the time: nobody would have thought of seeing the end of childhood in puberty. The idea of childhood was bound up with the idea of dependence: the words 'sons', 'varlets' and 'boys' were also words in the vocabulary of feudal subordination. One could leave childhood only by leaving the state of dependence, or at least the lower degrees of dependence. That is why the words associated with childhood would endure to indicate in a familiar style, in the spoken language, men of humble rank whose submission to others remained absolute – lackeys, for instance, journeymen and soldiers. A 'little boy' (*petit garçon*) was not necessarily a child but a young servant, just as today an employer or a foreman will say of a worker of twenty to twenty-five: 'He's a good lad.' Thus in 1549, one Baduel, the principal of a college, an educational establishment, wrote to the father of one of his young pupils about his outfit and attendants: 'A little boy is all that he will need for his personal service' (Gaufrés, 1880).

At the beginning of the eighteenth century, Furetière's dictionary gave an explanation of the usage:

'Child' is also a term of friendship used to greet or flatter someone or to induce him to do something. Thus when one says to an aged person: 'Goodbye, good mother' ('so long, grandma,' in the modern idiom) she replies: 'Goodbye, my child' ('goodbye, lad'). Or she will say to a lackey: 'Child, go and get me this or that.' A master will say to his men when setting them to work: 'Come along, children, get to work.' A captain will say to his soldiers: 'Courage, children, stand fast.' Front-line troops, those most exposed to danger, were called 'the lost children'.

At the same time, but in families of gentle birth, where dependence was only a consequence of physical infirmity, the vocabulary of childhood tended rather to refer to the first age. Its use became increasingly frequent in the seventeenth century: the expression 'little child' (*petit enfant*) began to take on the meaning we give it. The older usage had preferred 'young child' (*jeune enfant*), and this expression had not been completely abandoned. La Fontaine used it, and again in 1714, in a translation of Erasmus, there was a reference to a 'young girl' who was not yet five: 'I have a young girl who has scarcely begun to talk.' The word *petit* or 'little one' had also acquired a special meaning by the end of the sixteenth century: it referred to all the pupils of the 'little schools', even those who were no longer children. In England, the word 'petty' had the same meaning as in French, and a text of 1627 on the subject of school spoke of the *lyttle petties*, the smallest pupils (Brinsley, 1917).

It was above all with Port-Royal and with all the moral and pedagogic literature which drew its inspiration from Port-Royal (or which gave more general expression to a need for moral discipline which was widely felt and to which Port-Royal too bore witness), that the terms used to denote childhood became common and above all modern: Jacqueline Pascal's pupils at Port-Royal were divided into 'little ones', 'middle ones' and 'big ones'. 'With regard to the little children,' she wrote, 'they even more than all the others must be taught and fed if possible like little doves' (Pascal, 1721). The regulations of the little schools at Port-Royal stated: 'They do not go to Mass every day, only the little ones.' People spoke in a new way of 'little souls' and 'little angels', expressions which foreshadowed the eighteenth century and Romanticism. In her tales, Mlle L'Héritier claimed to be addressing 'young minds', 'young people'. These pictures probably lead young people to reflections which perfect their reasoning.' (Storer, 1928). It can thus be seen that that seventeenth century which seemed to have scorned childhood, in fact brought into use expressions and phrases which remain to this day in our language. Under the word 'child' in his dictionary, Furetière quoted proverbs which are still familiar to us: 'He is a spoilt child, who has been allowed to misbehave without being punished. The fact is, there are no longer any children, for people are beginning to have reason and cunning at an early age.' 'Innocent as a new-born child.'

All the same, in its attempts to talk about little children, the French language of the seventeenth century was hampered by the lack of words to distinguish them from bigger ones. The same was true of English, where the word 'baby' was also applied to big children. Lily's Latin grammar in

English, which was in use from the beginning of the sixteenth century until 1866, was intended for 'all lytell babes, all lytell chyldren'.

On the other hand there were in French some expressions which seem to refer to very little children. One of these was the word *poupart*. In one of the *Miracles de Notre-Dame* there was a 'little son' who wanted to feed a picture of the Infant Jesus. 'Tender-hearted Jesus, seeing the insistence and good will of the little child, spoke to him and said: *"Poupart,* weep no more, for in three days you shall eat with me."' But this *poupart* was not really what the French today would call a *bébé*: he was also referred to as a *clergeon* or 'little clerk', wore a surplice and served at Mass: 'Here there were also little children who had few letters and would rather have fed at their mother's breast than do divine service!' In the language of the seventeenth and eighteenth centuries the word *poupart* no longer denoted a child, but instead, in the form *poupon*, what the French today still call by the same name, but in the feminine: a *poupée*, or doll.

French was therefore reduced to borrowing from other idioms – either foreign languages or the slang used in school or trade – words to denote in French that little child in whom an interest was henceforth going to be taken. This was the case with the Italian *bambino* which became the French *bambin*. Mme de Sévigné also used in the same sense a form of the Provençal word *pitchoun*, which she had doubtless learnt in the course of one of her stays with the Grignans.[8] Her cousin Coulanges, who did not like children but spoke of them a great deal, distrusted 'three-year-old *marmousets*', an old word which in the popular idiom would become *marmots*, 'brats with greasy chins who put a finger in every dish'. People also used slang terms from school Latin or from sporting and military academies: a little *frater*, a *cadet*, and, when there were several of them, a *populo* or *petit peuple* (Bouzonnet-Stella, 1657). Lastly the use of diminutives became quite common: *fanfan* is to be found in the letters of Mme de Sévigné and those of Fénelon.

In time these words would come to denote a child who was still small but already beginning to find his feet. There would still remain a gap where a word was needed to denote a child in its first months of life; this gap would not be filled until the nineteenth century, when the French would borrow from the English the word 'baby', which in the sixteenth and seventeenth centuries had denoted children of school age. This borrowing was the last stage of the story: henceforth, with the French word *bébé*, the very little child had a name.

8. 'You do me an injustice in thinking that I love the little one better than the *pichon* . . .' Mme de Sévigné, 1675.

Even when a vocabulary relating to infancy appeared and expanded, an ambiguity remained between childhood and adolescence on the one hand and the category known as youth on the other. People had no idea of what we call adolescence, and the idea was a long time taking shape. One can catch a glimpse of it in the eighteenth century in two characters – one literary, as presented by Chérubin, and the other social, the conscript. In Chérubin it was the ambiguity of puberty that was uppermost, and the stress was laid on the effeminate side of a boy just emerging from childhood. Strictly speaking, this was not a new thing: since social life began at a very early age, the full, round features of early adolescence, about the age of puberty, gave boys a feminine appearance. This is the explanation of the ease with which men disguised themselves as women and vice versa in countless baroque novels at the beginning of the seventeenth century – two youths becoming friends when one was a girl in disguise, and so on; however credulous readers of adventure stories have always been, the very minimum of probability demands that there should have been some resemblance between a beardless boy and a girl. However, that resemblance was not presented at the time as a characteristic of adolescence, a characteristic of age. Those beardless men with soft features were not adolescents for they already behaved like fully grown men, fighting and giving orders. But in Chérubin the feminine appearance was linked with the transition from child to adult: it expressed a condition during a certain period, the period of budding love.

Chérubin was not destined to have any successors. On the contrary, it was manly strength which, in boys, would express the idea of adolescence, and the adolescence was foreshadowed in the eighteenth century by the conscript. Witness the text of this recruiting poster[9] dating from the end of the eighteenth century. It is addressed to 'shining youth' (*brillante jeunesse*): 'Those youths (*jeunes gens*) who wish to share in the reputation which this fine corps has won for itself can apply to M. d'Ambrun ... They (the recruiters) will reward those who bring them some upstanding men (*beaux hommes*).'

The first typical adolescent of modern times was Wagner's *Siegfried*: the music of *Siegfried* expressed for the first time that combination of (provisional) purity, physical strength, naturism, spontaneity and *joie de vivre* which was to make the adolescent the hero of our twentieth century, the century of adolescence. What made its appearance in Wagnerian Germany was to enter France at a later date, in the years around 1900. The 'youth' which at this time was adolescence soon became a literary theme

9. For the Royal Piedmont Regiment at Nevers, 1789; at *L'Affiche* exhibition, 1953, Bibliothèque Nationale.

and a subject of concern for moralists and politicians. People began wondering seriously what youth was thinking, and inquiries were made by such writers as Massis and Henriot. Youth gave the impression of secretly possessing new values capable of reviving an aged and sclerosed society. A like interest had been evidenced in the Romantic period, but not with such specific reference to a single age group, and moreover it had been limited to literature and the readers of that literature. Awareness of youth became a general phenomenon, however, after the end of the First World War, in which the troops at the front were solidly opposed to the older generations in the rear. The awareness of youth began by being a feeling common to ex-servicemen, and this feeling was to be found in all the belligerent countries, even in the America of Dos Passos. From that point, adolescence expanded: it encroached upon childhood in one direction, maturity in the other. Henceforth marriage, which had ceased to be a 'settling down', would not put an end to it: the married adolescent was to become one of the most prominent types of our time, dictating its values, its appetites and its customs. Thus our society has passed from a period which was ignorant of adolescence to a period in which adolescence is the favourite age. We now want to come to it early and linger in it as long as possible.

This evolution has been accompanied by a parallel but contrary evolution of old age. We know that old age started early in the society of the past. We are familiar with such examples as Molière's old men, who appear to be still young to our eyes. Moreover the iconography of old age does not always represent it in the guise of a decrepit invalid: old age begins with the losing of one's hair and the wearing of a beard, and a handsome old man sometimes appears simply as a man who is bald. This is the case with the old man in Titian's concert, which is also a representation of the ages of life. But generally speaking, before the eighteenth century the old man was regarded as ridiculous. One of Rotrou's characters[10] tries to force his daughter to accept a quinquagenarian: 'He is only fifty, and hasn't a tooth in his head. In the whole of Nature there's not a man who doesn't think he was born in the age of Saturn or the time of the Flood. Of the three feet on which he walks, two are gouty. They stumble at every step and are always having to be propped up or picked up.' And in another ten years he will look like this sexagenarian in Quinault's *La Mère Coquette*: 'Bent over his stick, the little old man coughs, spits, blows his nose, cracks jokes, and bores Isabelle with tales of the good old days.'

Old France had little respect for old age: it was the age of retirement, books, churchgoing and rambling talk. The picture of the whole man in

10. In *La Soeur*.

the sixteenth and seventeenth centuries was that of a younger man: the officer in the sash at the top of the steps of the ages. He was not a young man, although he would be today. He corresponded to that second category of the ages, between childhood and old age, which in the seventeenth century was called youth. Furetière, who still took very seriously the archaic problems of the division of life into periods, thought up an intermediate concept of maturity; but he recognized that it was not current and admitted: 'Jurists see only one age in youth and maturity.' The seventeenth century recognized itself in this military youth, as the twentieth century recognizes itself in its adolescents.

Today old age has disappeared, at least from spoken French, where the expression *un vieux*, 'an old fellow', has survived with a colloquial, contemptuous or patronizing significance. This evolution has taken place in two stages. First of all there was the venerable old man, the silver-haired ancestor, the wise Nestor, the patriarch rich in precious experience: the old man of Greuze, Restif de la Bretonne and the whole nineteenth century. He was not yet very agile, but he was no longer as decrepit as the old man of the sixteenth and seventeenth centuries. There still remains something of this respect for the old man in the received ideas of the present day. But the fact is that this respect no longer has any object, for in our time, and this is the second stage, the old man has disappeared. He has been replaced by 'the elderly man' and by 'well-preserved ladies or gentlemen' – a concept which is still middle-class, but which is tending to become popular. The technological idea of preservation is replacing the biological and moral idea of old age.

It is as if, to every period of history, there corresponded a privileged age and a particular division of human life: 'youth' is the privileged age of the seventeenth century, childhood of the nineteenth, adolescence of the twentieth.

The variations from one century to another bear witness to the naive interpretations which public opinion has given, in each and every period, of its demographic structure, when it could not always form an objective idea of it. Thus the absence of adolescence and the contempt for old age on the one hand, and on the other hand the disappearance of old age – at least as a degradation – and the introduction of adolescence, express society's reactions to the duration of life. Prolongation of the average lifespan brought into existence tracts of life to which the scholars of the Byzantine Empire and the Middle Ages had given names even though they had not existed for the generality; and the modern language has borrowed these old terms, which were originally purely theoretical, to denote

new realities: the last phase of a long familiar and now forgotten theme, that of the 'ages of life'.

In periods when life is short, the idea of a privileged age is even more important than in our period of longevity. In the following pages, we shall pay particular attention to the indications of childhood. In the course of this study we must never forget to what extent this representation of childhood remains relative, in comparison with the preference given to 'youth' in the period under examination (pre-nineteenth century). That time was not one of children or of adolescents or of old men: it was a period of *young men*.

Chapter 2
The Discovery of Childhood

Medieval art until about the twelfth century did not know childhood or did not attempt to portray it. It is hard to believe that this neglect was due to incompetence or incapacity; it seems more probable that there was no place for childhood in the medieval world. An Ottonian miniature of the twelfth century provides us with a striking example of the deformation which an artist at that time would inflict on children's bodies.[1] The subject is the scene in the Gospels in which Jesus asks that little children be allowed to come to Him. The Latin text is clear: *parvuli*. Yet the miniature has grouped around Jesus what are obviously eight men, without any of the characteristics of childhood; they have simply been depicted on a smaller scale. In a French miniature of the late eleventh century the three children brought to life by St Nicholas are also reduced to a smaller scale than the adults, without any other difference in expression or features.[2] A painter would not even hesitate to give the naked body of a child, in the very few cases when it was exposed, the musculature of an adult: thus in a Psalter dating from the late twelfth or early thirteenth century, Ishmael, shortly after birth, has the abdominal and pectoral muscles of a man.[3] The thirteenth century, although it showed more understanding in its presentation of childhood, remained faithful to this method.[4] In St Louis's moralizing Bible, children are depicted more often, but they are still indicated only by their size. In an episode in the life of Jacob, Isaac is shown sitting between his two wives, surrounded by some fifteen little men who come up to the level of the grown-ups' waists: these are their children. When Job is rewarded for his faith and becomes rich once more, the illuminator depicts his good fortune by placing Job between an equal number of cattle on the left and children on the right: the traditional picture of fecundity inseparable from wealth. In another illustration in the Book of Job, some children are lined up in order of size.

1. Gospel-book of Otto III, Munich.
2. 'Vie et Miracle de Saint Nicolas', Bibliothèque Nationale.
3. Psalter of St Louis of Leyden.
4. Compare the scene, 'Suffer the little children to come to me' in Otto's Gospel-book and in the *Bible Moralisée de Saint Louis*.

In the thirteenth-century Gospel-book of the Sainte-Chapelle, in an illustration of the miracle of the loaves and fishes, Christ and one of the Apostles are shown standing on either side of a little man who comes up to their waists: no doubt the child who carried the fishes.[5] In the world of Romanesque formulas, right up to the end of the thirteenth century, there are no children characterized by a special expression but only men on a reduced scale. This refusal to accept child morphology in art is to be found too in most of the ancient civilizations. A fine Sardinian bronze of the ninth century BC shows a sort of Pietà: a mother holding in her arms the somewhat bulky body of her son.[6] The catalogue tells us 'The little masculine figure could also be a child which, in accordance with the formula adopted in ancient times by other peoples, had been represented as an adult.' Everything in fact would seem to suggest that the realistic representation of children or the idealization of childhood, its grace and rounded charms, was confined to Greek art. Little Eroses proliferated in the Hellenistic period, but childhood disappeared from iconography together with the other Hellenistic themes, and Romanesque art returned to that rejection of the special features of childhood which had already characterized the periods of antiquity before Hellenism. This is no mere coincidence. Our starting-point in this study is a world of pictorial representation in which childhood is unknown; literary historians such as Mgr Calvé have made the same observation about the epic, in which child prodigies behave with the courage and physical strength of doughty warriors. This undoubtedly means that the men of the tenth and eleventh centuries did not dwell on the image of childhood, and that that image had neither interest nor even reality for them. It suggests too that in the realm of real life, and not simply in that of aesthetic transposition, childhood was a period of transition which passed quickly and which was just as quickly forgotten.

Such is our starting-point. How do we get from there to the little imps of Versailles, to the photographs of children of all ages in our family albums?

Around the thirteenth century, a few types of children are to be found which appear to be a little closer to the modern concept of childhood. There is the angel, depicted in the guise of a very young man, a young adolescent – a clergeon, as Père du Colombier (1951) remarks. But how old is this 'little clerk'? The clergeons were children of various ages who were trained to make the responses in church and who were destined for holy orders,

5. Gospel-book in the Sainte-Chapelle.
6. Exposition des Bronzes Sardes, Bibliothèque Nationale, 1954.

seminarists of a sort in a period when there were no seminaries and when schooling in Latin, the only kind of schooling that existed, was reserved for future clerks. 'Here,' says one of the *Miracles de Notre-Dame*, 'there were little children who had few letters and would rather have fed at their mother's breast [but children were weaned very late at that time: Shakespeare's Juliet was still being breast-fed at three] than do divine service.' The angel of Reims, to take one example, is a big boy rather than a child, but the artists have stressed the round, pretty, and somewhat effeminate features of youths barely out of childhood. We have already come a long way from the small-scale adults of the Ottonian miniature. This type of adolescent angel was to become extremely common in the fourteenth century and was to last to the very end of the Italian *Quattrocento*: the angels of Fra Angelico, Botticelli and Ghirlandajo all belong to it.

The second type of child was to be the model and ancestor of all the little children in the history of art: the Infant Jesus, or the Infant Notre-Dame, for here childhood is linked to the mystery of motherhood and the Marian cult. To begin with, Jesus, like other children, is an adult on a reduced scale: a little God-priest in His majesty, depicted by Theotokos. The evolution towards a more realistic and more sentimental representation of childhood begins very early on in painting: in a miniature of the second half of the twelfth century, Jesus is shown wearing a thin, almost transparent shift and standing with His arms round His mother's neck, nestling against her, cheek to cheek.[7] With the Virgin's motherhood, childhood enters the world of pictorial representation. In the thirteenth century it inspires other family scenes. In St Louis's moralizing Bible, there are various family scenes in which parents are shown surrounded by their children with the same tender respect as on the rood-screen at Chartres: thus in a picture of Moses and his family, husband and wife are holding hands while the children (little men) surrounding them are stretching out their hands towards their mother. These cases, however, remained rare: the touching idea of childhood remained limited to the Infant Jesus until the fourteenth century, when, as is well known, Italian art was to help to spread and develop it.

A third type of child appeared in the Gothic period: the naked child. The Infant Jesus was scarcely ever depicted naked. More often than not, like other children of His age, He was chastely wrapped in swaddling-clothes or clad in a shift or a dress. He would not be undressed until the end of the Middle Ages. Those few miniatures in the moralizing Bibles which depicted children showed them fully dressed, except in the case of

7. *Manuscrits à Peinture du 7e au 12e Siècle*, Exhibition at the Bibliothèque Nationale, 1954.

the Innocents or the dead children whose mothers Solomon was judging. It was the allegory of death and the soul which was to introduce into the world of forms the picture of childish nudity. Already in the pre-Byzantine iconography of the fifth century, in which many features of the future Romanesque art made their appearance, the bodies of the dead were reduced in scale. Corpses were smaller than living bodies. In the *Iliad* in the Ambrosian Library the dead in the battle scenes are half the size of the living. In French medieval art the soul was depicted as a little child who was naked and usually sexless. The Last Judgments[8] lead the souls of the righteous to Abraham's bosom in this form. The dying man breathes the child out through his mouth in a symbolic representation of the soul's departure. This is also how the entry of the soul into the world is depicted, whether it is a case of a holy, miraculous conception – the Angel of the Annunciation presenting the Virgin with a naked child, Jesus's soul[9] – or a case of a perfectly natural conception : a couple resting in bed apparently quite innocently, but something must have happened, for a naked child can be seen flying through the air and entering the woman's mouth – 'the creation of the human soul by natural means'.[10]

In the course of the fourteenth and particularly the fifteenth century, these medieval types would develop further, but in the direction already indicated in the thirteenth century. We have already observed that the angel/altar-boy would go on playing its part without very much change, in the religious painting of the fifteenth century. On the other hand the theme of the Holy Childhood would never cease developing in both scope and variety from the fourteenth century on. Its popularity and fecundity bear witness to the progress, in the collective consciousness, of that idea of childhood which only a keen observer can distinguish in the thirteenth century and which did not exist at all in the eleventh century. In the group of Jesus and His mother, the artist would stress the graceful, affectionate, naive aspects of early childhood : the child seeking its mother's breast or getting ready to kiss or caress her, the child playing the traditional childhood games with fruit or a bird on a leash, the child eating its pap, the child being wrapped in its swaddling-clothes. Every gesture that could be observed – at least by somebody prepared to pay attention to them – would henceforth be reproduced in pictorial form. These features of sentimental realism would take a long time to extend beyond the frontiers of religious iconography, which is scarcely surprising when one remembers that this was also the case with landscape and genre painting. It remains

8. Rampilly.
9. See note 4, page 31.
10. *Miroir d'Humilité*, Valenciennes, early fifteenth century.

none the less true that the group of Virgin and Child changed in charac-
ter and became more and more profane : the picture of a scene of everyday
life.

Timidly at first, then with increasing frequency, the painters of religious
childhood went beyond that of Jesus. First of all they turned to the child-
hood of the Virgin, which inspired at least two new and popular themes;
firstly the theme of the birth of the Virgin – people in St Anne's bedroom
fussing over the new-born child, bathing her, wrapping her in swaddling-
clothes and showing her to her mother, and then the theme of the Virgin's
education – a reading lesson, with the Virgin following the words in a book
held by St Anne. Then came other holy childhoods; those of St John,
the Infant Jesus's playmate, St James, and the children of the holy women,
Mary Zebedee and Mary Salome. A completely new iconography thus
came into existence, presenting more and more scenes of childhood, and
taking care to gather together in similar groups these holy children, with
or without their mothers.

This iconography, which generally speaking started with the fourteenth
century, coincided with a profusion of priors' tales and legends, such as
those in the *Miracles de Notre-Dame*. It continued up to the seventeenth
century and its development can be followed in painting, tapestry and
sculpture. We shall in any case have occasion to return to it with regard to
the religious practices of childhood.

From this religious iconography of childhood, a lay iconography
eventually detached itself in the fifteenth and sixteenth centuries. This
was not yet the portrayal of the child on its own. Genre painting was
developing at this time by means of the transformation of a conventional
allegorical iconography inspired by the antiquo-medieval concept of
Nature: ages of life, seasons, senses, elements. Subject pictures and
anecdotal paintings began to take the place of static representations of sym-
bolic characters. We shall have cause to deal with this evolution at some
length later on, in Part 3, Chapter 15. Let us merely note here that the
child became one of the characters most frequently found in these anec-
dotal paintings : the child with his family; the child with his playmates,
who were often adults; the child in a crowd, but very definitely 'spot-
lighted' in his mother's arms, or holding her hand or playing or even
piddling; the child among the crowds watching miracles or martyrdoms,
listening to sermons, or following liturgical rites such as presentations or
circumcisions; the child serving as an apprentice to a goldsmith or a
painter or some other craftsman; or the child as school, an old and popular
theme which went back to the fourteenth century and would go on inspir-
ing subject paintings up to the nineteenth century.

These subject paintings were not as a general rule devoted to the exclusive portrayal of childhood, but in a great many cases there were children among the characters depicted, both principal and secondary. And this suggests the ideas, first that children mingled with adults in everyday life, and any gathering for the purpose of work, relaxation or sport brought together both children and adults; and secondly, that painters were particularly fond of depicting childhood for its graceful or picturesque qualities (the taste for the picturesque anecdote developed in the fifteenth and sixteenth centuries and coincided with the appreciation of childhood's charms). They delighted in stressing the presence of a child in a group or a crowd. Of these two ideas one now strikes us as out of date, for today, as also towards the end of the nineteenth century, we tend to separate the world of children from that of adults; the other foreshadows the modern idea of childhood.

The origins of the themes of the angel, the holy childhoods, and their subsequent iconographical developments date as far back as the thirteenth century; two new types of child portrayal appeared in the fifteenth century: the portrait and the *putto*. The child, as we have seen, was not missing from the Middle Ages, at least from the thirteenth century on, but there was never a portrait of him, the portrait of a real child, as he was at a certain moment of his life.

In the funeral effigies listed in the Gaignières Collection,[11] the child appeared only at a very late date, in the sixteenth century. Curiously enough, his first appearance was not on his own tomb or that of his parents but on that of his teachers. On the tombs of the masters of Bologna, the teacher was shown surrounded by his pupils. As early as 1378, Cardinal de La Grange, the Bishop of Amiens, had the two princes he had tutored portrayed at the ages of ten and seven on a 'handsome pillar' in his cathedral.[12] No one thought of keeping a picture of a child if that child had either lived to grow to manhood or had died in infancy. In the first case, childhood was simply an unimportant phase of which there was no need to keep any record; in the second case, that of the dead child, it was thought that the little thing which had disappeared so soon in life was not worthy of remembrance: there were far too many children whose survival was problematical. The general feeling was, and for a long time remained, that one had several children in order to keep just a few. As late as the seventeenth century, in *Le Caquet de l'accouchée*, we have a neighbour, standing at the bedside of a woman who has just given birth, the mother of

11. Gaignières, *Les Tombeaux*.
12. Before this, the representation of children on tombs was rare.

five 'little brats', and calming her fears with these words: 'Before they are old enough to bother you, you will have lost half of them, or perhaps all of them.' A strange consolation! People could not allow themselves to become too attached to something that was regarded as a probable loss. This is the reason for certain remarks which shock our present-day sensibility, such as Montaigne's observation: 'I have lost two or three children in their infancy, not without regret, but without great sorrow', or Molière's comment on Louison in *Le Malade imaginaire*: 'The little girl doesn't count.' Most people probably felt, like Montaigne, that children had 'neither mental activities nor recognizable bodily shape'. Mme de Sévigné (1671) records without any sign of surprise a similar remark made by Mme de Coetquen when the latter fainted on receiving the news of her little daughter's death: 'She is greatly distressed and says that she will never again have one so pretty.'

Nobody thought, as we ordinarily think today, that every child already contained a man's personality. Too many of them died. 'All mine die in infancy', wrote Montaigne. This indifference was a direct and inevitable consequence of the demography of the period. It lasted until the nineteenth century in the depths of the country, in so far as it was compatible with Christianity, which respected the immortal soul in every child that had been baptized. It is recorded that the people of the Basque country retained for a very long time the custom of burying children that had died without baptism in the house, on the threshold, or in the garden. Here we may perhaps see a survival of ancient rites, of sacrificial offerings, or rather it may be that the child that had died too soon in life was buried almost anywhere, much as we today bury a domestic pet, a cat or a dog. He was such an unimportant little thing, so inadequately involved in life, that nobody had any fears that he might return after death to pester the living. It is interesting to note that in the frontispiece to the *Tabula Cebetis* Mérian has placed the little children in a sort of marginal zone, between the earth from which they have emerged and the life into which they have not yet entered, and from which they are separated by a portico bearing the inscription *Introitus ad vitam*. This feeling of indifference towards a too fragile childhood is not really very far removed from the callousness of the Roman or Chinese societies which practised the exposure of new-born children. We can now understand the gulf which separates our concept of childhood from that which existed before the demographic revolution or its preceding stages. There is nothing about this callousness which should surprise us: it was only natural in the community conditions of the time. On the other hand, there are grounds for surprise in the earliness of the idea of childhood, seeing that conditions

were still so unfavourable to it. Statistically and objectively speaking, this idea should have appeared much later. True, there was the taste for the picturesque, pleasing aspects of the little creatures, the idea of the charms of childhood and the entertainment to be derived from the ingenuous antics of infancy: 'puerile nonsense', as Montaigne said, in which we adults take an interest 'for our amusement, like monkeys'. But this idea could quite easily go hand in hand with indifference towards the essential, definitive personality of the child, the immortal soul. The new taste for the portrait indicated that children were emerging from the anonymity in which their slender chance of survival had maintained them. It is in fact quite remarkable that at that period of demographic wastage anyone should have felt a desire to record and keep the likeness of a child that would go on living or of a child that was dead. The portrait of the dead child in particular proves that that child was no longer generally considered as an inevitable loss. This solicitous attitude did not exclude or eliminate the opposite attitude, that of Montaigne, the neighbour at the mother's bedside, and Molière: down to the eighteenth century they coexisted. It was only in the eighteenth century, with the beginning of Malthusianism and the extension of contraceptive practices, that the idea of necessary wastage would disappear.

The appearance of the portrait of the dead child in the sixteenth century accordingly marked a very important moment in the history of feelings. This portrait was a funeral effigy to begin with. The child was not at first portrayed alone, but on his parents' tomb. Gaignières's records show the child by his mother's side and very tiny, or else at his parents' feet. These tombs all date back to the sixteenth century: 1503, 1530, 1560. Among the interesting tombs in Westminster Abbey, let us note that of the Marchioness of Winchester, who died in 1586. The recumbent figure of the Marchioness is life-size; represented on the front of her tomb on a smaller scale are her husband the Marquess, kneeling, and the tiny tomb of a dead child. At Westminster too, on a tomb dating from 1615 to 1620, the Earl and Countess of Shrewsbury are represented in a pair of recumbent figures, with their little daughter kneeling at their feet, her hands folded in prayer. It should be noted here that the children who surround the dead are not always dead themselves: the whole family is gathered round the heads of that family, as if it were at the time when they breathed their last. But beside the children who are still alive the sculptor has portrayed those who are already dead; there is always an indication to distinguish them: they are smaller and they hold a cross in their hands (as on John Coke's tomb at Holkham, 1639) or else a skull (on Cope of Ayley's tomb at Hambledon, 1633, there are four boys and three girls around the

dead parents, and one boy and one girl are holding a skull) (see Bond, 1909).

At Toulouse in the Musée des Augustins there is an extremely interesting triptych that comes from the Du Mège Collection. The volets are dated 1610. On either side of a 'Descent from the Cross' the donors, a husband and wife, are depicted on their knees, together with their ages. Both are sixty-three. Next to the man there is a child, wearing what was then the fashion for very little children, under five years of age: a girl's dress and pinafore and a big bonnet with feathers. The child is dressed in bright, rich colours, green brocaded in gold, which throw into relief the severity of the donors' black clothes. This woman of sixty-three cannot possibly have a child of five. It is clearly a dead child, no doubt an only son whose memory the old couple treasured and whom they wanted to show beside them in his best clothes.

It was a pious custom in the old days to present churches with a picture or a stained-glass window, and in the sixteenth century the donor had himself portrayed with his whole family. On the walls and pillars of German churches one can still see a great many pictures of this kind which are in fact family portraits. In St Sebastian's in Nürnberg, in a portrait from the second half of the sixteenth century, the father is shown in the foreground with two full-grown sons behind him and then a scarcely distinguishable bunch of six boys crowded together, hiding behind each other so that some of them are barely visible. Surely these must be dead children.

A similar picture, dated 1560, and kept in Bregenz Museum, has the children's ages recorded on the banderoles: three boys, aged one, two and three; five girls, aged one, two, three, four and five. But the eldest girl of five has the same size and dress as the youngest of one. She has been given her place in the family group just as if she had gone on living, but she has been portrayed at the age when she died.

These family groups are naive, clumsy, monotonous works without style; their painters, like their models, remain unknown or obscure. It is a different matter when the donor has obtained the services of a celebrated painter: in such instances art historians have carried out the research required to identify the figures in a famous painting. This is the case with the Meyer family which Holbein portrayed in 1526 at the Virgin's feet. We know that of the six people in the picture three had died in 1526: Jacob Meyer's first wife and her two boys, one of whom were dead at the age of ten and the other, who is shown naked, at an earlier age.

Here in fact we have a custom which became widespread in the sixteenth century and remained so until the mid-nineteenth century.

Versailles Museum has a picture by Nocret portraying the families of Louis XIV and his brother; this painting is famous because the King and the princes are half-naked – the men at least – like gods of Olympus. We would draw attention to one detail here: in the foreground, at Louis XIV's feet, Nocret has placed a framed picture showing two little children who had died in infancy.

Gaignières's records note as early as the end of the sixteenth century some tombs bearing effigies of children on their own: one dates from 1584, the other from 1608. The child is shown in the costume peculiar to his age, in a dress and bonnet, like the child in the Toulouse 'Descent from the Cross'. When within the two years of 1606 and 1607 James I lost two daughters, one when she was three days old and the other at two years of age, he had them portrayed fully dressed on their tombs at Westminster, and he gave instructions that the younger should be shown lying in an alabaster cradle in which all the accessories – the lace of her swaddling-clothes and her bonnet – should be faithfully reproduced to create the illusion of reality. The inscription on the tomb gives a good idea of the pious feeling which endowed this three-day-old child with a definite personality: *Rosula Regia prae-propero Fato decerpta, parentibus erepta, ut in Christi Rosario reflorescat.*

Apart from these mortuary effigies, portraits of children shown separately from their parents were a rarity until the end of the sixteenth century: witness the painting of the Dauphin, Charles Orlando, by the Maître de Moulins, another instance of the pious regard felt for children who had died at an early age. On the other hand, they became very common at the beginning of the seventeenth century; it is clear that it had become customary to preserve by means of the painter's art the ephemeral appearance of childhood. In the portraits of this period the child parted company with the family, just as a century earlier, at the beginning of the sixteenth century, the family had parted company with the religious section of the presentation portrait. Henceforth he would be depicted by himself and for himself: this was the great novelty of the seventeenth century. The child would be one of its favourite models. There are countless examples among the leading painters of the period: Rubens, Van Dyck, Franz Hals, Le Nain, Philippe de Champaigne. Some of these painters portray little princes, as in the picture of Charles I's children by Van Dyck or that of James II's children by Largillière; others, the offspring of great lords, such as the three children painted by Van Dyck, the eldest of whom is wearing a sword; and others, well-to-do bourgeois such as those depicted by Le Nain or Philippe de Champaigne. Sometimes there is an inscription giving the child's name and age, as used to be the custom for adults. Now

the child is all alone (see Philippe de Champaigne's work at Grenoble), now the painter gathers together several children from the same family. This last is a popular type of portrait, favoured by a great many anonymous painters, and often to be found in provincial art galleries or in antique shops. Henceforth every family wanted portraits of its children, and portraits painted while they were still children. The custom originated in the seventeenth century and is still with us. Photography took over from painting in the nineteenth century : the idea remained the same.

Before finishing with the portraits, we must mention the pictures of children on *ex-votos*, the plaques placed in churches to record the making or granting of a prayer. There are some in the museum of Puy Cathedral, and the Eighteenth Century Exhibition of 1958 in Paris revealed an astonishing portrait of a sick child which must also be an *ex-voto*.

Thus, although demographic conditions did not greatly change between the thirteenth and seventeenth centuries, and although child mortality remained at a very high level, a new sensibility granted these fragile, threatened creatures a characteristic which the world had hitherto failed to recognize in them: as if it were only then that the common conscience had discovered that the child's soul too was immortal. There can be no doubt that the importance accorded to the child's personality was linked with the growing influence of Christianity on life and manners.

This interest shown in the child preceded by more than a century the change in demographic conditions which can be roughly dated from Jenner's great discovery. Correspondences such as that of General de Martange (Bréard, 1898) show that certain families insisted at that time on having their children vaccinated; this precaution against the smallpox reveals a state of mind which must have favoured other hygienic practices at the same time, producing a reduction in the death-rate which was counterbalanced to some extent by an increasingly widespread control of the birth-rate.

Another type of child portraiture unknown to the Middle Ages is the *putto*, the naked child. The *putto* made its appearance at the end of the fourteenth century and obviously represented a revival of the Hellenistic Eros. The theme of the naked child was immediately welcomed with extraordinary enthusiasm, even in France, where Italian art was encountering a certain native resistance. The Duc de Berry, according to his inventories, had a 'children's room', in other words a room hung with tapestries decorated with *putti*. Van Marle wonders 'whether sometimes the scribes responsible for the inventories did not use the word "children" to denote these semi-pagan angels, these *putti* who so often adorned the foliage of tapestries in the second half of the fifteenth century.'

In the sixteenth century the *putto* invaded the world of painting and became an ornamental motif which was repeated *ad nauseam*. Titian in particular used or rather abused it: witness the 'Triumph of Venus' in the Prado.

The seventeenth century showed no sign of tiring of it, whether in Rome, in Naples, or at Versailles, where the *putti* still kept the old name of *marmousets*. Religious art succumbed to them, thanks to the transformation of the medieval angel/altar-boy into a *putto*. Henceforth, with one exception (the guardian angel) the angel would no longer be the adolescent still to be seen in Botticelli's paintings: he too had become a little naked Eros, even if, in order to satisfy post-tridentine modesty, his nudity was concealed behind clouds, mists and veils.

The *putto*'s nudity spread even to Jesus and the other holy children. If the artist was reluctant to adopt this complete nudity, he simply made it a little more discreet, taking care not to give Jesus too many clothes: He was shown with His mother undoing His swaddling-clothes,[13] or His shoulders and His legs were uncovered. Père du Colombier has already pointed out with regard to the paintings by Lucca della Robbia in the Hôpital des Innocents that it was impossible to portray childhood without stressing its nudity. The taste for child nudity was obviously linked with the general taste for classical nudity which had even begun to affect modern portraiture. But it lasted much longer and it affected the whole of ornamental art: witness Versailles or the ceiling of the Villa Borghese in Rome. The taste for the *putto* corresponded to something far deeper than the taste for classical nudity, something which can be ascribed only to a broad surge of interest in childhood.

Like the medieval child – a holy child, or a symbol of the soul, or an angelic being – the *putto* was never a real, historic child in either the fifteenth or the sixteenth century. This is all the more remarkable in that the theme of the *putto* originated and developed at the same time as the child portrait. But the children in fifteenth- and sixteenth-century portraits are never, or scarcely ever, naked children. Either they are wrapped in swaddling-clothes even when they are portrayed kneeling in prayer,[14] or else they are shown wearing the dress of their age and station. Nobody could visualize the historic child, even when he was very small, in the nudity of the mythological and ornamental child, and this distinction remained in force for a long time.

The final phase of child iconography was to be the application of the *putto*'s ornamental nudity to the child portrait, and this too was to take

13. Baldovinetti, 'Virgin and child', Louvre.
14. 'Virgin enthroned', supposedly a portrait of Beatrice d'Este, 1496.

place in the seventeenth century. True, a few portraits of naked children are to be noted in the sixteenth century, but they are comparatively rare. One of the oldest is probably the child in Holbein's painting of the Meyer family who had died in infancy (1521). Then too, in one of the halls in Innsbruck Palace, there is a fresco in which Maria Theresa wanted to gather together all her children: next to the living, a dead princess is portrayed in a very chastely draped state of nudity.

In a picture by Titian of 1571 or 1575,[15] Philip II in a dedicatory gesture is shown holding out to Victory his son, the child Ferdinand, who is completely naked: he looks like Titian's usual *putto*, and he seems to be finding the situation extremely funny: the *putti* were often depicted at play.

In 1560 Veronese in accordance with custom portrayed the Cucina-Fiacco family in front of the Virgin and Child: three men, including the father, one woman – the mother – and six children. On the far right a woman is almost cut in half by the edge of the picture: she is holding a naked child in her arms just as the Virgin is holding the Holy Child, a resemblance stressed by the fact that the woman is not wearing the dress of her time. Pushed to one side as she is, she cannot be the mother of the family: perhaps she is the wet-nurse of the youngest child.[16] A mid-sixteenth-century painting by the Dutchman P. Ærtsen shows a family: the father, a boy about five, a girl of four, and the mother sitting with a naked child in her lap.

There are sure to have been other cases which more extensive research would bring to light, but they were not numerous enough to create a general taste.

In the seventeenth century, portrayals of this sort became more numerous and more typical: witness the portrait at Munich of Helen Fourment carrying her naked son, who is distinguished from the ordinary *putto* not only by the resemblance to his mother but also by a plumed bonnet of the sort that children wore at the time. The youngest of Charles I's children painted by Van Dyck in 1637 is shown next to his brothers and sisters, naked, and half covered by the linen on which he has been laid.

'When, in 1647,' writes L. Hautecoeur, 'Le Brun portrays the banker and collector Jabach in his Rue Saint-Merri house, he shows us this powerful man casually dressed, with his stockings pulled on anyhow, displaying his latest acquisition to his wife and son ... his other children are present: the last-born, naked as an Infant Jesus, is lying on a cushion, and one of his sisters is playing with him.' (Hautecoeur, 1945). The little Jabach, more than the naked children of Holbein, Veronese, Titian, Van

15. 'Glorification of the victory of Lepanto', Prado.
16. Dresden, Pinakothek.

Dyck and even Rubens, has exactly the same pose as that of the modern baby in front of the studio photographer's camera. Henceforth the nudity of the little child was to be a convention of the genre, and all the little children who had always been so ceremoniously dressed up in the time of Le Nain and Philippe de Champaigne would be depicted naked. This convention is to be found both in the work of Largillière, the painter of the upper-middle class, and in that of Mignard, the court painter: the Grand Dauphin's youngest child, in the painting by Mignard in the Louvre, is lying naked on a cushion by his mother, just like the little Jabach.

Either the child is completely naked, as in Mignard's portrait of the Comte de Toulouse,[17] where his nudity is scarcely veiled by the loop of a ribbon which has come undone for the occasion, or in Largillière's portrait of a child holding a billhook (Rouches, 1923); or else he is dressed not in a real costume similar to the clothes generally worn at the time but in a *négligé* which fails to cover his nudity and indeed often reveals it (witness the children's portraits by Belle in which the legs and feet are bare, or Mignard's Duc de Bourgogne, dressed in nothing but a flimsy shift). There is no need to follow any further the history of this theme, which by now had become conventional. It can be found again at its conclusion in the family albums and studio photographers' shop windows of yesterday: babies baring their little bottoms just for the pose – for they were normally carefully covered, swaddled or breeched – and little boys and girls who were dressed for the occasion in nothing but a pretty transparent shift. There was not a single child whose likeness was not preserved in a nude study, directly inherited from the *putti* of the Renaissance: a remarkable example of the persistence in the collective taste (bourgeois as much as lower-class) of a theme which was originally ornamental. The Eros of antiquity, rediscovered in the fifteenth century, went on serving as a model for the 'artistic portraits' of the nineteenth and twentieth centuries.

The reader of the preceding pages will not have failed to notice the importance of the seventeenth century in the evolution of the themes of childhood. It was in the seventeenth century that portraits of children on their own became numerous and commonplace. It was in the seventeenth century, too, that the family portrait, a much older genre, tended to plan itself around the child. This concentration on the child is particularly striking in the Rubens family group in which the mother is holding the child by the shoulder while the father has him by the hand,[18] and in the

17. Versailles museum.
18. About 1609, Karlsruhe.

works of Franz Hals, Van Dyck and Lebrun, whose children kiss, cuddle and generally enliven the group of serious adults with their games or their affection. The baroque painter depended on them to give his group portrait the dynamism that it lacked. In the seventeenth century too, subject painting gave the child a place of honour, with countless childhood scenes of a conventional character: the reading lesson, in which the theme of the Virgin's lesson survived in lay form from the religious iconography of the fourteenth and fifteenth centuries, the music lesson, and groups of boys and girls reading, drawing and playing. One could go on indefinitely listing these themes which were extremely common in painting, especially in the first half of the century, and in engraving later. Finally, as we have seen, it was in the second half of the seventeenth century that nudity became an essential convention in child portraiture. No doubt the discovery of childhood began in the thirteenth century, and its progress can be traced in the history of art in the fifteenth and sixteenth centuries. But the evidence of its development became more plentiful and significant from the end of the sixteenth century and throughout the seventeenth.

This is confirmed by the interest shown at that time in little children's habits and 'jargon'. We have already noted, in the preceding chapter, how they were given new names: *bambins*, *pitchouns* and *fanfans*. People also amused themselves by picking up their children's expressions and using their vocabulary, that is to say, the vocabulary used by their nannies when speaking to them. It is a rare thing for literature, even of the most popular kind, to preserve traces of children's jargon. Yet some such traces are to be found in the *Divina Commedia*: 'What further glory will you have if you leave an aged flesh than if you had died before you had stopped saying *pappo* and *dindi*.'[19] *Pappo* is bread. The word existed in the French language of Dante's time: *le papin*. It is to be found in one of the *Miracles de Notre-Dame*, that of 'the little child who feeds the picture of Jesus in Our Lady's arms'. But is the word *papin* really confined to childhood, or does it not rather belong to the familiar speech of everyday life? Be that as it may, the *Miracles de Notre-Dame*, like other sixteenth-century texts, bears witness to a certain taste for childhood painted from life. But references to children's jargon are unusual before the seventeenth century. In the seventeenth century they are to be found in abundance. To take one example, a collection of prints by Bouzonnet and Stella, dated 1657: this collection contains a series of engravings showing *putti* at play. There is nothing original about the drawings, but the captions, written in appalling doggerel, speak the jargon of infancy and also schoolboy slang, for the

19. *Purgatorio.*

limits of infancy were still anything but clear at the time. A plate showing *putti* playing with hobby-horses is entitled 'Le Dada'.

> Some *putti* are playing at dice.
> One goes away, and number two
> Consoles himself with his *toutou*.

The *papin* of the fourteenth and fifteenth centuries must have been dropped, at least from the speech of French bourgeois children, possibly because it was not confined to infancy. But other childish words had appeared which are still in use today: *toutou* and *dada*.

Apart from this nursery language, the *putti* also use school slang or the slang of military academies. In the caption to a drawing of a sledge game the word *populo*, from school Latin, is used. In the same childish sense, Mme de Sévigné would refer to Mme de Grignan's children as *ce petit peuple*. One child who shows exceptional skill is referred to as *ce cadet*, a term used in the academies where young gentlemen at the beginning of the seventeenth century were taught fencing, riding and the arts of war. Under another picture, we are told that children go and play tennis as soon as they have *campos*: an academy expression, a military term, which means 'to have leave'. It was widely used in everyday speech, and can be found in Mme de Sévigné. Again, we are shown some children bathing and are told that the others are drinking to the health of their *camarades*. This term, which was also new or at least did not date back further than the late sixteenth century, was obviously of military origin (possibly it came from the Germans or German-speaking mercenaries) and went through the academies. Incidentally it would always be more or less confined to the familiar speech of the French middle class. It is still not used in French lower-class speech, which prefers the older word *copain*, from the medieval *compaing*.

But let us return to the jargon of infancy. In Cyrano de Bergerac's *Le Pédant joué*, Granger calls his son his *toutou*: 'Come and kiss me, come my *toutou*.' The word *bonbon*, which I suppose originated in nannies' jargon, was admitted to everyday speech. And attempts were even made to give onomatopoeic renderings of the speech of children who had not yet learnt to talk. Thus Mme de Sévigné laboriously noted the noises made by her little daughter and reported them to Mme Grignan who was then in Provence: 'She talks most amusingly: titota, tetita, y totata.' Already, at the beginning of the century, Heroard, Louis XIII's doctor, had carefully recorded in his diary his charge's childish pronunciation of certain words: *vela* for *voilà*, *équivez* for *écrivez*, and so on.

When she describes her little daughter, her 'little darling', Mme de

Sévigné paints genre pictures similar to those of Le Nain or Bosse, with the pretty affectation of late seventeenth-century engravers and eighteenth-century artists besides. 'Our daughter is a dark-haired little beauty. She is very pretty indeed. Here she comes. She gives me sticky kisses, but she never screams.' 'She kisses me, she recognizes me, she laughs at me, she calls me just plain *Maman* [instead of *Bonne Maman*].' 'I simply adore her. I have had her hair cut: it is a happy-go-lucky style now which is just made for her. Her complexion, her chest and her little body are admirable. She does a hundred and one different things: she caresses, she slaps, she makes the sign of the cross, she begs pardon, she drops a curtsy, she blows a kiss, she shrugs her shoulders, she dances, she strokes, she holds her chin: in a word she is pretty in every particular. I watch her for hours on end.' Countless mothers and nannies had already felt the same way. But not a single one had admitted that these feelings were worthy of being expressed in such an ambitious form. These literary scenes of childhood correspond to those of contemporary genre painting and engraving: each reflected the discovery of infancy, of the little child's body, habits and chatter.

Chapter 3
Children's Dress

The marked indifference shown until the thirteenth century – except where the infant Virgin was concerned – to the special characteristics of childhood does not appear simply in the world of pictures: the dress of the period shows to what extent, in the circumstances of real life, childhood was distinguished from manhood. As soon as the child abandoned his swaddling-band – the band of cloth that was wound tightly round his body in babyhood – he was dressed just like the other men and women of his class. We find it difficult to imagine this confusion, we who for so many years wore knickerbockers, the now shameful insignia of retarded infancy. In my generation we came out of knickerbockers at the end of the fifth year at school: my parents, urging me to be patient, quoted the case of an uncle of mine who was a general and who had gone up to the military academy in knickerbockers! Nowadays, adolescence has spread upstream as well as downstream, and sports clothes, adopted by both adolescents and children, are tending to take the place of the clothes which were the distinguishing marks of childhood in the nineteenth century and the early twentieth century. Be that as it may, if the period 1900 to 1920 still prolonged late into adolescence the special features of a form of dress confined to childhood, the Middle Ages dressed every age indiscriminately, taking care only to maintain the visible vestiary signs of the differences in the social hierarchy. Nothing in medieval dress distinguished the child from the adult.

In the seventeenth century, however, the child, or at least the child of quality, whether noble or middle-class, ceased to be dressed like the grown-up. This is the essential point: henceforth he had an outfit reserved for his age group, which set him apart from the adults. This can be seen from the first glance at any of the numerous child portraits painted at the beginning of the seventeenth century.

Let us consider the fine painting by Philippe de Champaigne, in Reims Museum, of the seven children of the Habert family, the eldest of whom is ten years of age and the youngest eight months old. This painting is of great interest for our subject because the artist has inscribed the exact age, to the nearest month, of each of his models. The eldest, at ten, is already

dressed like a little man, wrapped in his cloak; in appearance at least, he belongs to the world of adults. No doubt it is just in appearance: he must be still at school, and school life prolongs the age of childhood; but he will probably not stay at school much longer but leave early in order to mix with the men whose dress he is already wearing and whose life he will soon be sharing in camp or court or commerce. But the two twins, fondly holding each other by the hand and the shoulder, are only four years nine months old: they are no longer dressed like adults but are wearing a long robe, different from that worn by women in that it opens in the front and is fastened with buttons, elsewhere with laces – it looks like a priest's cassock. The same robe is to be found again in the 'picture of human life' by Cebes.[1] The first age, not far removed as yet from non-existence, is naked; the two following ages are in swaddling-clothes. The third, which must be about two years old and cannot yet stand by itself, is already wearing a robe, and we can tell that it is a boy. The fourth age, sitting astride its hobby-horse, is wearing the same long robe, buttoned down the middle and opening in front like a cassock, as with the Habert twins in the Philippe de Champaigne picture. This robe was worn by little boys throughout the seventeenth century. We find it again on the child Louis XIII, in countless portraits of French, English and Dutch children, and as late as the beginning of the eighteenth century – for example, on the young de Bethisy painted by Belle about 1710.[2] In this last picture the boy's robe is no longer buttoned down the front, but it remains different from that of the girls and has no linen accessories.

The robe can be very simple, like that of the child riding the hobby-horse in the 'picture of human life'. On the other hand it can be extremely ornamental and have a train attached, like the robe worn by the young Duc d'Anjou in the engraving by Arnoult.[3]

This robe in the form of a cassock was not the first type of clothing worn by the child after he had come out of his swaddling-band. Let us return to Philippe de Champaigne's portrait of the Habert children. François, who is twenty-three months old, and the youngest child, who is eight months old, are both dressed exactly like their sister, that is to say, like little women: in skirt, robe and apron. This is the dress of the youngest boys; it had become customary in the sixteenth century to clothe them like girls. Erasmus gives us a description of this style of dress which his French publisher in 1714 found easy to translate, as something which still existed in his day: 'They [children] are burdened with a vest, a pair of

1. *Tabula Cebetis*, Mérian.
2. 'Catherine de Bethisy and her brother', Versailles Museum.
3. 'Le Duc d'Anjou enfant', Cabinet des Estampes.

warm stockings, a thick petticoat, and an outer garment which encumbers the shoulders and the hips with a great quantity of stuff and pleats, and they are given to understand that all this paraphernalia gives them a wonderful air.' Erasmus condemned this fashion which was new in his time and recommended greater freedom for young bodies; his opinion carried little weight against the force of accepted usage, and it was the end of the eighteenth century before children's dress became lighter and looser and allowed greater freedom of movement. A drawing by Rubens[4] shows us a little boy's outfit which is still similar to that described by Erasmus: the open robe under which the skirt can be seen. The child is starting to walk and he is being held by braces hanging behind him, which were known at the time as leading-strings. In Heroard's diary, which allows us to follow Louis XIII's childhood day by day, we read in the entry for 28 June 1602 (Louis XIII was nine months old at the time): 'Leading-strings have been attached to his robe to teach him to walk.' The same Louis XIII did not like his sister to wear a robe resembling his: 'Madame arrived wearing a robe just like his, and he sent her away out of jealousy.' As long as boys wore this feminine costume, they were said to be *à la bavette,* or 'in a bib and tucker'. This was until the age of four or five. Jean Rou, who was born in 1638, records in his memoirs that he was a precocious child and that he was sent to Harcourt College accompanied by a servant-girl: 'When I was still in a bib and tucker, that is to say, before I had donned the long robe with a collar that came before the wearing of breeches ... I was the only one accoutred in the manner I have just described [i.e. dressed like a girl], so that I was like a new phenomenon in that place, such as had never been seen before.' The collar of the robe was a man's collar. Henceforth custom dictated rules of dress for children according to their age: the bib and robe as worn by girls, then 'the long robe with a collar' which was also known as the *jaquette* or 'frock'. The regulations of a little school, or parish school, of 1654 stated that on Sunday the children should be taken to church to hear Mass after receiving religious instruction, and that the little children should not be mixed up with the bigger ones, the short robes with the long robes: 'The little ones in frocks shall be placed together.'

The diary of Louis XIII's childhood which Heroard kept every day shows how seriously children's dress was treated from that time on: it made visible the stages of the growth which transformed the child into a man. These stages had become, as it were, rites which had to be respected and which Heroard carefully recorded as matters of importance. On 17 July 1602, leading-strings were attached to the Dauphin's robe. He was to wear them for over two years; at the age of three years two months,

4. In the Louvre.

he was given 'the first robe without leading-strings'. The child was de-
lighted, and told the Captain of the Guard: ''Tan [note the imitation of
childhood speech], I haven't any leading-strings, I am going to walk by
myself.' For his fourth birthday he wore a pair of breeches under his robe,
and a year later, on 7 August 1606, his 'child's bonnet' was taken away to
be replaced by a man's hat. This too was a red-letter day: 'Now that your
bonnet has been taken away, you have stopped being a child, you have
begun to become a man.' But six days later, the Queen ordered him to put
his bonnet on again.

8 January 1607: 'He asked when he would be allowed to wear breeches
[instead of the robe]. Mme de Montglat told him that it would be when
he was eight.'

On 6 June 1608, when he was seven years eight months old, Heroard
recorded with a certain solemnity: 'Today he was dressed in a doublet
and breeches, abandoned the clothing of childhood [i.e., the robe] and
took cloak and sword.' There were days, however, when he was made to
put on the robe again, just as he had been made to put on the bonnet again,
but he hated this: in doublet and breeches 'he is very happy and joyful,
and does not want to put on his robe.' It can be seen that fashion in cloth-
ing is not just a frivolous matter. Here the connection between dress and
the understanding of what it stands for is obvious.

In the schools, the pupils who boarded by the week wore a robe over
their breeches. Cordier's dialogues, written in 1586, describe the awaken-
ing of a boarder: 'After waking up, I got out of bed, I put on my doublet
and sagathy, I sat on a stool, I took my breeches and stockings and pulled
both on, I took my shoes, I fastened my breeches to my doublet with
laces, I tied my stockings with garters above the knee, I took my belt, I
combed my hair, I took my bonnet which I arranged carefully, I put on
my robe, and then I left the bedroom ...'

In Paris at the beginning of the seventeenth century: 'Imagine Francion
coming into the classroom with his underpants coming out of his breeches
on top of his shoes, his robe all askew, and his portfolio under his arm,
trying to give a rotten apple to one and a rap on the nose to another.'[5] In
the eighteenth century, the regulations at the La Flèche boarding-school
stated that the pupil's outfit should include 'a boarder's robe' which had to
last for two years (de Rochemonteix, 1889).

This difference in dress was not to be found among the girls, who were
dressed like little women as soon as they came out of their swaddling-
clothes. However, if we look closely at pictures of seventeenth-century
children, we shall see that the feminine dress of the little boys as well as

5. At Lisieux College (Sorel, 1926).

of the little girls included a peculiar ornament which the women did not wear: two broad ribbons fastened to the robe behind each shoulder and hanging down the back. These ribbons can be seen, for example, on the third of the Habert children from the left, on the fourth age in the *Tabula Cebetis* (the child in a robe riding a hobby-horse), and on the little ten-year-old girl on the early eighteenth-century ladder of the ages, 'human misery or the passions of the soul in all its ages'. The ribbons are to be found in a great many child portraits, down to Lancret and Boucher. They disappear at the end of the eighteenth century, at the time when children's dress was radically altered. Possibly one of the last portraits of a child wearing these ribbons down the back is that painted by Mme Gabrielle Guiard in 1788 for Mmes Adelaïde and Victoire.[6] It shows their sister, Mme Infante, who had been dead some thirty years. Mme Infante had lived to the age of thirty-two, but Mme Gabrielle Guiard none the less portrayed her as a child with her nanny – the desire to preserve the memory of a woman of thirty by showing her in her childhood reveals a very novel feeling – and this child is wearing the ribbons down the back which were still customary about 1730, but which had gone out of fashion by the time the picture was painted.

Thus in the seventeenth century and the early eighteenth century these ribbons down the back had become sartorial indications of childhood, for boys as well as girls. Modern writers have not failed to be intrigued by them. They have been mistaken for 'leading-strings' (braces for little children who were still unsteady on their feet).[7] In the little museum in Westminster Abbey, there are a few mortuary effigies in wax which represented the dead person and which were laid on top of the coffin during the funeral ceremony, a medieval practice which was continued in England until about 1740. One of these effigies represents the little Marquess of Normanby, who died at the age of three. He was dressed in a yellow silk skirt under a velvet robe (the usual costume for little children), and wearing the flat ribbons of childhood. The catalogue describes these as leading-strings, but in fact leading-strings were cords which bore no resemblance to these ribbons; an engraving by Guérard illustrating 'manhood' shows us a child which could be a boy or a girl, dressed in a robe, wearing a Fontange hair style, and seen from behind: between the two ribbons hanging from the shoulders, one can clearly see the cord used to help the child to walk, the leading-string.[8]

6. Guard, 'Portrait de Madame Infante pour Mesdames', 1788, Versailles Museum.
7. 'Louis XV en 1715 tenu en usière par Mme de Ventadour', engraving, Cabinet des Estampes.
8. Guérard, 'L'agé vinl', engraving, about 1700.

This analysis has enabled us to pick out certain customs of dress confined to childhood that were generally adopted at the end of the sixteenth century and preserved until the middle of the eighteenth century. These customs distinguishing between children's clothing and adult clothing reveal a new desire to put children on one side, to separate them by a sort of uniform. But what is the origin of this childhood uniform?

The child's robe is simply the long coat of the Middle Ages, of the twelfth and thirteenth centuries, before the revolution which in the case of men banished it in favour of the short coat and visible breeches, the ancestors of our present-day masculine costume. Until the fourteenth century everybody wore the robe or tunic; the men's robe was not the same as the women's – often it was a shorter tunic, or else it opened down the front. On the peasants in the thirteenth-century calendars it stops at the knee, while on the great and important it reaches to the feet. There was in fact a long period during which men wore a long fitted costume, as opposed to the traditional draped costume of the Greeks or Romans: this continued the fashions of the Gallic or Oriental barbarians which had been added to the Roman fashions during the first centuries of our era. It was uniformly adopted in the East as in the West, and was the origin of the Turkish style of dress as well.

In the fourteenth century men abandoned the robe for the short coat, which was sometimes even tight-fitting, to the despair of moralists and preachers who denounced the indecency of these fashions, describing them as signs of the immorality of the times. In fact respectable people went on wearing the robe, whether they were respectable on account of their age (old men are depicted wearing the robe until the beginning of the seventeenth century) or on account of their station in life (magistrates, statesmen, churchmen). Some have never given up wearing the long coat and still wear it today, at least on occasion (barristers, judges, professors and priests). The priests, incidentally, came very near to abandoning it, for when the short coat had become generally accepted, and when in the seventeenth century the scandal attending its origins had been completely forgotten, the priest's cassock became too closely connected with his ecclesiastical function to be in good taste. A priest would change out of his cassock to go into society, or even to call on his bishop, just as an officer would change out of his uniform to appear at court (Mme de Sévigné, 1671).

Children, too, kept the long coat; at least, children of good family. A miniature in the fifteenth-century *Miracles de Notre-Dame* shows a family gathered round the mother's bed; the father is wearing a short coat, doublet and breeches, but the three children are dressed in long robes.

In the same series the child feeding the Infant Jesus has a robe split down the side.

But in Italy most of the children painted by the artists of the *Quattrocento* are wearing the tight-fitting breeches of adults. In France and Germany it seems that this fashion failed to find favour and that children were kept in the long coat. At the beginning of the sixteenth century the habit became a general rule: children were always dressed in the robe. German tapestries of the period show four-year-old children wearing the long robe, open in front (Göbel, 1923). Some French engravings by Jean Leclerc on the subject of children's games show the children wearing, over their breeches, the robe buttoned down the front which became the uniform of their age.[9]

The flat ribbons down the back which likewise distinguished children from adults in the seventeenth century had the same origins as the robe. Cloaks and robes in the sixteenth century often had sleeves which one could slip into or leave empty at will. In Leclerc's picture of children playing at chucks, some of these sleeves can be seen to be fastened only by a few stitches. People of fashion, especially women, liked the effect of these hanging sleeves: they stopped putting their arms into them, with the result that the sleeves became useless ornaments. Like organs which have ceased to function, they wasted away, lost the hollow inside into which the arm fitted, and, flattened out, looked like two broad ribbons fastened behind the shoulders: the children's ribbons of the seventeenth and eighteenth centuries were all that remained of the false sleeves of the sixteenth century. These atrophied sleeves were also to be found in other clothes of a popular or a ceremonial nature: the peasant cloak which the Ignorantine friars adopted as their religious costume at the beginning of the eighteenth century, the first purely military uniforms such as those of the musketeers, the livery of valets, and finally the page's uniform – the ceremonial uniform of the children and young boys of noble birth who were placed with families for whom they performed certain domestic services. The pages of the age of Louis XIII wore baggy breeches in the sixteenth-century style and false sleeves. This page's uniform tended to become the ceremonial costume which was donned as a token of honour and respect: in an engraving by Lepautre some boys in an archaic page's uniform are shown serving Mass.[10] But these ceremonial costumes were somewhat rare, whereas the flat ribbon was to be found on the shoulders of all the children, whether boys or girls, in families of quality, whether aristocratic or middle-class.

9. Jean Leclerc, 'Les trente-six figures contenant tous les jeux', 1587.
10. Cabinet des Estampes.

Thus in order to distinguish the child who had hitherto dressed just like an adult, features of old-fashioned costumes which the grown-ups had abandoned, sometimes a long time before, were reserved for his sole use. This was the case with the robe or long coat and the false sleeves, also with the bonnet worn by little children still in their swaddling-clothes: in the thirteenth century the bonnet was still the normal masculine headwear, which the men used to keep their hair in position at work, as can be seen from the calendars of Notre-Dame d'Amiens, etc.

The first children's costume was the costume which everybody used to wear about a century before, and which henceforth they were the only ones to wear. It was obviously out of the question to invent a costume out of nothing for them, yet it was felt necessary to separate them in a visible manner by means of their dress. They were accordingly given a costume of which the tradition had been maintained in certain classes, but which nobody wore any more. The adoption of a special childhood costume, which became generalized throughout the upper classes as from the end of the sixteenth century, marked a very important date in the formation of the idea of childhood.

We have to remember the importance which dress had in the France of old. It often represented a large capital sum. People spent a great deal on clothes, and when somebody died they went to the trouble of drawing up an inventory of his or her wardrobe, as we would today only when fur coats were involved. Dress was very expensive, and attempts were made by means of sumptuary laws to put a curb on luxury clothes, which ruined some and allowed others to mislead the gullible as to their birth and station in life. Even more than in our present-day society – where it is still true of the women, whose dress is a visible and necessary sign of a couple's prosperity or the importance of their social position – dress pin-pointed the place of the wearer in a complex and undisputed hierarchy: a man wore the costume of his rank, and the etiquette books laid great emphasis on the impropriety of dressing in any other way than that befitting one's age or birth. Every social nuance had its corresponding sign in clothing. At the end of the sixteenth century, custom dictated that childhood, henceforth recognized as a separate entity, should also have its special costume.

We have seen that childhood dress originated in an archaism: the survival of the long coat. This archaizing tendency continued. Towards the end of the eighteenth century, in the time of Louis XVI, little boys were dressed in Louis XIII or Renaissance collars. The children painted by Lancret and Boucher are often dressed after the fashion of the previous century.

But two other tendencies were to influence the development of chil-

dren's dress from the seventeenth century on. The first emphasized the effeminate appearance of the little boy. We have seen earlier in this work that the boy 'in bib and tucker', before the age of 'the robe with a collar', wore the same robe and skirt as a girl. This effeminization of the little boy, which became noticeable about the middle of the sixteenth century, was at first a novelty and barely hinted at. For instance, the upper part of the boy's costume retained the characteristics of masculine dress; but soon the little boy was given the lace collar of the little girl, which was exactly the same as that worn by the ladies. It became impossible to distinguish a little boy from a little girl before the age of four or five, and this costume became firmly established for something like two centuries. About 1770 boys stopped wearing the robe with the collar after four or five, but until they reached that age they were dressed like little girls, and this would be the case until the end of the nineteenth century: this effeminate habit would be dropped only after the First World War, and its abandonment can be compared to that of the woman's corset as symptomatic of the revolution in dress corresponding to the general change in manners.

It is interesting to note that the attempt to distinguish children was generally confined to the boys: the little girls were distinguished only by the false sleeves, abandoned in the eighteenth century, as if childhood separated girls from adult life less than it did boys. The evidence provided by dress bears out the other indications furnished by the history of manners: boys were the first specialized children. They began going to school in large numbers as far back as the late sixteenth century and the early seventeenth century. The education of girls started in a small way only in the time of Fénelon and Mme de Maintenon and developed slowly and tardily. Without a proper educational system, the girls were confused with the women at an early age just as the boys had formerly been confused with the men, and nobody thought of giving visible form, by means of dress, to a distinction which was beginning to exist in reality for the boys but which still remained futile for the girls.

Why, in order to distinguish the boy from the man, was he made to look like the girl who was not distinguished from the woman? Why did that costume, so novel and surprising in a society in which people started adult life at an early age, last almost to the present day, at least until the beginning of this century, in spite of the changes in manners and the prolongation of the period of childhood? Here we are touching on the as yet unexplored subject of a society's consciousness of its behaviour in relation to age and sex: so far only its class-consciousness has been studied.

Another tendency, which, like archaizing and effeminizing, probably originated in the taste for fancy dress, led the children of middle-class

families to adopt features of lower-class or working dress. Here the child would forestall masculine fashion and wear trousers as early as the reign of Louis XVI, before the age of the sans-culottes. The costume worn by the well-dressed child in the period of Louis XVI was at once archaic (the Renaissance collar), lower-class (the trousers) and military (the military jacket and buttons).

In the seventeenth century there was no distinctive lower-class costume and *a fortiori* no regional costumes. The poor wore the clothes which they were given or which they bought from old-clothes dealers. The lower-class costume was a second-hand costume, just as today the lower-class car is a second-hand car. (The comparison between the costume of the past and the car of the present day is not as artificial as it may seem: the car has inherited the social significance which dress used to have.) Thus the man of the people was dressed like the man of the world a few decades earlier; in the streets of Louis XIII's Paris he wore the plumed bonnet which had been fashionable in the sixteenth century, while the women wore the hood favoured by ladies of the same period. The time-lag varied from one region to another, according to the rapidity with which the local gentry followed the prevailing fashions. At the beginning of the eighteenth century, the women of certain regions – along the Rhine, for instance – were still wearing fifteenth-century coifs. In the course of the eighteenth century this evolution came to a stop, as the result of a moral estrangement between the rich and the poor and also a physical separation. Regional dress originated in both a new taste for regionalism (it was the period of the great regional histories of Brittany, Provence, etc., and also of a revival of interest in the regional languages which had become dialects as the result of the progress of French) and differences in dress due to variations in the time which the fashions of town and court took to reach different parts of the country.

In the great lower-class suburbs, at the end of the eighteenth century, the men started wearing a more distinctive costume, namely the trousers which were the equivalent at that time of the workman's smock in the nineteenth century and the dungarees of today: the sign of a class and a function. It is noteworthy that in the eighteenth century the dress of the lower class in the big cities stopped being the beggarly costume it was in the seventeenth – shapeless, anachronistic rags, or cast-offs from an old-clothes dealer. Here we can see the spontaneous expression of a collective characteristic, something like an awakening of class-consciousness. Thus from then on there was a kind of artisan's uniform: trousers. Trousers, long breeches reaching down to the feet, had for a long time been an article of seamen's dress. While they might appear in Italian

comedy, they were commonly worn by sailors and also by the inhabitants of seaports, Flemings, Rhinelanders, Danes and Scandinavians. The latter were still wearing trousers in the seventeenth century, if we judge by collections of the clothes of that period. The English had given them up, although they had worn them as far back as the twelfth century. They had become the uniform of the naval forces when the better-organized states had regulated the dress of their ships' crews. Apparently at the same time they spread to the lower classes in the suburbs of the big cities, who henceforth refused to wear other people's cast-offs, and to little boys of good family.

The newly created uniform was rapidly adopted by the children of the middle classes, first of all in the private boarding-schools, which had become more numerous since the expulsion of the Jesuits and which often prepared boys for military academies and military careers. The silhouette caught the people's fancy, and adults took to dressing their boys in a costume inspired by military or naval uniform: thus was created the sailor-boy fashion which has lasted from the end of the eighteenth century to the present day.

The adoption of trousers for children was due in part to this new taste for uniform which was to spread to adults in the nineteenth century, when the uniform became court or ceremonial dress, something it had never been before the Revolution. It was also inspired, no doubt, by the desire to free the child from the constraint of his traditional dress, to give him a more casual costume, a costume which the suburban lower-class would henceforth wear with a kind of pride. The boy was thus spared both the unfashionable or over-childish robe and the over-ceremonious breeches, thanks to the trousers of lower class and navy. This happened all the more easily in that it had always been thought amusing to give children of good family a few characteristics of lower-class dress, such as the labourer's, peasant's or convict's cap, which the revolutionaries with their classical tastes called the Phrygian bonnet: one of Bonnard's engravings shows us a child wearing a cap of this kind.[11] In our own days we have seen a transfer of dress which offers certain resemblances to the adoption of trousers by the boys of Louis XVI's time: the workman's dungarees, made of coarse blue cloth, have become the 'blue jeans' which young people proudly wear as the visible sign of their adolescence.

We have come from the sixteenth century, when the child was dressed like an adult, to the specialized childhood costume with which we are familiar today. We have already pointed out that this change affected boys

11. Cabinet des Estampes.

more than girls. The idea of childhood profited the boys first of all, while the girls persisted much longer in the traditional way of life which confused them with the adults: we shall have cause to notice more than once this delay on the part of the women in adopting the visible forms of the essentially masculine civilization of modern times.

If we confine our attention to the evidence afforded by dress, we must conclude that the particularization of children was limited for a long time to boys. What is certain is that it occurred solely in middle-class or aristocratic families. The children of the lower classes, the offspring of the peasants and the artisans, those who played on the village greens, in the city streets, in the craftsmen's workshops, in the tavern taprooms and in the kitchens of great houses, went on wearing the same clothes as adults: they were never depicted in robes or false sleeves. They kept up the old way of life which made no distinction between children and adults, in dress or in work or in play.

Chapter 4
A Modest Contribution to the History of Games and Pastimes

Thanks to the diary kept by the doctor Heroard, we can imagine what a child's life was like at the beginning of the seventeenth century, what games he played, and to what stages of his physical and mental development each of his games corresponded. Although the child concerned was a Dauphin of France, the future Louis XIII, his case remains typical for all that, for at Henri IV's court the royal children, legitimate or illegitimate, were treated in the same way as all aristocratic children, and there was as yet no real difference between the King's palaces and the gentry's castles. Apart from the fact that he never went to college, as some of the aristocracy already did, young Louis XIII was brought up like his companions. Thus he was given fencing and riding lessons by the same instructor who, in his academy, taught the young aristocracy the arts of war: M. de Pluvinel. The illustrations of M. de Pluvinel's manual of horsemanship, the fine engravings of C. de Pas, show Louis XIII on horseback at the riding-school. In the second half of the seventeenth century the monarchical cult separated the little prince at an earlier age – in infancy in fact – from other mortals, even of noble birth.

Louis XIII was born on 27 September 1601. His doctor, Heroard, has left us a detailed record of all his activities. Heroard writes that at seventeen months he 'plays the violin and sings at the same time'. Before that, he had played with the usual toys given to very little children, a hobby-horse, a windmill and a whipping-top. But as early as seventeen months a violin was put into his hands. The violin had not yet won recognition as a noble instrument: it was still the fiddle played for the dancing at village weddings and fêtes. At the same age we find him playing mall: 'The Dauphin, playing mall, muffed his shot and injured M. de Longueville.' This is just as if an English boy were to start playing cricket or golf at the age of seventeen months. At twenty-two months we are told that he 'continues to beat his tambourin with all sorts of rhythms': every company had its own drum and its own drumbeat. He

started to talk: 'They are making him pronounce the syllables separately, before saying the words.' The same month, August 1603, 'the Queen, going in to dinner, had him brought along and placed at the end of her table.' Prints and paintings of the sixteenth and seventeenth centuries often show a child at table, perched in a little high-chair out of which he cannot fall; it must have been in one of these chairs that he sat at his mother's table, like other children in other families. This little fellow is barely two years old, yet now we find him being 'taken to the King's apartments and dancing all sorts of dances to the music of a violin'. Again we see how early in life music and dancing were introduced into the education of the little men of this period: this explains the frequency, in the families of professionals, of what we should now call infant prodigies, such as the young Mozart; such cases would become rarer and at the same time seem more prodigious as familiarity with music, even in its elementary or bastard forms, grew less common or disappeared.

The Dauphin began talking. Heroard keeps a phonetic record of his chatter: 'Tell Papa' for 'I shall tell Papa', *équivez* for *écrivez*. He was often given a whipping: 'Naughty, whipped (for refusing to eat): calming down, he asked for his dinner and dined.' 'Went off to his room, screaming at the top of his voice, and was soundly whipped.' Although he now mingled with adults, playing, dancing and singing with them, he still played at children's games. He was two years seven months old when Sully presented him with 'a little carriage full of dolls'.

He liked the company of soldiers: 'The soldiers are always glad to see him.' 'He played with a little cannon.' 'He conducted little military actions with his soldiers. M. de Marsan put a high collar on him, the first he had ever worn, and he was delighted.' 'He played at military engagements with his little lords.' We know too that he played tennis as well as mall – yet he still slept in a cradle. On 19 July 1604, when he was two years nine months old, 'he saw his bed being made with great joy, was put to bed for the first time.' He already knew the rudiments of his religion: at Mass, at the Elevation, he was shown the host and told that it was *le bon Dieu*. We might note in passing this expression, *le bon Dieu*, which is constantly employed nowadays by priests and churchgoers, but of which no trace can be found in religious literature of the *ancien regime*. We can see here that at the beginning of the seventeenth century, when the expression was probably not very old, it belonged to the language of children or of parents and nannies when talking to children. It contaminated the language of adults in the nineteenth century, and, with the effeminization of religion, the God of Jacob became *le bon Dieu* of little children.

The Dauphin could now talk, and occasionally came out with those

cheeky remarks which amuse grown-ups: 'The King showed him the birch and asked him: "Who is that for?" He answered angrily: "For you." The King could not help laughing.'

He was three years old when, on Christmas Eve 1604, he took part in the traditional festivities. 'Before supper he saw the Yule log being lit, and he danced and sang at the coming of Christmas.' He was given some presents: a ball, and also some 'little baubles from Italy', including a clockwork pigeon, toys intended as much for the Queen as for him. During the winter evenings, when he was kept indoors, 'he amused himself by cutting paper with scissors'. Music and dancing still occupied an important place in his life. Heroard writes with a hint of admiration: 'The Dauphin can dance all the dances'. He remembered the ballets which he had seen and in which he would soon be taking part, if indeed he had not already begun doing so: 'Remembering a ballet performed a year ago [when he was two years old], he asked: "Why was the little Ram bare?"' 'He played Cupid stark naked.' 'He danced the galliard, the saraband, the old bourrée.' He enjoyed playing Boileau's mandora and singing the song of Robin. He would be four years old in a few days' time, and he knew at least the names of the different strings of the lute. 'He played with the tips of his fingers on his lips, saying: "Here is the bass."' But his early acquaintance with the lute did not prevent him from listening to the less aristocratic fiddles played at the wedding of one of the King's chefs – or to a bagpipe player, one of the masons who were 'repairing his fireplace': the 'Dauphin listened to him for quite a long time'.

This was the time when he was being taught to read. At the age of three years five months 'he amused himself with a book of characters from the Bible: his nanny named the letters and he knew them all.' Next he was taught Pibrac's quatrins, a collection of rules of etiquette and morality which children had to recite from memory. At the age of four, he was given writing lessons by a clerk of the palace chapel called Dumont. 'He had his writing-desk taken into the dining-room to write under Dumont's guidance, and said: "I am putting down my example and going to school."' (The example was the handwriting model which he had to copy.) 'He wrote for his example, following the impression made on the paper, and followed it very well, taking pleasure in it.' He started learning Latin words. When he was six a professional scribe took the place of the chapel clerk: 'He wrote his example. Beaugrand, the King's scribe, showed him how to write.'

He still played with dolls: 'He played with some little toys and a German cabinet [wooden miniatures made by Nürnberg craftsmen]. M. de Loménie gave him a little nobleman splendidly dressed in a scented

collar ... He combed his hair and said: "I am going to marry him to Madame's [his sister's] doll." ' He still enjoyed paper-cutting. He had stories read to him too : 'His nanny told him the stories of Renard the Fox, Dives and Lazarus.' 'In bed, he was being told the stories of Melusina. I told him that they were fairy-stories and not true stories.' (A remark which already foreshadows modern education practice.) Children were not the only ones to listen to these stories: they were also told to adults at evening gatherings.

At the same time as he played with dolls, this child of four or five practised archery, played cards, chess (at six), and adult games such as 'racket-ball', prisoners' base and countless parlour games. At three, he was already playing at crambo, a game common to both children and young people. With the pages of the King's Chamber, who were older than he was, he played at 'Do you like company?'. 'He was the master [the leader of the game] now and then, and when he did not know what he had to say, he asked; he played these games, such as the game of lighting a candle blindfold, as if he were fifteen years old.' When he was not playing with pages, he was playing with soldiers: 'He played various games, such as "I want your place", fiddle-de-dee, hand-clapping, and hide-and-seek, with some soldiers.' At the age of six he played trades and charades, parlour games which consisted of guessing trades and stories that were represented in pantomime. These were also games played by adolescents and adults.

To an ever increasing extent, the Dauphin mixed with adults and took part in their amusements. At the age of five 'he was taken to the meadow behind the kennels [at Fontainebleau] to see Bretons from the King's workshops wrestling.' 'Taken to join the King in the ballroom to see the dogs fighting the bears and the bull.' 'He went to the covered tennis court to see a badger race.' And above all he took part in the court ballets. At the age of four and a half 'he put on a mask, went to the King's apartments to dance a ballet, and then refused to take off his mask, not wishing to be recognized.' He often dressed up as a 'Picardy chambermaid', a shepherdess or a girl (he was still wearing a boy's tunic). 'After supper he watched some dancing to the songs of a certain Laforest', a soldier-choreographer who was also the author of some farces. At the age of five 'he watched without great enthusiasm a farce in which Laforest played the comic husband, the Baron de Montglat the unfaithful wife, and Indret the lover who seduced her.' At the age of six 'he danced a ballet, smartly dressed as a man, in a doublet and breeches on top of his tunic.' 'He watched the ballet of the devils and magicians devised by the Piedmontese Jean-Baptiste [another soldier-choreographer] danced by soldiers under M. de Marsan's

command.' He did not dance only ballets and court dances, but also took part in what we should now call folk-dances. When he was five, he took part in one which reminds me of a Tyrolean dance which I once saw some lads in leather breeches perform in an Innsbruck café: 'The King's pages danced the branle "There are cabbages on Midsummer Day" and kicked each other in the bottom; he danced it and did as they did!' On another occasion he was dressed as a girl for a play: 'When the farce was over, he took his robe off and danced "There are cabbages on Midsummer Day", kicking his companions in the bottom. He liked this dance.'

Finally he joined the adults in the traditional festivities of Christmas, Twelfth Night and Midsummer Day; it was he who lit the Midsummer Day bonfire in the courtyard of the Château of Saint-Germain. On the eve of Twelfth Night: 'He was the King for the first time. Everyone shouted: "The King drinks!" God's share is left: he who eats it has to pay a forfeit.' 'Taken to the Queen's apartments, from which he watched the maypole being set up.'

Things changed when he was nearly seven: he abandoned his childhood clothes and henceforth his education was entrusted to men; he left 'Mamonglas', Mme de Montglas, and came under the jurisdiction of M. de Soubise. An attempt was now made to persuade him to give up the games of infancy, and in particular to stop playing with dolls: 'You must stop playing with these little toys [the German toys] and playing the wagoner: you are a big boy now, you are no longer a child.' He started learning the arts of riding, shooting and hunting. He played games of chance: 'He took part in a raffle and won a turquoise.' It seems indeed that his age of seven marked a stage of some importance: it was the age usually given in the moralistic and pedagogic literature of the seventeenth century as the age for starting school or starting work. But we should beware of exaggerating its importance. For all that he had stopped playing, or should have stopped playing, with his dolls, the Dauphin went on leading the same life as before: he was still given a whipping from time to time, and his pastimes scarcely changed at all. He went more and more to the theatre, and was soon going nearly every day – a sign of the importance of comedy, farce and ballet in our ancestors' frequent indoor and open-air entertainments. 'He went into the great gallery to watch the King tilting at the ring.' 'He listened to some naughty stories by La Clavette and others.' 'Played in his apartments with some little noblemen at heads or tails, like the King, with three dice.' 'Played at hide-and-seek' with a lieutenant of the Light Horse. 'He went to play tennis and then went to the great gallery to watch them tilting at the ring.' 'Dressed up and danced the Pantaloon.' He was nine years old now: 'After supper, he went

to the Queen's apartments, played blindman's buff, and made the Queen, the princesses and the ladies play it too.' 'He played "I sit down"' and the usual parlour games. 'After supper the King's nanny told him some stories, and he enjoyed this.' At thirteen we find him still playing hide-and-seek.

Rather more dolls and German toys before seven, and more hunting, riding, fencing and possibly playgoing after seven; the change was almost imperceptible in that long succession of pastimes which the child copied from the adults or shared with them. The novelist and historian Sorel would write a treatise on parlour games intended for adults. But at the age of three Louis XIII was playing crambo, and at six, trades and charades, all games which occupied an important place in Sorel's *Maison des Jeux*. At five he was playing cards. At eight he won a prize in a raffle, a game of chance in which fortunes used to change hands.

The same was true of musical or theatrical entertainments: when he was three, Louis XIII was dancing the galliard, the saraband and the old bourée, and taking part in the court ballets. At five, he was watching farces, and at seven, comedies. He sang, and played the violin and the lute. He was in the front row of the spectators at a wrestling-match, a ring-tilting contest, a bullfight or a bearfight, or a display by a tightrope walker. Finally he took part in the great collective festivals that were the religious and seasonal feast-days: Christmas, May Day, Midsummer Day ... It seems, therefore, that in the early seventeenth century there was not such a strict division as there is today between children's games and those played by adults. Young and old played the same games.

At the beginning of the seventeenth century this polyvalency no longer applied to the very small children. We are familiar with their games, for, ever since the fifteenth century when the *putti* had made their appearance in iconography, countless artists had depicted little children at play. In their pictures we can recognize the hobby-horse, the windmill, the bird on a leash ... and sometimes, though not so often, dolls. It is obvious that these dummies were reserved for little children. Yet one is entitled to wonder whether this had always been true and whether these toys had not previously belonged to the world of adults. Some toys originated in that spirit of emulation which induces children to imitate adult processes, while reducing them to their own scale. This is the case with the hobbyhorse, at a time when the horse was the principal means of transport and traction. Similarly, the little sails spinning round on the end of a stick could not be anything but the imitation by children of a technique which, unlike that of the horse, was not very old: the windmill technique introduced in the Middle Ages. The same reflex governs the

children of today when they imitate a lorry or a car. But while the wind-mill has long ago disappeared from our countryside, the child's windmill is still on sale in toyshops and market or fair-ground stalls. Children form the most conservative of human societies.

Other games seem to have some other origin than the desire to imitate adults. Thus the child is often depicted playing with a bird: Louis XIII had a shrike of which he was extremely fond; the reader himself may per-haps remember trying to tame a wounded crow in his childhood. The bird in these pictures is usually attached to a leash which the child is holding in his hand. Sometimes it may have been just a wooden dummy. In any case, judging by the iconographic evidence, the bird on a leash would seem to have been one of the most common of toys. The historian of the religions of Greece, Nilsson, tells us that in ancient Greece, as indeed in modern Greece, it was customary during the first days of March for boys to make a wooden swallow turning on a pivot and adorned with flowers. They would then take it from house to house and be given presents: here the bird or its image was not an individual toy but an element of a collective, seasonal festivity in which youth took part in the role which its age group assigned to it. What eventually became an individual toy unconnected with the community or the calendar and devoid of any social content, would appear to have been linked at first with traditional ceremonies which brought together children and adolescents – between whom, in any case, there was no clear distinction – and adults. Nilsson also shows how the see-saw and the swing, which were still frequently to be found in the iconography of games and pastimes in the eighteenth century, figure among the rites of one of the festivals provided for in the calendar: the Aiora, the festival of youth. The boys used to jump on skins filled with wine and the girls were swung backwards and forwards on swings; Nilsson sees the latter scene, which can be found on painted vases, as a fecundity rite. There was a close connection between the communal reli-gious ceremony and the game which formed its essential rite. Later this game lost its religious symbolism and its communal character to become at once profane and individual. In the process of becoming profane and in-dividual, it was increasingly confined to children, whose repertory of games became the repository of collective demonstrations which were henceforth abandoned by adult society and deconsecrated.

The problem of the doll and miniature toys leads us to similar hypo-theses. Historians of the toy, and collectors of dolls and toy miniatures, have always had considerable difficulty in separating the doll, the child's toy, from all the other images and statuettes which the sites of excavations yield up in wellnigh industrial quantities and which more often than not

had a religious significance: objects of a household or funerary cult, relics from a pilgrimage, etc. How many times have we been shown 'toys' which were in fact miniature replicas of familiar objects placed in tombs? I am not suggesting that in the past children did not play with dolls or replicas of adult belongings. But they were not the only ones to use these replicas; what in modern times was to become their monopoly, they had to share in ancient times, at least with the dead. The ambiguity of the doll and the replica continued during the Middle Ages, lasting even longer in country districts: the doll was also the dangerous instrument of the magician and the witch. This taste for representing in miniature the people and things of daily life, nowadays confined to little children, resulted in an art and industry designed as much to satisfy adults as to amuse children. The famous Neapolitan cribs are one of the manifestations of this art of illusion. The museums, especially in Germany and Switzerland, possess complicated collections of houses, interiors and sets of furniture which reproduce on a small scale all the details of familiar objects. Were they really dolls' houses, these little masterpieces of complex ingenuity? It is true that this popular adult art was also appreciated by children: there was a considerable demand in France for 'German toys' or 'Italian baubles'. A single word was used in France to refer to this industry, whether its products were designed for children or adults: *bibeloterie* ('knick-knackery'). The *bibelot* or knick-knack of old was also a toy. The evolution of language has robbed it of its childish, popular meaning, while on the other hand the evolution of ideas has restricted the use of miniature replicas to children. In the nineteenth century the knick-knack became something for the drawing-room or the showcase, but it remained a model of a familiar object: a little sedan chair, a little piece of furniture or a tiny piece of crockery, which had never been intended for a child to play with. In the taste for the knick-knack we can recognize a middle-class survival of the popular art of the Italian crib or the German house. The society of the ancien regime remained faithful for a long time to the little baubles which we would describe today as childish, probably because they have now fallen for good and all within the domain of childhood.

In 1747 we find Barbier writing: 'In Paris some toys have been devised called puppets ... These little figures represent Harlequin and Scaramouch [Italian comedy], or else bakers [trades and crafts], shepherds and shepherdesses [the taste for rustic fancy-dress.] These ridiculous things have taken the fancy of Parisian society to such an extent that one cannot go into any house without finding them dangling from every mantelpiece. They are being bought to give to women and girls, and the craze has reached such a pitch that this New Year all the shops are full of them ...

The Duchesse de Chartres has paid 1500 livres for one painted by Boucher.' The worthy bibliophile Jacob, quoting this passage, admits that in his day nobody would dream of getting up to such childish practices: 'Society people, who are much too busy nowadays, no longer join in such crazes as in the good old days of idleness which saw the height of the fashion for puppets: now we leave baubles to children.'

The puppet-show appears to have been another manifestation of the same popular art of illusion in miniature which produced the knick-knacks of Germany and the cribs of Naples. It underwent the same evolution too: the Guignol of early nineteenth-century Lyons was a character of a lower-class but adult theatre, while today Guignol has become the name of a puppet-show reserved for children.

No doubt this persistent ambiguity of children's games also explains why, from the sixteenth century until the beginning of the nineteenth century, the doll was used by the well-dressed woman as a fashion model. In 1571 the Duchesse de Lorraine, wanting to give a present to a friend who had just had a baby, put in an order for ' . . . some dolls, not too big and up to four and six, the best dressed dolls you can find, for the child of the Duchess of Bavaria, who has recently been delivered'. The gift was intended for the mother, but was sent in the child's name! Most of the dolls in public and private collections are not children's toys, which are usually crude objects roughly treated by their owners, but fashion dolls. The fashion doll eventually disappeared, its place being taken by the fashion drawing, largely thanks to the process of lithography (Fournier, 1889).

By 1600, approximately, toys had become an infantile speciality, with a few differences of detail with regard to present-day usage. We have seen in connection with Louis XIII that boys as well as girls used to play with dolls. Within the limits of infancy the modern discrimination between girls and boys was not so clearly defined: both sexes wore the same clothes, the same robe. There was probably some connection between the infantile specialization in toys and the importance of infancy in the ideas revealed by iconography and dress since the end of the Middle Ages. Childhood was becoming the repository of customs abandoned by the adults.

In 1600 the specialization of games and pastimes did not extend beyond infancy; after the age of three or four it decreased and disappeared. From then on the child played the same games as the adult, either with other children or with adults. We know this from the evidence furnished by an abundant iconography, for from the Middle Ages to the eighteenth century artists delighted in showing people at play: an indication of the place

occupied by amusement in the social life of the ancien regime. We have already seen that from his earliest years, Louis XIII, as well as playing with dolls, also played tennis and hockey, which we nowadays consider as games for adolescents or adults. In an engraving by Arnoult of the late seventeenth century,[1] we can see children playing bowls: children of good family, judging by the little girl's false sleeves. People had no objection to allowing children to play card games and games of chance, and to play for money. One of Stella's engravings devoted to the subject of *putti* at play gives a sympathetic picture of the child who has lost all his money (Bouzonnet-Stella, 1657). The Caravagesque painters of the seventeenth century often depicted bands of soldiers gambling excitedly in taverns of ill fame: next to the old troopers one can see some very young boys, twelve years old or so, who seem to be enthusiastic gamblers. A painting by S. Bourdon shows a group of beggars standing round two children and watching them playing dice.[2] The theme of children playing games of chance for money obviously did not shock public opinion as yet, for the same theme is to be found in pictures portraying neither old soldiers nor beggars but Le Nain's solemn characters.

Conversely, adults used to play games which today only children play. A fourteenth-century ivory shows the frog-game: a young man sitting on the ground is trying to catch hold of the men and women who are pushing him around.[3] Adélaïde de Savoie's book of hours, dating from the late fifteenth century, contains a calendar which is largely illustrated with pictures of games, and games which are not of a knightly character.[4] (To begin with, the calendars depicted trades and crafts, except for the month of May, which was reserved for a court of love. Games were then introduced and occupied more and more space: knightly sports such as hunting, but also popular games.) One of these is the faggot-game: one person is playing the candle in the centre of a ring of couples in which each lady is standing behind her cavalier and holding him tightly round the waist. In another part of the calendar the whole population of the village is having a snowball fight: men and women, children and grown-ups. In an early sixteenth-century tapestry, some peasants and noblemen – the latter more or less convincingly dressed as shepherds – are playing hot cockles: there are no children.[5] Several Dutch pictures of the second half of the seventeenth century also show people playing hot cockles. In one of them a few

1. Arnoult, engraving, Cabinet des Estampes, Oa 52 pet. fol. f° 164.
2. Geneva Museum.
3. Louvre.
4. Chantilly.
5. Victoria and Albert Museum.

children appear, but they are mixed up with adults of all ages: one woman is standing with her head hidden in her apron and one hand held open behind her back.[6] Louis XIII and his mother used to play hide-and-seek together. People played blind-man's buff at the Grande Mademoiselle's home, the Hôtel de Rambouillet (Fournier, 1889). An engraving by Lepautre shows that adult peasants also played this game.[7]

One can accordingly understand the comment which this study of the iconography of games and pastimes drew from the contemporary historian Van Marle: 'As for the games played by grown-ups, one cannot honestly say that they were any less childish than those played by children' (Marle, 1932). Of course not: they were the same!

Children also took part, in their allotted place among the other age groups, in seasonal festivities which regularly brought together the whole community. To realize the importance of games and festivities in the society of old is hard for us today, when for countryman and city-dweller alike there is only a very narrow margin between a laborious, hypertrophied professional activity and a demanding, exclusive family vocation. The whole of political and social literature, faithfully mirroring contemporary opinion, deals with living and working conditions; trade unionism which safeguards real earnings, and insurance which reduces the risk of sickness and unemployment – such are the principal achievements of the lower classes, or at least the achievements most apparent in public opinion, literature and political debate.

In the society of old, work did not take up so much time during the day and did not have so much importance in the public mind: it did not have the existential value which we have given it for something like a hundred years. One can scarcely say that it had the same meaning. On the other hand, games and amusements extended far beyond the furtive moments we allow them: they formed one of the principal means employed by a society to draw its collective bonds closer, to feel united. This was true of nearly all games and pastimes, but the social role was more obvious in the great seasonal and traditional festivals. They took place on fixed dates of the calendar, and their programmes, broadly speaking, followed traditional patterns. They have been studied only by experts on folklore or popular traditions, who give the impression that they were almost exclusively rural. In fact they concerned the whole of society, of whose vitality they were a manifestation. Children – children and adolescents – took part in them on an equal footing with all the other members of society, and more often than not played a part in them which was reserved

6. Berndt, 'Cornelis de Man' and 'Molinar'.
7. Lepautre engraving, Cabinet des Estampes.

for them by tradition. I do not of course propose to write here a history of these festivals – a huge subject and certainly one of great importance in social history – but a few examples will suffice to give an idea of the place occupied in them by children. The relevant documentation is extremely rich, even if little recourse is had to the predominantly rural descriptions of folklore literature. An abundant iconography and countless urban, middle-class paintings are sufficient in themselves to show the importance of these festivals; people took pains to depict them and preserve the recollection of them beyond the brief moment of their duration.

One of the favourite scenes with the artists and their clients was Twelfth Night, probably the greatest festival of the year. In Spain it has preserved this primacy which in France it has lost to Christmas. When Mme de Sévigné, who was then staying in her château at Les Rochers, learnt that a grandson had been born to her, she wanted her servants to share her joy, and in order to show Mme de Grignan that she had done things fittingly, she wrote to her: 'I gave my servants as much food and drink as on Twelfth Night' (de Sévigné, 1671). A miniature of Adélaïde de Savoie's book of hours depicts the first episode of the festival.[8] This was at the end of the fifteenth century, but the rites remained unaltered for a long time. Some men and women, friends and relations, are gathered together round the table. One of the guests is holding the Twelfth-cake, is in fact holding it on end. A child, between five and seven years old, is hiding under the table. The artist has placed in his hand a sort of scroll bearing an inscription which begins with the letters Ph. He has thus recorded the moment when, in accordance with tradition, it was a child who shared out the Twelfth-cake. The whole operation was carried out in accordance with a set formula. The child hid under the table. Then one of the guests cut a piece of the cake and called out to the child, 'Phaebe, Domine . . .' (whence the letters Ph in the miniature), and the child replied by giving the name of the guest to be served. And so it went on. One of the pieces was reserved for the poor, and the guest who ate it had to give them alms. When the festival lost its religious character, this alms-offering became an obligation for the king to pay a forfeit or give another cake, not to the poor, but to the other guests; but that is of little importance here. Let us simply note the role which tradition allotted to the child in the Twelfth Night ritual. The procedure adopted in the official lotteries of the seventeenth century was in all probability based on this custom; the frontispiece of a book entitled *Critique sur la loterie* shows the lots being drawn by a child (in d'Allemagne, 1906), a tradition which has been maintained down to the present day. The lottery draw is carried out in the same way as the Twelfth Night

8. Chantilly.

draw. The playing of this part by the child implies his presence in the midst of the adults during the long hours of the Twelfth Night vigil.

The second and supreme episode of the festival is the toast drunk to the guest who has found the traditional bean in his portion of the cake and has thus become the 'bean king': 'The king drinks.' The Flemish and Dutch painters were particularly fond of this theme; the famous Jordaens picture in the Louvre is well known, but the subject is also treated by a great many other Northern painters. For example, the picture by Metsu,[9] of a less burlesque and more truthful realism, gives us a very good idea of this evening gathering around the king, of people of all ages and probably all assembled round the table. The king, an old man, is drinking. A child is taking his hat off to him – probably the child who a little earlier had shared out the pieces of the Twelfth-cake, according to tradition. Another child, too young as yet to play this role, is perched in one of those enclosed high-chairs which were still very widely used. He cannot stand on his two feet yet, but he has to be allowed to join in the festivities with everybody else. One of the guests is dressed as a jester; the seventeenth century loved fancy dress and the most grotesque of costumes were appropriate on this occasion, but the jester's costume is to be found in other pictures of this familiar scene, and it is clear that it formed part of the ritual: the king's jester.

It was of course perfectly possible for one of the children to find the bean. Thus Heroard noted in his entry for 5 January 1607 (the festivities were held on the eve of Epiphany), that the future Louis XIII, then aged six, 'was the king for the first time'. A picture by Steen of 1668 commemorates the coronation of the painter's youngest son. The latter is wearing a paper crown, he has been perched on a bench as on a throne, and an old woman is tenderly giving him a glass of wine to drink.

Then began the third episode, which lasted until morning. Some of the guests can be seen to be wearing fancy dress; sometimes they have a label attached to their headgear which fixes their part in the play. The 'fool' takes command of a little expedition composed of a few mummers, a musician (usually a fiddler), and once again a child. Tradition allotted this child a well-defined role: he carried the candle of the kings. In Holland it seems that it was black. In France it was in a variety of colours: Mme de Sévigné once said of a woman that she 'was dressed in as many colours as the candle of the kings'. Led by the jester, the 'singers of the star' – that was what they were called in France – went round the neighbourhood begging for food and fuel. An engraving by Mazot of 1641 shows the procession of

9. 'The Feast of Kings'.

the singers of the star: two men, a woman playing a guitar, and a child holding the candle of the kings.[10]

Thanks to a painted fan of the early eighteenth century,[11] we can follow this procession as it makes its way to a neighbouring house. The hall of the house has been cut open vertically as in the scenery in mystery plays and fifteenth-century paintings, so as to show both the interior of the hall and the street behind the door. In the hall, the toast to the king is being drunk and the queen is being crowned. In the street, a band of mummers is knocking at the door, which will soon be opened to them.

Throughout this festival we can see children taking an active part in the traditional ceremonies. The same is true of Christmas Eve. Heroard tells us that Louis XIII, at the age of three, 'watched the Yule log being lit, and danced and sang at the coming of Christmas'. Perhaps it was he on this occasion who threw salt or wine on the Yule log, in accordance with the ritual described for us in the late sixteenth century by the German-Swiss Thomas Platter when he was studying medicine at Montpelier. He was spending Christmas at Uzès. A big log is laid across the fire-dogs. When it has caught, the household gathers together. The youngest child takes a glass of wine in his right hand, together with some breadcrumbs and a pinch of salt, while in his left hand he holds a lighted taper. All heads are bared and the child begins to intone the sign of the cross. In the name of the Father ... he drops a pinch of salt at one end of the hearth. In the name of the Son ... at the other end of the hearth ... and so on. The embers, which are supposed to have a beneficial quality, are preserved after the ceremony. Here again the child plays one of the essential roles laid down by tradition. He played a like role on occasions which were less exceptional but which at the time possessed the same social character: family meals. It was traditional for grace to be said by one of the youngest children and for the meal to be served by all the children present: they poured out the drinks, changed the dishes, carved the meat ... We shall have occasion to study the significance of these customs more closely when we come to examine the structure of the family. Let us just note here how common was the custom, from the fourteenth to the sixteenth century, of entrusting children with a special role in the ritual accompanying family and social gatherings, both ordinary and extraordinary.

Other festivals, though still concerning the entire community, gave youth the monopoly of the active roles, and the other age groups looked on as spectators. These festivals already had the appearance of festivals of childhood or youth; we have already seen that the frontier was vague and

10. Engraving by F. Mazot, 'La Nuit'.
11. From an Exhibition of painted fans, Galerie Charpentier, 1924.

ill-defined between these two groups, which today are so clearly separated.

In the Middle Ages, on the feast of the Holy Innocents, the children occupied the church; one of them was elected bishop by his companions and presided over the ceremony, which ended with a procession, a collec-lection and a banquet (Jarman, 1951). Still observed in the sixteenth cen-tury was a custom that on the morning of that day adolescents should surprise their friends in bed in order to give them a whipping, or as the expression went, 'in order to give them the innocents'.

Shrove Tuesday was apparently the feast day of schoolchildren and youth. Fitz Stephen has described it in twelfth-century London in con-nection with his hero Thomas Becket, who was then a pupil at the cathedral school of St Paul's: 'All the schoolchildren brought their fighting-cocks to their master.' (Jarman, 1951). Cockfighting – still popular where it survives, but intended for adults – was connected with youth and even with school in the Middle Ages. This is borne out by a fifteenth-century text from Dieppe which lists the payments due to the ferryman at a certain crossing: 'The master who keeps the school at Dieppe, one cock. when the games are being held at the school or elsewhere in the town, and all the other schoolboys of Dieppe shall be carried for this fee.' (Robillard de Beaurepaire, 1872). In London, according to Fitz Stephen, Shrove Tuesday began with cockfighting, which went on all through the morning. 'In the afternoon, the young people of the town went into the outskirts for the famous ball game ... The adults, relatives and notables came on horse-back to watch the young people's games and to become young again with them.' The ball game brought together several communities in a collective action, setting either two parishes or two age groups against one another: 'The ball game is a game which is played on Christmas Day by the mem-bers of the guilds of Cairac in Auvergne [and elsewhere of course]; this game is diversified and divided in such a way that the married men are on one side and the unmarried on the other side; and the aforementioned ball is carried from one place to another and taken from one man by another in order to win the prize, and he who carries it best has the prize for that day.' (Jusserand, 1901).

At Avignon, in the sixteenth century, the carnival was organized and led by the abbot of attorneydom, the president of the guild of notaries' and attorneys' clerks (Achard, 1869); these youth leaders were usually, at least in the south of France, 'pleasure leaders', to use the expression coined by a modern scholar, and bore the title of prince of love, king of attorneydom, abbot or captain of youth, or abbot of the guildsmen or children of the town. At Avignon on carnival day the students had the privilege of thrashing Jews and whores unless a ransom was paid.

The history of the University of Avignon tells us that on 20 January 1660, the Vice-Legate fixed the amount of this ransom at a crown a whore. The great festivals of youth were those of May and November. We know from Heroard that Louis XIII as a child went on to the Queen's balcony to watch the maypole being set up. May Day came next to Twelfth Night in popularity with the artists, who were fond of depicting it as one of the most popular festivals. It inspired countless paintings, engravings and tapestries. Varagnac has recognized the theme in the Botticelli 'Primavera' in the Uffizi Gallery (Varagnac, 1948). Elsewhere the traditional ceremonies are depicted with greater realism. A tapestry of 1642 enables us to see what a village or small market town looked like on May Day in the seventeenth century.[12] We are in the street. A middle-aged couple and an old man have come out of one of the houses and are standing on their doorstep waiting to greet a group of girls coming towards them. The first of the girls is carrying a basket of fruit and cakes. These young people go from door to door, and everyone gives them something to eat in return for their good wishes: the house-to-house collection was one of the essential elements of the festivals of youth. In the foreground some little boys, who are still dressed in tunics, like girls, are putting on wreaths of flowers and leaves which their mothers have made for them. In other pictures the procession of young collectors has formed up behind a boy who is carrying the may-tree: this is the case in a Dutch painting of 1700.[13] The group of children is running through the village behind the may-tree; the little children are wearing wreaths of flowers. The grown-ups have come out on their doorsteps to greet the procession of children. The may-tree is sometimes represented symbolically by a pole wreathed in leaves and flowers.[14] But the may-tree or maypole does not concern us here. Let us simply note the collections taken by the young people from the adults, and the crowning of the children with flowers, which one must associate with the idea of rebirth implicit in vegetation, an idea symbolized too by the tree which is carried through the streets and then planted.[15] These wreaths of flowers became, perhaps a pastime for the children, certainly the sign of their age group in pictorial representations. In the portraits of the time, both of individuals and families, children are shown wearing garlands of flowers or foliage. Thus in the Nicolas Maes picture of two little girls, in the Musée des Augustins, Toulouse, the first girl is putting on a wreath of flowers with one hand, and with the other is taking

12. 'The Seasons' by H. Göbel, 1923.
13. Brokenburgh, 1650–1702.
14. Tapestry at Tournai.
15. See also Mariette and Merian, Cabinet des Estampes.

flowers from a basket which her sister is holding out to her. Another group of festivals of childhood and youth was held at the beginning of November. 'On the 4th and 8th [of November],' writes the student Platter at the end of the sixteenth century, 'there was a masquerade called the masquerade of the cherubim. I too put on a mask and went to Dr Sapota's house, where there was a ball.' This was a masquerade for young people, and not simply children. It has completely disappeared from our calendar, ousted by the proximity of All Souls' Day. Public opinion refused to allow a joyful children's masquerade to follow so closely on such a solemn day – but this festival has survived in North America under the name of Hallowe'en. A little later on, Martinmas was the occasion of demonstrations confined to the young and more particularly perhaps to schoolchildren. 'Tomorrow is Martinmas,' we read in a scholastic dialogue of the early sixteenth century describing life in the schools of Leipzig (Massabieau, 1878). 'We schoolboys reap a rich harvest on that day ... it is customary for the poor [schoolboys] to go from door to door collecting money.' Here, as with May Day, we find the house-to-house collections: a practice which was sometimes a token of greeting and sometimes genuine mendicity. One has the impression of coming into contact with the last traces of a very old structure in which society was divided into age groups; nothing remained of this but the custom of reserving for youth an essential part in certain great collective celebrations. Moreover the ritual of these celebrations tended to make little or no distinction between children and adolescents; this relic of a time when the two age groups were treated as one no longer entirely corresponded with actual manners, as may be seen from the seventeenth-century habit of decorating only the little children, the little boys still in tunics, with the flowers and leaves which in the calendars of the Middle Ages adorned adolescents who had reached the age of love.

Whatever the role allocated to childhood and youth, primordial on May Day, incidental on Twelfth Night, it always followed a traditional pattern and corresponded to the roles of a collective game which mobilized the whole of society and brought all age groups together.

Other circumstances brought about the same participation of people of various ages in a single communal celebration. Thus from the fifteenth to the eighteenth century, and in Germany up to the beginning of the nineteenth century, countless subject pictures – painted, engraved and woven – represented the family gathering in which parents and children formed a little chamber orchestra and accompanied a singer. This was often on the occasion of a meal. Sometimes the table had been cleared. Sometimes the musical interlude occurred in the course of the meal, as in the Dutch picture by Lamen painted about 1640: the company are at table but the

meal has been interrupted; the boy who has been waiting at table has stopped; one of the guests, standing with his back to the fire-place with a glass in one hand, is singing, no doubt a drinking song, and another guest has taken up his lute to accompany him.[16]

We no longer have any idea of the place which music, singing and dancing used to occupy in everyday life. The author of an *Introduction to Practical Music*, published in 1597, tells how circumstances made a musician of him. He was dining in company: 'But supper being ended, and music books, according to custom, being brought to the table, the mistress of the house presented me with a part, earnestly requesting me to sing: but when, after many excuses, I protested unfeignedly that I could not, everyone began to wonder; yes, some whispered to others, demanding how I was brought up.' (Thomas Morley, quoted in Watson, 1907.) If the ability to sing a part or play an instrument was perhaps rather more common in Elizabethan England than on the Continent, it was also widespread in France, Italy, Spain and Germany, in accordance with an old medieval tradition which, in spite of changes in taste and technical improvements, lasted into the eighteenth and nineteenth centuries, dying out sooner or later according to the region. It no longer exists today except in Germany, Central Europe and Russia. It was very strong in those days in aristocratic and middle-class circles where groups of people liked to have themselves portrayed taking part in a concert of chamber music. It was strong too in lower-class circles, among peasants and even beggars, whose instruments were the bagpipe or the hurdy-gurdy, or else the fiddle, which had not yet been raised to the dignity of the present-day violin. Children made music from an early age. Louis XIII when he was very young sang popular or satirical songs which bore no resemblance to the children's songs of the past two centuries; he also knew the names of the strings of the lute. Children took part in all the concerts of chamber music depicted in the iconography of old. They also played among themselves, and it became a commonplace of painting to depict them holding some musical instrument: witness the two boys portrayed by Franz Hals,[17] one of whom is accompanying on the lute his brother or friend who is singing; witness the countless children depicted playing the flute by Franz Hals or Le Nain.[18] In a picture by Brouwer,[19] some rather ragged urchins in the street are shown eagerly listening to a hurdy-gurdy being played by a blind man straight out of a court of miracles: a very common theme in the seventeenth century. A Dutch painting by Vinckelbaons deserves

16. 'The musical interlude'.
17. 'Child musicians'.
18. Franz Hals, Berlin; Le Nain, Detroit; 'La charette', in the Louvre.
19. 'Hurdy-gurdy grinder surrounded by children', Studio of Georges de la Tour.

special mention on account of a significant detail illustrating the new attitude to childhood. As in other paintings of its kind, a hurdy-gurdy grinder is playing for an audience of children, and the scene has been captured just as the children are running up at the sound of the music. One of them is too small and has been left behind the rest, so his father has picked him up and is running after the others so that the child shall not miss anything: the delighted child is holding his hands out towards the hurdy-gurdy.

The same precocity is to be seen in dancing. We have already observed that Louis XIII at the age of three danced the galliard, the saraband and the old bourrée. Let us compare a painting by Le Nain and an engraving by Guérard.[20] In Le Nain's painting we are shown a round-dance of little girls and boys; one of the latter is still wearing a tunic with a collar. Two little girls have joined hands and are holding them up high to form a bridge, and the round is passing underneath. The Guérard engraving also depicts a round-dance, but the dancers are adults, and one of the young women is jumping in the air like a little girl with a skipping-rope. There is scarcely any difference between the children's dance and that of the adults. Later, however, the adults' dance would change in character and finally, with the waltz, be limited to the individual couple. Abandoned by town and court, by middle-class and aristocracy alike, the old collective dances would survive in the country districts, where the modern folklorists would discover them, and in the children's round-dances of the nineteenth century: in both these forms they are dying out today.

It is impossible to separate dance and drama. Dancing in those days was more of a collective activity and less clearly distinguished from ballet than our modern ballroom dancing in couples. We have seen in Heroard's diary how much Louis XIII's contemporaries liked dancing, ballet-dancing and play-acting, genres which were still fairly closely linked: a man would play a part in a ballet as naturally as he would dance at a ball (the link between the two words is significant: the same word later split into two, the ball for amateurs and the ballet for professionals). There were ballets in plays, even in the scholastic theatre of the Jesuit colleges. At Louis XIII's court, authors and actors were recruited on the spot from the nobles but also from the valets and soldiers; children both acted in the plays and attended the performances.

Was this true only of the court? No, it was common practice. A passage from c. Sorel (1642) shows that in the country villages people had never given up performing plays more or less comparable to the old mystery plays or to the present-day Passion plays of Central Europe. 'I think that he [Ariste, who found professional actors boring] would have been de-

20. Engraving, Cabinet des Estampes.

lighted if he could have seen as I have *all the boys* in a village performing the tragedy of Dives on a stage higher than the roof-tops, on which all the characters walked round seven or eight times in pairs to show themselves off before the play began, like the little figures above a clock ... I was fortunate enough on another occasion to see the Story of the Prodigal Son and that of Nebuchadnezzar, and later the Loves of Médor and Angélique, and the Descent of Radamont into the Underworld, performed by actors of such quality.' Sorel's speaker is being sarcastic; he did not really appreciate these popular entertainments. In most cases the text and the setting were governed by oral tradition. In the Basque country this tradition was established before the plays disappeared. Towards the end of the eighteenth century some 'Basque pastorals' were written and published, the subjects of which came from the romances of chivalry and the Renaissance pastorals.

Like music and dancing, these plays united the whole community and brought together the various age groups in both actors and audience.

We are now going to see what was the traditional moral attitude towards these popular games and pastimes. The vast majority accepted games indiscriminately and without any reservations. At the same time, a powerful and educated minority of rigid moralists condemned nearly all of them out of hand and roundly denounced them as immoral, allowing scarcely any exceptions. The moral indifference of the majority and the intolerance of a prudish elite existed side by side for a long time. A compromise was arrived at in the course of the seventeenth and eighteenth centuries which foreshadowed the modern attitude to games, an attitude fundamentally different from the old. It concerns us here because it also bears witness to a new attitude to childhood: a desire to safeguard its morality and also to educate it, by forbidding it to play games henceforth classified as evil and by encouraging it to play games henceforth recognized as good.

The high regard in which games of chance were still held in the seventeenth century enables us to gauge the extent of the old attitude of moral indifference. Nowadays we regard games of chance as suspect and dangerous, and the proceeds of gambling as the least moral and least respectable of revenues. We still play games of chance, but with an uneasy conscience. This was not yet the case in the seventeenth century: the uneasy conscience is the result of a thoroughgoing process of moralization which made the nineteenth century a society of 'right-minded people'.

La Fortune des gens de qualité et des gentilhommes particuliers (1661) is a book of advice to young noblemen on how to carve out a career for themselves. The author, the Maréchal de Caillière, certainly has nothing

of the trickster or adventurer about him: he has written an edifying bibliography of the works of Père Ange de Joyeuse, the Holy Leaguer monk; he is a pious man if not a bigot; and he has no originality or talent whatever. His observations accordingly represent current opinion among respectable opinion in 1661, the date when his book was published. He is for ever putting young people on their guard against loose living; if the latter is the enemy of virtue, it is also the enemy of wealth, for one cannot possess the one without the other: 'The young rake sees the occasions of pleasing his Master escape him through the windows of the brothel and the tavern.' The twentieth-century reader, glancing through these commonplaces with a somewhat weary eye, is all the more surprised to find this punctilious moralist discussing the social utility of games of chance. One chapter is entitled: 'If a Particulier [an abbreviation of *gentilhomme particulier*, as compared with the *gens de qualité*, in other words a minor nobleman in more or less impoverished circumstances] should play games of chance and how?' It is not just a matter of course: the Maréchal admits that the professional moralists, the clergy, expressly condemn all forms of gambling. This might be expected to cause our author some embarrassment, and in fact it obliges him to explain himself at some length. He remains faithful to the old attitude of the laity, which he endeavours to justify on moral grounds: 'It is not impossible to prove that it can be more useful than harmful if it is accompanied by the necessary circumstances ... I maintain that gambling is as dangerous for a man of quality [i.e. a rich nobleman] as it is useful for a Particulier [i.e. an impoverished nobleman]. The one risks a great deal because he is extremely rich, and the other risks nothing because he is not, yet a Particulier can hope for as much from the luck of the game as a great lord.' The one has everything to lose, the other everything to gain – a curious moral distinction!

But gambling, according to Caillière, offers other advantages besides financial profit: 'I have always held that the love of gambling was a gift of Nature whose utility I have recognized.' 'I take as the basis of my argument the fact that we have a natural love of gambling.' 'Games of skill [which we should be more inclined to recommend today] are pleasant to watch but unsuitable for making money.' 'I have heard a wise gambler who had made a considerable fortune out of gambling say that he had found no better way of turning gambling into an art than that of mastering his passion and regarding this skill as a money-making profession.' The gambler should have no anxiety, for bad luck will not leave him at a loss – a gambler always finds it easier to borrow money 'than a good tradesman'. 'What is more, this skill gives the Particulier admission to the best society, and a clever man can turn this to good account if he knows how to use

his opportunities ... I know men who have no revenue but a pack of cards and three dice, but who live in greater luxury and magnificence than provincial lords with their great estates [but no ready money].'

And the worthy Maréchal concludes with this advice: 'I advise the man who knows and loves games of chance to risk his money on them: as he has little to lose, he is not risking much and can gain a great deal.' For the biographer of Père Ange, the game of chance is not simply a pastime but a profession, a means of making one's fortune and extending one's acquaintances – a perfectly honourable means.

Caillière is not the only one of this opinion. The Chevalier de Méré, regarded in his time as a typical man of the world or man of breeding, expounds the same idea in his *Suite du Commerce du Monde* (ed. Boudhors, 1930): 'I would point out too that gambling has a good effect when a man indulges in it skilfully and with good grace: it is the means by which a man can obtain admission to any company where gambling is practised, and princes would often be extremely bored if they were unable to indulge in it.' He cites some august examples: Louis XIII (who as a child won a turquoise in a lottery), Richelieu 'who found relaxation in gambling', Mazarin, Louis XIV, and 'the Queen his mother [who] no longer did anything but gamble and say her prayers'. 'Whatever merits one may have, it is difficult to win a great reputation without entering high society and gambling is an easy way of obtaining admission. It is even a sure means of enjoying good company without saying a word, especially if one plays like a man of honour' – that is to say, avoiding 'eccentricity', 'caprice' and superstition. 'One must play like a man of honour, ready to win or lose without showing whether one has won or lost in one's expression or behaviour.' But one should beware of ruining one's friends: try as we may to talk ourselves out of it, 'we cannot help harbouring a grudge against those who have ruined us'.

If games of chance aroused no moral condemnation, there was no reason to forbid children to play them: hence the countless scenes, which art has handed down to us, of children playing cards, dice, backgammon, etc. The scholastic dialogues which schoolboys used as both manuals of etiquette and Latin glossaries sometimes gave recognition to games of chance as a practice too common to be condemned if not condoned. The Spaniard Vivès (1571) confines himself to giving a few rules in the interests of moderation: thus he says when one should gamble, with whom (one should avoid unruly persons), at what games, for what stake ('the stake should not be a trifle, since this is ridiculous and not worth playing for, nor should it be so high that it troubles the mind before the game begins'), 'in what manner', as a good gambler, that is to say, and for how long.

Even in the colleges, which afforded the best opportunities for raising moral standards, playing for money continued for a long time, in spite of the repugnance which the pedagogues felt for it. At the beginning of the eighteenth century the regulations of the Oratorian College at Troyes stated: 'There shall be no playing for money, unless it is for very small sums and by permission.' The modern university teacher who quoted this text in 1880, somewhat shocked by customs so far removed from the educational principles of his time, added: 'This was practically tantamount to permitting playing for money.' (G. Carré, 1881.)

As late as 1830 or so, there was undisguised gambling and heavy betting in the English public schools. The author of *Tom Brown's Schooldays*, Thomas Hughes, describes the betting fever which the Derby aroused at that time among the boys at Rugby; Dr Arnold's reforms would later rid the English schools of practices several centuries old. From the seventeenth century to the present day a somewhat complex moral attitude towards games of chance has evolved: as the opinion gained ground that gambling was a dangerous passion, a serious vice, then custom tended to change some of the gambling games in order to reduce the element of chance – which still remained – in favour of the mental skill and intellectual efforts of the gambler, so that certain card or chess games became less liable to the censure applied to the principle of the game of chance.

Another pastime underwent a different evolution: dancing. We have seen that dancing occupied an important place in the everyday life of both children and adults. Our present-day morality ought to find this less shocking than the general practice of gambling. We know that monks and nuns themselves danced on occasion without scandalizing public opinion, at least before the seventeenth-century movement to reform the religious communities. We know what life was like at Maubuisson Abbey when Mère Angélique Arnauld arrived there at the beginning of the seventeenth century to reform it. It was not particularly edifying but not necessarily scandalous – to worldly, if anything. 'On summer days,' M. Cognet (1951) tells us, quoting Mère Angélique de Saint-Jean, her sister's biographer, 'when the weather was fine, after vespers had been finished with, the Prioress used to take the community for a walk a good way from the Abbey, beside the ponds by the Paris road, when often the monks of Saint-Martin de Pontoise, who live near by, would come and dance with these nuns, and this as naturally as one would do something nobody would dream of criticizing.' These round-dances of monks and nuns aroused the indignation of Mère Angélique de Saint-Jean, and it cannot be denied that they did not correspond with the spirit of monastic life; but they did not have the same shocking effect on public opinion that would be pro-

duced today by monks and nuns dancing together clasped in each other's arms as the modern style of dancing demands. Certainly these religious persons had easy consciences. There were traditional observances too which allowed for dances of clerics on certain occasions. At Auxerre every new canon marked his elevation by presenting the parishioners with a ball which was then used for a great community game. This game was always played between two sides, either bachelors against married men or parish against parish. The festivities at Auxerre began with the singing of the *Victimae laudes Paschai*: and ended with a round danced by all the canons together. The historians tell us that this custom, which went back to the fourteenth century, was still alive in the eighteenth. In all probability the advocates of the Trent reforms looked on this round-dance as disapprovingly as Mère Angélique de Saint-Jean had looked on the dances of the nuns of Maubuisson and the monks of Pontoise: different times have different ideas about what is profane. Dances in the seventeenth century did not have the sexual character they would acquire much later, in the nineteenth and twentieth centuries. There were even some professional and trade dances: in Biscay there were special dances for wet-nurses in which the latter carried their charges in their arms.[21] In the society of the ancien regime, games in all their various forms – the sport, the parlour game, the game of chance – had an importance which they have lost in our technological society but which they still have today in certain primitive or archaic societies (Caillois, 1951). Yet to this passion which affected all ages and conditions, the Church opposed an absolute disapproval, and with the Church, laymen enamoured of order and discipline who were also eager to tame what was still a wild population, to civilize what was still a primitive way of life.

The medieval Church also condemned games in all their forms, especially in the communities of scholarship clerks which were to become the colleges and universities of the ancien regime. We can obtain some idea of this intransigence from the statutes of these communities. Reading them, the English historian of the medieval universities, J. Rashdall, was struck by the general proscription of all pastimes, the refusal to admit that there might be any innocent pastimes, in schools whose pupils for the most part were none the less aged from ten to fifteen (1895). They condemned the immorality of games of chance, the indecency of parlour games, the theatre and dancing, and the brutality of physical sports, which in point of fact often did degenerate into brawls. The statutes of the colleges were drawn up in such a way as to limit the opportunities for recreation as much as the risks of delinquency. *A fortiori*, the ban was

21. This dance was called the Karrikdanza. Information given by Mme Gil Reicher.

strict and binding on the religious, who were forbidden by an edict of the Council of Sens of 1485 to play tennis, especially in their shirts (it is true that in the fifteenth century a man without a doublet or robe, and with his breeches undone, was practically naked). One has the impression that the Church, incapable as yet of controlling a laity given up to riotous amusements, set out to safeguard its clerics by forbidding them to play any games whatever, thus establishing a fantastic contrast in ways of life – if the ban had really been observed. Here, for example, is what the regulations of Narbonne College had to say about its scholars' pastimes in 1379: 'Nobody in the house is to play tennis or hockey or other dangerous games [*insultuosos*], under pain of a fine of six deniers; nobody is to play dice, or any other games played for money, or indulge in table amusements [*comessationes*: blow-outs], under pain of a fine of ten sous.' Games and guzzling are put on the same level. Is there never to be any relaxation then? 'Scholars may only join occasionally and at rare intervals [what precautions, but how quickly they must have been swept aside, for the words opened the door to all the forbidden excesses!] in respectable or recreational games [but which, seeing that even tennis was forbidden? Perhaps parlour games?], staking a pint of wine or else some fruit, and on condition that such games are played quietly and not habitually [*sine mora*].'

At Seez College in 1477: 'We decree that nobody shall play dice, or other evil or forbidden games, or even recognized games such as tennis, especially in the common places [i.e. the cloister and the common-room used as a refectory], and that if such games are played elsewhere it shall be infrequently [*non nimis continue*].' In the Bull of Cardinal d'Amboise that founded Montaigu College in 1501 one chapter is entitled: *De exercitio corporali*. What is understood by that? The text begins with a somewhat ambiguous statement: 'Physical exercise seems to be of little use when it is combined with spiritual studies and religious exercises; on the other hand, it greatly develops the health when it is indulged in alternately with theoretical and scientific studies.' But by 'physical exercises' the author means not so much games as manual work (as opposed to intellectual work), and he gives pride of place to domestic tasks, thus recognizing their value as a form of relaxation: work in the kitchen, cleaning, serving at table. 'In all the above exercises [i.e. these domestic tasks] it must never be forgotten that one should work as hard and as speedily as possible.' Games come along only after the tasks have been completed, and with considerable reservations! 'When the Father [the head of the community] considers that the minds wearied by work and study need the relaxation afforded by recreations, he will tolerate these [*indulgebit*].' Certain games

are allowed in the common places, decent games which are neither tiring nor dangerous. At Montaigu, there were two groups of students: scholarship boys who, as in other foundations, were called the *pauperes*, and boarders who paid for board and lodging. The two groups lived apart from one another. The regulations stipulate that the scholars must not play so often or for so long as the boarders, no doubt because they were under an obligation to be better pupils and therefore had to work harder. The decrees reforming the University of Paris in 1452, decrees inspired by what was already a modern desire for discipline, maintain all the traditional severity: 'The masters [of the colleges] will not allow their students, at trade festivals or elsewhere, to dance immoral and immodest dances, or to wear indecent lay coats [short coats, without a robe]. But they will allow them to play decently and enjoyably, as a relaxation and just recreation after work.' 'They will not allow them, in the course of these festivals, to drink in the town or to go from house to house' (Théry, 1858). This ban is aimed at the door-to-door greetings, accompanied by collections, which tradition conceded to young people during the seasonal festivals. In one of his scholastic dialogues, Vivès sums up the situation in Paris in the sixteenth century in the following terms: 'Among the students, no other game than tennis can be played with the masters' permission, but sometimes the students secretly play cards and chess, the little children play garignons, and the naughtiest boys play dice.' In fact the students, like other boys, made no bones about visiting taverns and brothels, playing dice and going dancing. Yet the strictness of the regulations was never modified in the light of their inefficacy, the authorities showing a stubbornness quite astonishing to the modern mind, which is more concerned about efficacy than principle.

Magistrates, police officers and jurists, all enamoured of order and good administration, discipline and authority, gave their support to the schoolmasters and churchmen. For centuries on end, an uninterrupted succession of decrees was published forbidding the admission of students to gaming-rooms. Decrees of this kind were still appearing in the eighteenth century; witness this edict issued by the Lieutenant-General of Police of Moulins on 27 March 1752, of which a copy intended for public display is kept in the Musée des Arts et Traditions Populaires: 'It is forbidden for the masters of tennis-courts and billiard-rooms to allow students and servants to play during school hours, and for the masters of bowling and skittle alleys to allow students and servants to play at any time.' The reader will have noted the linking of servants with students: they were often of the same age and gave similar grounds for fearing their high spirits and lack of self-control. Bowls and skittles, nowadays quiet

pastimes, used to inspire so many brawls that in the sixteenth and seventeenth centuries the police magistrates sometimes banned them completely, trying to extend to the whole of society the restrictions which the churchmen wanted to impose on clerics and students. Thus these champions of social discipline to all intents and purposes classified games among quasi-criminal activities such as drunkenness and prostitution, which could be tolerated at a pinch, but which had to be forbidden at the slightest sign of excess.

This attitude of outright condemnation was modified in the course of the seventeenth century, however, largely owing to the influence of the Jesuits. The humanists of the Renaissance, in their anti-scholastic reaction, had already noted the educational possibilities of games. But it was the Jesuit colleges which gradually induced the authorities to assume a more tolerant attitude towards games. The Fathers realized from the start that it was neither possible nor even desirable to suppress them or to make them dependent on occasional, precarious and shameful permission. They proposed to assimilate them, to introduce them officially into their curricula and regulations, on condition that they chose and controlled them. Brought under discipline in this way, those pastimes which were deemed to be wholesome were accepted and recommended, and were henceforth regarded as means of education no less respectable than study. Not only was there no more talk of the immorality of dancing, but dancing was taught in school, because by harmonizing the movements of the body it eliminated awkwardness and gave a boy a good bearing, 'a fine air'. Similarly play-acting, which the seventeenth-century moralists condemned out of hand, found its way into school. The Jesuits began with Latin dialogues on sacred subjects, then went on to French plays on profane subjects. Even ballet-dancing was allowed, despite the opposition of the authorities of the Company: 'The taste for dancing', writes Père de Dainville, 'so pronounced among the contemporaries of the Roi Soleil, who in 1669 was to found the Académie de la Danse, prevailed over the edicts of the Fathers General. After 1650 there was scarcely a single tragedy which did not have a ballet in the interval.' (Dainville, 1958.)

An album of engravings by Crispin de Pas, dated 1602, depicts scenes of school life 'in a Batavian college'. The class-rooms and the library are shown to us, but so is a dancing lesson, a game of tennis and a ball game. A new attitude had thus made its appearance: education had adopted games which it had hitherto forbidden or else tolerated as a lesser evil. The Jesuits published Latin treatises on gymnastics giving the rules of the recommended games. The need for physical exercise was admitted to an ever greater extent. Fénelon wrote: 'The games which children like best

are those in which the body is in motion; they are happy provided they can change position.' The doctors of the eighteenth century, taking as their inspiration the old 'exercise games' in the Jesuits' Latin treatises, elaborated a new technique of bodily hygiene: physical culture. In the *Traité de l'éducation des enfants* of 1722, by de Crousaz, a professor of philosophy and mathematics at Lausanne, we read: 'While it is growing, it is essential for the human body to be greatly agitated ... I consider games affording exercise to be preferable to all others.' Tissot's *Gymnastique médicale et chirurgicale* recommends physical games as the best exercises: 'They exercise all the parts of the body at the same time ... quite apart from the fact that the action of the lungs is constantly stimulated by the shouts and calls of the players.'

At the close of the eighteenth century, games found another justification, this time patriotic: they prepared a man for war. This was the time when the training of a soldier became what was virtually a scientific technique, the time too which saw the birth of modern nationalism. A link was established between the educational games of the Jesuits, the gymnastics of the doctors, the training of the soldier and the demands of patriotism. Under the Consulate there appeared a *Gymnastique de la Jeunesse, ou Traité élémentaire des jeux d'exercices considérés sous le rapport de leur utilité physique et morale*. The authors, Duvivier and Jauffret, stated bluntly that military drill is 'the drill which has been the basis of gymnastics from the beginning of time and which is particularly suitable for the period [the year XI] and the country in which we are writing'. 'Dedicated in advance to the common defence by the nature and spirit of our constitution, our children are soldiers before they are born.' 'Everything military breathes something great and noble which raises a man above himself.'

Thus, under the successive influence of the humanist pedagogues, the doctors of the Enlightenment and the first nationalists, we have come from the violent and suspect games of the Middle Ages to gymnastics and military training, from popular tussles to gymnastic societies.

This evolution was dictated by considerations of morality, health and the common weal. A parallel evolution divided up according to age and rank games which were originally common to the whole of society.

In his history of classical literature Daniel Mornet wrote, in 1940, of parlour games: 'When the young people of the middle classes of my generation [Mornet was born in 1878] played "parlour games" at the *matinées dansantes* of their families, they rarely suspected that these games, more numerous and complex than in their time, had been the delight of high society two hundred and fifty years before.' Much earlier than that in

fact. In the fifteenth-century book of hours of the Duchesse de Bourgogne we have an example of a 'paper game': a lady is sitting with a basket in her lap in which some young people are putting slips of paper. At the end of the Middle Ages 'selling games' were very fashionable. 'A lady would give a gentleman or a gentleman would give a lady the name of some flower or object, and the other had to respond immediately and without a moment's hesitation with a compliment or a rhymed epigram.' It is the modern editor of Christine de Pisan's poetry whom we have to thank for this description of the rules of the game – Christine de Pisan wrote seventy epigrams for 'selling games'. This procedure doubtless originated in courtly manners. It then passed into popular song and also into children's games: the game of crambo which, as we have seen, amused Louis XIII at the age of three. But it was kept up too by adults or youths who had left childhood far behind. A nineteenth-century sheet of 'tuppence-coloured' pictures still shows the same games, but it bears the title 'Games of old', which suggests that fashion was dropping them, and that they were becoming either provincial or childish – hot cockles, the whistle game, the knife in the water-jug, hide-and-seek, forfeits, sweet knight, blind-man's buff, the little man who doesn't laugh, the love-pot, the sulker, the stool of repentance, the kiss under the chandelier, the cradle of love. Some would become children's games, while others would retain the ambiguous and far from innocent character which had previously earned them the condemnation of the moralists, even the more tolerant moralists such as Erasmus.

Sorel's *Maison des Jeux* enables us to study this evolution at an interesting stage, in the first half of the seventeenth century. Sorel makes a distinction between parlour games, 'games of exercise' and 'games of chance'. The last two, he observes, are 'common to every sort of person, being played by valets as much as by masters ... as easy for the vulgar and the ignorant as for the clever and the learned'. Parlour games on the other hand are 'games of wit and conversation'. In principle 'they can appeal only to persons of quality, bred on civility and gallantry, quick at repartee and speeches, and full of knowledge and judgment, and cannot be played by others'. This at least is Sorel's opinion: this is what he would like parlour games to be. In fact, at this time parlour games were also popular with children and people of humble birth, 'the vulgar and the ignorant'. Sorel has to admit this. 'To begin with, we shall consider the children's games ... There are some which are exercises' – hockey, spinning the top, ladders, ball, battledore and shuttlecock, and 'trying to catch one another with one's eyes open or blindfolded'. But 'there are others which depend rather more on the mind', and he cites as an example

the 'rhymed dialogues', Christine de Pisan's 'selling games', which still amused grown-ups and children alike. Sorel guesses at the origins of these games: 'These children's games in which there are a few rhymed words (crambo, for instance) are usually couched in very old and very simple words, and these are taken from some history or romance of olden days, which shows how people amused themselves in the past by means of a naive imitation of what had happened to knights or to ladies of high degree.'

Sorel finally observes that in the lower classes these children's games are also played by adults, an observation of great interest and importance for us: 'As these are children's games, they also serve for rustic persons whose minds are not more advanced than children's in this respect.' Yet at the beginning of the seventeenth century Sorel has to admit that 'sometimes persons of quite high rank could play these games for recreation', and public opinion sees nothing wrong in this: these 'mixed' games, those common to all ages and conditions, 'are deemed respectable on account of the good use to which they have always been put'. 'There are certain kinds of games in which the mind is not very active, so that the very young can play them, although it is true that aged and very serious persons also engage in them on occasion.' But some people – Ariste in Sorel's *Maison des Jeux*, for instance – consider these pastimes of children and villeins unworthy of a respectable man. Sorel's speaker is reluctant to ban them so completely: 'Even those which seem lowly can be elevated by giving them a different application from the first, which I have described so that it can be used as a model.' And he then tries to raise the intellectual level of the parlour games played indoors. Truth to tell, the modern reader, after studying Sorel's description of the game of mora – in which the leader raises one, two or three fingers, and the company have to repeat the same gesture immediately – finds it hard to see in what respect mora is more elevated and intelligent than crambo, which Sorel dismisses as fit only for children. But he finds it even more surprising that a novelist and historian such as Sorel should devote a monumental work to the description and revision of these pastimes; here in fact we have further proof of the importance which games occupied in the preoccupations of the society of old.

Thus in the seventeenth century a distinction was made between the games of adults and noblemen and the games of children and yokels. The distinction was an old one, dating back to the Middle Ages. But in the Middle Ages, from the twelfth century to be precise, it applied only to certain games, few in number and distinctive in character: the courtly games. Before that, before the final constitution of the idea of nobility,

games were common to all people, whatever their rank. Certain games retained their universality for a long time: François I and Henri II did not regard wrestling as beneath them, and Henri II used to join in all ball games – something which would no longer have been accepted in the next century. Richelieu vaulted in his gallery like Tristan at the court of King Mark, while Louis XIV played tennis. But these traditional games were to be dropped in their turn in the eighteenth century by people of quality.

As far back as the twelfth century, certain games had been reserved for nobility and specifically for adults (see de Vriès and Marpugo, 1904–10). Thus while wrestling was a common sport, the tournament and the ring were knightly games. Villeins were denied admission to tournaments, and no children, even of noble birth, were allowed to take part in them: for what was perhaps the first time, tradition forbade children, and at the same time villeins, to participate in collective games. The result was that the children amused themselves by imitating the forbidden tournaments: the calendar of the Grimani breviary shows us some grotesque children's tournaments, in which one participant is thought to be the future Charles V, with the children sitting astride barrels instead of horses.

This marked the beginning of the idea that noblemen should avoid mixing with villeins and taking their sport among them: an idea which did not succeed in imposing itself everywhere, at least until the eighteenth century, when the nobility disappeared as a class with a social function and was replaced by the bourgeoisie. In the sixteenth and at the beginning of the seventeenth century, a great many iconographic documents bear witness to the mixing of the classes at the seasonal festivals. In one of the dialogues in *The Courtier* by Balthazar Castiglione, a sixteenth-century classic translated into every language, the subject arouses various opinions: 'In our land of Lombardy,' says Pallavicino, 'we do not hold this opinion [that the courtier should play only with other noblemen]. Thus there are several noblemen who at festival-time dance all day in the sun with the peasants, and play with them at throwing the bar, wrestling, running and vaulting, and I see no harm in this.' A few of those present protest; they concede that at a pinch a nobleman may play with peasants, but only if he can 'win the day' with no obvious effort: he must be 'practically sure of winning'. 'If there is anything which is too ugly and shameful for words, it is the sight of a nobleman being defeated by a peasant, especially in wrestling.' The sporting spirit did not exist at that time, except in knightly games, and then in a different form inspired by the feudal concept of honour.

At the end of the sixteenth century the tournament died out. Other games took its place in the gatherings of young noblemen at court, and in

the classes in military training at the academies where, during the first half of the seventeenth century, noblemen were given instruction in riding and the use of arms. There was the quintain: the player, on horseback, tilted at a wooden target, which took the place of the living target of the old tournaments, a Turk's head. And there was the ring: the player had to unhook a ring as he rode past. In the book by Pluvinel, the principal of one of these academies, an engraving by Crispin de Pas shows Louis XIII as a child tilting at the quintain.[22] The author writes of the quintain that it was something between 'the ferocious pleasure of breaking a lance with an adversary [the tournament] and the gentle pastime of tilting the ring'. At Montpellier in the 1550s, so the medical student Félix Platter tells us, 'On June 7th the nobility played at tilting the ring; the horses were richly comparisoned, covered with cloths and decked with plumes of all colours.' Heroard, in his diary of Louis XII's childhood, makes frequent mention of ring-tilting contests at the Louvre and Saint-Germain. 'The practice of tilting at the ring is engaged in every day', observes the specialist Pluvinel. The quintain and the ring, as games reserved for the nobility, took the place of the tournaments and knightly games of the Middle Ages. But then what happened to them? They did not disappear completely as one might imagine; but nowadays you will not find them on the sports grounds of upper-class districts but at the fair, where you can still shoot at Turks' heads and where the children, on the wooden horses of the roundabouts, can still tilt at the ring. This is what remains of the knightly tournaments of the Middle Ages: children's games and popular amusements.

There is no lack of other examples of this evolution which gradually transfers the games of old into the repository of childish and popular games. Take the hoop for instance. In the late Middle Ages the hoop was not a children's monopoly. In a sixteenth-century tapestry we can see adolescents playing with hoops; one of them is just about to start his rolling with a stick. In a woodcut by Jean Leclerc dating from the late sixteenth century there are some quite big children who, not content with bowling their hoops along, are jumping through them as if they were playing with a skipping-rope. The hoop was used for acrobatics, difficult figures on occasion. It was familiar enough to young people, and old enough, too, to be used in traditional dances such as that at Avignon in 1596 described for us by the Swiss student Félix Platter: on Shrove Tuesday, groups of young men gathered together, wearing masks and dressed as pilgrims, peasants, seamen, Italians, Spaniards, Alsatians, or women, and escorted by musicians. 'In the evening they danced in the street the dance of the hoops, in which many youths and girls of the

22. In the Cabinet des Estampes.

nobility took part, dressed in white and covered with jewels. Each person held a white-and-gold hoop in the air as he danced. They went into the inn where I followed them to see them from close to. It was wonderful to see them passing backwards and forwards under those rings, bending and straightening up and passing one another in time, to the sound of the instruments.' Dances of this kind are still to be found in the repertory of villages in the Basque country.

By the end of the seventeenth century it seems that in the towns the hoop had been left to the children: an engraving by Mérian[23] shows us a little child bowling his hoop as little children would during the whole of the nineteenth century and part of the twentieth. From being the plaything of all ages, and an accessory used in dancing and acrobatics, the hoop would gradually be confined to smaller and smaller children until it was finally abandoned altogether, illustrating once again the truth that, in order to retain the favour of children, a toy must have some connection with the world of adults.

We saw at the beginning of this chapter that Louis XIII as a child was told stories, the stories of Mélusine, fairy-stories. But these stories were also intended for grown-ups. 'Mme de Sévigné,' observes M. E. Storer, the historian of the fashion for fairy-stories at the end of the seventeenth century, 'was brought up on fairy-tales'. Though amused by M. de Coulanges's witticisms about a certain Cuverdon, she did not respond to them 'for fear that a toad might jump up at her face to punish her for her ingratitude'. Here she was referring to a fable by the troubadour Gauthier de Coincy which had been handed down by tradition.

On 6 August 1677, we find Mme de Sévigné writing: 'Mme de Coulanges ... was kind enough to tell us the stories with which the ladies of Versailles are amused: this is known as coddling them. So she coddled us and told us about a green island on which a princess was brought up who was lovelier than the day. It was the fairies who breathed on her all the time ... This story went on for a good hour.' We know too that Colbert 'in his leisure moments had servants specially employed to tell him stories very similar to fairy-tales'.

However, in the second half of the century, people began to consider these stories too simple, while at the same time a new sort of interest was taken in them which tended to make a fashionable literary genre out of oral recitations of a naive, traditional character. This taste found expression both in publications intended for children, at least in principle, such as Perrault's tales, and in more serious works meant for grown-ups, from which children and the lower orders were excluded. The evolution of the

23. In the Cabinet des Estampes.

fairy-story recalls that of the parlour game described above. This is Mme de Murat speaking to the modern fairies: 'The old fairies, your predecessors, now seem very frivolous creatures compared to you. Their occupations were menial and childish, and could amuse only servant-girls and nannies. Their only interest was in sweeping out the house, putting on the stew, doing the washing, rocking the children and sending them to sleep, milking the cows, churning the butter, and a thousand other trivialities of that kind ... That is why nothing remains to us today of their activities but fairy-tales ... They were nothing but beggar-girls ... But you, my ladies [the modern fairies], have taken a new road. You busy yourselves only with great things, of which the least importance are to give wits to those who have none, beauty to the ugly, eloquence to the ignorant, and wealth to the poor.'

But some authors continued to appreciate the flavour of the old stories, which they had listened to in the past, and sought rather to preserve it. Mlle L'Héritier introduces her stories in the following way: 'A hundred times my nanny or my love told me this story at night beside the fire; all I am doing is adding a little embroidery. You may well think it surprising ... that these tales, incredible though they are, should have been handed down to us from century to century without anyone taking the trouble to write them down. They are not easy to believe, but as long as there are children in this world, mothers and grandmothers, they will be remembered.'

People began to consolidate a tradition which had hitherto been oral: certain tales 'which had been told me when I was a child ... have been put on paper by ingenious pens within the last few years'. Mlle Lhéritier thought that the sources were very old: 'Tradition tells me that the troubadours or story-tellers of Provence invented Finette a long time before Abelard or the famous Comte Thibaud de Champagne produced their romances.' Thus the story became a literary genre approximating to the philosophical tale, or else affecting an old-fashioned style, like Mlle Lhéritier's work: 'You must admit that the best stories we have are those which imitate most closely the style and simplicity of our nannies'.'

At the end of the seventeenth century, while the story was becoming a new form of serious written literature, the oral recitation of stories was being abandoned by the very people for whom the fashion of the written story was intended. Colbert and Mme de Sévigné listened to the stories which were told them and nobody thought of stressing the fact as something out of the ordinary; it was a commonplace recreation like reading a detective story today. In 1771, however, this was no longer the case, and among adults in good society the old, half-forgotten stories of the oral

tradition were sometimes the object of a curiosity of an archaeological or ethnological nature foreshadowing the modern interest in folklore and slang. We find the Duchesse de Choiseul writing to Mme du Deffand that Choiseul 'is having fairy-stories read to him all day. We are all reading them now. We find them just as probable as present-day history.' This was as if one of our twentieth-century statesmen, after a political defeat, started reading Tintin or Mickey Mouse in his retirement. The Duchesse de Choiseul was tempted, and wrote two stories; she adopted the tone of the philosophical tale, if we judge by the beginning of *Le Prince enchanté*: ' "Sweet Margot, you who in my study sent me to sleep or woke me up with pretty fairy-tales, tell me some sublime story with which I can entertain the company." "No," said Margot, "nothing sublime. All that men need is fairy-stories." '

According to another anecdote of the same period, a lady in a moment of boredom experienced the same curiosity as the Choiseuls. She rang for her maid and asked for the story of Pierre de Provence and the fair Maguelonne, which would be completely forgotten today but for Brahms's admirable Lieder. 'The astonished maid had to be asked three times over, and heard this strange order with obvious contempt; however, she had to obey; she went down to the kitchen and came back with the pamphlet, blushing scarlet.'

There were in fact certain publishers, especially at Troyes, who in the eighteenth century issued printed editions of fairy-stories for the rural public who had learnt to read and whom they reached by means of hawkers. But these publications (known as the Bibliothèque Bleue or the 'blue tales' because they were printed on blue paper) owed nothing to the literary fashion of the late seventeenth century; they transcribed, as faithfully as the inevitable evolution of taste would permit, the old stories of the oral tradition. A 1784 publication of the Bibliothèque Bleue contains, as well as the story of Pierre de Provence and the fair Maguelonne, the stories of Robert le Diable and the four Aymon sons, Perrault's tales and those of Mlle de la Force and Mme d'Aulnay.

Apart from the books of the Bibliothèque Bleue, there were still occasional story-tellers to while away the long winter evenings, and also professional story-tellers, the heirs of the reciters, singers and jongleurs of old. In the paintings and engravings of the seventeenth and eighteenth centuries, and the picturesque lithographs of the early nineteenth century, the story-teller or charlatan is a popular subject. The charlatan is shown perched on a platform, telling his story and pointing with a stick to the text written on a big board which a companion is holding up in the air so that the audience can read while they listen. In some provincial towns the

lower-middle class had sometimes kept this pastime alive. A memorialist, M. Grosley, in 1787, tells us that at Troyes, towards the end of the eighteenth century, the men of the town would gather together, in winter in the taverns, in summer 'in the gardens where, taking off their wigs, they would put on their little caps'. This was called a *cotterie*. 'Each cotterie had at least one story-teller on whom each person modelled his talent.' The memorialist recalls one of the story-tellers, an old butcher. 'Two days I spent with him when I was a child were given up to stories whose charm, effect and naivety could scarcely be, I will not say rendered, but appreciated by the present generation.'

Thus the old stories which everyone listened to in the time of Colbert and Mme de Sévigné were gradually abandoned, first by the nobility and then by the bourgeoisie, to the children and the country-dwellers. The latter in their turn abandoned them when the newspaper took the place of the Bibliothèque Bleue; the children then became their last public, but not for long, for children's reading is at present undergoing the same evolution as games and manners.

Tennis used to be one of the most common games; of all the physical games, it was the one which the moralists of the late Middle Ages tolerated with the least repugnance: it was the most popular game, common to all ranks of society, to kings and villeins alike, for several centuries. But towards the end of the seventeenth century there was a swift decline in the popularity of tennis with the nobility. In Paris in 1657 there were one hundred and fourteen tennis courts; in 1700, in spite of the growth of the population, their number had fallen to ten; in the nineteenth century there were only two left, one in the Rue Mazarine and the other on the terrace of the Tuileries, where it was still to be found in 1900. In the seventeenth century, according to Jusserand, the historian of games and pastimes, Louis XIV had shown a marked lack of enthusiasm for tennis. Though the well-bred adult abandoned this game, the peasant and the child (even the well-bred child) remained faithful to it in different forms of rounders or pelota or battledore and shuttlecock; in the Basque country it lasted until its revival in the improved forms of grand or little chistera.

An engraving by Mérian[24] dating from the late seventeenth century shows us a ball game that has brought together children and adults: the ball is being blown up in the picture. But at that time the ball game, rough in nature, was already suspect to experts on etiquette and good manners. Thomas Elyot and Shakespeare warned noblemen against it. James I of England forbade his son to play it. According to du Cange, only peasants

24. In the Cabinet des Estampes.

played it: 'The chole, a kind of ball which each player kicks hard and which is still used in a game played by the peasants in our provinces.' A game played in Brittany for example, as late as the nineteenth century: 'The lord of the manor would throw into the midst of the crowd a ball full of bran which the men from the different cantons would try to snatch from one another ... when I was a child [the author was born in 1749] I saw a man break his leg jumping through a ventilator to get the ball. These games fostered physical strength and courage, but, as I have already said, they were dangerous.'

Many other 'games of exercise' were to pass like this into the province of children and the lower classes. Mall, for instance, of which Mme de Sévigné wrote in a letter of 1685 to her son-in-law: 'I have had two games of mall with the players [at Les Rochers]. Oh, my dear Count, I keep thinking of you and the grace with which you hit the ball. I wish you had such a fine alley at Grignan. All these games of bowls, skittles and croquet, abandoned by the nobility and the bourgeoisie, were relegated in the nineteenth century to the country for adults, to the nursery for children.

The survival among children and the lower classes of games hitherto common to the whole community is likewise responsible for the preservation of one of the most widespread types of amusement in former times: fancy dress. From the sixteenth to the eighteenth century, novels were full of stories of disguise – boys disguised as girls, princesses as shepherdesses, and so on. Literature reflected a taste which found expression at every opportunity provided by the seasonal or occasional festivals: Twelfth Night, Shrove Tuesday, the November festivals. For a long time it was customary, especially among women, to wear a mask to go out. The well-born were fond of having their portraits painted in their favourite fancy-dress costumes. After the eighteenth century, fancy-dress festivals became rarer and more discreet in good society; the carnival became a lower-class amusement and even crossed the seas to America. Today, with few exceptions, children are the only ones who put on masks at carnival time and dress up for fun.

In every case the same evolution takes place with repetitious monotony. At first some games were common to all ages and all classes. The phenomenon which needs to be emphasized is the abandonment of these games by the adults of the upper classes and their survival among both the lower classes and the children of the upper classes. It is true that in England the upper classes have not abandoned the old games as they have in France, but they have completely transformed them, and it is in unrecognizable modern forms that the games have been adopted by the middle-class sportsman.

It is important to note that the old community of games was destroyed at one and the same time between children and adults, between lower class and middle class. This coincidence enables us to glimpse already a connection between the idea of childhood and the idea of class.

Chapter 5
From Immodesty to Innocence

One of the unwritten laws of contemporary morality, the strictest and best respected of all, requires adults to avoid any reference, above all any humorous reference, to sexual matters in the presence of children. This notion was entirely foreign to the society of old. The modern reader of the diary in which Henri IV's physician, Heroard, recorded the details of the young Louis XIII's life is astonished by the liberties which people took with children, by the coarseness of the jokes they made, and by the indecency of gestures made in public which shocked nobody and which were regarded as perfectly natural. No other document can give us a better idea of the non-existence of the modern idea of childhood at the beginning of the seventeenth century.

Louis XIII was not yet one year old: 'He laughed uproariously when his nanny waggled his cock with her fingers.' An amusing trick which the child soon copied. Calling a page, 'he shouted "Hey, there!" and pulled up his robe, showing him his cock.'

He was one year old: 'In high spirits,' notes Heroard, 'he made everybody kiss his cock.' This amused them all. Similarly everyone considered his behaviour towards two visitors, a certain de Bonières and his daughter, highly amusing: 'He laughed at him, lifted up his robe and showed him his cock, but even more so to his daughter, for then, holding it and giving his little laugh, he shook the whole of his body up and down.' They thought this so funny that the child took care to repeat a gesture which had been such a success; in the presence of a 'little lady', 'he lifted up his coat, and showed her his cock with such fervour that he was quite beside himself. He lay on his back to show it to her.'

When he was just over a year old he was engaged to the Infanta of Spain; his attendants explained to him what this meant, and he understood them fairly well. 'They asked him: "Where is the Infanta's darling?" He put his hand on his cock.'

During his first three years nobody showed any reluctance or saw any harm in jokingly touching the child's sexual parts. 'The Marquise [de Verneuil] often put her hand under his coat; he got his nanny to lay him on her bed where she played with him, putting her hand under his coat.'

'Mme de Verneuil wanted to play with him and took hold of his nipples; he pushed her away, saying: "Let go, let go, go away." He would not allow the Marquise to touch his nipples, because his nanny had told him: "Monsieur, never let anybody touch your nipples, or your cock, or they will cut it off." He remembered this.' Again: 'When he got up, he would not take his shirt and said: "Not my shirt, I want to give you all some milk from my cock." We held out our hands, and he pretended to give us all some milk, saying: "Pss, pss," and only then agreeing to take his shirt.'

It was a common joke, repeated time and again, to say to him: 'Monsieur, you haven't got a cock.' Then 'he replied: "Hey, here it is!" – laughing and lifting it up with one finger.' These jokes were not limited to the servants, or to brainless youths, or to women of easy virtue such as the King's mistress. The Queen, his mother, made the same sort of joke: 'The Queen, touching his cock, said: "Son, I am holding your spout." ' Even more astonishing is this passage: 'He was undressed and Madame too [his sister], and they were placed naked in bed with the King, where they kissed and twittered and gave great amusement to the King. The King asked him: "Son, where is the Infanta's bundle?" He showed it to him, saying: "There is no bone in it, Papa." Then, as it was slightly distended, he added: "There is now, there is sometimes." '

The Court was amused, in fact, to see his first erections: 'Waking up at eight o'clock, he called Mlle Bethouzay and said to her: "Zezai, my cock is like a drawbridge; see how it goes up and down." And he raised it and lowered it.'

By the age of four, 'he was taken to the Queen's apartments, where Mme de Guise showed him the Queen's bed and said to him: "Monsieur, this is where you were made." He replied: "With Mamma?" ' 'He asked his nanny's husband: "What is that?" "That," came the reply, "is one of my silk stockings." "And those?" [after the manner of parlour-game questions] "Those are my breeches." "What are they made of?" "Velvet." "And that?" "That is a cod-piece." "What is inside?" "I don't know, Monsieur." "Why, a cock. Who is it for?" "I don't know, Monsieur." "Why, for Madame Doundoun [his nanny]." '

'He stood between the legs of Mme de Montglat [his governess, a very dignified, highly respectable woman, who however did not seem to be put out – any more than Heroard was – by all these jokes which we would consider insufferable today]. The King said: "Look at Madame de Montglat's son: she has just given birth." He went straight away and stood between the Queen's legs.'

When he was between five and six, people stopped talking about his sexual parts, while he started talking more about other people's. Mlle

Mercier, one of his chambermaids who had stayed up late the night before, was still in bed one morning, next to his bed (his servants, who were sometimes married, slept in his bedroom and do not appear to have allowed his presence to embarrass them). 'He played with her, toyed with her toes and the upper part of her legs, and told his nanny to go and get some birch twigs so that he could beat her, which he did ... His nanny asked him: "What have you seen of Mercier's?" he replied calmly: "I have seen her arse." "What else have you seen?" He replied calmly and without laughing that he had seen her private.' On another occasion, 'after playing with Mlle Mercier, he called me [Heroard] and told me that Mercier had a private as big as that (showing me his two fists) and that there was water inside.'

After 1608 this kind of joke disappeared: he had become a little man – attaining the fateful age of seven – and at this age he had to be taught decency in language and behaviour. When he was asked how children were born, he would reply, like Molière's Agnès, 'through the ear'. Mme de Montglat scolded him when he 'showed his cock to the little Ventelet girl'. And if, when he awoke in the morning, he was still put in Mme de Montglat's bed between her and her husband, Heroard waxed indignant and noted in the margin of his diary: *insignis impudentia*. The boy of ten was forced to behave with a modesty which nobody had thought of expecting of the boy of five. Education scarcely began before the age of seven; moreover, these tardy scruples of decency are to be attributed to the beginnings of a reformation of manners, a sign of the religious and moral restoration which took place in the seventeenth century. It was as if education was held to be of no value before the approach of manhood.

By the time he was fourteen, however, Louis XIII had nothing more to learn, for it was at the age of fourteen years two months that he was put almost by force into his wife's bed. After the ceremony he 'retired and had supper in bed at a quarter to seven. M. de Gramont and a few young lords told him some broad stories to encourage him. He asked for his slippers and put on his robe and went to the Queen's bedchamber at eight o'clock, where he was put to bed beside the Queen his wife, in the presence of the Queen his mother; at a quarter past ten he returned after sleeping for about an hour and performing twice, according to what he told us; he arrived with his cock all red.'

The marriage of a boy of fourteen was perhaps becoming something of a rare occurrence. The marriage of a girl of thirteen was still very common.

There is no reason to believe that the moral climate was any different in other families, whether of nobles or commoners; the practice of associating children with the sexual ribaldries of adults formed part of contemporary

manners. In Pascal's family, Jacqueline Pascal at the age of twelve was writing a poem about the Queen's pregnancy.

Thomas Platter, in his memoirs of life as a medical student at the end of the sixteenth century, writes: 'I once met a child who played this trick [knotting a girl's aiguillette when she married, so that her husband became impotent] on his parents' maidservant. She begged him to break the spell by undoing the aiguillette. He agreed and the bridegroom recovering his potency, was immediately cured.' Père de Dainville, the historian of the Society of Jesus and of humanist pedagogics, also writes: 'The respect due to children was then [in the sixteenth century] completely unknown. Everything was permitted in their presence: coarse language, scabrous actions and situations; they had heard everything and seen everything' (Dainville, 1940).

The lack of reserve with regard to children surprises us: we raise our eyebrows at the outspoken talk but even more at the bold gestures, the physical contacts, about which it is easy to imagine what a modern psychoanalyst would say. The psycho-analyst would be wrong. The attitude to sex, and doubtless sex itself, varies according to environment, and consequently according to period and mentality. Nowadays the physical contacts described by Heroard would strike us as bordering on sexual perversion and nobody would dare to indulge in them publicly. This was not the case at the beginning of the seventeenth century. There is an engraving of 1511 depicting a holy family: St Anne's behaviour strikes us as extremely odd – she is pushing the child's thighs apart as if she wanted to get at its privy parts and tickle them. It would be a mistake to see this as a piece of ribaldry.

The practice of playing with children's privy parts formed part of a widespread tradition, which is still operative in Moslem circles. These have remained aloof not only from scientific progress but also from the great moral reformation, at first Christian, later secular, which disciplined eighteenth-century and particularly nineteenth-century society in England and France. Thus in Moslem society we find features which strike us as peculiar but which the worthy Heroard would not have found so surprising. Witness this passage from a novel entitled *The Statue of Salt*. The author is a Tunisian Jew, Albert Memmi, and his book is a curious document on traditional Tunisian society and the mentality of the young people who are semi-Westernized. The hero of the novel is describing a scene in the tram taking him to school in Tunis.

In front of me were a Moslem and his son, a tiny little boy with a miniature tarboosh and henna on his hands; on my left a Djerban grocer on his way to market, with a basket between his legs and a pencil behind his ear. The

Djerban, affected by the warmth and peace inside the tram, stirred in his seat. He smiled at the child, who smiled back with his eyes and looked at his father. The father, grateful and flattered, reassured him and smiled at the Djerban. 'How old are you?' the grocer asked the child. 'Two and a half,' replied the father. 'Has the cat got your tongue?' the grocer asked the child. 'No,' replied the father, 'he hasn't been circumcised yet, but he will be soon.' 'Ah!' said the grocer. He had found something to talk about to the child. 'Will you sell me your little animal?' 'No!' said the child angrily. He obviously knew what the grocer meant, and the same offer had already been made to him. I too [the Jewish child] was familiar with this scene. I had taken part in it in my time, provoked by other people, with the same feelings of shame and desire, revulsion and inquisitive complicity. The child's eyes shone with the pleasure of incipient virility [a modern feeling, attributed to the child by the educated Memmi who is aware of recent discoveries as to early sexual awakening in children; in former times people believed that before puberty children had no sexual feelings] and also revulsion at this monstrous provocation. He looked at his father. His father smiled: *it was a permissible game* [our italics]. Our neighbours watched the *traditional scene* with complaisant approval. 'I'll give you ten francs for it,' said the Djerban. 'No,' said the child. 'Come now, sell me your little ...' the Djerban went on. 'No! No!' 'I'll give you fifty francs for it.' 'No!' 'I'll go as high as I can: a thousand francs!' 'No!' The Djerban assumed an expression of greediness. 'And I'll throw in a bag of sweets as well!' 'No! No!' 'You still say no? That's your last word?' the Djerban shouted, pretending to be angry. 'You still say no?' he repeated. 'No!' Thereupon the grown-up threw himself upon the child, a terrible expression on his face, his hand brutally rummaging inside the child's fly. The child tried to fight him off with his fists. The father roared with laughter, the Djerban was convulsed with amusement, while our neighbours smiled broadly.

This twentieth-century scene surely enables us to understand better the seventeenth century before the moral reformation. We should avoid anachronisms, such as the explanation by Mme de Sévigné's latest editor that the baroque excesses of her mother love were due to incest. All that was involved was a game whose scabrous nature we should beware of exaggerating: there was nothing more scabrous about it than there is about the racy stories men tell each other nowadays.

This semi-innocence, which strikes us as corrupt or naive, explains the popularity of the theme of the urinating child as from the fifteenth century. The theme is treated in the illustrations of books of hours and in church pictures. In the calendars in the Hennessy book of hours (Destrée, 1895) and the Grimani breviary, dating from the early sixteenth century, a winter month is represented by the snow-covered village; the door of one house is open, and the woman of the house can be seen spinning, the man

warming himself by the fire; the child is in full view, urinating on to the snow in front of the door.

A Flemish 'Ecce homo' by P. Pietersz, doubtless intended for a church, shows quite a few children in the crowd of onlookers: one mother is holding her child above the heads of the crowd so that he can have a better view. Some quick-witted boys are shinning up the doorposts. A child can be seen urinating, held by his mother. The magistrates of the High Court of Toulouse, when they heard Mass in the chapel in their own Palace of Justice, could have had their attention distracted by a similar scene. They had before them a great triptych depicting the story of John the Baptist.[1] On the centre volet the Baptist was shown preaching. There were children in the crowd; a woman was suckling her child; there was a boy up a tree; a little way away, facing the magistrates, a child was holding up his robe and urinating.

The frequency with which one finds children in crowd scenes, and the repetition of certain themes (the child being breast-fed, the child urinating) in the fifteenth and especially the sixteenth century, are clear signs of a new and special interest.

It is noteworthy too that at this time one scene of religious iconography recurs frequently: the Circumcision. This scene is depicted in almost surgical detail. It seems in fact that the Presentation of the Virgin in the Temple and the Circumcision were treated in the sixteenth and seventeenth centuries as festivals of childhood: the only religious festivals of childhood before the solemn celebration of the First Communion. In the parish church of Saint-Nicolas we can see an early seventeenth-century painting which comes from the Abbey of Saint-Martin-des-Champs. The scene of the Circumcision is surrounded by a crowd of children, some of them with their parents, others climbing the pillars to get a better view. For us, surely, there is something strange, almost shocking, about the choice of the Circumcision as a festival of childhood, depicted in the midst of children. Shocking for us, perhaps, but not for a present-day Moslem or for a man of the sixteenth or early seventeenth century.

Not only were children associated with an operation, admittedly of a religious nature, on the male sexual organ, but gestures and physical contacts were freely and publicly allowed which were forbidden as soon as the child reached the age of puberty, or in other words was practically adult. There were two reasons for this. In the first place the child under the age of puberty was believed to be unaware of or indifferent to sex. Thus gestures and allusions had no meaning for him; they became purely gratuitous and lost their sexual significance. Secondly, the idea did not yet exist

1. Musée des Augustins, Toulouse.

that references to sexual matters, even when virtually devoid of dubious meanings, could soil childish innocence, either in fact or in the opinion people had of it: nobody thought that this innocence really existed.

Such at least was the general opinion: it was no longer that of the moralists and pedagogues, or at least of the better ones, innovators who found little support for their ideas. Their retrospective importance is due to the fact that in the long run they managed to win acceptance for their ideas – which are ours too.

The current of ideas can be traced back to the fifteenth century, a period when it was strong enough to bring about a change in the traditional discipline of the schools.[2] Gerson was then its principal representative. He expressed his ideas on the question with great clarity, showing himself to be an excellent observer, for his period, of childhood and its sexual practices. This study of the sexual manners of childhood, and the importance which he attributed to them by devoting a treatise to them, *De confessione mollicei*, 1706, reveal a novel attitude: this attitude can be compared to the indications we have already noted in iconography and dress as showing a new interest in childhood.

Gerson studies the sexual behaviour of children for the benefit of confessors, to help the latter to arouse a feeling of guilt in the hearts of their little penitents (between ten and twelve years of age). He knows that masturbation and erection without ejaculation are general practices: if someone is questioned and denies all experience of masturbation then he is lying. For Gerson, this is a very serious matter. The *peccatum mollicei*, 'even if, because of the child's age, it has not been accompanied by pollution . . . has taken away the child's virginity even more than if the child, at the same age, had gone with a woman'. What is more, it borders on sodomy. Gerson's judgment is closer to modern teaching, which regards masturbation as an inevitable stage of premature sexuality, than are the sarcastic remarks of the novelist Sorel, who sees it as the result of the scholastic confinement of the boarding-school.

The child, according to Gerson, does not feel any sense of guilt to begin with: '*Sentiunt ibi quemdam pruritum incognitum tum stat erectio* and they think that it is permissible that *se fricent ibi et se palpent et se tractent sicut in aliis locis dum pruritus inest.*' This is a consequence of original corruption: *ex corruptione naturae.* We are still a long way from the idea of childish innocence, but we are already quite close to an objective knowledge of the child's behaviour, the originality of which is obvious in the light of what has been said above. How is childhood to be safeguarded against this danger? By the confessor's advice, but also by chang-

2. See Chapter 10.

ing the way in which children are brought up, by behaving differently towards them. One should speak decently to them, using only chaste expressions. One should see that when playing together they do not kiss each other, touch each other with their bare hands, or look at each other: *figerent oculi in eorum decore.* One should guard against any promiscuity between children and adults, at least in bed: *pueri capaces doli, puellae, juvenes* should not sleep in the same bed as older people, even of the same sex; cohabitation in the same bed was a widespread practice then in all classes of society. We have seen that it still existed at the end of the sixteenth century, even at the French court: Henri IV's frolics with his son, Louis XIII, brought to his bed together with his sister, justified Gerson's prudence of nearly two hundred years before. Gerson forbids people to touch each other *in nudo,* and warns his readers to beware '*a societaliatibus perversis ubi colloquia prava et gestus impudici fiunt in lecto absque dormitione*'.

Gerson returns to the topic in a sermon against lechery for the fourth Sunday of Advent: the child must prevent others from touching him or kissing him, and if he has failed to do so, he must report this in every instance in confession (this demand needs to be emphasized, because, generally speaking, people saw no harm in caresses). Later on, he suggests that it 'would be a good thing' to separate children at night – he recalls the case cited by St Jerome of a boy of nine who begot a child – but he does not dare to say more than 'it would be a good thing', for it was a general practice to put all the children of a family together when they were not sleeping with a valet, a maidservant or relatives.

In the regulations which he drew up for the school of Notre-Dame-de-Paris he tries to isolate the children, to keep them under constant supervision of the master: this is the spirit of the new discipline which we shall study in a later chapter.[3] The singing master must not teach *cantilenas dissolutas impudicasque,* and the boys must report any of their classmates who are guilty of misbehaviour or immodesty (punishable misdemeanours include speaking *gallicum* – instead of Latin – swearing, lying, cursing, dawdling in bed, missing the Hours, and chattering in church). A nightlight must be kept burning in the dormitory: 'as much out of devotion to the image of Our Lady as for the natural functions, and so that they perform in the light the only acts which can and must be seen'. No child may change beds during the night: he must stay with the companion he has been given. *Conventicula, vel societates ad partem extra alias* are not allowed either by day or night. Every care is taken, in fact, to avoid special friendships and dangerous company, especially that of the servants: 'The

3. See Chapter 10.

servants must be forbidden to engage in any familiarity with the children, not excepting the clerks, the *capellani*, the church staff [there is a certain absence of trust here]: they must not speak to the children except when the Masters are present.' Children not on the foundation are not allowed to mix with the schoolboys, even to study with them (except by special permission of the Superior), 'so that our children do not contract bad habits from the example of others'.

This is all quite new: it must not be imagined that life in the school was really like this. We shall see later what it was like and how much time and effort was needed to obtain strict discipline. Gerson was far ahead of the institutions of his time. His regulations are interesting for the moral ideal which they reveal, which had not been formulated with such clarity before, and which was to become the ideal of the Jesuits, of Port-Royal, of the Brothers of Christian Doctrine, and of all the moralists and strict pedagogues of the seventeenth century.

In the sixteenth century the pedagogues were more easygoing, for all that they took care not to overstep certain bounds. We know this from books written for the schoolboys, from which they learnt reading, writing, Latin vocabulary, and finally etiquette; the treatises on etiquette and the conversations which, to make the lesson more lifelike, involved several schoolboys or a schoolboy and a master. These dialogues are excellent documents on school life. In Vives's dialogues we find certain passages which would not have been to Gerson's taste but which were traditional: 'Which is the more shameful part: the part in front [note the discreet euphemism] or the hole in the arse?' 'Both parts are extremely improper, the behind because of its unpleasantness, and the other part because of lechery and dishonour.'

The coarsest jokes, as well as topics of anything but educational value, are to be found in these dialogues. In Charles Hoole's English dialogues we have a number of quarrels: one takes place in a tavern – and taverns at that time were far less respectable places than the modern public house. There is a lengthy argument about which inn sells the best beer. However, even in Vivès, a certain modesty is observed: 'The third finger is called the shameful one. Why?' 'The master has said that he knows the reason, but that he does not want to give it because it is dirty and unpleasant; however, do not press the matter, *for it is unseemly for a child of good character to ask about such unpleasant things.*' This is quite remarkable for the time. Broad talk was so natural that even later on the strictest reformers would introduce into their sermons to children and students comparisons which would seem shocking today. Thus in 1653 we find the Jesuit Father Lebrun exhorting the 'noble boarders of Cler-

mont College' to avoid gluttony: 'They are fastidious about their food, *tanquam praegnantes mulierculae.*'

But towards the end of the sixteenth century a much more obvious change took place: certain pedagogues, whose ideas were to carry weight and who would succeed in imposing their concepts and scruples on others, refused to allow children to be given indecent books any longer. The idea originated of providing expurgated editions of the classics for the use of children. This was a very important stage, which may be regarded as marking the beginning of respect for childhood. This attitude was to be found among both Catholics and Protestants, in France and England. Until then nobody had hesitated to give children Terence to read, for he was a classic. The Jesuits removed him from their curriculum. In England the schools used an expurgated edition by Cornelius Schonaeus, published in 1592 and reprinted in 1674 – Brinsley recommends it in his schoolmaster's manual.

The French Protestant schools used Cordier's conversations (1586), which took the place of the conversations of Erasmus, Vivès, Mosellanus, etc. They reveal a new decorum, a desire to avoid any word or expression which might be considered offensive or indecent. The most that is allowed is a joke about the uses of paper – 'schoolboy paper', 'envelope paper', 'blotting paper' – in a parlour game. Finally one boy gives up but the other guesses the answer: 'paper used for wiping your bottom in the privy'. An innocent concession to the traditional jokes. Cordier really could be 'put into anybody's hands'. In any case, his dialogues were used in conjunction with some religious dialogues by a certain S. Castellion.

Port-Royal in its turn produced a heavily expurgated edition of Terence: *Comedies of Terence made very decent while changing very little*, by Pomponius and Trobatus.

As for modesty of behaviour, the Jesuit colleges introduced new precautions, duly recorded in the regulations, regarding the administration of corporal punishment. It was laid down that the breeches of the victims, *adolescentum*, were not to be removed, 'whatever the boy's rank or age'. Just enough of the skin was to be exposed as was necessary to inflict the punishment, but not more: *non amplius.*

A great change in manners took place in the course of the seventeenth century. The least of the liberties permitted at the court of Henri IV would not have been allowed by Mme de Maintenon with the King's child, legitimate or illegitimate, any more than they would have been in the homes of the free-thinkers. It was no longer a case of a few isolated moralists like Gerson, but of a great movement which manifested itself on

all sides, not only in a rich moral and pedagogic literature but also in devotional practices and a new religious iconography.

An essential concept had won acceptance: that of the innocence of childhood. It was already to be found in Montaigne, for all that he had few illusions about the chastity of young students: 'A hundred schoolboys have caught the pox before getting to Aristotle's lesson, *On Temperance.*' But he also tells an anecdote which reveals a different attitude: Albuquerque, 'in great danger of shipwreck, took a young boy on his shoulders, so that in their association in danger his *innocence* would serve him as a surety and a recommendation to gain God's favour and bring him safely to land'. A hundred years later, the idea of the innocence of childhood had become a commonplace. Witness the caption to an engraving by F. Guérard[4] showing children's toys (dolls and drums): 'This is the age of innocence, to which we must all return in order to enjoy the happiness to come which is our hope on earth; the age when one can forgive anything, the age when hatred is unknown, when nothing can cause distress; the golden age of human life, the age which defies Hell, the age when life is easy and death holds no terrors, the age to which the heavens are open. Let tender and gentle respect be shown to these young plants of the Church. Heaven is full of anger for whosoever scandalizes them.'

What a long way we have come to reach this point! It can be traced by means of an abundant literature, a few works of which we shall now examine.

L'Honneste garçon, described as 'the art of instructing the nobility in virtue, learning and all the exercises suitable to its rank', and published by M. de Grenaille of Chatauniers in 1642, is a good example. The author had already written *L'Honneste fille.* The interest in education, in 'the institution of childhood', is worthy of note. The author knows that he is not the only writer on the subject and apologizes in his foreword: 'I do not believe that I am encroaching on M. Faret's province (see Faret, 1630) in dealing with a subject on which he has only touched, and in speaking of the education of those whom he has depicted in their finished condition ... Here I lead the Boy from early infancy as far as youth. I deal first with his birth and then with his education; I polish his mind and his manners at the same time; I instruct him in both religion and the proprieties, so that he shall be neither impious nor superstitious.' Treatises on etiquette were already in print which were simply manuals of *savoir-vivre*, books on good manners, and they continued to enjoy widespread favour until the early nineteenth century. In addition to these etiquette books which were meant for children, in the early seventeenth century a peda-

4. In the Cabinet des Estampes.

gogic literature for the use of parents and teachers came into being. Although it referred to Quintilian, Plutarch and Erasmus, it was something new. So new that M. de Grenaille feels called upon to defend himself against those who see the education of youth as a practical matter and not a subject for a book. 'There is Quintilian, and so on ... but there is something else, and the subject has a special seriousness for a Christian ... Since the Lord of Lords summons little innocents to Him, I do not believe that any of His subjects has the right to repulse them, nor that men should show reluctance to educate them, seeing that in doing so they are simply imitating the angels.' The comparison of angels with children was to become a common theme of edification. 'It is said that an angel in the shape of a child enlightened St Augustine, but on the other hand he took pleasure in communicating his wisdom to children, and in his works we find treatises intended for them as well as others for the greatest theologians.' He cites St Louis, who wrote a directive for his son. 'Cardinal Bellarmin wrote a catechism for children.' Richelieu, 'that great prince of the Church, gave instruction to the smallest as well as counsel to the greatest'. Montaigne too, whom one hardly expected to find in such good company, showed concern about bad teachers, especially pedants.

M. de Grenaille continues: 'It must not be imagined that when one speaks of childhood one is always speaking of something weak; on the contrary, I am going to show here that a condition which certain people consider contemptible is positively illustrious.' It was in fact at this time that people did talk of the weakness and imbecility of childhood. Hitherto they had tended to ignore childhood, as a transitional period soon finished with and of no importance. This stress laid on the contemptible side of childhood may have been a consequence of the classical spirit and its insistence on reason, but it was above all a reaction against the importance which the child had assumed in the family and the idea of the family. That feeling of irritation with childishness thus arose which is the modern reverse of the idea of childhood. With it went the contempt which that society of men of the open air and men of the world felt for the professor, the college regent, the 'pedant', at a time when the colleges were becoming more numerous and better attended, and when childhood was already beginning to remind adults of their schooldays. In reality, the antipathy to children shown by solemn or peevish spirits is evidence of the importance, in their eyes the excessive importance, which was attributed to childhood.

For the author of *L'Honneste garçon*, childhood is illustrious on account of Christ's childhood. This, he points out, was sometimes interpreted as a token of the humiliation accepted by Christ in adopting not only the

human condition but the state of childhood: thereby putting himself on a lower level than the first Adam, according to St Bernard. On the other hand there are the holy children: the Holy Innocents, the child martyrs who refused to worship the idols, and the little Jew of St Gregory of Tours whose father tried to burn him in an oven because he had turned Christian. 'I can show too that in our own days the Faith has had its child martyrs as in past ages. The history of Japan tells of a little Louis who, at the age of twelve, showed greater courage than grown men.' A woman died at the same stake as Dom Carlo Spinola, together with 'her little child', which shows that 'God draws his praises from the mouths of children'. And the author piles up the examples afforded by the holy children of the two Testaments, adding a further example, drawn from French medieval history: 'I must not forget the courage of those French boys whose praises Nauclerus has sung, and who took the cross to the number of twenty thousand in the time of Pope Innocent III to go and deliver Jerusalem from the hands of the infidels.' The children's crusade.

We know that the children in the medieval verse-chronicles and romances of chivalry behaved like true knights, affording proof, in M. de Grenaille's eyes, of the courage and good sense of children. He cites the case of a child who appointed himself the champion of the Empress, the wife of the Emperor Conrad, against 'a famous gladiator'. 'Read in the romances of chivalry what the Rinaldos, the Tancreds and all those other knights are said to have done; legend does not attribute more to them in a single fight than true History grants that little Achilles.'

'After that, can anyone deny that the first age is comparable, indeed often preferable, to all the rest?' 'Who would dare to say that God favours older people more than children? He favours them on account of their innocence, which comes close to impeccability.' They have neither passions nor vices: 'Their lives seem to be most reasonable at a time when they seem least capable of using their reason.' Obviously there is no mention here of the *peccatum mollicei*, and in this respect the worthy nobleman of 1642 strikes the modern reader, familiar with psycho-analysis, as more old-fashioned than Gerson. The explanation is that the very idea of immodesty and sensuality in a child embarrasses M. de Grenaille, as being an argument used by those who consider childhood to be 'silly' and 'corrupt'.

The new attitude was to be found again at Port-Royal, exemplified first of all by Saint-Cyran. His Jansenist biographers all tell us of the lofty idea he had of childhood and of the respect due to children: 'He admired the Son of God, who, in the most august functions of His ministry, would not allow children to be prevented from coming to Him, who kissed and blessed them, who commanded us not to despise or neglect them, and who

finally spoke of them in terms so favourable and so astonishing that they are capable of dumbfounding those who scandalize the little ones. Accordingly M. de Saint-Cyran always showed children a kindness which amounted to a sort of respect, in order to do honour to the innocence in them and the Holy Ghost which inhabits them.' (Cadet, 1887). M. de Saint-Cyran was 'very enlightened' and 'far from approving these worldly maxims [contempt for pedagogues], and as he was aware of the importance of the care and education of youth, he regarded it in a totally different light. However disagreeable and humiliating people might find it, he none the less employed persons of merit for it who never felt that they had any right to complain.'

The result was the formation of that moral concept which insisted on the weakness of childhood rather than on what M. de Grenaille called its 'illustrious nature', but which associated its weakness with its innocence, the true reflection of divine purity, and which placed education in the front rank of man's obligations. It reacted at one and the same time against indifference towards childhood, against an excessively affectionate and selfish attitude which turned the child into a plaything for adults and encouraged his caprices, and against the reverse of this last feeling, the contempt of the man of reason. This concept dominates late seventeenth-century literature. This is what Coustel wrote in his rules (1887) for the education of children, on the need to love children and to overcome the repugnance which they arouse in thinking men: 'If one considers the child's exterior, which is nothing but weakness and infirmity of either body or mind, it cannot be denied that there is no apparent reason for holding it in high esteem. But one changes one's opinion if one looks into the future and acts in the light of Faith.' Beyond the child one will then be able to see 'the good magistrate', 'the good priest', 'the great lord'. But above all it must be remembered that children's souls, still possessed of their baptismal innocence, are the dwelling-place of Jesus Christ. 'God sets us an example by commanding Angels to accompany them on all their errands without ever leaving them.'

That is why, according to Varet (1666), 'the education of children is one of the most important things in the world.' And Jacqueline Pascal, in the regulations for the little boarders of Port-Royal, writes: 'Looking after children is so important that we are bound to prefer that duty to all others when obedience imposes it on us, and what is more, to our personal pleasures, even if these are of a spiritual nature.'

This is not a case of isolated observations but of a real doctrine – generally accepted by Jesuits as by Oratorians or Jansenists – which partly accounts for the profusion of educational institutions, colleges, little

schools and special establishments, and the evolution of school life in the direction of stricter discipline.

A few general principles that were deduced from this doctrine were cited as commonplaces in the literature of the time. For example, children must never be left alone. This principle dated back to the fifteenth century and originated in monastic experience, but it was never really put into practice until the seventeenth century, by which time the logic of it was obvious to the public at large and not simply to a handful of monks and 'pedants'. 'As far as possible, all the apertures of the cage must be closed ... A few bars will be left open to allow the child to live and to enjoy good health; this is what is done with nightingales to make them sing and with parrots to teach them to talk.' This was done with a certain subtlety, for both the Jesuit colleges and the schools at Port-Royal had become increasingly familiar with child psychology. In the regulations for the children at Port-Royal we have Jacqueline Pascal writing: 'A close watch must be kept on the children, and they must never be left alone anywhere, whether they are ill or in good health.' But 'this constant supervision should be exercised gently and with a certain trustfulness calculated to make them think that one loves them, and that it is only to enjoy their company that one is with them. This makes them love this supervision rather than fear it.'

This principle was absolutely universal, but it was carried out to the letter only in the Jesuit boarding-schools, in the schools at Port-Royal and in some private boarding-schools; in other words it affected only a small number of very rich children. The object was to avoid the promiscuity of the colleges, which for a long time had a bad reputation, though not as long in France – thanks to the Jesuits – as in England. Coustel writes: 'As soon as the young people set foot in that sort of place [the college], they rapidly lose that innocence, that simplicity, that modesty which hitherto made them so pleasing to God and to men.' There was a general reluctance to entrust a child to a single tutor: the extreme sociability of manners was opposed to this solution. It was held that the child ought to get to know people and converse with them from an early age; this was very important, even more necessary than Latin. It was better 'to put five or six children with a good man or two in a private house', an idea which Erasmus had already put forward.

The second principle was that children must not be pampered and must be accustomed to strict discipline early in life: 'Do not tell me that they are only children and that one must be patient with them. For the effects of concupiscence appear only too clearly at this age.' This was a reaction against the 'coddling' of children under eight, and against the

opinion that they were too small to make it worthwhile finding fault with them. Courtin's manual of etiquette of 1671 explains at some length: 'These little people are allowed to amuse themselves without anyone troubling to see whether they are behaving well or badly; they are permitted to do as they please; nothing is forbidden them; they laugh when they ought to cry, they cry when they ought to laugh, they talk when they ought to be silent, and they are mute when good manners require them to reply. It is cruelty to allow them to go on living in this way. The parents say that when they are bigger they will be corrected. Would it not be better to deal with them in such a way that there was nothing to correct?' The third principle was modesty. At Port-Royal: 'As soon as they have retired for the night the girls' beds are faithfully inspected to see if they are lying with fitting modesty, and also to see if they are properly covered up in winter.' A real propaganda campaign was launched to try to eradicate the age-old habit of sleeping several to a bed. The same advice was repeated all the way through the seventeenth century. We find it, for instance, in *La Civilité chrétienne* by St Jean-Baptiste de la Salle, which was first published in 1713: 'Above all, one must not, unless one is married [this is a reservation which nobody would dream of introducing into a book intended for children, but at that time books intended for children were not read only by children], go to bed in the presence of a person of the opposite sex, this being utterly contrary to prudence and decency. It is even less permissible for persons of different sexes to sleep in the same bed, even in the case of *very young children*, for it is not fitting for even persons of the same sex to sleep together. These are two things which St Francis of Sales especially recommended to Mme de Chantal with regard to children.' And: 'Parents must teach their children to conceal their bodies from one another when going to bed.'

The insistence on decency was to be found again in the matter of reading and conversation: 'Teach them to read books in which purity of language and wholesome subject-matter are combined.' 'When they start writing, do not allow them to be given examples full of unseemly expressions.' We are a long way here from the outspoken talk of the child Louis XIII, which amused even the worthy Heroard. Naturally novel-reading, dancing and theatre-going were banned, and adults too were advised against indulging in these distractions. A close check was recommended on songs, an important and necessary precaution in a society where music was so popular: 'Take particular care to prevent your children from learning modern songs.' But the old songs were not rated any more highly: 'Of the songs which are known everywhere and which are taught to children as soon as they start to talk ... there are scarcely any which are not full of

the most horrible slanders and calumnies, and which are not biting satires which spare neither the sacred persons of the sovereigns nor those of the magistrates, nor those of the most innocent and pious persons.' These songs were described as expressing 'dissolute passions' and as being 'full of indecent expressions'.

St Jean-Baptiste de la Salle (1713), maintained this mistrust of entertainments: 'It is no more seemly for a Christian to attend a puppet-show [than a theatrical performance].' 'A respectable person must regard entertainments of this sort with nothing but contempt . . . and parents must never allow their children to attend them.' Plays, balls, dances, and the 'more ordinary entertainments' provided by 'jugglers, mountebanks and tightrope walkers' were forbidden. Only educational games, that is to say, games which had been integrated in the educational system, were permitted; all other games were and remained suspect.

Another recommendation recurs frequently in this pedagogic literature, with its insistence on 'modesty': a warning not to leave children in the company of servants. This is a recommendation which went against an absolutely universal practice: 'Leave them as little as possible with servants, and especially with lackeys ['servants' had a wider significance then than it has now, and included what we would call companions]. These persons, in order to insinuate themselves into children's good graces, usually tell them nothing but nonsense and fill them with a love of gambling, amusement and vanity.'

Again, in the eighteenth century, we have the future Cardinal de Bernis recalling his childhood – he was born in 1715: 'Nothing is more dangerous for the morals and perhaps also for the health than to leave children too long in the care of the servants.' *'People take liberties with a child which they would not risk with a young man.'* This last sentence clearly refers to the mentality which we have analysed above in discussing the court of Henri IV and the scene between the Moslem boy and the Djerban in Tunis in the twentieth century. It still existed in the lower classes, but it was no longer tolerated in enlightened circles. The stress laid by the moralists on the need to separate children from the varied world of 'the servants' shows how well aware they were of the dangers presented by this promiscuity of children and servants (the servants themselves were often very young).

The fourth principle was simply another application of this insistence on decency and 'modesty': the old familiarity must be abandoned and its place taken by great moderation of manners and language, even in everyday life. This policy took the form of war on the use of the familiar *tu* form. In the little Jansenist college of Le Chesnay: 'They had been so

accustomed to treat each other with respect that they never used the *tu* form of address, nor were they ever known to make the slightest remark which they might have considered likely to offend certain of their companions.'

A 1671 manual of etiquette recognizes that good manners call for the *vous* form, but it has to make some concessions to the old French usage – this it does with a certain embarrassment: 'One normally says *vous*, and one must not say *tu* to anybody, unless it is to a little child and you are much older and it is customary for even the most polite and well-bred persons to speak thus. However, fathers with their children up to a certain age (in France until they are emancipated), masters with their pupils, and others in similar positions of authority, seem, according to common usage, to be allowed to say *tu* and *toi*. For close friends too, when they are conversing together, it is customary in certain places for them to say *tu* and *toi*; in other places people are more reserved and civilized.'

Even in the little schools, where the children were younger, St Jean-Baptiste de la Salle forbade the masters to use the *tu* form of address: 'They must speak to the children with reserve, never saying *tu* or *toi*, which would be showing too much familiarity.' It is certain that under this pressure the use of *vous* became more widespread. From Colonel Gérard's memoirs one learns with surprise that at the end of the eighteenth century a couple of soldiers, one aged twenty-five and the other twenty-three, could actually say *vous* to one another. And Colonel Gérard himself could use the *vous* form without feeling ridiculous.

At Mme de Maintenon's Saint-Cyr, the young ladies were told to avoid 'saying *tu* and *toi*, and adopting manners contrary to the proprieties' (see Lavallée, 1862). 'One must never adapt oneself to children by means of childish language or manners; on the contrary, one must raise them to one's own level by always talking reasonably to them.'

Already, in the second half of the sixteenth century, the schoolboys in Cordier's dialogues were saying *vous* in the French text, whereas they naturally said *tu* in Latin.

In fact, the campaign for greater seriousness would triumph only in the nineteenth century, in spite of the contrary evolution of child welfare and more liberal, realistic pedagogics. An American professor of French, L. Wylie, who spent his sabbatical year 1950–51 in a village in the south of France, was astonished by the seriousness with which the masters at the primary school treated their pupils, and the parents, who were peasants, their children. The contrast with the American attitude struck him as enormous: 'Every step in the child's development seems to depend

on the development of what people call its *raison* ...' 'The child is now considered to be *raisonnable*, and it is expected to remain *raisonnable*.'

This *raison*, this self-control and this seriousness, which are required of the French child at an early age, while he is working for his certificate of study, and which are no longer known in the United States, are the final result of the campaign launched at the end of the sixteenth century by monks and moralists. It should be added that this state of mind is beginning to disappear from the French town: it remains only in the country, where the American observer met it.

The idea of childish innocence resulted in two kinds of attitude and behaviour towards childhood: firstly, safeguarding it against pollution by life, and particularly by the sexuality tolerated if not approved of among adults; and secondly, strengthening it by developing character and reason. We may see a contradiction here, for on the one hand childhood is preserved and on the other hand it is made older than its years; but the contradiction exists only for us of the twentieth century. The association of childhood with primitivism and irrationalism or prelogicism characterizes our contemporary concept of childhood. This concept made its appearance in Rousseau, but it belongs to twentieth-century history. It is only very recently that it passed from the theories of psychologists, pedagogues, psychiatrists and psycho-analysts into public opinion; it is this concept which Professor Wylie used as a standard of comparison by which to gauge that other attitude which he discovered in a village in the Vaucluse, and in which we can recognize the survival of another concept of childhood, a different and older concept, which was born in the fifteenth and sixteenth centuries and which became general and popular from the seventeenth century on.

In this concept, which seems old to us in relation to our contemporary mentality, but which was new in relation to the Middle Ages, the ideas of innocence and reason were not opposed to one another. '*Si puer prout decet, vixit*', is translated into French in Courtin's manual of etiquette of 1671 as: 'If the child has lived like a man ...'

In this new moral climate, a whole pedagogic literature for children as distinct from books for adults made its appearance.[5] It is extremely difficult, with the countless manuals of etiquette produced from the sixteenth century on, to distinguish between those intended for adults and those intended for children. This ambiguity is due to factors connected with the structure of the family and the relationship between the family and society, which are examined in the last part of this study.

5. See Chapter 7.

The Jesuit Fathers published new manuals of etiquette or took over existing manuals, in the same way as they expurgated the classical writers or gave their patronage to treatises on gymnastics: witness *Bienséance de la conversation entre les hommes*, written in 1617 for the boarders of the Society of Jesus at Pont-à-Mousson and La Flèche. The *Règles de la bienséance et de la civilité chrétienne* for the use of the Christian boys' schools of St Jean-Baptiste de La Salle was published in 1713 and reprinted all through the eighteenth century and into the nineteenth: this was a classic work for a long time and its influence on manners was probably considerable. However, even this work was not yet addressed directly and openly to children. Certain pieces of advice were intended rather for parents (for all that it was a book from which children learned how to read, which provided examples of handwriting, which taught them how to behave, and which they learned off by heart), or even for adults inadequately versed in good manners.

This ambiguity was dispelled in the new editions of the manuals of etiquette published in the second half of the eighteenth century. Here for instance is a 'simple and decent' manual of 1761: 'For the instruction of children, containing at the beginning the way to learn to read, pronounce and write correctly, newly revised [for all the manuals claimed to be new editions of the old manuals by Cordier, Erasmus or della Casa: it was a traditional genre, and any new ideas were cast in an old form, whence the continuation of certain notions which had undoubtedly gone out of fashion] and enlarged at the end with a fine Treatise on orthography. Drawn up by a Missionary with precepts and instructions for the education of Youth.' The tone of the book is new; the author addresses himself specifically to children and writes in a sentimental style: 'This book will not be useless to you, dear children, it will teach you ... Note, none the less, dear children ...' 'Dear child, whom I regard as a child of God and as a brother of Jesus Christ, begin early in life to look for the good ... I intend to teach you the rules of a decent Christian.' 'As soon as you rise in the morning, make the sign of the cross.' 'If you are in the bedchamber of your Father and Mother, bid them good morning.' At school: 'Do not be disagreeable to your schoolfellows ...' 'Do not talk in school.' 'Do not use the words *tu* and *toi* too often.' But this sweetness, this very eighteenth-century tenderness does not detract in any way from the ideal of character, logic and dignity which the author is trying to instil into the child: 'Dear children, do not be among those who talk incessantly and who do not give others time to say what they think.' 'Keep your promises; that is the duty of a *man* of honour.' The spirit is still that of the seventeenth century, but the manner is already that of the nineteenth: 'Dear

children.' The child's province is clearly distinguished from that of the adult.

There still remained some strange survivals from the old indifference to the matter of age. For a long time Latin, and even Greek, had been taught to children in couplets wrongly attributed to Cato. The pseudo-Cato is quoted in *Le Roman de la Rose*. This practice continued throughout the seventeenth century at least, and there was still an edition of Cato's couplets in existence in 1802. But the spirit of these extremely crude moral recommendations is the spirit of the Byzantine Empire and the Middle Ages, which were totally devoid of the delicacy of Gerson, Cordier, the Jesuits, Port-Royal, and in fact of seventeenth-century opinion as a whole.[6] Thus children continued to be given maxims of this kind to translate: 'Do not believe your wife when she complains about your servants, for the wife often detests those who love the husband.' Or else: 'Do not attempt to discover the designs of Providence by means of wizardry.' 'Flee the wife who seeks to rule by virtue of her dowry; do not retain her if she becomes unbearable', etc.

True, at the end of the sixteenth century these lessons in morality had been judged inadequate, and children were given Pibrac's quatrains, written at that time in a more Christian, more edifying and more modern spirit. But Pibrac's quatrains did not replace the pseudo-Cato; they simply joined him until the beginning of the nineteenth century: the last editions still contained both texts. The pseudo-Cato and Pibrac then sank together into oblivion.

Corresponding to this evolution of the idea of childhood in the seventeenth century, a new tendency appeared in religious devotion and iconography.

From the beginning of the seventeenth century, religious painting, engraving and sculpture gave considerable importance to representation of the Infant Jesus, by himself, no longer with the Virgin or as one of the Holy Family. As can be seen from the Van Dyck at Dresden, the Infant Jesus is usually shown in a symbolic attitude: He has His foot on the serpent, is leaning on a globe, is holding a cross in the left hand, and with the other hand is giving a blessing. This dominating child is also shown standing erect over the doorways of certain churches (the Dalbade in Toulouse for instance). A special devotion was now offered to the Holy Childhood. It had been prepared for, in religious iconography at least, by all the pictures of the Holy Family, the Presentation and the Circumcision of the fifteenth and sixteenth centuries. But in the seventeenth century it was given a different emphasis. The subject has been thoroughly

6. See Chapter 7.

explored. All that I would do here is to stress the connection which was immediately established between this devotion to the Holy Childhood and the great development of interest in childhood, of the provision of little schools and colleges, and of educational theory. Juilly College was dedicated by Cardinal de Bérulle to the mystery of the Infant Jesus. In her regulations for the little girl boarders at Port-Royal, Jacqueline Pascal inserted two prayers, one of which was also 'in honour of the mystery of the Childhood of Jesus Christ'. It deserves to be quoted here: 'Be like new-born children . . . Grant, O Lord, that we may always be children in our simplicity and innocence, as people of the world are always children in their ignorance and weakness. [Here we find once more the two aspects of the concept of childhood in the seventeenth century, the innocence which has to be preserved, and the ignorance or weakness which has to be suppressed or modified.] Give us a holy childhood, which the course of the years may never take from us, and from which we may never pass into the old age of old Adam, or into the death that is sin; but which may make us increasingly new creatures in Jesus Christ and lead us to His glorious immortality.'

A nun of the Carmelite convent at Beaune, Marguerite du Saint-Sacrement, was well known for her devotion to the Holy Childhood. Nicolas Rolland, the founder of several little schools at the end of the seventeenth century, made a pilgrimage to her tomb (see Rigault, 1937). On this occasion the prioress of the convent gave him 'a statue of the Infant Jesus which the venerable Sister Marguerite used to honour with her prayers'. The teaching institutes dedicated themselves to the Holy Childhood, as did Cardinal de Bérulle's Oratorian colleges: in 1685 Père Barré registered the *Statuts et Règlements* of the Christian charity schools of the Holy Infant Jesus. The Dames de Saint-Maur, the paragon of the teaching orders, assumed the official title: Institute of the Holy Infant Jesus. The first seal adopted by the Institution of the Brothers of the Christian Schools, the Ignorantine Friars, showed the Infant Jesus being led by St Joseph.

The moral and pedagogic literature of the seventeenth century frequently quotes those passages in the Gospel in which Jesus speaks of children. In *L'Honneste garçon*: 'Since the Lord of Lords summons little children to Him, I cannot see that any of His subjects has the right to reject them.' The prayer which Jacqueline Pascal inserts in her regulations for the children of Port-Royal paraphrases expressions used by Christ: 'Be like new-born children . . . Unless you become like children, you will not enter the Kingdom of Heaven.' And the end of this prayer recalls an episode in the Gospel which was to obtain new favour in the

seventeenth century: 'Lord, permit us to be among those children whom you summon to you, whom you allow to approach you, and from whose mouths you draw your praises.'

The scene in question, in which Jesus asks little children to be allowed to come to Him, was not absolutely unknown in the iconography of former times; we have already had occasion to mention[7] that Ottonian miniature in which children are depicted as adults, but on a smaller scale, gathered around Christ. Pictures of this scene are also to be found in the moralizing Bibles of the thirteenth century, but they are fairly rare and are treated as commonplace illustrations, devoid of any real fervour or significance. On the other hand, from the end of the sixteenth century on, this scene recurs frequently, especially in engraving, and it is obvious that it corresponds to a new and special form of devotion. This can be seen from a study of a fine print by Stradan, whose engravings, as is well known, were an inspiration to the artists of his time.[8] The subject is given by the caption: *'Jesus parvulis oblatis imposuit manus et benedixit eis.'* Jesus is seated. A woman is presenting her children – naked *putti* – to Him; other women and children are waiting their turn. It is significant that the child here is accompanied by his mother; in the medieval pictures, which were in closer conformity to the letter of the text, a text which did not appeal sufficiently to the artists' imagination to prompt them to embellish it, the children were alone with Christ. Here the child is not separated from his family: an indication of the fresh importance assumed by the family in the general sensibility. A Dutch painting, by Volckert in 1620, shows the same scene. Christ is squatting on the ground, in the middle of a crowd of children pressing round Him. Some are in their mothers' arms. Others, who are naked, are playing or fighting (the theme of *putti* fighting was a common one at the time), or crying and shouting. The bigger children are more reserved, and have their hands folded in prayer. Christ's expression is smiling and attentive: that mixture of tenderness and amusement which grownups of modern times, and the nineteenth century in particular, assume when speaking to children. He is holding one hand above one of the little heads, and is raising the other to bless another child running towards him. This scene became extremely popular: the engraving was probably given to children as a devotional picture, just as they would later be given First Communion pictures. The catalogue of an exhibition at Tours in 1947 devoted to the child in art mentions an eighteenth-century engraving on the same subject.

7. See Chapter 2.
8. Stradan (1523–1605) engravings, Cabinet des Estampes.

Henceforth there was a religion for children, and one new devotion was to all intents and purposes reserved for them: that of the guardian angel. 'I would add,' we read in *L'Honneste garçon*, 'that although all men are accompanied by these blessed spirits which minister to them in order to help them to make themselves fit to receive the inheritance of salvation, it seems that Jesus Christ granted only to children the privilege of having guardian angels. It is not that we do not share this privilege; but manhood derives it from childhood.' For their part, he explains, the angels prefer the 'suppleness' of children to the 'rebellious character of men'. And Fleury in his 1686 treatise on studies maintains that 'the Gospel forbids us to despise children for the excellent reason that they have blessed angels to guard them'. The soul guided by an angel, and depicted in the form of a child or a youth, became a familiar feature of religious iconography in the sixteenth and seventeenth centuries. There are countless examples, for instance a Dominiquin in which a little child in a flared skirt is being defended by an angel, a rather effeminate boy of thirteen or fourteen, against the Devil, a middle-aged man who is lying in wait for him.[9] The angel is holding his shield between the child and the middle-aged man, providing an unexpected illustration of this sentence in *L'Honneste garçon*: 'God possesses the first age, but the Devil possesses in many persons the best parts of old age as well as of the age which the Apostle calls accomplished.'

The old theme of Tobias led by the angel would henceforth symbolize the soul-child and its guide, the guardian angel. Witness the fine painting by Tournier shown in London and Paris in 1958, and the engraving by Abraham Bosse.[10] In an engraving by Mariette the angel is showing the child, whom it leads, other angels carrying the cross in the sky.[11]

The theme of the guardian angel and the soul-child was used in the decoration of baptismal fonts. I have come across an example in a baroque church in the south of Germany, the Church of the Cross at Donauwörth. The lid of the font is surmounted by a globe with the serpent wound around it. On the globe, the angel, a somewhat effeminate young man, is guiding the soul-child. This depiction is not simply a symbolic representation of the soul in the traditional form of the child (incidentally, it is a curiously medieval idea to use the child as the symbol of the soul), but an illustration of a devotion peculiar to childhood and derived from the sacrament of baptism: the guardian angel.

9. In Naples Art Gallery.
10. Tournier, 'L'Ange gardien', Narbonne, 1656–7, exhibition at the Petit Palais, 1958; Abraham Bosse, engraving, Cabinet des Estampes.
11. In the Cabinet des Estampes.

The period of the sixteenth and seventeenth centuries was also that of the child paragons. The historian of the Jesuit college of La Flèche, C. de Rochemonteix, recounts from the annals of the Congregation of La Flèche for 1722 the edifying life of Guillaume Ruffin, born on 19 January 1657. In 1671, at the age of fourteen, he was in the third class. He belonged of course to the Congregation (a pious society confined to the good pupils and dedicated to the Virgin: it still exists, I believe, in the Jesuit colleges). He used to visit the sick and he gave alms to the poor. In 1674 he had nearly finished his first year in the philosophy class (there were two at that time) when he fell ill. The Virgin appeared to him twice. He was told in advance of the date of his death, 'the day of the feast of my good Mother', the feast of the Assumption. While reading this text I found myself unable to banish a recollection of my own childhood, in a Jesuit college where some of the boys undertook a campaign for the canonization of a little pupil who had died some years before in the odour of sanctity, at least so his family maintained. It was quite easy to attain sanctity in a short schoolboy's life, and that without any exceptional prodigies or particular precocity: on the contrary, by means of the mere application of the childish virtues, by the mere preservation of one's initial innocence. This was the case with St Louis of Gonzaga, often cited in seventeenth-century works dealing with the problems of education.

Apart from the lives of little saints, schoolchildren were given as subjects of edification accounts of the childhood years of full-grown saints – or else of their remorse at their misspent youth. In the annals of the Jesuit college of Aix for 1634 we read: 'Our young people did not fail to have their sermons twice a week in Lent. It was Père de Barry, the Rector, who addressed the aforesaid exhortations to them, taking as his subject the heroic deeds of the saints in their youth.' The previous Lent, in 1633, 'he had taken as his subject St Augustine's regrets for his youth.' (Méchin, 1892.)

In the Middle Ages there were no religious festivals of childhood, apart from the great seasonal festivals which were often pagan rather than Christian. From the fifteenth century on, as we have already seen, artists depicted certain episodes, such as the Presentation of the Virgin and particularly the Circumcision, in the midst of a throng of children, many more than were usually present in the crowds of the Middle Ages or the Renaissance. But these Old Testament festivals, for all that they had become festivals of childhood in religious iconography, could no longer play this role in religious life, especially in the refined religious life of seventeenth-century France. First Communion gradually became the great religious festival of childhood, which it still is today, even where the

Christian observance is no longer practised regularly. First Communion has also taken the place of the old folklore festivals. Perhaps it owes its continuation, in spite of the de-Christianization of the modern world, to the fact that it is the child's individual festival, celebrated collectively in church but more particularly in private, within the family: the most collective festivals are those which have disappeared most rapidly.

The increasingly solemn celebration of First Communion was due in the first place to the greater attention given, especially at Port-Royal, to the necessary conditions for the proper reception of the Eucharist. It seems probable that previously children took communion without any special preparation, much as they started going to Mass, and probably quite early in life, judging by the general precocity of manners and the mingling of children and adults in everyday life. Jacqueline Pascal, in her regulations for the children of Port-Royal, stresses the necessity of carefully gauging the moral and spiritual capacity of children before allowing them to take communion, and of preparing them for it a long time ahead: 'Young children, and especially those who are mischievous, frivolous or wedded to some considerable defect, must not be allowed to take communion. They must be made to wait until God has effected some change in them, and it is wise to wait a long time, a year for instance or at least six months, to see if their actions are followed up. For I have never regretted making children wait: on the contrary, this has always served to advance in virtue those who were already well disposed and to bring about a recognition of their unreadiness in those who were not. *One cannot take too many precautions where First Communion is concerned*: for often all the rest depend on that first one.'

First Communion was delayed at Port-Royal until after Confirmation: 'When we are given children who have not been confirmed ... if they have not made their First Communion either, we usually defer it until after Confirmation, so that being filled with the spirit of Jesus, they are better prepared to receive His Sacred Body.'

By the eighteenth century, First Communion had become an organized ceremony in the convents and colleges. Colonel Gérard recalls for us in his memoirs his recollections of a difficult First Communion. He was born in 1766, one of six children in a poor family. Left an orphan, he worked as a servant from the age of ten until the curate of his parish, taking an interest in him, sent him to the Abbey of Saint-Avit where he had become assistant chaplain. The first chaplain was a Jesuit who took a dislike to the boy. He must have been about fifteen when he was 'admitted' – this was the current expression – to the First Communion: 'It had been decided that I should make my First Communion *at the same*

time as several boarders. The day before, I was playing with the farm dog when M. de N., the Jesuit, happened to pass by. "Have you forgotten," he exclaimed, "that it is tomorrow you are due to receive Our Lord's Body and Blood?" The Abbess sent for me and informed me that I would not be taking part in the *ceremony* next day ... Three months after doing penance ... I made my First Communion. After my second, I was ordered to take communion every Sunday and Holy Day.'

First Communion had become the ceremony which it has remained. As early as the middle of the eighteenth century it was customary to commemorate the occasion with an inscription on a devotional picture. At Versailles in 1931 an engraving was exhibited showing St Francis of Assisi.[12] On the back was written : 'To certify the First Communion made by François Bernard, on 26 of April 1767, Low Sunday, in the parish of Saint-Sébastien of Marly. Barail, parish priest of Saint-Sébastien.' This was a certificate inspired by the official documents of the Catholic Church.

All that remained to be done was to add to the solemnity of the occasion by prescribing a special costume, and this was done in the nineteenth century.

The First Communion ceremony was the most visible manifestation of the idea of childhood between the seventeenth and the late nineteenth century : it celebrated at one and the same time the two contradictory aspects of that idea, the innocence of childhood on the one hand and on the other its rational appreciation of the sacred mysteries.

12. Exhibition, 'Enfants d'autrefois', Versailles, 1931.

Summary
The Two Concepts of Childhood

In medieval society the idea of childhood did not exist; this is not to suggest that children were neglected, forsaken or despised. The idea of childhood is not to be confused with affection for children: it corresponds to an awareness of the particular nature of childhood, that particular nature which distinguishes the child from the adult, even the young adult. In medieval society, this awareness was lacking. That is why, as soon as the child could live without the constant solicitude of his mother, his nanny or his cradle-rocker, he belonged to adult society. That adult society now strikes us as rather puerile: no doubt this is largely a matter of its mental age, but it is also due to its physical age, because it was partly made up of children and youths. Language did not give the word 'child' the restricted meaning we give it today: people said 'child' much as we say 'lad' in everyday speech. The absence of definition extended to every sort of social activity: games, crafts, arms. There is not a single collective picture of the times in which children are not to be found, nestling singly or in pairs in the *trousse* hung round women's necks (see Père Michault, 1931, p. 119); or urinating in a corner, or playing their part in a traditional festival, or as apprentices in a workshop, or as pages serving a knight, etc.

The infant who was too fragile as yet to take part in the life of adults simply 'did not count': this is the expression used by Molière, who bears witness to the survival in the seventeenth century of a very old attitude of mind. Argan in *Le Malade Imaginaire* has two daughters, one of marriageable age and little Louison who is just beginning to talk and walk. It is generally known that he is threatening to put his elder daughter in a convent to stop her philandering. His brother asks him: 'How is it, Brother, that rich as you are and having only one daughter, *for I don't count the little one,* you can talk of putting her in a convent?' The little one did not count because she could disappear.

The quotation from Molière shows the continuance of the archaic attitude to childhood. But this survival, for all that it was stubborn, was precarious. From the fourteenth century on, there had been a tendency to express in art, iconography and religion (in the cult of the dead) the personality which children were seen to possess, and the poetic, familiar

significance attributed to their special nature. We have followed the evolution of the *putto* and the child portrait. And we have seen that in the sixteenth and seventeenth centuries the child or infant – at least in the upper classes of society – was given a special costume which marked him out from the adults. This specialization of the dress of children and especially of little boys, in a society in which clothes and outward appearances had considerable importance, bears witness to the change which had taken place in the general attitude towards children: they counted much more than Argan's brother imagined. In fact, *Le malade imaginaire*, which seems as hard on little children as do certain remarks by La Fontaine, contains a whole conversation between Argan and little Louison: 'Look at me, will you!' 'What is it, papa?' 'Here!' 'What?' 'Haven't you anything to tell me?' 'If you wish, I can tell you, to amuse you, the story of the Ass's Skin, or else the fable of the Fox and the Crow which I was taught not so long ago.' A new concept of childhood had appeared, in which the child, on account of his sweetness, simplicity and drollery, became a source of amusement and relaxation for the adult.

To begin with, the attitude was held by women, women whose task it was to look after children – mothers and nannies. In the sixteenth-century edition of *Le Grand propriétaire de toutes choses* (1556) we are told about the nanny: 'She rejoices when the child is happy, and feels sorry for the child when he is ill; she picks him up when he falls, she binds him when he tosses about, and she washes and cleans him when he is dirty.' She brings the child up and teaches him to talk: 'She pronounces the words as if she had a stammer, to teach him to talk better and more rapidly ... she carries him in her hands, then on her shoulder, then on her lap, to play with him when he cries; she chews the child's meat for him when he has no teeth so that he can swallow profitably and without danger; she plays with the child to make him sleep and she binds his limbs to keep them straight so that he has no stiffness in his body, and she bathes and anoints him to nourish his flesh ...' Thomas More dwells on the subject of the schoolboy being sent to school by his mother: 'When the little boy will not rise in time for her, but lies still abed and slugg, and when he is up, weepeth because he hath lien so long, fearing to be beaten at school for his late coming thither, she telleth him then that it is but early days, and he shall come time enough, and biddeth him: "Go, good son, I warrant thee, I have sent to thy master myself, take thy bread and butter with thee, thou shalt not be beaten at all." ' Thus she sends him off sufficiently reassured not to burst into tears at the idea of leaving her at home, but she does not get to the bottom of the trouble and the late arrival will be well and truly beaten when he gets to school. (Quoted by Jarman, 1951.)

Children's little antics must always have seemed touching to mothers, nannies and cradle-rockers, but their reactions formed part of the huge domain of unexpressed feelings. Henceforth people would no longer hesitate to recognize the pleasure they got from watching children's antics and 'coddling' them. We find Mme de Sévigné admitting, not without a certain affection, how much time she spends playing with her grand-daughter: 'I am reading the story of Christopher Columbus's discovery of the Indies, which is entertaining me greatly; but your daughter enter-tains me even more. I do so love her ... she strokes your portrait and caresses it in such an amusing way that I have to kiss her straight away.' 'I have been playing with your daughter for an hour now; she is delight-ful.' And, as if she were afraid of some infection, she adds, with a levity which surprises us, for the death of a child is something serious for us and nothing to joke about: 'I do not want her to die.' For, as we have seen from Molière, this first appreciation of childhood went with a certain indifference, or rather with the indifference that was traditional.

The 'coddling' attitude towards children is even better known to us by the critical reactions it provoked at the end of the sixteenth century and particularly in the seventeenth century. Peevish persons found insufferable the attention paid to children. Montaigne bristles: 'I cannot abide that passion for caressing new-born children, which have neither mental activities nor recognizable bodily shape by which to make themselves lovable, and I have never willingly suffered them to be fed in my presence.' He cannot accept the idea of loving children 'for our amusement, like monkeys', or taking pleasure in their 'frolicking, games and infantile nonsense'.

Another example of this state of mind, a century later, is to be seen in Coulanges, Mme de Sévigné's cousin. He was obviously exasperated by the way his friends and relatives fussed over their children, for he composed a song dedicated to 'fathers of families', urging them not to spoil their offspring or allow them to eat with adults.

It is important to note that this feeling of exasperation was as novel as 'coddling', and even more foreign than 'coddling' to the indifferent atti-tude of people in the Middle Ages. It was precisely to the presence of children that Montaigne and Coulanges, like Mme de Sévigné, were hypersensitive; it should be pointed out that Montaigne and Coulanges were more modern than Mme de Sévigné in so far as they considered it necessary to keep children apart from adults. They held that it was no longer desirable that children should mingle with adults, especially at table; no doubt because if they did they were 'spoiled' and became ill-mannered.

The seventeenth-century moralists and pedagogues shared the dislike felt by Montaigne and Coulanges for 'coddling'. Thus the austere Fleury, in his treatise on studies, speaks very much like Montaigne: 'When little children are caught in a trap, when they say something foolish, drawing a correct inference from an irrelevant principle which has been given to them, people burst out laughing, rejoice at having tricked them, or kiss and caress them as if they had worked out the correct answer. It is as if the poor children had been made only to amuse the adults, like little dogs or little monkeys.'

The author of *Galatée*, the manual of etiquette commonly used in the best colleges, those of the Jesuits, speaks like Coulanges: 'Those persons are greatly at fault who never talk of anything but their wives, their little children and their nannies. "My little son made me laugh so much! Just listen to this . . ." '

M. d'Argonne, in his treatise on education, *L'Éducation de Monsieur de Moncade* (1690), likewise complains that people take an interest in very small children only for the sake of their 'caresses' and 'antics'; too many parents 'value their children only in so far as they derive pleasure and entertainment from them'.

It is important to remember that at the end of the seventeenth century this 'coddling' was not practised only by people of quality, who, in fact, were beginning to disdain it. Its presence in the lower classes was noted and denounced. J.-B. de la Salle in his *Conduite des écoles chrétiennes* (1720) states that the children of the poor are particularly ill-mannered because 'they do just as they please, their parents paying no attention to them, even treating them in an idolatrous manne. . .·hat the children want, they want too.'

In the moralists and pedagogues of the seventeenth century, we see that fondness for childhood and its special nature no longer found expression in amusement and 'coddling', but in psychological interest and moral solicitude. The child was no longer regarded as amusing or agreeable: 'Every man must be conscious of that insipidity of childhood which disgusts the sane mind; that coarseness of youth which finds pleasure in scarcely anything but material objects and which is only a very crude sketch of the man of thought.' Thus Balthazar Gratien in *El Discreto*, a treatise on education published in 1646 which was still being translated into French in 1723. 'Only time can cure a person of childhood and youth, which are truly ages of imperfection in every respect.' To be understood, these opinions need to be put back in their temporal context and compared with the other texts of the period. They have been interpreted by some historians as showing ignorance of childhood, but in fact they mark the

beginning of a serious and realistic concept of childhood. For they do not suggest that people should accept the levity of childhood: that was the old mistake. In order to correct the behaviour of children, people must first of all understand it, and the texts of the late sixteenth century and the seventeenth century are full of comments on child psychology.[1] The authors show a great solicitude for children, who are seen as witnesses to baptismal innocence, comparable to the angels, and close to Christ who loved them. But this interest calls for the development in them of a faculty of reasoning which is still fragile, a determined attempt to turn them into thinking men and good Christians. The tone is sometimes grim, the emphasis being laid on strictness as opposed to the laxity and facility of contemporary manners; but this is not always the case. There is even humour in Jacqueline Pascal, and undisguised tenderness. In the texts published towards the end of the century, an attempt is made to reconcile sweetness and reason. Thus the Abbé Goussault, a counsellor at the High Court, writes (1693): 'Familiarizing oneself with one's children, getting them to talk about all manner of things, treating them as sensible people and winning them over with sweetness, is an infallible secret for doing what one wants with them. They are young plants which need tending and watering frequently: a few words of advice offered at the right moment, a few marks of friendship and affection given now and then, touch them and bind them. A few caresses, a few little presents, a few words of cordiality and trust make an impression on their minds, and they are few in number that resist these sweet and easy methods of making them persons of honour and probity.'

The first concept of childhood – characterized by 'coddling' – had made its appearance in the family circle, in the company of little children. The second, on the contrary, sprang from a source outside the family: churchmen or gentlemen of the robe, few in number before the sixteenth century, and a far greater number of moralists in the seventeenth century, eager to ensure disciplined, rational manners. They too had become alive to the formerly neglected phenomenon of childhood, but they were unwilling to regard children as charming toys, for they saw them as fragile creatures of God who needed to be both safeguarded and reformed. This concept in its turn passed into family life.

In the eighteenth century, we find those two elements in the family, together with a new element: concern about hygiene and physical health. Care of the body was not ignored by seventeenth-century moralists and

1. As can be seen in the 1568 *ratio* of the Jesuits and in Jacqueline Pascal's regulations for the little girls brought up at Port-Royal.

pedagogues. People nursed the sick devotedly (at the same time taking every precaution to unmask malingerers), but any interest shown in healthy bodies had a moral purpose behind it: a delicate body encouraged luxury, sloth, concupiscence – all the vices in fact!

General de Martange's correspondence with his wife gives us some idea of a family's private life and preoccupations about a century after Mme de Sévigné. Martange was born in 1722 and married in 1754. He shows great interest in everything concerning his children's life, from 'coddling' to education; he watches closely over their health and even their hygiene. Everything to do with children and family life has become a matter worthy of attention. Not only the child's future but his presence and his very existence are of concern: the child has taken a central place in the family.

Part Two
Scholastic Life

Chapter 6
Medieval Scholars Young and Old

It is impossible to grasp the particular nature of school life in the past, even at the end of the ancien regime, without some idea of what education was like in the Middle Ages. No doubt the humanist Renaissance has had greater influence than the Middle Ages on curricula as on culture, in the upper regions of knowledge and the transmission of knowledge. But the schoolboy's life, in school and out of school, depended for a long time – until the beginning of the nineteenth century – on habits contracted in the Middle Ages. These habits depended on a whole system which it is difficult for modern man to visualize, because for a long time medievalists have studied the organization of the universities and the movement of philosophical ideas in university society rather than the conditions of life in the school and its environment.

There is a way of understanding the medieval school: first of all by getting to know its origins, but also by discovering what it has become in the course of history, for at bottom a phenomenon is characterized not so much by its origins as by the chain of other phenomena which it has directly determined. Only then shall we be able to distinguish some of the features of school life in the Middle Ages which can help to shed light on our subject.

The origins are well known. There is some controversy as to whether, in Italy, certain law schools and certain private schools dated back to antiquity. It is known that in Byzantium the ancient system had continued without interruption. This system, as H. I. Marrou has shown (1948), had retained its secular character after the triumph of Christianity, even in theocratic Byzantium. The heir of a Hellenistic tradition, it was characterized by stages more or less comparable to our stages of primary, secondary, and higher education. But in the Gallo-Roman era the educational institutions and techniques of the Byzantine Empire had completely disappeared. It is of no importance to us here if certain Latin subjects and authors, unknown to the Middle Ages, were later reintroduced into curricula: they did not determine the composition of the school. In this respect, there was a radical break between the ancient school and the

medieval school. The latter came into existence to satisfy the requirements of ecclesiastical recruiting.

Previously the Church had entrusted the secular school of the Hellenistic type with the literary education of its pupils, a literary education which was indispensable for the acquisition of sacred knowledge in a learned religion – as Christianity, the religion of the Book and its patristic commentaries, had rapidly become. After the fifth century the Church would no longer depend on that traditional institution, which had been dragged down in the collapse of the ancient culture and ruined by the decadence of the urban way of life (for the ancient school belonged to the city and did not exist in the country). But the exercise of the priesthood still called for a minimum of knowledge: knowledge which one might call literary (the liturgical texts of the divine office) and knowledge which one might call scientific (such as the computation of Easter) or artistic (such as plain-song). Without this knowledge, the celebration of Mass and the distribution of the sacraments would become impossible and religious life would become arid. It was therefore necessary for the clergy and particularly the bishops (sometimes, in certain countries such as England and Ireland, the monasteries) to organize the instruction of the young clerks themselves. This instruction, contrary to the ancient tradition, was given in the church itself: for a long time the habit remained of saying, '*a juventute in ista ecclesia nutritus – in gremio sancte matris ecclesie ab annis puerilibus enutritus*' (see Clerval, 1895), and the Church signified not only a society but a place, the porch of a church or its cloister.

This instruction was therefore essentially professional or technical. M. Marrou calls it 'choir-school education'. The pupils learned what they needed to know in order to say and sing the offices, namely the Psalms and the Canonic Hours, in Latin of course, the Latin of the manuscripts in which these texts had been established. Thus this instruction was predominantly oral and addressed to the memory, like the instruction given at present in the Koran schools in Moslem countries: anyone who has heard the alternating recitation of the verses of the Koran in the great mosque at Kairwan will have an idea of the medieval school, not only as it was in its distant sixth-century origins, but as it would remain, at least at its elementary level, for centuries. The pupils all chanted in unison the phrase spoken by the teacher, and they went on repeating the same exercise until they had learnt it by heart. The priests could recite nearly all the prayers in the office from memory. Henceforth reading was no longer an indispensable tool of learning. It only served to aid their memory in the event of forgetfulness. It only allowed them to 'recognize'

what they already knew and not to discover something new, with the result that the importance of reading was greatly reduced.

This extremely specialized instruction was given in the cathedral churches, under the supervision of the bishops, for the clerks of their households. It soon passed into the hands of their auxiliaries, who later became their rivals: the canons of the chapter. But the councils of the early Middle Ages also laid an obligation on the priests of the new country churches to train their successors – that is to say, to teach them the Psalms, the Canonical Hours and plain-song. For the parish priests were not appointed as they are today by the bishop, but by a patron, and the cathedral school did not necessarily provide incumbents for the rural parishes. Here we can see the distant origins of the country school, an institution unknown to the ancient world.

In so far as rural education existed in these early times, it remained at this elementary level. But, at least in the Carolingian period, the cathedral school went beyond these limits, and it is the cathedral school which is the original cell of our entire scholastic system in the West. The teaching of the Psalms and plain-song continued, the 'choir-school' aspect remained, and often the canon in charge of the school, the *scolasticus*, was also the choirmaster. However, some new subjects were added, and these were none other than the Latin *artes liberales*, inherited from Hellenistic culture and brought back to Gaul from Italy, where they had probably never stopped being taught in some private schools, and from England or Ireland, where the tradition had been preserved in the monasteries. Henceforth in the medieval schools the teaching of the Psalms and plain-song would be complemented by that of the arts – the trivium (grammar, rhetoric, dialectics) and the quadrivium (geometry, arithmetic, astronomy, music) – and finally by that of theology, that is to say, of the Scriptures and canon law. As a result the canon in charge of the school sometimes called in the help of assistants: one for the elementary work – the Psalter – and others for certain subjects such as branches of the arts or theology or law. But this multiplication of masters was not universal, and probably took place only in a few schools which acquired a considerable reputation and began to attract teachers or students, sometimes from distant parts, as was the case at Chartres or Paris. In all probability most of the cathedral schools existed for a long time with one or two masters teaching most of the subjects, or at least the arts. But by the twelfth century they were no longer sufficient. The chapters were obliged to authorize other churches to maintain schools. They had to allow teaching by private masters, on condition that they authorized them, and the reluctance they showed in agreeing to this arrangement resulted in the formation of an

association of masters and pupils directed against them, namely, the university. Little by little, in the course of the twelfth century, a network of schools was established, some of them famous and giving rise in a few cases to universities, the others more modest.

A final phenomenon, the specialization of theology and law, gave the medieval educational system its definitive form. Theology ceased to be taught in the same schools as the arts. This led to a remarkable system of specialization which was to last until the nineteenth century: from the thirteenth century on, there was separate instruction in the arts, which in the university towns gave its name to a Faculty – the Faculty of Arts – and which, like a propaedeutic, prepared pupils for admission to the higher schools: theology, canon law, civil law and medicine. The universities of the thirteenth century finally established this hierarchy of knowledge. They generally consisted of at least two Faculties: a Faculty of Arts and one or more higher Faculties (in Paris, for example, theology and canon law); they were never confined to the Faculty of Arts alone. For the arts were not sufficient in themselves and merely prepared the way for a different sort of education. The influence of the universities concerns us here in so far as it helped to effect a complete separation between the arts on the one hand and theology and law on the other. Instruction in the higher, more specialized subjects tended, in fact, to be concentrated not unnaturally in university towns inhabited by famous teachers, and the students attracted by the latter's prestige. On the other hand, the arts, relieved of parasitic subjects such as theology and law, (though they too were taught by certificated masters of the universities), were not always absorbed by the universities; Arts schools were set up wherever the latter existed, and even in places where there was no university, and these schools doubtless tended to multiply at the end of the Middle Ages.

The result was that instruction in the arts, both inside the universities and out, was given all over the country, under the obedience here of the chapter, there of the bishop, there again of the abbot, and covering in its curricula Latin (including the Psalter), but not theology, canon or civil law, or medicine. It is this instruction in the arts, in the definitive form which it took in the thirteenth century, which concerns us here.

There is a hiatus between the ancient school and the medieval school, but we pass without any interruption, by means of imperceptible alterations, from the medieval school to our present educational system. The comparison of the two systems seems *a priori* a monstrous anachronism, but this apparently unthinkable comparison is in fact inevitable.

We are struck first of all by the differences. The medieval school was confined to the tonsured, to the clerics and the religious. From the end of the Middle Ages it extended its teaching to ever wider sections of the population. However, up to the mid-eighteenth century, it remained a Latin institution, and when it became French (when the use of the vernacular ceased to be punished), it retained the study of Latin in the centre of its secondary curricula. For this characteristic we have to look further back than those periods which practised a deliberate cult of Roman Antiquity; we have to look to the Middle Ages, when Latin was first of all the language of the clerks and their professional schools. For centuries it was taught as a living language rather than as a cultural language, a language as necessary to the clerk as to the man of law and the administrator. It was only at the beginning of the eighteenth century that its modern function as an element of general education became predominant.

A second difference between medieval and modern education is the absence of primary education in the earlier period. Primary education as we understand it today is neither a technical education nor an education in general culture. It teaches reading, writing, use of the mother tongue, and what it is essential to know in order to be able to get along in life, whatever one's trade or station. But in the Middle Ages and at the beginning of modern times this elementary and empirical knowledge was not taught in school: it was acquired at home or in apprenticeship to a trade.[1] The usefulness of the school began with Latin, and it stopped at the level of Latin studies necessary for the purpose to which the pupil intended to put them. The incumbent of a country parish could be satisfied with learning the liturgical texts by heart; a future attorney had to be more demanding. True, the medieval school provided elementary instruction in Latin – the Latin of the Psalter from which pupils were taught reading – and no doubt this instruction formed the inspiration for modern primary education at the beginning of the seventeenth century, as we shall see later.[2] But the Psalter represented only the rudiments of the Latin school. When it was transferred to the French of the 'little school', the whole spirit of it changed and it became something entirely different.

The third difference: the lack of higher education in letters and the sciences. Admittedly there were Faculties of Theology, Law and Medicine, and these have continued to the present day under the same names. But there was nothing in medieval France to be compared with either higher education in the Hellenistic world, which was essentially scientific,

1. See Chapter 15.
2. See Chapter 12.

rhetorical and philosophical in character, or the Faculties of Letters and the Sciences which were born at the beginning of the nineteenth century with the Napoleonic university. This is a surprising gap when one considers the importance of philosophy in the intellectual life of the Middle Ages. The discovery of the unknown works of Aristotle and the great Thomist synthesis should have resulted in separate instruction in the liberal arts and theology. In fact, ethics and metaphysics assumed such an important position in the curricula that parts of the arts were absorbed by philosophy. Thus the old dialects of the trivium disappeared in favour of logic, which permanently ousted the trivium from scholastic terminology; and logic then became synonymous with philosophy. The question then was whether this philosophy would coexist with grammar, and with the rudimentary forms of grammar, or whether it would break away to become a form of higher education. In this respect education developed differently in France and England.

In England, the Latin schools became affiliated to the universities; the colleges at Oxford and Cambridge were markedly different from the other, non-university, Latin schools. It became customary to begin the study of the arts at the nearest Latin school – which could be, for instance, the cathedral school of St Paul's in London. Later these schools, which were just like the Latin schools in France, would be called 'grammar schools'. It was only on leaving the grammar school, at about fourteen, that the young Englishman was sent to Oxford or Cambridge. The difference in age corresponded to a difference in curricula : philosophy and the sciences were reserved for the universities, in principle at least, for the distinction was not really strictly observed until the eighteenth century. In reality the borderline was much vaguer. First of all because in the university colleges, apart from philosophy, the pupils also had to study all over again the precepts and authors they had already studied at the grammar school, in accordance with the principle of repetition dear to medieval pedagogy. Then again, it sometimes happened in the fifteenth and sixteenth centuries that logic was read in the grammar schools. The place of certain subjects remained for a long time in dispute – such as rhetoric, which Brinsley claimed for the universities, although it was on the curriculum of the grammar schools and stayed there. The argument was still going on at the beginning of the seventeenth century. However, things were finally arranged in accordance with what was already ancient usage : the grammar schools prepared pupils for the universities, and the universities had the monopoly of the instruction in philosophy which was regarded as the necessary complement of the ordinary studies, before admission to the specialities of law, theology or medicine. Philosophy then became the

embryo of a higher cultural education in the modern sense. The same evolution occurred in Germany.[3]

In France, on the other hand, the schools of 'artists' (pupils studying the arts) attached to the universities did not succeed in distinguishing themselves, either by their recruitment or by their curricula, from the schools of 'artists' in other towns which did not give birth to universities. No doubt in thirteenth-century Paris, in the Paris of St Thomas's time, conditions could have developed in the same way as at Oxford and Cambridge. The Parisian schools were attracting from distant parts students who had already been taught in other schools. Already, in the twelfth century, it is recorded that once they had reached the age of puberty the better students used to leave their schools to go to Chartres, Tournai, Orléans and Bologna. However, these schools, though more famous than the rest, did not stop teaching young boys, and it did not become customary for them to take in only students who had already received a preliminary education, as it did at Oxford and Cambridge. In Paris, this state of affairs may have been due to the presence of a far bigger native population than that of the little English towns, so that the schools had to satisfy the requirements not only of a foreign clientele, similar to that of the present Faculties in France, but also of a local clientele like that of the colleges or *lycées*. However that may be, philosophy was not separated from grammar and its rudiments; accordingly the curriculum was the same in the schools of the university towns as in those of the non-university towns, provided that the latter were sufficiently important.

The consequences are still perceptible today. Philosophy remained on the curriculum of the grammar schools, and when, after the fourteenth century, education was divided into parts according to the difficulty of the subject and the age of the pupil, philosophy was pushed to the very end of the cycle of Latinity; it formed the subject-matter of the last two classes under the name of logic and physic – which were to become the modern philosophy classes. The logics and physics classes of the sixteenth century corresponded both to the English university colleges and to the present-day Faculties of Letters and the Sciences in France. The existence of a second baccalaureate in France today is due to the fact that in France philosophy has not detached itself from the rest of the arts. In England, on the contrary, there is no second baccalaureate because there was never

3. There is no faculty of law in England. In Germany another source of higher education was the academy, which did not follow the medieval tradition of the arts. The new sciences were taught in these academies by means of methods which were already modern.

any instruction in philosophy, never any logic or physics, in the English grammar schools.

What in England became part of university education was absorbed in France by what became secondary education. Thus the creation by Napoleon of a Faculty of Letters was not based on any French tradition, and the inspiration for it had to be sought in foreign, and particularly German, models. That is why, in France, it has not become customary to regard university education in Letters and the Sciences as the necessary complement to a good education. At the end of the nineteenth century, the social equivalent in France of Oxford or Cambridge was not the Sorbonne but Louis-le-Grand or Stanislas or else a Jesuit college. Nowadays it is the École des Sciences Politiques, the 'Sciences Po'.

So far, the comparison of medieval education with our own has chiefly brought out differences. By difference I mean the impossibility for us of finding in the one the origins of the other: thus neither our primary nor our university education is directly descended from the medieval system. But in French secondary education in the nineteenth century and at the beginning of the twentieth century, when that education was still predominantly Latin, we can recognize the natural culmination of the liberal arts of the Middle Ages. The arts had been considerably modified in the interval, notably at two points: under the humanist influence of the sixteenth century, when the classical Latin authors were substituted for the authors of the Byzantine Empire, and in the eighteenth century, when the use of French was introduced into the schools together with a few new scientific ideas. But they still remained recognizable, and their traditional terminology was still used. True, the word 'artist', as applied to students, went out of use after the sixteenth century, although it remained in the administrative, non-spoken language to denote the Faculty of Arts, as opposed to the other higher Faculties. But the expressions which served, almost to the present day, to denote the principal divisions of secondary education – or of what became secondary education – still belong to the traditional vocabulary of the arts. During the last two centuries of the ancien regime and in the nineteenth century too, the normal cycle was divided in the following way: grammar classes up to the third form, then the fifth form or humanities class, then the sixth form or rhetoric class, then logic and finally physics. Grammar and rhetoric are two branches of the old trivium. Logic is the former dialectics, raised to a more philosophical than oratorical level by the Aristotelian renaissance of the Middle Ages. Physics is simply the former quadrivium. The humanities represent the contribution of the humanist thought of the sixteenth century, effected by the Jesuits in particular. In the nineteenth century, logic

and physics were replaced by the present-day classes of philosophy and mathematics. The mere enumeration of the names of these classes, from the sixteenth century to the present day, summarizes the entire history of the Latin school: the original trivium and quadrivium, the philosophical deposits of the Middle Ages, the humanistic contribution of the Renaissance, and the modernization of the old logic and physics into the modern philosophy and mathematics. The stages are clearly defined, but they are the stages of a single evolution. We can trace it back from the modern French *lycée* (before the reforms which brought secondary education into a closer relationship with primary and technical education) to the college of the ancien regime and from the college to the medieval Latin school which taught 'grammar and the arts'. This does not mean that in the Middle Ages the teaching of the arts corresponded to the teaching of the arts in the modern French secondary school, but simply that it was the starting-point of the development which resulted in our secondary education.

We have tried to situate the medieval school by linking it up with both its origins and its posterity. Now that it has become rather more familiar to us, let us go on to consider certain features of it which are concerned with our study of the relationship between the ages: the lack of gradation in the curricula according to difficulty of the subject-matter, the simultaneity with which the subjects were taught, the mixing of the ages, and the liberty of the pupils.

The lack of gradation

Nobody thought of having a graduated system of education, in which the subjects for study would be distributed according to difficulty, beginning with the easiest. The most striking example is that of grammar. Today we regard grammar – as we have done ever since the fifteenth century – as an elementary subject, and the further we advance in time, the more elementary it becomes. But in ancient times grammar was a science, and a difficult science at that, corresponding to our modern philology. The Middle Ages inherited from ancient times this concept of grammar, which was one of the branches of the trivium; advanced students did not consider the study of it beneath them. Thus John of Salisbury, in the twelfth century, attended classes in grammar for three years, between the ages of sixteen and twenty. Students read over and over again the *Commentarium grammaticorum libri XVII* by Priscian, a fifth-century Latin grammarian. In 1215 the University of Paris issued a decree stipulating that in the arts schools one of Priscian's books should be studied for at least two years (see Théry, 1858). Later, Priscian was replaced by

Alexandre de Villedieu's *Doctrinale puerorum*, a thirteenth-century work of twelve chapters: the declensions, the *eteroclites* or irregularities, the degrees of comparison, the articles or the genders, the preterites and supines, the defective and abnormal verbs, the four types of verb, transitive, intransitive or reciprocal constructions, short syllables and long syllables, stress and figures of speech. The *Doctrinal* would be the manual of grammar until the end of the fifteenth century, when it would be replaced in France by Despautère's manual, which was scarcely any easier but which at least, for the first time, described itself as a pedagogic initiation rather than a scientific *summa*.

This scientific grammar was also what was taught just after reading from the Psalter, or at the same time, to boys of ten. No doubt they did not begin with Priscian or the *Doctrinal*. Their first book was Donat, that is to say the *De octo partibus orationis* by Donat, a fourth-century grammarian. It was called *Donatus minor* to distinguish it from other books by Donat, or else *Ars minor*, which suggests that it was an elementary work, but an elementary work which formed part of the general study of the arts. Later on, Donat became synonymous with the rudiments of grammar: when one knew one's Donat, one could find one's way about. Certain private masters had been given permission by the chapter to teach Donat but not other authors.

In many manuscripts Donat is followed by extracts from Priscian, whom one would have thought to be an author for more advanced students. At the beginning of the eleventh century, the Anglo-Saxon Aelfric wrote a Latin dialogue with a juxtalinear translation intended for beginners at the Donat level; he accompanied this with *Excerptiones de Prisciano minore vel majore*, a sort of condensation or anthology of Donat and Priscian. To take another document, we find a Donat included in the inventory of a Bologna student's luggage stolen in 1393, and this work is mentioned next to a *Doctrinal* and a Boethius (an author who dealt with dialectics, music, the quadrivium): as if a little French grammar were found today among the schoolbooks of a boy in the philosophy class. Thus grammar was at once a science and a rudimentary subject, studied by both the big clerk aged from fifteen to twenty and the little clerk of ten. And it was always the same grammar, with examples from the same authors of the Byzantine Empire (see Adamson, 1919, 1920 and 1930).

Another example of the lack of gradation is provided by John of Salisbury's cycle of studies in the middle of the twelfth century. John of Salisbury was born about 1137. He arrived in Paris at the age of fourteen. By this time he had already received a primary education: the Psalter,

Donat, and a smattering of the liberal arts. He came to Paris to complete his education at the feet of famous masters. These could be, as in the thirteenth century, specialists in certain branches of the arts – one master teaching grammar, another rhetoric, a third dialectics or logic and a fourth the quadrivium – but this was not always the case. Generally speaking, the same master taught all the arts, laying special emphasis on a favourite discipline. Thus in the sixteenth century Odon de Tournai, who was in charge of two hundred pupils, taught all the arts, although *'praecipue tamen in dialectica eminebat'*. And if, in the twelfth and thirteenth centuries, in Paris and the university towns, the most famous of the masters sometimes specialized to a certain extent, this specialization tended to diminish later on. On his arrival in Paris, the fourteen-year-old John of Salisbury did not address himself first of all to a grammar master. He took a course of dialectics – that is to say, he spent most of his time studying the commentaries on Aristotle's *Organon* by Boethius and Porphyrus. He remained on this course for two years, but when he returned after a long absence, he found the same classmates under the same master, still doing these exercises in dialectics which by that time he considered useless but which none the less offered sufficient interest to retain a faithful public for about five years at a time. Thus in the thirteenth century it was still a common thing for a student to linger over the study of one of the liberal arts. Dialectics did not distract John of Salisbury from grammar, which he had no intention of neglecting, for all that he had begun his studies in Paris with dialectics. He returned to it for three years, until he was about twenty, providing another example of the medieval antiquity of grammar, at once a rudimentary subject and a science. At twenty, he went ahead with his studies. He enrolled with a master who went through the whole cycle of the arts all over again (*ab eo* [Richard l'Évêque] *cuncta relegi*) and taught him the quadrivium, that is to say the sciences, of which he was still ignorant (*et inaudita quaedam ad quadrivium pertinentia*). Then he went on to rhetoric, with which he was already familiar (*relegi quoque rhetoricam*), and finished with logic, in which he resumed acquaintance with Aristotle's *Organon*, which he had already studied in dialectics. After that he in his turn taught the arts, to earn his living, and when he returned to the schools, it was in a higher Faculty, in order to study theology. During his long years as an 'artist', John of Salisbury had not followed any plan, and there is no sign of any gradation in his studies: dialectics, grammar, review of the trivium, the quadrivium, review of rhetoric, logic. The order could have been entirely different: it does not correspond to any traditional succession. Every master arranged his programme according to his preferences, and masters taught at one and the

same time subjects which general opinion placed on the same level of difficulty and importance.

However, the reform of the University of Paris in 1366 by Cardinal de Saint-Marc and Cardinal de Saint-Martin showed signs of a tendency in favour of a gradation of the curricula, a tendency very foreign to the reform of 1215 by Robert de Courçon. This text gives the programme of the university examinations. First of all, for the *determinatio*, the future baccalaureate, the requirements were:

1. Grammar – *sint in grammatica edocti, et Doctrinale et Graecismum audiverint*;

2. Logic – *veterem artem totam*, to wit Aristotle's *Organon* and also his *De anima*. For the *licencia docendi*: physics and Aristotle's scientific treatises, *de generatione et corruptione, de caelo et mundo, parva naturalia*. For the mastership of arts: Aristotle's *Ethics* and *Meteors*.

Here one might be tempted to see the elements of a system of gradation: grammar and logic which together occupied the biggest place in the arts curriculum, the quadrivium and moral philosophy. But this gradation remained very vague, for it left grammar and logic on the same level: what we really have here is a classification corresponding to more systematic teaching, to a better planned system of examinations designed to impose subjects for the licentiate's degree and the mastership which were not also required of the candidate for the baccalaureate. Moreover this distribution of the various subjects between the three examinations prejudged neither their difficulty – for the *Organon* or the *De Anima* were no easier than the *Physics* or the *Ethics* – nor the order in which they would be taught, for the dates of the examinations for the baccalaureate, the licentiate's degree and the mastership came closer together until they concurred at the beginning of modern times, when to all intents and purposes they became different formalities of one and the same examination.

Simultaneity

The arts, at least grammar and logic, were not ranked in a progressive order. However, if the subjects were not graduated in order of difficulty, they could have been distributed – i.e. each could have been taught to the pupil at a different time. In fact this distribution became inevitable in the twelfth- and thirteenth-century schools, such as those attended by John of Salisbury, which gave advanced instruction in the arts: but we know that in France this hierarchy of the arts schools changed fairly quickly. It was compromised by the junior clientele made up of the children of the town, and also by the tendency to cut short the duration of the course of

studies. John of Salisbury's university career lasted twelve years, and to these we must add the five or six years at his first school which preceded them. His companions in the dialectics class remained in that branch of study for nearly ten years. But as early as this there was also a contrary tendency, to which the same John of Salisbury bears witness in a treatise called the *Metalogicon*, directed against those who wanted to cut short the duration of the course of studies, and even, so he maintains, reduce it to two or three years. Three years instead of ten or twelve! John of Salisbury heaps contempt on these people. Yet it was they who eventually triumphed, and Cornificius, the object of his derision, appears to us as the precursor of modern education, characterized as far back as the fifteenth century by a shorter cycle than that of the Middle Ages. None the less it was a case of anticipation, and the Middle Ages retained a long cycle of studies which can be explained by the fact that education was the monopoly of clerks who were often already beneficed and in no hurry to settle down. It was shortened when the Latin school began drawing more of its pupils from the laity. But even then the long cycle of studies remained for a long time as a model. The humanists, for all that they were so hostile to medieval pedagogy, still thought that an ideal education ought to extend a long way into life, beyond childhood and adolescence – of which they could distinguish neither the age limits nor the existential character.

The effect of cutting short the duration of the course of studies was to rob the university schools (which were already attended by beginners from the town) of their character as institutions of complementary education, provided by masters who were more or less specialists. The course of studies at these schools was cut short at the top and invaded at the bottom. The result was that the university schools rapidly became polyvalent, as most of the non-university arts schools had always been. The same master taught all the arts (like the modern primary-school teacher), or at least grammar, logic, the quadrivium. Some of these subjects, which did not belong to the basic grammar-logic cycle, were for a long time the object of a special course in Paris: ethics was still taught separately in the late fifteenth century, when Standonc was in charge of the course. He complained, incidentally, that the bachelors of arts were no longer taking it. Between 1492 and 1517 it was finally suppressed.

Even in the case of these distinct and special lessons, instruction still remained simultaneous, in accordance with the tradition which we find described in the reform of the University of Paris in 1215 by Robert de Courçon, and which was wholly in keeping with the spirit of medieval pedagogy. From this text we learn that the arts were divided into two

cycles: one given in the *scolae ordinariae* – grammar and logic, in other words Priscian and the *Organon* – and the other *ad cursum*. In these *cursariae*, the pupils studied rhetoric, the *quadrivilia* (physics from Aristotle, music from Boethius, etc.), but also a grammatical treatise, Donat's *Barbarismum* (whereas the *De octo partibus* formed part of the ordinary cycle) and finally a sort of optional subject: ethics. To the first cycle belonged the basic disciplines, and the reformer of 1215 saw to it that they were not extended too far. The second cycle consisted of the complementary subjects. But these two cycles did not follow one another: on the contrary, they were, in effect, taught simultaneously: the ordinary classes were held on weekdays, while the *cursariae* were given only on holidays, which were, of course, frequent. It was as if the time-tables had been arranged so that the same pupils could follow both cycles at the same time. It can now be seen why the Bologna student possessed both a Donat and a Boethius. The older students were distinguished from the new not by the subjects they studied – they were the same – but by the number of times they had repeated them. Moreover the scarcity of manuscript books, and the need to rely on memory above all, also made this wearisome repetition inevitable.

The mixing of the ages and the liberty of the students

The lack of gradation of the curricula, the simultaneity of the teaching, the oral method of repetition: the features of this pedagogy have to be kept in mind if we are to understand the astonishing demographic structure of the medieval school.

At what age did the medieval child start school? On this point the answer given by the historians varies, because, when the historians are French, it is not clear whether they are talking about the elementary school or about the higher school as it existed only in the twelfth and thirteenth centuries. If, on the other hand, they are English, then we have a better idea of what they are talking about, because in England the distinction between elementary schools and higher schools providing instruction in the arts survived the thirteenth century and has lasted down to the present day. But even in what appear to be the clearest cases an ambiguity remains.

In the fourteenth century, in England, Chaucer in 'The Prioress's Tale' depicts a little schoolboy: 'Now among the children there was a widow's son, a little cleric seven years of age who was accustomed to go to school every day.' He was precocious for his time. In Paris, in 1339, at the Ave Maria College, the youngest pupils were eight years old. Boys entered Winchester College between eight and seventeen. The age given by

Adamson, the English educational historian, seems to have been the usual one: from nine to twelve. It can be assumed that on the average it was at about the age of ten that the little cleric began his Psalter. It should be noted that at that age, nowadays, he would be entering the first form and would already have four or five years at a primary school behind him – more if he had been to nursery school. The little medieval cleric was four or five years behind the boy of our own day, and those four or five years represented at that time a much longer period, comparatively speaking, than today. So the medieval child started school fairly late. How long did he stay there? Here again, we must be careful to distinguish one period from another. Until the twelfth century approximately, a pupil can scarcely have stayed on much after thirteen or fourteen, the age of puberty. Then, in the twelfth and thirteenth centuries, with the university move-ment, it became customary to have a long cycle of studies which started where the elementary school finished and, taking the student at thirteen or fourteen, accompanied him to about the age of twenty. This would be the English system: until fourteen, the elementary school or the grammar school, as it was later called, and the university college from fourteen to eighteen, after which the student specialized in theology or spent a period reading law.

In France the teaching of the arts in two stages did not survive the thirteenth century. The Paris university schools must have had a propor-tion of pupils aged over fourteen who raised the average age-level, students attracted by the fame of the city's masters. But these same schools un-doubtedly took in younger beginners, since they did not succeed in estab-lishing themselves as complementary schools which pupils could enter only after receiving a preliminary education. That was the great difference between them and the English schools. The students often stayed at school a long time in the twelfth and thirteenth centuries, so that the long cycle of studies, lasting to the age of twenty and beyond, became customary; there is reason to think that the teaching of the arts attracted and retained many masters: famous teachers preferred the arts to law and theology because they were more remunerative – their arts courses were better attended, and attended for a longer period by adults. We know on the other hand that from the fourteenth century on the masters taught the liberal arts only while waiting for something better. Soon they were no longer, as in the twelfth and thirteenth centuries, eminent specialists such as Anselm or Abelard, but occasional teachers who taught the arts at the same time as they were studying for examinations in the higher Faculties: theology, law or medicine. And this latter formula carried the day until the Jesuits restored to the teaching body a prestige which was, however, very relative;

the masters in the Jesuit colleges were more often than not students in the higher Faculties who earned their living by teaching, just as students in the Faculties of Letters and the Sciences now give private lessons or teach in private schools. This drop in the quality of the teaching body suggests a change in the composition of the classes. It corresponded in fact to the transition from the long cycle to a shorter cycle, to the shortening of the course of studies. As the average age of the pupils dropped, the master giving instruction in the arts stopped being a scholar or a thinker, a dialectician or logician famed for the originality of his thought, and became a pedagogue, a pedant, a mere labourer treated with scant respect. This evolution started at the end of the Middle Ages, with the victory of a shorter cycle of studies; a programme that ended when the student was about fifteen.

However, we should beware of giving this speculation about ages more importance than it deserves. No doubt we are introducing into this analysis a totally modrn concept, namely, that of the correspondence between age and studies – a concept foreign to the Middle Ages. It is only very rarely that one comes across a precise reference in a text to the pupils' ages. When, despite the opposition of the chapters, the private schools multiplied and threatened the monopoly of the cathedral schools, the canons in self-defence tried to set limits to their rivals' activity. These limits were never age limits. The canons confined themselves to forbidding the private schools to teach anything more advanced than Donat, which was synonymous with elementary grammar. And this absence of any reference to age continued for a very long time: the lack may be noted very often in the seventeenth-century moralists. The lodging contracts – something like articles of apprenticeship by which families fixed the terms of accommodation of their schoolboy sons – rarely mention the boy's age, as if it were of no importance. We know that as a general rule the youngest pupils were about ten years old. But their contemporaries paid little attention to their age, and considered it perfectly natural too for an adult who was anxious to learn to join a class of children, for it was the subject being taught that mattered. An adult could listen to the work of Donat at the same time as a precocious boy was studying the *Organon*.

In the medieval school all the ages were mixed together in the same classroom. At that time the school did not have huge buildings at its disposal. The master installed himself in the cloister after clearing it of parasitic commercial activity, or else in the church or at the church door. But later on, as the number of authorized schools increased, he sometimes contented himself with a street corner when he was short of money, and St Thomas occasionally shows a touch of contempt for these impoverished

creatures who speak '*coram pueris in angulis*'. Generally the master hired a room, a *schola* at a fee which, incidentally, was fixed by regulation in the university towns; and in Paris these schools were concentrated in one street, the Rue du Fouarre: *vicus straminis*. These schools were, of course, independent of one another. The floor was strewn with straw, and the pupils sat on the floor. In the fourteenth century a few benches were provided, although this innovation encountered some opposition at first. Then the master waited for students to come to him, as a shopkeeper waits for customers. Sometimes one master would entice away the pupils of another. In this classroom boys and men of all ages were gathered together, from ten years of age to twenty or more. 'I saw the students in the school', wrote Robert of Salisbury in the twelfth century. 'Their numbers were great [there could have been two hundred or more]. I saw there men of diverse ages: *pueros, adolescentes, juvenes, senes*' – that is to say, all the ages of life, for there was no word to denote an adult and one went straight from *juvenes* to *senes*.

In the fifteenth century we find the masters in Perè Michault's *Doctrinal* (ed. T. Walton, 1931) addressing themselves to both the young and the old who made up their public: 'Good pupils with open minds, whether you be old or young, mature or green ...' 'And this school, with a great multitude of pupils, was reading the chapter on constructions [in the *Doctrinal* by Alexandre de Villedieu, Priscian's successor and Despautère's predecessor].' How could things be otherwise, seeing that there was no gradation of the curricula, and that the older students had simply repeated more often what the younger pupils had heard only once?

The mixing of the ages continued out of school. The solitary master, sometimes helped by an assistant, and with only one building at his disposal, was in no position to keep a check on the everyday life of his pupils; they escaped from his authority as soon as lessons were over. Now, to begin with, this authority, the master's *for*, was the only one they recognized. 'Old or young, mature or green', they were left to their own devices. A very few lived with their parents. Others lived in lodgings, either with the master himself or with a priest or a canon, on terms arranged in a contract similar to articles of apprenticeship. These pupils were the most closely supervised or at least the most closely watched; they belonged to a household, to the family of the clerk to whom they had been entrusted, and here there was a sort of compromise between the education by apprenticeship and academic education of the modern type. This was the only form of boarding-school. Most of the pupils lived where they could, in private lodgings, several to a room. And here too, old and young were mingled together; initiatory traditions bound the younger pupils closely to their

elders. This mingling of the ages surprises us today if it does not actually shock us : but at the time people were so indifferent to it that they did not notice it, as is the way with very familiar things. How could they be expected to notice the mixing of the ages when they were so indifferent to the very fact of age?

As soon as he started going to school, the child immediately entered the world of adults. This confusion, so innocent that it went unnoticed, was one of the most characteristic features of medieval society and one of the most enduring features too. At the end of the Middle Ages, we can make out the first signs of a contrary evolution which would result in our present very conscious differentiation of the ages. But until the end of the ancien regime at least, something of the medieval state of mind would remain. Its resistance to other factors of mental transformation marks it as a fundamental attitude to life, common to a long succession of generations.

Chapter 7
A New Institution: The College

The texts of the pontifical reformers of the University of Paris (of 1215 and 1366) spoke only of the school: the room in which, twice a day for the ordinary lessons and on free days for the extraordinary lessons, the master who had hired it gathered his pupils together and read or commented on the authors prescribed by custom. The reformers' intervention was limited to enforcing observance of the traditional curricula and fairness in the examinations. In 1452 another reformation took place, carried out by Cardinal d'Estouteville: this was the last time pontifical authority was exerted by its legate (see Théry, 1858). The next reformation of the University of Paris was the work of Henri IV and his officers, in 1598, and established the conditions of education until the mid-eighteenth century.

The reformation of 1452 bears witness to a spirit very different from that of the earlier period. In this text, some new expressions made their appearance: *collegium, pedagogium, domus artistorum*. Some new characters take the place of the former master: *magister principalis, pedagogus, regens*. According to this document, the Faculty of Arts was now composed of *collegia, pedagogia, domus artistorum*, entities which had been unknown or had gone unmentioned in the older texts. The institutions referred to in these terms did all the teaching of the arts, and the Cardinal was legislating for them alone, addressing himself directly to the *magistri principales*, who had become the chief cogs in the educational machine. This new organization had come into being between the reformations of the thirteenth and fourteenth centuries and the reformation of 1452: the old-type schools, the cathedral school or the school in the Rue du Fouarre, was replaced by the college or the pedagogica. Cardinal d'Estouville speaks of them as of institutions so familiar that it does not occur to him to mention their origins, recent though they were, or to compare them with the previous system. Yet his contemporaries were well aware of the importance the college had assumed in university life and occasionally they provided an indication of it. Thus in 1445 the University of Paris, in an address to the King, admitted that it now resided almost entirely – *quasi tota* – in its colleges, and that it would have perished in the recent troubles

– during the Hundred Years War – if it had not been safely established inside these colleges.

In the sixteenth century, Étienne Pasquier gave a precise description of this transformation, which had taken place just over a hundred years before. He began by reviewing the places where the students were given their lessons before the introduction of the colleges. The disorderliness of medieval education shocked him: at that time 'studies were in a jumble ... the rooms on one side were leased to students and on the other to whores, so that under the same roof there was a school of learning together with a school of whoring'. Pasquier expressed surprise that 'at that time there was no more discipline than that, and that the University of Paris had none the less acquired such a high reputation'. His comments show to what extent medieval freedom was no longer understood or tolerated: freedom for the graduate master to teach where he liked, as he liked; freedom for the pupil to live free of supervision outside school hours. People now saw nothing in the old state of affairs but licence and anarchy. Revulsion had brought about 'the institution of the colleges which put a new complexion on things'. According to Pasquier, the institution took place in two stages. First of all, 'certain lords and particularly ecclesiastics decided to build houses in this University, which were called colleges, for the benefit of the poor students whom they wanted to be lodged therein under the name of Scholars, and to be fed and taught at the expense of the revenue set aside for this purpose'. Next, well-to-do families got into the habit of sending their sons to these colleges for scholars, which had acquired a good reputation for discipline, and thus came to desert the 'jumble' in the Rue du Fouarre: 'The discipline kept by these poor Scholarship Students who were confined in the colleges was considered so good that the majority of fathers and mothers, sending their children to study in Paris, also wanted them to lodge in the colleges in order to avoid debauchery.' Thus, with the institution of the college appeared a feeling unknown to the Middle Ages and which would go on growing in strength until the end of the nineteenth century: revulsion at the idea of the mingling of the ages. Henceforth schoolboys would tend to be separated from adults and submitted to a discipline peculiar to their condition, for the good reputation of the poor scholars was chiefly due to their 'confinement' (*réclusion*). Incidentally, we should beware of taking this word literally: the independence enjoyed by Pasquier's 'confined' students would alarm present-day parents! However, they were none the less submitted to a supervision, or rather an attempted supervision, such as their thirteenth-century predecessors had never known.

An important stage had been passed. The transition from the free

school of the Middle Ages to the disciplined college of the fifteenth century was the sign of a parallel movement in the world of feelings: it expressed a new attitude to childhood and youth.

The colleges, founded in the hospices from the end of the twelfth century onwards, started as homes for poor students. Thus in 1180 an Englishman back from Jerusalem took a palce in the Hôtel-Dieu in which to house eighteen poor students maintained by an endowment (Rashdall, 1895). This was the origin of the Collège des Dix-huit which in 1231, when the old Hôtel-Dieu was destroyed, installed itself in an independent house. Later the Collège des Dix-huit was combined with Louis-le-Grand.

Starting as a hostel, the college soon became an institution for scholars: a prelate or an abbot would give a university an endowment to maintain a few poor students from his diocese or native land, specifying the way in which the fund was to be applied. The endowment provided the college with a permanent financial basis: in particular it made possible its permanent installation in premises which to our eyes often seem far bigger than the limited number of beneficiaries seemed to require. Thanks to this permanence, the institutions for scholars absorbed all the teaching of the arts, which continued to be given in them until the Revolution. This home for scholars was still a long way from the college of the ancien regime. However, it came closer to it in the course of the thirteenth century with the institutes founded by the mendicant orders for their members at the universities. According to the English historian Rashdall, the regular college may have done a great deal to suggest the idea of secular foundations of a more organic nature, such as began to appear in the middle of the thirteenth century. As far as the arts were concerned, they increased in number at the beginning of the fourteenth century. From then on it was no longer just a question of providing poor students with the means of living in a university town: it was also proposed to impose on them a way of life which would shield them against secular temptations, and they were submitted to a community life inspired by monastic practices and governed by perpetual statutes. For example, they were compelled to take their meals together, and sometimes to remain silent at table or to take part in exercises of devotion and piety. According to their statutes, which are extremely precise and detailed, at least about administration and moral and social conduct, these communities governed themselves under the distant and ineffectual control of the founder or of the person he had nominated to succeed him. They were managed in a very democratic fashion by one of the older scholars chosen by his fellows, usually from

among the theology students. Thus these foundations rescued the poor students, who otherwise had to live on charity, from the poverty and promiscuity of hospices and casual lodgings, and installed them within the bounds of an organized community with its own revenue, regulations and hierarchy. We can, of course, recognize in these communities the origins of the type of society which would later characterize the scholastic environment.

However, they still lacked three of the specific features of the modern college. In the first place, they were simply hostels or lodging-houses, and no instruction was given in them: the scholars went for their lessons to the traditional schools, the schools in the Rue du Fouarre. Secondly, these communities contained only a small number of scholars, whereas the colleges of the sixteenth, seventeenth and eighteenth centuries had a large academic population: it was a difference between a few dozen scholars and several hundred or even several thousand pupils. Finally, the system of self-government in these communities remained a long way from the authoritarian discipline which was imposed after the fifteenth century.

But now let us consider the stages by which the transition was made from the scholars' college of the thirteenth and fourteenth centuries to the college providing a 'full course' – the college in which there were masters to give lessons – of the sixteenth, seventeenth and eighteenth centuries.

In the course of the fourteenth and fifteenth centuries, the real exercise of education passed from the traditional schools of the Rue du Fouarre to the colleges which had begun as mere hostels for scholarship boys. The transfer started with the younger pupils, for whom it was made possible by the beginning of a graduation within the liberal arts in favour of grammar. There was a feeling – which began, rather timidly, towards the end of the thirteenth century – that grammar was a subject for beginners which ought to be finished with before starting on philosophy. For a long time academic jargon, in its stereotyped formulas, would go on combining grammar with logic. In the statutes of the choir-school of Notre-Dame, Gerson stipulated that the children were to be instructed *in grammaticalibus et logicalibus* although we know that this was a grammar school of the new sort. In fact the term most commonly used would be *parva logicalia*. The statutes of Seez College in 1450 stated that the scholars should already have received instruction *in grammaticalibus et in summulis et parvis logicalibus*. One can sense here the authorities' difficulty in accepting a gradation which had been hitherto unknown. Yet henceforth the tendency would be towards the specialization of grammar. In 1315

Navarre College, the most important of the Paris colleges before Louis-le-Grand, was, according to its foundation statutes, divided into three quite separate groups under the authority of three different masters. One group consisted of theologians, the second of logicians, the third of grammarians. This last group was directed by a *grammaticus* of good character and morals, assisted by a *submagister*, and he was given the task of instructing the children *in primitivis scientiae grammaticae* – grammar here being regarded and taught as an elementary subject. Thus, early in the fourteenth century, in Navarre College, there was an independent grammar school. Similarly in England, at Winchester (1379), next to a college of students of law, of the arts (logicians) and of theology, William of Wykeham founded a 'grammar school' with seventy scholarships.

In the text of Cardinal d'Estouteville's reformation of 1452, the specialization of the grammarians and their place in a new gradation of the curricula is very clearly specified. The reformer forbids the masters to allow their pupils to attend the *logicales lectiones* if they have not been sufficiently instructed in grammar and prosody (*in arte metrificandi*). Specialization in grammar led to the formation of a school for beginners, the Latin grammar school. In the allegorical iconography of the fifteenth century, grammar is depicted with younger children than are the other arts, and is armed with a whip or a birch.

It is probable that the lessons in elementary grammar were given first of all in private schools in the vicinity of the universities or the cathedral schools, by the same masters whom the canons or the universities authorized to teach the Donat. A statute of the University of Paris of 1276 prohibited lessons *in locis privatis*, except *in grammaticalibus et logicalibus* (by which we are to understand *parvis logicalibus*). These schools would grow and would not give instruction only in the rudiments of grammar. They would take their place in the Parisian university system to become pedagogicas or halls, which Cardinal d'Estouteville distinguishes from the colleges or foundations for scholars. Thus we have Maître Guillaume Verlet's pedagogica for instance, where *parvi scholares, tanquam in collegio, aluntur*. These pedagogicas were private, unendowed grammar schools, consisting of a master, his assistants and a number of day-boys. Only these institutions had no statutory existence.

A century later, the word 'pedagogica' had changed its meaning, and in the sixteenth century it no longer denoted a school in which lessons were provided, but a hall of residence which gave no instruction but sent its pupils for lessons in another college. This was because by the sixteenth century the pedagogica had joined an endowed college, introducing the 'complete course' of teaching to it if it did not already provide it.

The introduction of the teaching of grammar into the colleges took place in very different ways.

Generally speaking, the masters at private pedagogicas were senior scholars from the colleges, and they lived in the colleges. The grammar school therefore became a sort of annex of the college, for which no provision was made in the statutes. In Cardinal Lemoine College, founded in 1315, part of the premises was leased to a scholar who held classes there (see Jourdain, 1876). In this case, then, a college of scholars who were given no tuition was juxtaposed with a pedagogica providing tuition and installed in the college itself. The principal of the pedagogica assumed such importance in the life of the college that he laid claim to the office of Grand Master and used every possible means to obtain recognition of his authority. But it was only in 1647 that, as the result of arbitration, the Grand Master of the College was finally confirmed 'until the end of his days' in 'the principality and pedagogica of the college'. This is one example of the fusion of a private pedagogica with an endowed college which thereafter provided a 'complete course' of tuition.

Another case which was probably similar was that of Harcourt College (see Bouquet, 1891). Some seventeenth-century documents indicate that tuition in grammar was given there in the fourteenth century. According to an audited inventory of 1434–50, one of the college buildings was assigned to the school of the 'grammatists'. Some of the college's senior scholars kept the grammar school.

It could also happen that a free pedagogica – a pedagogica without any statutory resources – became a college as the result of an endowment or the foundation of a scholarship. Sainte-Barbe is an example of this. About 1450 a grammar teacher at Navarre College, M. Lenormant, together with his brother, founded a pedagogica in a building which he bought for the purpose: another instance of a college scholar – for the masters, principals, etc., were scholars on the same grounds as the students – who ran a private school. But Navarre College was worried about the competition and the Navarre theologians who governed the community raised difficulties. They tried to compel the Lenormant brothers to sleep in the college, in accordance with the statutes, so as to prevent them from supervising their pupils – which shows, incidentally, that these pedagogicas were also boarding schools. But the Lenormant brothers succeeded in keeping their independence. The pedagogica carried on a precarious existence, like that of a church school in present-day France, until 1576, when an endowment of fifty scholarships by the King of Portugal gave it the same stability as an endowed college.

It was not always the private pedagogica that introduced the 'complete

course' of tuition to the college. The statutes of certain fourteenth-century colleges, according to Du Boulay, suggest that they provided tuition from the start. Thus the statutes of Navarre College stipulate that a *grammaticus* and a *submagister* are to instruct the *juniores in primitivis scientiae grammaticae.* Similarly the statutes of Dormans-Beauvais College, founded in 1370 for the scholars of the district of Dormans (twelve in 1370, twenty-four in 1373), state that a master and an assistant master are to 'initiate the children in at least the elements of grammar'.

Tuition was therefore introduced into the communities of scholars by the grammarians, the *parvi scholares.* This tuition depended on a gradation of the curricula which itself corresponded to a differentiation of the ages : the little schoolboy was the first to be distinguished from the heteroclite academic population of the medieval university.

Instruction in philosophy and the sciences cannot have moved into the colleges as early as tuition in grammar did. In 1456 we still find references to 'regents' or form-masters taking their pupils to logic classes in the Rue du Fouarre : *regens habens proprios scolares quos continue ducat ad vicum straminis et quibus legat libros logicales.* There must have been a period in the late fourteenth century and part of the fifteenth century when logic was still taught in the schools in the Rue du Fouarre, while instruction in grammar was limited to the colleges and pedagogicas. This state of things, as we know, continued in England, with the first educational cycle in the grammar schools and the second cycle in the university colleges. In France, on the other hand, the logicians joined the grammarians in the colleges where private lessons were already beginning to supplement the logic lessons of the traditional schools, which were left with only the monopoly of the quadrivium and soon with only ethics.

At Cardinal Lemoine College, we can find traces of the beginnings of logic tuition. In the 1320 statutes – which make no mention of the grammarians, pupils of the private pedagogica attached to the college – it is stated that two scholars who are masters of arts are to give lessons in logic, and that two scholars who need not be masters are to give extraordinary lessons. The difference in grade between the tutors is interesting. The more highly qualified man taught logic, which seems to suggest that his tuition tended to be more comprehensive; on the other hand, the reader in physics and ethics was exempted from being a master of arts, doubtless because he had to take his pupils to receive tuition from the accredited masters of the Rue du Fouarre. Already we can see here the outline of a complete cycle of the arts.

At Navarre College, the logicians were grouped in a separate section, under the direction of a *magister in artibus* : at this time *in logico* and *in*

artibus had become synonymous. The statutes stipulated that no logician should attend the classes in the Rue du Fouarre before his determinance. Therefore tuition in logic must have been given in the college itself, until determinance, while tuition in physics and ethics was still confined to the Rue du Fouarre and was reserved for bachelors who were candidates for the mastership. Another example is provided by Seez College, a little foundation of six scholars dating from 1427. It was intended for boys of fifteen or over who had been at grammar school: *nullus recipiatur nisi sufficienter fuerit in grammaticalibus eruditus, et in summulis et parvis logicalibus.* This was a survival from the time when little grammarians and big logicians were still kept apart. There could be no question of providing tuition on the spot for such a small number of scholars. Were they to go then to the classes in the Rue du Fouarre? Not directly. They were first of all to go every day to the nearest college: *aedat paedagogium satis prope* (in this text 'pedagogica' is synonymous with 'college', and the founder uses the two words indiscriminately). But this college, which must have been comparatively crowded, did not entirely take the place of the schools in the Rue du Fouarre. It was assumed that the scholars' education would be sufficient to allow them to attend the classes in the Rue du Fouarre: *adeo quod ad vicum straminis eumdem ad audiendum libros sufficienter sit doctus.* However, if they went *ad vicum,* it was not alone and independently, but with their schoolmates from the college, *cum sociis pedagogii,* under the supervision of their principal, in accordance with the custom of the college: *juxta morem bursariorum dicti collegii.* They would attend the ordinary classes, the ethics classes on holidays, and the disputations. No doubt private lessons and disputations were also held in the college.

These examples enable us to understand how the teaching of logic was transferred to the colleges. First of all there were only private lessons, which did not take the place of the classes to which the pupils were taken under the supervision of their form-masters; then the tuition in logic was given in the college itself. The pupils still went to the Rue du Fouarre for certain disputations or for the classes in ethics which disappeared in their turn at the beginning of the sixteenth century.

The transfer took place all the more easily in that it was the senior scholars of the colleges who also taught in the Rue du Fouarre: in 1452 Cardinal d'Estouteville asked the form-masters of the colleges to go to the Rue du Fouarre to give their lessons as usual at the stated times. A text of 1456 mentions form-masters who not only took their pupils to the Rue du Fouarre but also lectured to them on the logic books. Despite the objections of the traditionalists, there would come a time when the form-

masters would consider it simpler to stay in college to give all their lessons there, thus avoiding excursions which provided the occasion for squabbles and brawls.

Étienne Pasquier has left us an excellent account of this evolution which installed in the colleges of Paris the teaching first of grammar, then of philosophy. He remembers that when the colleges were first founded the scholars attended the classes of the traditional schools: 'When their general rendezvous was at the great Schools in the Rue du Fouarre.' He recalls that though tuition was gradually transferred to the colleges, the Rue du Fouarre still retained a certain activity: 'Neither then [under the reign of Charles V] nor for a long time afterwards were the lessons discontinued which were given in the great Schools in the Rue du Fouarre, especially in philosophy in order to become a Master of Arts.' He recognizes that the transfer has begun with the youngest pupils and with the subject-matter that will henceforth be called the humanities: 'But as the lessons in Humanities had gradually moved into the colleges, those in Philosophy did the same, something of which Cardinal d'Estouteville complained in his reformation of our University . . . there being nothing left to us of this ancient institution save that the cap of Master of Arts is still given there.'

Thus in France the grammarians, that is to say the youngest pupils aged from eight to fifteen at the most, did not remain segregated from the philosophers, aged about fifteen. The latter were soon installed in the colleges, with the grammarians. As far as the age groups were concerned, the situation obtaining in the twelfth and thirteenth centuries seemed to have been restored, at least in the case of the shorter cycle of studies, that of John of Salisbury's Cornificius. However, if it had been restored, it had also been turned upside down. By that I mean that in the twelfth and thirteenth centuries, children of ten and boys of fifteen were mixed up with adults; in the fourteenth and fifteenth centuries, children and adolescents continued to study together but were separated from adults.

This separation of the ages existed only in the colleges. In the society of the same period, a boy aged between thirteen and fifteen was already a full-grown man and shared in the life of his elders, without causing any surprise. And this state of affairs was to continue for a long time. Thus the college was out of step with society, and at the same time ahead of it, and would gradually encourage a new sensibility.

The separation of the ages, in the colleges, combined in one and the same group children of about ten and adolescents of fifteen or so. Cardinal d'Estouteville grouped all the arts students together in the *regimen puerorum* – as if, the better to distinguish schoolboys from adults, it were

necessary to exaggerate the puerility of their characters, even of the oldest among them. We can see here the origins of a tendency which would become habitual for pedagogues and constitute one of the essential features of their professional psychology. Eventually, but not before the nineteenth century, it would spread to the parents. True, in the nineteenth century, when it triumphed, this tendency would also correspond to a secret desire to postpone the dreaded triumph of puberty. Any such idea of sexual morality was completely foreign to the reformers of the fifteenth and sixteenth centuries. But the desire to treat all pupils as very young children does not always spring from a sexual taboo, a puritanical impulse. On the contrary it precedes it: it seems in fact to be a manifestation of the modern idea of distinguishing the ages in a society in which they had become confused.

Tuition was now given in institutions which had originally been simply halls of residence: income from endowments or payment for board and lodging assured them of revenue and consequently of stability and permanence. What is more, the boarding-school system benefited from community life, from a discipline inspired by the example of the regular orders. The colleges and pedagogicas owed their success of course to their residential character. However, if the boarding-school was eminently suitable for a small number of clerks, it did not correspond to the sociological conditions of the time. Educational historians used to attribute excessive importance to it, misled by the fact that the only written documents which have come down to us – the college statutes – describe a boarding-school system, and that the only institutions which have survived stem from boarding-schools: the colleges for scholars. In fact, the boarding-school system merely gave the institution a financial and structural basis. The number of boarders remained absurdly small: particularly the number of scholars, the only one we know for certain. At Navarre, in 1304, there was provision for only twenty scholarships in grammar, thirty in arts and twenty in theology. At Dormans-Beauvais, twenty-four in grammar in 1373. At Harcourt College, twenty-eight in arts and twelve in theology in 1311. At Winchester, seventy in grammar in 1375. At other colleges there were only about a dozen scholarships and sometimes fewer than that. Admittedly the principals and form-masters had their private boarders, but they could not take in more than they could accommodate. These figures are insignificant in relation to the mass of Parisian students.

Are we to suppose that the day-boys remained faithful to the masters of the Rue du Fouarre? No, they too made their way to the colleges and pedagogicas, and with their numbers swamped the boarders on the foundation and the principal's boarders. The colleges, which were originally

boarding-schools, became huge day-schools in which masters taught immense numbers of pupils who lived where they could, and in which the boarders were reduced to an insignificant privileged minority.

The statutes of Dormans-Beauvais College give us an idea of the respective positions of the boarders and the day-boys in 1373. There were twenty-five scholarships financed by the foundation, and others were added later. It often happened that these scholarships, intended for poor pupils, were taken over at a price by well-to-do beneficiaries, who held them as they would a living, without receiving any tuition from the college. But the statutes also provided for other boarders apart from the scholars: 'If some good and respectable students, strangers to the college, wish to live in the college at their own expense with our scholars, under the authority of the Masters [it will be noticed that there is no question of tuition] . . . according to the custom of certain Paris colleges, we give permission for them to be admitted on condition that their admission does not inconvenience in any way the titular scholars, does not deprive them of their room, does not interfere with their usual way of life, and does not prejudice in any way the general order of the house.' Dormans-Beauvais was a college for grammarians, but its boarders could also study law or theology. All that was asked of them was that they should be students, and even this was not required of the priests. 'These extraneous students must pursue studies in theology, law, logic or grammar, or else they must be priests, and in that case they must celebrate Mass from time to time in chapel.' The statutes went on to fix the cost of their board and lodging and stipulated that they were to submit to the college regulations and in particular to eat at the common table. Thus they were not necessarily young boys wishing to attend the classes in grammar and to share in the material and moral advantages of the scholars' community. Indeed this sort of case must have been extremely rare, for most of the boarders were advanced students, or beneficiaries who lodged in the college as present-day students in Paris lodge in the Cité Universitaire. Living in the college, they would perhaps attend the Sorbonne classes, for example, the classes in the Faculty of Theology. There cannot at any time have been a great many of them: in 1496, there were eighteen, including one Benedictine monk.

The college still remained a community governed by a rule, and it was still regarded in that light at the beginning of the sixteenth century in the *familia pauperum studentium* of Standonc at Montaigu. It took some time for this original, pseudo-religious character to be finally effaced.

However, another article of the Dormans-Beauvais statutes authorized the extension of the college's tuition to day-boys. This does not mean that the founder had the definite intention of providing tuition for all and

sundry, as the Jesuits were to try to do in the late sixteenth century. He was merely authorizing the masters of the junior scholars, who were themselves senior scholars, to admit to their classes pupils who were not members of the college, and to charge them a fee: 'We also gladly permit the masters and assistant masters, present and to come [who taught in the college] to undertake the instruction of any good children who present themselves, and to admit them to our scholars' classes, on condition that these children stay in the college only during the day, and that they do not detract from the cleanliness of the house.' Thus these pupils from outside were forbidden to live in the college. Far from creating a boarding-school for grammarians, the tendency was rather to reduce the number of grammarian boarders to the scholars, and to exclude pupils from outside by preventing them from living in the college. This strange attitude was doubtless adopted for reasons of discipline, in order to preserve the clerical character of the community. In reality this prohibition was not strictly obeyed. A certain number of pupils were lodged with their form-masters, and these form-masters also lived in the college. Accordingly, boarders, masters and scholars inevitably lived together. The same confusion existed at Navarre, where furthermore some of the day-boys took their meals in the college and became day-boarders. In 1459, as a consequence of the inevitable incidents which punctuated the life of these societies of young people, a royal commission decided that the founder's intentions were no longer being respected and that the tranquillity of the community's life was being disturbed. Their attitude with regard to this educational institution was like that of the reformers of a religious community: another consequence of the ambiguous nature of the college. The commissioners therefore tried to exclude the form-masters' pupils from the college by forbidding the masters to lodge them with the scholars: this implies that previously boarders and scholars lived together. Similarly they confined partial board to those who lodged in the college or in the neighbouring house: a house which must have been hired by a master for his boarders. The idea of separating the scholars from the other pupils, an idea which we find again in the statutes of the poor students of Standonc at Montaigu, more or less disappeared from France, in the face of the massive invasion of the day-boys, who were soon to be numbered not in dozens but in hundreds and then thousands. Tolerated at first as pupils, attending the senior scholars' classes, *they became the principal element of the academic population of the colleges*: they completely swamped the colleges, which, from the end of the fifteenth century at least, became to all intents and purposes big day-schools. It was the day-boys who, together with the provision of full teaching facilities, gave the college, once a

scholars' foundation, the character of a modern educational establishment.

Henceforth the college embraced the whole scholastic population in the arts. Where it did not exist, in the non-university towns, the big cathedral school of the Middle Ages changed to follow its example, and city magistrates copied it in the foundations they created in the fifteenth and sixteenth centuries. This in fact was the time when academic education ceased to be limited to cultured clerical circles, and families got into the habit of sending their children to a college for at least a few years. The development of the day-boy system removed a great deal of the monastic spirit which had inspired the college's origins and which would be replaced by a more authoritarian discipline.

This crowd of day-boys could just as well have simply attended the form-masters' classes and taken no part in the life of the college. These students would have retained in college the same freedom that their elders had once enjoyed in the schools. This was in fact what first happened: to the end of the sixteenth century there were complaints about the 'martinets' or 'old fogies' (*galoches*) who, as Pasquier puts it, 'go to the classes of one Regent or another as the fancy takes them'. This is how Buchanan describes their noisy entrance into a classroom: 'Here come the bands of idlers that the town has sent us; their arrival is heralded by the clatter of their hobnailed pattens. They come in and open ears as intelligent as those with which Marsyas listened to Apollo. They are annoyed at not having seen notices of the classes posted up at the street corners [the reaction of a big student, such as would still be met with in the thirteenth and fourteenth centuries], furious that the lesson is not being devoted to Alexandre's *Doctrinal* [Alexandre de Villedieu], and shocked by a master who does not read out of a bulky book loaded with marginal glosses [they are wedded to tradition and suspicious of the new methods of the humanist masters]. They get up and go off in an uproar to Montaigu or some of those sanctuaries scented with the perfume of white beet.' These gyrovagous students did not disappear completely until the early sixteenth century. However, in the fifteenth and sixteenth centuries, though there might be some left, perhaps even a good many, they were no longer accepted by public opinion. The university authorities tried to suppress them or discipline them, either by keeping a check on their lodgings or by forbidding them to change masters in the course of the year. These prohibitions were anything but new, and their repetition tended to confirm their ineffectiveness. They would not be obeyed until public opinion refused to tolerate such independence on the part of the students. The authorities then took to compelling the students, that is to say the dayboys, not

only to attend the classes but also to take part in all the college activities.

We have seen that the scholars of Seez used to go to the nearest college. They could have gone there simply for classes or private lessons. But the statutes insisted that they be present in the college and given tuition all through the day: *omni die*. This custom became established everywhere, because the superiority of the college, in the eyes of parents and pedagogues alike, lay above all in the regulations which governed it. Thus Gerson, one of the first modern educationalists, stated explicitly when he was reorganizing the grammar school of Notre-Dame de Paris: 'Above all we want the children to have regulations *sicut habent communiter in domibus paedagorum*' – that is to say, not only in the colleges but in all the grammar schools. Submission to collective regulations had become an essential educational principle. The rules formulated in the early fourteenth century by the founders of the scholars' communities no longer satisfied the strict requirements of fifteenth-century pedagogues such as Gerson. The older statutes, which for a long time were copied and reproduced, fixed the details of the administration, the number and the duration of the scholarships: at Cardinal Lemoine, eight years for the artists and ten for the theologians. The statutes also prescribed the appointment of the dignitaries: at Navarre, the three masters of the grammarians, logicians and theologians were elected by an electoral college composed of student delegates (three grammarians, six artists and six theologians); at Seez the bursar was elected for one or two years by the whole community. Also arranged by the statutes was the administration of the chapel and the household, and particularly of the stewardship, an office which was not permanently entrusted to one person, but which each scholar in turn occupied for a week – he was called the *praepositus* – handing over the keys and accounts to the scholar who succeeded him.

These statutes endeavoured to regulate the life of the scholars and to sanction it with a penal code: it was forbidden to go drinking in taverns or to visit places of ill repute; forbidden to sleep out, to make a din, to play noisy games, to sing; and forbidden to bring women into college 'unless [states a reservation at Harcourt] they are so respectably escorted that the Prior of the house and the scholars are convinced that no evil suspicion can result'.

At Seez it was even explicitly forbidden to have carnal knowledge of a woman who might have been brought into the college on the pretext of providing water or lighting fires. It was forbidden to go out without good reason: *nisi causa lectionis, sermonis* (the sermon was a method of instruction, like the lesson, especially for the theologians), *aut praepositurae* (i.e. on an errand for the steward or the bursar). It was forbidden to damage

the kitchen utensils or the property of the community, particularly the library of manuscripts. At Harcourt, 'let nobody deposit refuse at the foot of the walls of the house, but only in the place provided for that purpose.' At Narbonne, it was forbidden to throw straw or hay into the latrines. 'All members of the college' or of the 'household' were urged to dress decently, especially for mealtimes: they were to take care not to go barefoot, not to stay in rags, and not to put on short or indecent clothes. Above all – and this was the essential principle on which the whole of this code of behaviour was based – they were to live together in friendship, *amicaliter*, and consequently to respect the customs of community life, especially the meals in common – always being punctual, not bringing in guests too often, and never bringing in women, even if they were respectable. At Narbonne: 'There shall be no separate table in the house, and all are to eat in the same room.' Horseplay was to be avoided and respect was to be shown to the senior scholars and graduates. None of these regulations had any reference to the scholar's academic condition, except for an occasional mention of the obligation to speak Latin at table – when silence was not imposed. None of these regulations concerned the scholar's studies. Moreover they were inspired by religious constitutions which applied to adults, and therefore by their very nature they made no distinction between grown men and children. If, in the thirteenth and fourteenth centuries, they represented a considerable advance on the almost unlimited freedom of the student population, by treating the students more or less as monks, they remained too egalitarian, too inadequately hierarchized for the needs of the fifteenth century. They were therefore modified by custom and given a more authoritarian bias: a chain of command was established. The *lectores* had at first been regarded as friends, whom certain statutes admittedly urged the scholars to respect, but who were often treated to a copious meal, or more economically to a drink: the drink of friendship, *potum amicabilem*, is what the official charter of Harcourt College calls it. Henceforth the gap between the teacher and his pupils would widen. The oldest schoolmate would become the formmaster who would govern his people with cane or birch. Similarly the college would no longer be administered simply by a bursar chosen by his peers, a *primus inter pares*. It would also be governed from above by a principal, who would have the 'principality'. This master chose his formmasters and supervised them, while they in turn supervised and punished their pupils.

The new regulations, such as those of the *familia pauperum studentium* at Montaigu in 1501, were no longer content with fixing the general conditions of the college's life. They went into the details of everyday life and

carefully laid down a daily routine. Standonc even gave a time-table for the whole day, from morning to night, with as much precision as the habits of the time allowed. And this precision, which strikes us as only approximate, with obvious gaps here and there, was quite remarkable and almost revolutionary for the time. It introduced a new concern for time, and enmeshed the pupil in a network of obligations which covered the whole day and reduced his initiative. Reveille was fixed at about (*circa*) four o'clock. Then there was a lesson until Mass at six o'clock: the text informs us that these movements were governed by a bell. Standonc describes the order of assembly: when the bell rang, the pupils went down *ad publica loca*, to the classrooms. The form-master came in. The monitors assisting him inspected the pupils and made a note of any absentees and delinquents. Everything here is provided for with a strictness unknown to the old statutes. After Mass, from about eight to ten, there was a lesson, the big morning lesson (it was customary to have one big lesson in the morning and another in the afternoon). At eleven o'clock the community gathered together in the refectory for dinner. At three o'clock the big afternoon lesson began and went on till six o'clock.

A similar time-table was in force at Sainte-Barbe at the same period. The colleges of the ancien regime kept to roughly the same system until the Revolution.

This is the way the change took place from regulations laying down the basic principles of a code of behaviour and a way of life to regulations dictating the manner in which every part of the day was to be occupied, from a collegiate administration to an authoritarian system, from a community of masters and pupils to the strict government of pupils by masters.

This separation of masters and pupils, this progress made by the spirit of authority, conflicted with the old traditions based on the first statutes. But the evolution corresponded to the general movement of society, which was carrying it towards the political forms of absolutism that were taking shape in the fifteenth century, in the time of Louis XI, Commines and Machiavelli. It would reach its final consummation when the masters were recruited from a religious community and were thus naturally separated from the pupils, and when the government of the college coincided with the government of the masters' religious community, *a fortiori* if this teaching order was particularly concerned to develop the spirit of obedience and gave the age-old principles of discipline a new character of semi-military efficiency.

This development took place with the Jesuits, at the end of the sixteenth century, and their *ratio studiorum*, the rule governing their colleges, marks the culmination of the evolution towards an authoritarian system and the

segregation of the young – though the segregation was not so complete as it would be in the nineteenth and early twentieth centuries. In these last years of the sixteenth century, an important stage was reached. The success of the Jesuit colleges was due to the same factor that ensured the success of the scholars' communities in the early fourteenth century: the existence of a rule, the Jesuits' rule being the stricter and more effective of the two. Just as the first colleges had taken over the tuition given by the schools, the Jesuit colleges absorbed the middle-class and even the lower-class clientele, and their success, due to the strictness of their discipline, threatened the colleges of the university, where respect for the old statutes, even when they had been improved on in practice, maintained an excessive liberty which was now regarded as licence.

As a result, in order to fight against the victorious competition of the Jesuits, the University of Paris reformed itself in the first years of the seventeenth century (see Jourdain, 1862). The object of this reformation was to give all the old colleges of the university the principles of order and discipline which parents admired in the Jesuit colleges and no longer found to a sufficient degree, to a degree corresponding to the new exigencies of French manners, in the university. These *leges et instituta in usum academiae et Universitatis parisiensis* were a plagiarization of the regulations adopted in the Jesuit colleges, just as the latter were the result of an evolution of which Standonc's statute at Montaigu or the statute of the Frères de la Vie Commune at Liège marked one of the stages. With this document the Paris colleges received what their statutes had failed to give them: a code of studies and a code of discipline, *un règlement de discipline*. We find this new and significant expression, which made its appearance in the seventeenth century, applied to the Collège de Bourgogne in 1680. A previous code of regulations for this college had been drawn up in 1624. In these regulations of 1624 certain paragraphs still recall the particularistic spirit of the old fourteenth-century statutes: for instance it is stipulated that the principal has no right to appoint the porter without the agreement of the first chaplain 'as co-administrator', or even of the community of scholars (it is true that the college had only higher classes in logic and physics). It was not so easy to suppress what remained of the traditions handed down from the thirteenth century, and it took time for the reformation of 1598 to penetrate the old-established colleges in which a good many abuses had taken root: for example the habit of regarding scholarships as saleable pensions. As much time, in fact, as it took for the spirit of the Council of Trent to penetrate the religious communities, at the price of serious monastic upheavals. We must regard the text of 1624 as the reformation of this particular college, a means of introducing into the

college the spirit of the 1598 laws and statutes of the University of Paris and overcoming the opposition which these were encountering. It was aimed simply at putting the college in order and suppressing certain abuses. This reformation must have been successful, for it was followed – though not until 1680 – by a 'code of discipline' which established a strict time-table for the boarders, a time-table which was very similar to that in force at Montaigu or at Cardinal Lemoine, and which we also find in the late sixteenth century in the Jesuit colleges. It is interesting to note that, in the matter of school hours, the code of discipline simply refers to the practice adopted in the colleges of the University of Paris ever since 1598, thus affording proof that it was now the general rule: 'School will begin at the same time as the University.' The 1598 reformation thus prescribed for the colleges, whatever their origins or their statutes, a scholastic code and a time-table. This does not mean that it violated the old statutes, which remained in force despite their antiquity, but which contained no detailed provisions such as the university authorities now laid down – on the pattern of the Jesuits' *ratio studiorum*. In other words the 1598 reformation completed the statutes by adding to them a code of discipline.

The 1598 text briefly recapitulates the traditional prescriptions – the ban on swearing, on fighting, the meals at the common table, and so on – without dwelling on them. It then tackles the real questions of discipline: the system of punishments, and the immobilization of the pupil, who is no longer free to change his master in order to avoid a punishment. Above all it lays down regulations regarding the order of studies, the intermediate examinations, the times for recreation, the supervision of pupils in school and out of school, the checking of attendances, the principal's authority, the curricula and the time-tables: six hours' tuition every day in the class-rooms – *in auditoriis*, three in the morning, three in the afternoon. In addition, every day at ten o'clock in the morning and at five o'clock in the afternoon there was an exercise in disputation or versification. Every Saturday there was a recapitulation and the weekly presentation of the marks to the principal.

Both in the Jesuit colleges and in the old-established, newly reformed colleges of the university, a formula had now been perfected, a formula which would remain unchanged for nearly two centuries, to be copied by other teaching communities such as the Oratorians. This was the college of the ancien regime, an institution still further removed from first scholars' colleges of the fourteenth century than from the French colleges and *lycées* of the present day, of which it is the direct ancestor, in spite of obvious differences (particularly the absence of the boarding-school system). The final establishment of a code of discipline completed an evolu-

tion which led from the medieval school, a mere classroom, to the modern college, a complex institution, designed not only for the tuition but also for the supervision and care of youth.

This evolution of the educational institution is bound up with a parallel evolution of the concepts of age and childhood. To begin with, public opinion had no difficulty in accepting the mixing of the ages. Later occurred a certain revulsion in this respect, first of all in favour of the youngest children. The little grammarians were the first to be distinguished for special attention; subsequently, the older pupils, the logicians, the physicians and all the artists, even though the age of some of them would have allowed them, out of school, to carry out already the functions reserved for adults. Yet there was no attempt to apply to them, in order to distinguish them from adults, a genuinely juvenile system of education, of which indeed there was no example to follow. All that was intended was to protect them from the temptations of secular life, a life which many clerks led too: to safeguard their morals. The pedagogues therefore took as their model the spirit of the thirteenth-century monastic foundations of the Dominicans and the Franciscans, which retained the principles of the monastic tradition while abandoning enclosure, reclusion and all that remained of the cenobitism of old. Admittedly the students were not bound by any vow. But they were submitted during the period of their studies to the *way of life* peculiar to these new communities. Thanks to this way of life, student youth was set apart from the rest of society, which remained faithful to the mixing of the ages, as also to the mixing of the sexes and the classes. Such was the situation in the fourteenth century.

Later, the object of this way of life, half-way between secular life and monastic life, altered. At first it had been regarded as a means of ensuring that a young cleric led a decent life. It now assumed an intrinsic value, and became the necessary condition of a good education, even for a layman. The idea was foreign to the concepts of the early fourteenth century. But in 1452 we find Cardinal d'Estouteville speaking of the *regimen puerorum* and the moral responsibilities of the masters in charge of souls. It was a matter of 'forming' the pupil as much as of instructing him, which was why it was thought necessary to submit schoolchildren to a strict discipline: the traditional college discipline, but made more authoritarian and hierarchical. The college now became an instrument for the education of children and youth in general.

At the same time, in the fifteenth century and still more in the sixteenth, the college altered and enlarged its recruitment. Formerly composed of a small minority of scholarly clerics, it opened its doors to an increasing number of laymen, chiefly from the nobility and the middle class, but also

from lower-class families. It thus became an essential social institution: the college with a separate teaching staff, a strict code of discipline, and large classes, in which the educated people of every generation under the ancien regime received their schooling. In the opinion of pedagogues, parents, monks and magistrates, the college constituted a massive age group, ranging from pupils of eight or nine to those of fifteen or over, who were submitted to different laws from those governing adults.

Chapter 8
The Origins of the School Class

In the everyday language of our contemporaries, at least of those connected with secondary education, public or private, the class or form is the essential unit which characterizes the situation of the child or youth. A man does not say that his son is at college or *lycée*, this being too vague a statement: he says that he is in the fifth form. The children themselves refer to their place in their everyday world by the class to which they belong. There is no more familiar notion nowadays, and it is so familiar that we tend to think that it is a very old notion, as old as the college itself and secondary education as a whole. But this structure, without which it is hard to imagine school life, dates back no further than the sixteenth or late fifteenth century, and did not assume its final form until the beginning of the seventeenth.

No doubt the ancients were not completely ignorant of the distribution of pupils in classes. The word 'class' itself, which was adopted in various countries, and particularly in the Jesuit sphere of influence, was taken by the humanists from Quintilian – *pueros in classes distribuere* – and those authors who used it knew its origins; witness Étienne Pasquier, who in his brief history of education writes of the 'class': 'Word used by Quintilian in the first book of his *Institutio* with regard to Pupils.' However, in the ancient school, division into classes remained a superficial disciplinary practice. H. I. Marrou wrote a bulky volume on the history of education in ancient times without mentioning classes once – proof enough that they scarcely counted in the structure of the school. Moreover, the few which might have existed in Quintilian's time disappeared in the Middle Ages, when the principles of simultaneity and repetition resulted in constant mixing and prevented any attempt at separating children according to age or capacity.

Today the class, the constituent cell of the school structure, presents certain precise characteristics which are entirely familiar: it corresponds to a stage in the progressive acquisition of knowledge (to a curriculum), to an average age from which every attempt is made not to depart, to a physical, spatial unit, for each age group and subject group has its special premises (and the very word 'class' denotes both the container and the

contents), and to a period of time, an annual period at the end of which the class's complement changes.

The extremely close connection between the age of the pupils and the organic structure which gathers them together gives each year a personality of its own: the child has the same age as his class, and each class acquires from its curriculum, its classroom and its master a distinctive complexion. The result is a striking differentiation between age groups which are really quite close together. The child changes his age every year at the same time as he changes his class. In the past, the span of life and childhood was not cut up into such thin slices. The school class has thus become a determining factor in the process of differentiating the ages of childhood and early adolescence. Where it does not exist, or where it is reduced to a vague division with no structural value, as is still often the case in the primary school and consequently in the lower classes of society, the ages have kept a great deal of their former uncertainty.

Hence the importance of the school class for our subject. We have to consider how it developed from medieval vagueness to the strictness of the modern concept, how and when the school class acquired its present-day appearance of an age-class.

The reformation of the University of Paris of 1452 by Cardinal d'Estouteville, so important for the study of the colleges and pedagogicas, ignored the existence of classes. This silence does not mean that they were entirely unknown; but pedagogues as well-informed as Cardinal d'Estouteville, though familiar with new institutions such as the college, considered it useless to record details of pedagogical practice and *a fortiori*, to impose and codify them.

But less than a century later the modern word 'class' made its appearance, not in 1539 as historians have been in the habit of repeating ever since Thurot, but as early as 1519, in the letter from Erasmus to Justin Jonas in which the humanist described St Paul's School in London: every class, he wrote, had sixteen pupils – *quaeque classis* – and the first in his class occupied a little seat which dominated the rest – *qui in sua classe*. The idea had preceded the word by a long margin, and it was already familiar when the terminology was established. At the end of the sixteenth century, in the Jesuits' *ratio studiorum* and the *leges et statuta* of the University of Paris, the cycle of classes had acquired its present-day periodicity. The evolution had therefore taken place during the fifteenth century, and at the beginning of the sixteenth century, in the colleges providing a full course of tuition.

Like the complete course of tuition, the class originated in the grammar schools: that is why the enumeration of the classes began with the rhetoric

class (the first class in France, the seventh form in England), while the classes in philosophy, logic and physics remained outside this reckoning.

At the beginning of the fifteenth century, the *grammaticus* and his assistant, if he had one, gave instruction together on the same premises to several dozen or several hundred children, all mingled together in spite of the difference in their ages. In the course of the fifteenth century a new distinguishing principle appeared. The heterogeneous body remained in a single room under the common supervision of the masters, but it was broken up into groups according to the extent of the pupils' knowledge, and the masters got into the habit of addressing each of these groups separately. This pedagogic practice was the result of the passage – an incomplete passage – from the simultaneous pedagogy of medieval tradition to the progressive pedagogy which would carry the day.

The order of this division, as yet in a very embryonic stage, was dictated by the succession of the chapters in the Donat or in Alexandre de Villedieu's *Doctrinal*, the basis of all instruction in grammar. An Italian document of 1444 (Serena, republished in 1912) gives us an idea of how a school was organized at that time. The contract entered into between the town of Treviso and its schoolmaster fixes the scale of remuneration for the latter, and it can be seen that this remuneration varies according to the pupil's degree of attainment. The document provides for four categories. The first goes from the Table (i.e. the alphabet) to the beginning of the Donat: this is elementary stuff, and worth half a ducat. The second goes from the beginning of the Donat, or of grammar, to the beginning of the Articles: these are the first four chapters of the *Doctrinal* – the declensions, the degrees of comparison, the genders, and the demonstrative and possessive adjectives – and this category is worth a ducat. The third category, which brings in a ducat and a half, finishes grammar. The fourth category, worth two ducats, is devoted to stylistic exercises or rhetoric. This text explains the division to us only because it fixes the schoolmaster's pay. Cardinal d'Estouteville's silence with regard to the class can therefore also be explained by the fact that in a document on the general aspects of discipline he could not be expected to go into the details of salaries.

In this division, which must have already become traditional, we can see the distant origins of our cycle of classes. There is a connection between the four categories at Treviso and those class curricula which we know, such as Melanchthon's at Basle (Bourchemin, 1882) and Baduel's at Nîmes (see Gaufrès, 1880) in the first third of the sixteenth century, or again, at the end of the same century, the curricula adopted by Narbonne College in Paris when it started a complete course of tuition in 1599.

The first category at Treviso corresponded to the lowest of the four classes at Basle, to the sixth at Nîmes. In 1599 at Narbonne College the youngest pupils already knew the rudiments of grammar, or were supposed to know them.

The second category at Treviso corresponded to the fifth at Nîmes, the sixth at Narbonne: in half a century, the rudiments had been pushed back beyond the sixth class.

The third category at Treviso corresponded to the two intermediary classes at Basle, to the fourth and third at Nîmes, and to the fifth, fourth and third at Narbonne.

Finally, the last category at Treviso corresponded to the highest class at Basle, to the second and first at Nîmes, and to the first at Narbonne, where, curiously enough, the second was missing.

However, there was a difference between the subdivision of the Treviso school and the classes which resulted from it. The subdivision was entirely empirical and depended on the master, even if certain traditions were beginning to impose themselves. For a long time to come, this uncertainty would continue, and the curricula and the order of the classes would vary from one college to the next: thus at Guyenne and Navarre there was a proliferation of little classes, and at Narbonne there was no second class. In the last years of the sixteenth century, a Montpellier student, Thomas Platter, visiting Tournon would write from the college: 'It has about eight classes.' About! It was only gradually that the class became the constituent element of a regular cycle, adopted by schools over the whole area of Western civilization. First of all it had to receive a name of its own. In 1466 Michault gave a description of the school, no doubt touched up for the purposes of his allegory, but based on reality. He has no name, or at least no French name, to denote the '*parquet* of little benches filled with pupils' surrounding each master's chair,[1] and the parquet is clearly a class: 'in this parquet the cases are declined', 'the regent in this second parquet'. However, in 1477 we find the Latin expression *lectio* being used in a sense which might well be that of the school class: *in prato clericorum ubi lectio contra lectionem insurgere solebat*. This does not appear to be a case of one college competing with another, school against school.

By 1501 the word *lectio* had imposed itself on Parisian usage. In the statutes of the new Montaigu College it denoted an organic unit. These statutes stipulated that in every *lectio* one of the best behaved pupils

1. See also the picture of a single schoolroom with two rostra facing one another with the pupils sitting round them in two groups (*Statutenbuch des Collegium Sapientiae*, P. Morgen Library.

should supervise *caeteros suae lectionis*. A head monitor should be chosen by the *suprema artium lectione*, which incidentally means that the arts themselves, logic and physics, were divided, at least at Montaigu, into *lectiones*. The statutes also tell us that each *lectio* had its own *excitator*. Thus it is clear that Montaigu College was divided into *lectiones*, although the statutes, which fix the time-table in some detail, do not specify their number or composition. The drafters of statutes no longer passed over in silence the division into *lectiones*: they now referred to it as to a commonplace, familiar idea.

The word *lectio* would soon be dropped in France in favour of the modern term 'class'. We have already seen this term being used by Erasmus in 1519. It was introduced by the humanists who were fond of borrowing from the ancients (in this case from Quintilian) terms that were unknown in medieval Latin. Protestant humanists such as Baduel and Sturm, founders of model colleges, used it in their turn, and their texts of 1538 and 1539 are generally regarded as the first examples of the modern use of the word 'class' in the sense of a school class. The Jesuits and the University of Paris were to adopt it in their turn. Thus the fifteenth-century *lectio* became the late sixteenth-century class.

After being equipped with a name of its own, the class would go on to be recognized by the pedagogical theoreticians as the essential element of any educational organization. For example, Baduel's biographer, Gaufrès (1880), has analysed the prospectus which Baduel published in 1538 for the establishment at Nîmes of a 'college, school and university in all the faculties of the Grammars and the Arts alone'. In this prospectus Baduel points out that the division into classes is indispensable for the proper organization of the school: hitherto 'everything had been mixed up and confused'. Henceforth, 'the school will be divided into various classes according to the age and development of the pupils.' At the same time Sturm was introducing this system to Strasbourg; the system was already in force in the Paris colleges and in the houses of the Frères de la Vie Commune, at Saint-Jérôme de Liége, from which Standonc of Montaigu and Sturm of Strasbourg hailed.

However, Baduel did not consider that this system could be applied beyond the teaching of grammar. After the rhetoric class, he writes, the pupil 'attends the public lessons and initiates himself in the higher sciences and the arts', in accordance with the humanist idea that study was no longer reserved for youth but could be prolonged late into life. Therefore, 'his studies are less organized and cease to be divided into different classes'. We find the same distinction between studies pursued in classes and studies pursued in lectures in Sturm's curriculum at Strasbourg:

here there are six classes corresponding to the four classes in grammar, the humanities class and the rhetoric class (Baduel had the same plan in theory, but in fact his pupils started straight away in the fourth class). 'After that,' writes Sturm, 'the second is reserved for public lessons [lectures after the humanities fashion] and the first for theology.' It will be noticed that Sturm does not use the numbering after the rhetoric class which was already used in Paris and which has continued to be used in France to the present day.

Like Baduel and the humanists, Sturm made a distinction between the classes reserved for the school population up to the age of fifteen or so, and the higher instruction, given in the form of public lectures and open to adults. If things had been left like this, it is probable that only the subjects taught in class would have remained, as in England, where schooling stopped with the seventh form or rhetoric class. Père de Dainville rightly maintains that the extension of the class system to logic, physics and sometimes theology was the work of the French Jesuits who wanted to keep alive a scholasticism revived by their Spanish colleagues, and so to save it from humanist criticism.

Thus, in the second half of the sixteenth century, the modern French cycle going from the sixth or fifth class to the first class, completed by philosophy, was finally established, at the end of an evolution of about a hundred and fifty years.

For a long time the Italian school retained the form described in the mid-fifteenth century contract at Treviso. As late as the sixteenth century Rapinius, in his advice regarding the establishment of a college at Venice, merely assigned separate places to children, adolescents and adults. If in other schools the class, from being the mere subdivision of a single auditorium, became an organic unit, that was thanks to the master who was in charge of it.

At first the grammar schools had one or two masters. When there were two of them, one was called the *grammaticus,* and the other the *submagister* (in English the high master and the usher). Often the *submagister* had to look after the youngest and the most ignorant pupils, to whom he taught the rudiments of grammar, while the *grammaticus* kept the higher range of schooling for himself. However, this specialization did not go far, and did not represent the whole of the two masters' responsibilities. In the fifteenth century, in the cathedral school of Paris, Gerson (1706) for all that he seemed to recognize that the two masters specialized respectively in grammar and singing, none the less charged them with a collective mission: *ambo taliter ordinent horas diurnas et nocturnas.*

John Colet's school, the cathedral school of St Paul's in London, gives

us some idea of the way in which the master and his assistant were led to share the classes between them. We know this school from different texts, in particular from the letter from Erasmus to Justin Jonas quoted above. We know too that this school took in one hundred and fifty-three free pupils. According to Erasmus they were divided into three classes. The first was reserved for the beginners, whom Erasmus compares to cate-chimens – as yet they did not really form part of the school. They were entrusted to the chaplain. We know of other cases where it was the porter who taught the rudiments of grammar: for instance at Gray in 1583, reported by Godard in 1887. The second class was in the care of the usher: Erasmus calls him the *hypodidascalus*, a word taken from Cicero's letters. The third was reserved for the master, whom Erasmus calls the *Superior*. Thus the two masters whom we found in charge of the grammar school when it came into being in the fourteenth century had arrogated two classes to themselves. A little extra teaching had been allotted to the chaplain, whose office already existed, as in all teaching communities, and thus the need to create a third master's post had been avoided.

The English grammar schools in fact hesitated for a long time to increase the number of masters. In 1560 there were still only two masters at Eton – the master and the usher – who shared between them not two classes but two groups of several classes. The usher's lower school consisted of the first three forms, the master's upper school of the fifth, sixth and seventh forms: a survival of the first period of the history of the school cycle, with its division into two parts, outmoded by the multiplication of classes in the sixteenth century. The fourth form, the last grammar class, corresponding to the third class in France, had lessons now from the master, now from the usher, in any case probably in the same room. The master entrusted each individual form to a monitor chosen from the pupils in that form.

In France the specialization of the masters and the increase in their numbers began much earlier, at least in the more important schools. This can be seen from a study of Père Michault's *Doctrinal du Temps Présent*, a work published in 1466. We have already seen that the *Doctrinale puerorum* was the grammar used in the Middle Ages. From the thirteenth century on, moralists gave the classic form of the *Doctrinal* to allegorical manuals, 'breviaries' of etiquette or 'good living' or plain didactic treatises (*Doctrinal de nature*, *Doctrinal de simples gens*, *Doctrinal de la messe*, *Doctrina des chambriers ou de noblesse*, Gerson's *Donatus moralisatus*, etc.).

In his *Doctrinal du Temps Présent*, Michault imagines two schools, that of Vice or Falsity and that of Virtue, in which instruction is given on life.

Thus the school of Falsity has twelve masters (as many masters as there are chapters in Alexandre de Villedieu's *Doctrinal* and months in the year), and each master symbolizes a vice: Boasting, Vainglory, Rapine, etc. While we cannot take an allegorical description of this sort literally, we must assume a basic likeness without which the allegory would have been incomprehensible. In this school 'there were thirteen masters; to wit a rector general and twelve subalterns.' Obviously we have a round dozen here simply to make possible twelve moral discourses. Moreover the school of Virtue has the more usual number of four masters. What we should note above all here is the hierarchy of the rector and the master, which we have already seen in the almost contemporary document to which we have often referred: Cardinal d'Estouteville's reformation of the University of Paris. Here in fact we have a college or a pedagogica with its authoritarian hierarchy.

A text of 1539, the curriculum for Sturm's *gymnasium* at Strasbourg, tells how it was found necessary at Saint-Jérôme de Liége, to impose the authority of a rector on masters who had hitherto been free. Originally 'each master tried to attract the pupils, teaching not what was best but what gave the more pleasure, and consulting not so much the students' minds as their tastes'. These masters 'read from authors above the age of their pupils, even when these readings could prove harmful to morals and judgment'. An authority accordingly had to be imposed on these excessively independent masters: 'It was in order to counter these drawbacks that a rector was appointed, and all the lessons, exercises and studies placed under his control.' But the school of Falsity already had a rector in 1466.

In this school every master had his own class or *lectio*: 'At the door there was a Porter who scarcely glanced at those who entered ... At the foot of every pillar there was a *parquet* of little benches filled with pupils. And at the top of the pillar there hung a board describing the subject which was being read in that spot.'

In the humbler schools, a single master looked after several classes, as at Eton in the sixteenth century. Even in the seventeenth century, when the class system had been finally established, in the school in the little town of Belley three masters shared the six traditional classes between them: one taking the rhetoric and humanities classes, another the fourth and third, another the fifth and sixth (see Rochet, 1898). Curiously enough, these three masters were not under a higher authority, but formed as it were three associated schools, financed by grants from three different sources: the tutorial prebend, the town magistrate and the provincial States.

But in France, from the end of the sixteenth century on, the principle of a master to every class was generally recognized – even if this sometimes meant that not all the classes were in one college, if it was not big enough. The principle was so thoroughly recognized at the end of the sixteenth century that a practice which was introduced at that time had to be forbidden: the practice of having not one master for several classes but two masters for one class; in other words the same class was sometimes entrusted to two masters, one for the morning lesson, the other for the evening lesson (Jourdain, 1866). As early as 1539 we find Sturm insisting in his curriculum that the first six classes at Strasbourg (corresponding to the cycle from the sixth class to the rhetoric class) must have only one master apiece. On the other hand he gives permission for recourse to the authority of several specialists for the subjects taught in the public lectures on philosophy and theology.

The class now had its master. It still lacked one feature which would bring it closer to the class in our present-day schools: special premises.

For a long time the masters and their *lectiones* were gathered together in a single room, which was called the *schola*. There was only one teaching room in each school, and people used the same word for both room and institution, as they would later with the class. This was the case in Père Michault's school of Falsity: 'The school was inordinantly big and there were twelve pillars down the length of it.' The pupils sat around their master 'at the foot of each pillar'. The school of Virtue was 'round', as St Paul's School would be later, 'and there were four big chairs there ... which were placed against the walls of the school, like a quadrangle.'

In London, according to Erasmus, St Paul's School was a single round room, with a floor in tiers on which the pupils sat. Erasmus explains that this circular arrangement was designed to prevent beds and tables being installed in the corners, practices which were doubtless current in the school of the time. This room was divided into four parts – that is to say the three classrooms and a sort of chapel with an altar – by curtains which could be opened or drawn at will: a sign of a penchant for isolation which did not go as far as complete separation. The custom of setting up an altar in the classroom lasted a long time: it was still observed in the eighteenth century in the little college at Mauriac described by Marmontel. At Eton in 1517 there was still only one schoolroom. About the same time the Swiss Thomas Platter (the elder) was leading the vagabond life of a mendicant student in Germany. He stopped for some time at a grammar school in Breslau (there was one in each parish). He slept in the schoolroom with the youngest of his companions, which was doubtless what John Colet of St Paul's wished to prevent. This is Platter's description of

St Elizabeth's School: 'Nine *baccalaurii* gave their lessons there at the same hour and in the same room.' With nine *baccalaurii* we are not far from the twelve masters in the school of Falsity: it is easy to imagine the din there must have been.

In England, the school kept this form for a long time. In 1612 John Brinsley in his *Ludus Litterarius*, a sort of schoolmaster's manual, reserved the right of punishment for the master; the usher was not to mete out punishment himself, unless he taught 'in a place separate from that of the master', which was rarely the case. As late as 1894 Max Leclerc saw some English schools consisting of a single room occupied by the master's rostrum and, in the four corners, the assistant masters' platforms – very like Père Michault's school of Virtue in 1466.

But in Paris and Liége it was endeavoured very early on to give each class its own premises. It may well be that as early as 1501 the *lectiones* at Montaigu had their own rooms. The 1501 regulations state that after breakfast in the common refectory the pupils must return to the *scholae*: the word is definitely in the plural and refers to the classrooms.

Sturm's memoir of 1538 on the plan to establish a *gymnasium* at Strasbourg discusses the provision of separate classrooms, and the curious objections which he raises show at least that the question was a topical one.

It is better to gather the classes together in a single place than to disperse them over several. It would be senseless, if one had ten sheep, to assign a shepherd and a field to each sheep, when a single meadow is sufficient. It would be just as senseless to entrust to several isolated masters the pupils which a single master can teach ... Bringing together pupils in large numbers gives greater force to the example of learning, greater opportunity to the desire to learn ... *Unless an excessive multitude of children necessitates the provision of more than one room*, instruction must be given in one room only.

In the institutions of the Frères de la Vie Commune, 'at Liége, Deventer, Zwolle and Wesel, only one room is provided for all the classes.' Sturm continues: 'When I was at Liége, a dispute arose between the masters *and some of them started teaching separately*. If this practice had been continued, it would have been the end of the famous *gymnasium* of Saint-Jérôme.' This show of independence did in fact result in the established order of the classes and their curricula being overthrown by the emulation between the masters and their endeavours to attract a more learned audience. 'The old order was finally restored', Sturm says, but we are not told whether this refers simply to the curricula of the classes, or whether the classes were also reinstalled in a single room. We know from another source that in spite of his preferences Sturm finally had separate class-

rooms at Strasbourg. In 1540 Thomas Platter was given the task of founding a school at Basle. He went to Strasbourg to study Sturm's school, which was regarded as something of a model establishment. 'On my return to Basle, I divided the pupils into four *separate* classes [the four classes of Melanchthon], whereas hitherto, in view of the small number of pupils, they were all kept in the downstairs room, the only one which was heated.'

The provision of separate rooms for each class would seem to have been forced upon the schools by the increase in the school population: at Saint-Jérôme there were over two hundred pupils in each class – and the classes in the big colleges such as Louis-le-Grand were of this size until the end of the eighteenth century. Little by little the disciplinarian advantages of less crowded premises became apparent; there was little or no mention of the matter in texts and theoretical writings, but the practice of having separate rooms became an established custom in the seventeenth century. At the end of the sixteenth century, in Cordier's dialogues, a pupil tells the rector: 'Master, there is nobody in the sixth class.' 'What's that? Where is Maître Philippe?' 'He is ill in bed.' 'Tell the master of the second class to send one of his people' – that is to say one of his older pupils. This conversation shows that the various classes were installed in separate rooms. Similarly, in Francion's time, the word 'class' began to be used for the room. In the Oratorian schools, where the room in question was called the 'chamber', a choicer word than 'class', there was the same tendency to use one term to denote place, curriculum and pupils. In both the Jesuit colleges and the University of Paris the separation of the classes had become an accomplished fact.

This last stage has finally brought us all the way from the mixed audience of the Middle Ages to the modern class. Starting at least at the beginning of the fifteenth century, the school population was divided into groups of equivalent capacity, but under the same master and in a single room (a transitional formula to which Italy remained faithful for a long time). Then, in the course of the fifteenth century, a particular master was allotted to each of these groups, though they were still kept within the same four walls, an arrangement which was still to be found in England in the second half of the nineteenth century. Finally, on an initiative originating in Flanders and Paris, the classes and their masters were isolated in special rooms, which resulted in the present-day structure of the class. We have here a change corresponding to a desire, new as yet, to adapt the master's teaching to the student's level. The desire to bring education within the pupil's understanding was in direct opposition not only to the medieval methods of simultaneity or repetition, but also to humanist pedagogy which made no distinction between child and man

and confused schooling (a preparation for life) and culture (an acquisition from life). The separation of the classes therefore revealed a realization of the special nature of childhood or youth and of the idea that within that childhood or youth a variety of categories existed. The creation of the hierarchized college in the fourteenth century had rescued schoolchildren from the hotchpotch in which, in the outside world, the ages were mixed up. The institution of classes in the sixteenth century established sub-divisions within that school population.

What then were these categories, roughed out sometimes for reasons of expediency, which at first bore no relation to what would later be expected from them in the way or order, discipline and educational efficacy? Were they age groups? Admittedly Baduel in 1538 saw in the class system a means of sharing out pupils according to 'their age and development'. In the same period Thomas Platter, at the end of a vagabond youth, went to a Schlestadt school which was attended by nine hundred *discipuli* at once. He already considered it not entirely normal that his ignorance should thrust him at the age of eighteen among a lot of children: he felt the need to record the incident as an anomaly – 'When I entered the school, I knew nothing, I could not even read Donat, yet I was eighteen years old. I took my place in the midst of the little children, like a hen in the midst of her chickens.'

However, we should beware of being misled by isolated anecdotes. Age and development sometimes but not always coincided, and when they did not, people were only slightly surprised, often not at all. They still paid much greater attention to development than to age. At the beginning of the seventeenth century, the class had not yet attained the demographic homogeneity which it has possessed ever since the end of the nineteenth century although it was constantly drawing nearer to that homogeneity. School classes had come into existence to separate students according to their capacities and the difficulty of the subject-matter, not to separate students according to their ages. The new penchant for analysis and division – which characterized the birth of modern consciousness in its most intellectual zone, namely pedagogics – inspired in its turn further distinctions and divisions. The desire to separate the ages was only gradually recognized, and separation asserted as a principle, when separation had already been established in practice after lengthy empirical experiments. And this leads us to make a closer study of schoolchildren's ages and their relation to the class structure.

Chapter 9
The Pupil's Age

We know from personal experience, if we recall our schooldays, the importance which a difference of a few years had in our childhood and youth. We know how we set our schoolmates' ages against the average age of our class, which was our only standard of comparison; our understanding of childhood or youth or adolescence depended on an academic hierarchy, first a succession of classes, then the passage from secondary to higher education. I had these distinctions in mind while I was collecting the documentary material for this chapter on pupils' ages before the nineteenth century. First among these sources are the memorialists' recollections of their childhood and schooldays, the writings in which they were perhaps most sincere. If one or other of these writers should be not entirely typical of the great majority of people, then a few more general statistics will enable us to put him in his proper perspective and to observe certain overall developments.

Thomas Platter, the elder, was born in 1499 in a village in the Valais. He was one of a large family (one of those nurseries of Swiss mercenaries from which the armies of Europe were recruited: two of his brothers died in battle). After the father died, leaving the mother penniless, the children soon left home. At the age of six, Thomas, who had not yet been attracted by camp life, was keeping a relative's goats. At the age of eight, he was still a goatherd: 'Sleeping on hay in the summer, and in winter on a mattress full of fleas and even lice, such is the common lot of the little herdsmen whom the peasants send up into the mountain solitudes.' Seeing him in our modern perspective, we imagine him permanently committed to manual occupations. And yet, when he was nine and a half, his mother, who dreamt of making a priest of him, entrusted him to one of her relatives, himself a priest, who was to teach him the rudiments of grammar It was not indispensable, even if one did not give up hope of a scholastic career, to go to school straight away, as soon as one had got free of mother or nanny at the age of five or six. People accepted the idea of a pre-school period which sometimes postponed the acquisition of the rudiments until after the age of ten. School was not yet regarded unambiguously as a

preparation for life: it was still confused with ways of life which we now tend to postpone until after school, with apprenticeship for instance. Consequently the age at which a child started school remained indefinite for a long time.

Thomas left this brutal master: 'My master used to beat me horribly; he used to seize me by the ears and lift me off the ground.' A cousin of Thomas Platter's happened to pass through the village. He had already attended the schools at Ulm and Munich and was living the endless roving life of the medieval student. When he left on another scholastic journey he took with him young Thomas, who must have been about ten years old and had learnt nothing from his priest except to sing the *Salve*. For Thomas this was the beginning of a long vagabondage of ten years or so, through the schools of Germany, Switzerland and Alsace, which took him to the age of twenty. Never staying long in one place, he travelled across Silesia and Saxony, stopping at Halle, Dresden and Breslau. At Breslau, 'we first of all attended the school of the Holy Cross, near the cathedral; but having heard that there were some Swiss in the next parish, St Elizabeth's, we went there.' These were, of course, Latin schools. At St Elizabeth's, where nine bachelors taught in the same room, only the *praeceptor* (one of the masters, or else a monitor chosen from the pupils) possessed a printed Terence. The others copied it at his dictation, then 'distinguished', next 'construed', and finally 'expounded'. Thomas and his cousin left Breslau, returned to Dresden, and settled down in Munich. After five years of this vagabondage the cousin took it into his head 'to return to the places we had not seen for five years and we travelled to the Valais'. They then went back to Munich. There Thomas, who with his fifteen years had acquired a spirit of independence, left his cousin and went off by himself. Going by way of Passau, Ulm and Constance, he arrived at Zürich, where for a few months he went round asking older students to give him lessons – but all in vain: 'I did not study at all.' Setting off once more, he landed up at Schlestadt where his studies took a more serious turn; Johannes Sapidus admitted him to his school, a prosperous establishment where 'there were up to nine hundred *discipuli* [not separated into classes].' Long years as a scholar gipsy had taught Thomas nothing: at the age of eighteen he could not read. 'When I entered the school I could not even read Donat, yet I was eighteen years old. I took my place in the midst of the little children, like a hen in the midst of her chickens.' Yet he did not stay at Schlestadt, doubtless because he did not have the means to live there.

He then returned to his native Valais, to do what he should have begun by doing ten years before – to learn the rudiments at a little school: 'There

I found a priest who taught me a little writing and I know not what else . . .
My other aunt's son taught me the ABC in one day.' At the age of nineteen,
at the end of his long schooling, we find him learning to read and write.
It is true that before being able to read he knew the Donat by heart: one
of the last survivals of a time when oral transmission was more important
than communication by writing.

He returned to Zürich, where 'rumour had it that a schoolmaster had
arrived . . . who was said to be very learned, but very strict': Myconius,
Pater Myconius, whose pupil, boarder and even disciple he became.
Thomas Platter, who had waited until he was nineteen before learning to
read, was now conquered by humanism and displayed a monstrous ap-
petite for erudition. In two or three years he learned Latin, and Greek and
Hebrew as well. After giving private lessons in his turn, he was then able
to open a school in his native Valais. When he was in his forties, he was
offered the rectorship of an important school in Basle, where he was to
introduce the new system of separate classes.

Thomas Platter's student life in the early sixteenth century takes us back
to the Middle Ages, with studies at countless schools where results were
of no account, classes did not exist and curricula were not arranged in any
order. The essential part of Thomas's store of knowledge was accumulated
in the last two years of a cycle of ten years or so, between the ages of
eighteen and twenty, after eight years which may seem sterile to our
modern eyes, but during which the illiterate youth had kept coming up
against the subjects of the trivium, taught orally in accordance with the
old customs. We must note above all that Thomas Platter did not begin
his active life with school – he was a goatherd until the age of nine – that
he was constantly in the company of older or younger companions, with
no age distinctions, and that humanism grafted itself easily on to his old
medieval stock of knowledge: as we have observed several times, human-
ism, for all that it introduced new methods of learning and new authors,
maintained the long-drawn, simultaneous teaching system of the Middle
Ages.

Thomas Platter's case emphasizes the archaic nature of school life in the
German-speaking countries; it does not, however, represent the typical
student's life in France.

Olivier Le Fèvre d'Ormesson belonged to the following generation: he
was born in 1525 of a father who was a clerk in the record office of the
High Court, and a mother who was the daughter of an attorney in the
Audit Office. He had two brothers and three sisters who all died, except
for his brother Nicolas. He lost his father when he was five. At the age of

eight, Olivier went to Navarre College. In France, the medieval schools of the type Thomas Platter went to in Germany were to be found only in small provincial towns, and they taught only the rudiments of Latin. Colleges teaching a wider range of subjects had taken their place and were attracting an ever greater number of pupils. In Paris, until Louis-le-Grand was founded, Navarre College was patronized by the children of the upper nobility and even of royal blood. However, the Le Fèvre family was not rich, and the widow could not afford to keep her two children at school. They had to start work early in life: 'They were both taken away [from school] after three years, for want of the means to maintain them there.' Thus Olivier stayed at school only from the age of eight or nine to the age of eleven. At eleven 'he was lodged with an attorney in the Audit Office to learn to write [that is to say 'write to perfection', to write deeds, the equivalent of typing today] and to earn his living'. He then became clerk to the Treasurer of the Dauphin, the future Henri II, who helped him and his family in their careers.

In Thomas Platter's schooling we saw the prolonged cycle of the medieval scholar who was also a cleric; like the humanist later on, he considered that study formed a notable part of his active life, and did not reduce it to the educational function of a preparation for that life: it did not separate the child from the adult.

Olivier Le Fèvre's cycle had an entirely different significance. In his day the college was no longer reserved for the lengthy studies of clerks or humanists. It was becoming an instrument of education which preceded and prepared for the pupil's entry into active life. However, it had not yet become a substitute for the other method of education which had been that employed by laymen before they had taken to going to college, an institution hitherto reserved for the clerks: apprenticeship.

Until the end of the Middle Ages, and in many cases afterwards too, in order to obtain initiation in a trade of any sort whatever – whether that of courtier, soldier, administrator, merchant or workman – a boy did not amass the knowledge necessary to ply that trade before entering it, but threw himself into it; he then acquired the necessary knowledge through everyday practice, from living and working with adults who were already fully trained. Thus Olivier was 'lodged with an attorney in the Audit Office to learn to write' and no doubt to count as well.

When academic instruction was extended to laymen, apprenticeship ceased to be a noble function and was gradually driven back towards the mechanical trades – the manual occupations – to the point where, in our own day, the development of technical and professional training, slow and tardy though it has been, is reducing it still further to a relic or a stage of

practical instruction. But this replacement of apprenticeship by academic instruction, in the upper and middle classes of society, was not at first universal. Children began by spending two or three years at school, in the little classes, the big classes still being reserved for Latin careers such as the Church or the law. This stay at school did not dispense a boy from serving his apprenticeship between about twelve and fifteen in the writing professions which were the qualification for work in law. Little by little, the school cycle lengthened at the expense of the period of apprenticeship.

The noble profession which remained faithful the longest to the apprenticeship system was the profession of arms. The military paintings of the seventeenth century depicted young boys, whom we should describe as children, in the midst of rascally-looking old soldiers. As late as the end of the seventeenth century, it often happened that a young nobleman, destined for the service, would spend only two or three years at school. Thus Claude de Bonneval, born in 1675, entered a Jesuit college at the age of nine. He left at eleven – at the same age as Olivier Le Fèvre a century earlier – to sign on as a marine in the King's Navy. At the age of thirteen he was a sub-lieutenant. Similarly Chevert, born in 1695, joined the service at the age of eleven, as his memorial tablet at Saint-Eustache reminds us. The creation of academies in the seventeenth century, and more especially of army schools in the eighteenth century, would gradually bring about the disappearance of these soldiers of eleven and twelve from camp life. In the nineteenth century, the university and the big schools would extend the period of instruction even further.

Another calling, which nowadays stands half-way between trade and the liberal professions, also maintained the practices of apprenticeship for a long time: pharmaceutics. In the eighteenth century the pharmaceutical apprentice started at the age of fourteen, and his contract was for four years. But he had to have studied enough grammar to be able to read a Latin prescription: consequently he had already attended the little classes of a college. His schooling was still wedged in between his early childhood and the beginning of an apprenticeship which plunged him into the world of adults. In the nineteenth century this sort of apprenticeship still existed: Claude Bernard began his at the age of thirteen.

Generally speaking, however, the prolongation of the school cycle had almost eliminated the apprenticeship by the late eighteenth century: after that time only the working classes, excluded from the Latin colleges to which they were still admitted at the end of the ancien regime, continued to practise apprenticeship.

The school career of Henri de Mesmes was also a short cycle, but not for the same reasons as in Olivier Le Fèvre's case: the latter was an

example of the coexistence of college and apprenticeship. Henri de Mesmes did not serve an apprenticeship, but he was typical of certain cases of precocity.

He was born in 1532, the son of a lawyer. 'My father gave me as a tutor J. Maludan, a disciple of Dorat's and a learned man, chosen for the innocence of his life, and of an age suitable for the guidance of my youth ... he relinquished his post only when I started my career.' In other words he stayed with Henri de Mesmes until he was eighteen. A tutor at that time was not responsible for all his charge's tuition: he was not a substitute for school. During the first few years, from five to seven or nine years of age, he taught his charge reading and the rudiments of grammar. When his pupil started school, the tutor accompanied him to school, where he served him as a private coach, while he too studied on his own account, possibly with his young master's valets. Thus in the regulations for the boards at the college of La Flèche, it is laid down that the pupils' *famuli* must be of an age and education to enter the fourth class.

So Henri de Mesmes started school with his tutor and his brother: 'I was sent to the Collège de Bourgogne in the year 1542.' He was then about ten years old, and he went straight into the third class, the last of the grammar classes, leaving out the lower classes. After the third class, he skipped the second and entered the first: 'Then I did one year, no less, in the first class.' This course does not seem to have been unusual at the time: it was also that of Nicolas de Beauvais-Nangis. The latter, born in 1582, was twelve years old when he entered Navarre College at the beginning of 1595. 'I entered the third class, where I remained until St Rémy's Day [October 2nd, 1595: generally the pupil went from Easter to St Rémy's Day or from St Rémy's Day to Easter], when I went up into the first class, where I remained until the month of May 1596, when the plague infected the aforesaid college, and I was brought back to Nangis where I studied philosophy under a tutor.'

Thus, at the end of a year in the first class Henri de Mesmes finished a schooling which had lasted no more than eighteen months. At the age of twelve he had finished with the arts; however, though he had completed his schooling in a hurry, it was not in order to enter an attorney's office any sooner; he had been quick, thanks to his natural precocity and to his tutor's coaching. These cases of child prodigies were very common between the fifteenth and seventeenth centuries. Père Ange de Joyeuse entered the rhetoric class at the age of ten, though admittedly 'to the astonishment of his masters', to quote his biographer Caillière. Baillet in 1688 also speaks of children who 'by the age of twelve or thirteen had

completed the ordinary course of college studies by means of extraordinary activity'.

This precocity could make it possible to start one's active career at the usual age, and to catch up with youths who had not been to school. But in the sixteenth and the early seventeenth century, it also enabled little prodigies to pursue advanced studies over a long period. This was the case with Henri de Mesmes: after his eighteen months at school, he set off at the age of twelve, still with his brother and his tutor, to enter the Faculty of Law at Toulouse (civil law was not taught in Paris), where they spent six years of hard study: 'After that, having taken our degrees as Doctors of Civil and Canon Law, we took the road for home.' He was eighteen years old, and he was now appointed to a post as counsellor to the Board of Excise 'because I was so young that I would not have been admitted anywhere else'. Of eight years of study, two had been devoted to grammar and the arts, the rest to law.

Cases of this type were to become rare in the seventeenth century, not only because precocity would strike public opinion as an anomaly, but also because the higher branches of study would disappear in favour of the college's classes, which would take over the whole cycle of instruction and thus take a young man up to the threshold of his future career. In the mid-sixteenth century, the Faculties of Law still enjoyed their old prestige – indeed this was their greatest period – and a continuous series of classes had not yet been accepted as a necessity in higher education: a student could easily skip a class or else spend only one semester in a class. The curriculum came to an end in fact at the end of the semester. Students were moved up to the next class either at Easter or on St Rémy's Day, that is to say at the end of every semester. In reality school started twice a year, on the above dates – whereas ever since the nineteenth century it has started only once a year, in October.

This custom of arranging the curricula in semesters continued until the end of the ancien regime. It was provided for in Henri IV's reformation of the University of Paris. In England, it was still in force in the mid-nineteenth century: Thomas Hughes reckons in half-years what we count in annual classes. Even then the system of half-yearly promotions favoured a certain precocity. But this was no longer the precocity of the sixteenth century, which can be explained by the same pre-scholastic spirit which I mentioned with regard to apprenticeship. We should not forget that schooling was still very recent in the mid-sixteenth century and restricted in many cases either to a few years of study or to a few people or classes. Outside school, in the army camps, in the offices of lawyers or administrators, in the courts where politics and diplomacy were conducted by

grandees or statesmen, and in the workshops where craftsmen plied their trades, boys between the ages of ten and fourteen mixed with adults in everyday life and above all in the fellowship of a common occupation. Some of them could show a precocious skill without causing excessive surprise to technicians used to cultivating professional values without regard to age: the precocity of an apprentice was accordingly barely distinguishable from other natural inequalities, such as the exceptional skill of an adult. In these psychological conditions, the precocity of a schoolboy did not seem any more extraordinary than the skill of a little artisan, the agility and courage of a child acrobat, or the virtuosity of a young musician. The school had not yet established a sufficient distinction between its pupils and the rest of the child population. These performances would no longer be tolerated once they were regarded as infractions of the special nature of childhood, and that special nature would be recognized in middle-class schoolchildren before it was extended to the children of the lower classes.

With the future Maréchal de Bassompierre, in the late sixteenth century, we approach the normal modern cycle.

Bassompierre was born in 1579. He stayed at home until he was twelve, except for five months when his mother was away and he was entrusted to an aunt who was an abbess. In the course of this period of education at home he learnt to read and write, 'and then the Rudiments', with a tutor who was joined in 1588 by 'two young men called Clinchamps and de la Motte, the former to teach us to write well [that is to say 'writing to perfection', Clinchamps being a 'scribe'] and the latter to teach us dancing, lute-playing and music'. This prolongation to the age of twelve of education at home was not exceptional, but the moralists of the sixteenth and seventeenth centuries condemned it because they feared the promiscuity of the servants, from whom the tutor was not very clearly distinguished, *a fortiori* when the child was left with the women of the house: 'How reprehensible', wrote the Jansenist Coustel in 1687, 'is the cruel and foolish affection of certain parents who think that they are doing a great deal for their children by leaving them until the age of twelve or thirteen in the arms and the often rather indecent embraces of nannies and governesses.' However, except in the case of the King's children, nobody ever considered extending this home education beyond twelve or thirteen: everybody went to school.

At the age of twelve, Bassompierre went to the Jesuit college at Freiburg im Breisgau, accompanied by his brother, the tutor, the writing-master

and the dancing-master. They entered the third class. For a child of good birth and average wealth, twelve years old was a normal age for the third class. However, the murder of the dancing-master by the tutor reduced the Bassompierres' stay in the third class to five months, and sent the boys back home, 'whence the same year [1592] my mother took us to the Jesuit college at Pont-à-Mousson to continue our studies there. We stayed only six weeks in the third class [they had thus spent a complete semester in the third and could regard it as finished], then spent the holidays with the family at Harouel. On our return we went up into the second class where we spent a year.' In 1593 'we went up to the first class'. The next year, after the holidays 'we returned to the same class'. Boys were often made to stay a second year in the same class, not so much because they were weak as in order to prolong their schooling. Here we have evidence of a new attitude to schooling, a tendency to leave the child or the young man at school a long time; whatever the division of the classes, and despite the fact that they were now quite distinct, progress through these classes mattered less than the length of the pupil's stay at school.

Bassompierre's second year in the first class was interrupted at the beginning of Lent by a tour of Germany and Austria. At that time people thought that travel, especially in Germany and Italy, had great educational value; young noblemen, entertained by their parents' correspondents, learned other languages and were initiated in the life of courtiers, diplomats or soldiers: this was another aspect of apprenticeship.

On his return from Germany, Bassompierre was about sixteen: 'We came back to continue our studies [at Pont-à-Mousson] until October, leaving the Physics class when we had reached the *De anima*: the Philosophy year.' Many pupils left school before the philosophy class, which was generally reserved for future lawyers and churchmen. Next, Bassompierre did something he calls a 'course', whose purpose I cannot quite grasp. It seems to have been a sort of substitute for advanced studies, in place of the Faculties of Civil Law, Canon Law and Medicine: 'And because we had another seven months of the course to do, I started studying at the same time [i.e. with a tutor] the Institutes of the Law [Justinian], on which I spent one hour in class, another hour on cases of conscience, one hour on the aphorisms of Hippocrates, and one hour on Aristotle's ethics and politics.' He thus provided himself with a smattering of law and medicine, as well as scholastic philosophy. 'I continued for the rest of that year, 1595, and the beginning of the year 1596. My course finished at Easter.'

This gives us, very roughly:

1591–2 12–13 years old, third class
1592–3 13–14 years old, second class
1593–4 14–15 years old, first class
1595–6 16–17 years old, physics and logic

The points to note here are the late entry into the third class, the continuity of the classes, and the repetition of the first class. The relation between ages and classes approximates to a pattern sufficiently common in the seventeenth century for Sorel to adopt it for one of his characters, Dorilas, who is in the rhetoric class from fourteen to sixteen.

We find a similar cycle and the same ages in the case of André Le Fèvre d'Ormesson, the son of that Olivier whom we met earlier. In the year 1586, when he was ten years old: 'I was sent to Cardinal Lemoine College under M. Le Dieu, a native of Picardy, the master of my class, with seven of my cousins who were already there.' During the siege of Paris 'our master M. Le Dieu' had not 'the means to feed us'. Thus the Le Fèvres were not boarders in the college, which probably housed only its scholars, but boarded with one of the masters – who perhaps lived in the college. It was unusual for a college to provide board and lodging itself.

André entered the seventh class. His master, Maître Jard, followed him, as was the custom at that time, into the sixth and the fifth: it is probable that the seventh was a subdivision of the sixth, and possible that the seventh and the sixth were held together with the fifth, in the same room.

In the fourth class he had a new master: he went 'under M. Seguin who has since been doctor to Queen Anne of Austria'. M. Seguin was a schoolmaster while he was pursuing his medical studies – grammar-school masters were often recruited from students in the Faculties of Law, Theology and Medicine. André was in the fourth class in 1589. This means that he had moved up one class a year from the seventh. 'The siege of Paris took place ... and my father took us away from school' (because their master could not feed them). He kept his two sons at home until October 1590, 'when I went with my brother to Navarre College, under M. Raquin', in 'the first class'. They therefore apparently skipped the third and the second. In fact they skipped only the third, for there was no second class at Navarre – but there must have been two firsts. That at least is the interpretation one can put on the following sentence: 'The year 1591 beginning in October, M. Gauthier, who has since become a doctor of theology, took *the first and the later first* for the second year.' So at Navarre there were two first classes, which presumably corresponded to the humanities class and the rhetoric class in other colleges. What is certain, in any case, is that André spent a second year in the first class, and that this

seemed quite normal. 'In October 1592 I went to study in the Logic class at the Jesuit college under Père Gaspard Seguiran, who has since become an excellent preacher and confessor to King Louis XIII.' With the class in logic, André completed the arts cycle between sixteen and seventeen. There then began for him, as for Henri de Mesmes, a lengthy period of law studies: first 'on the Institutes [of Justinian] under M. Marsibus [probably private lessons] and after that at the Universities at Orléans, under M. le docteur Luillier, the Dean and the most learned of all doctors in Orléans, until September 1595, then with M. Leclerc, doctor of Law, until my admission by the Grand Council, which took place on December 17th, 1598.' André had six years of law studies in all, the same time as was taken by Henri de Mesmes.

This cycle of studies can, therefore, be summarized as follows:

1586 10 years old, seventh class
1587 11 years old, sixth class
1588 12 years old, fifth class
1589 13 years old, fourth class
1590 14 years old, first class
1591 15 years old, first class
1592 16 years old, logic class
1593–8 17–22 years old, law studies

If we except the omission of the third class, we have here a normal cycle: the sixth class at eleven, the rhetoric class at fifteen, seven years at school and six years studying law, before starting professional life.

The cases we come across from the seventeenth century on are, generally speaking, of a normal character and, despite a certain precocity, tend to approach the classic pattern established in the nineteenth century.

Descartes had an education that was entirely 'scholastic' – that is, the classes at school were not supplemented by university studies. We know that Descartes entered the Jesuit college at La Flèche in 1604, starting in the sixth class at the age of eight, that in May 1610 he was in his first year in the philosophy class, and that he finished his schooling in August 1612, at the end of his third year in the philosophy class: he was then fifteen years old.

Thus he covered in five years, between 1604 and 1609, the cycle which went from the sixth class to the philosophy class: to do this he must either have skipped a class or covered two classes in two semesters. Eight years old was fairly young for the sixth class, but in every sixth or fifth there were a few pupils of eight or nine. A twelve year old in the rhetoric class was beginning to be a rarity, but we shall come across another case.

The period spent in the philosophy class here was three years, a period corresponding to a degree course at a university: it is easy to see how the college in France absorbed not only the grammar school but also the arts school which in England gave rise to a higher education distinct from and complementary to the grammar schools. In France the college came to offer tuition of every kind, sometimes even in theology: the young Jesuits at that time had no separate noviciate and did their three years of philosophy and their theology at school (none the less the Sorbonne, the name of the Paris Faculty of Theology, remained active until the end of the ancien regime). The importance attributed to the tuition given after the rhetoric class coincided with the decline of the higher Faculties, when it did not actually contribute to that decline, as in the case of the arts. A good academic education could be obtained by a long stay at school, particularly in the philosophy classes: these were in fact confined to a small number of pupils who specialized in philosophy and theology.

Descartes's long school career (eight years) therefore consisted of a pseudo-secondary education of five years, up to the rhetoric class, and a pseudo-higher education of three years. Eventually the normal school cycle, corresponding to our secondary education, would annex a year of philosophy. The complete cycle would then go up to the logic class, while a few specialists, future churchmen or 'intellectuals', would extend it for one or, in exceptional cases, two years.

Let us interrupt the chronological sequence of our biographical examples to compare with Descartes's case another case which also illustrates the disproportionate place assumed by the college in the education even of 'men of law': that of Charles Perrault, the author of the fairy-stories.

Charles Perrault, like Descartes, was a good pupil. He was born in 1628: 'My mother went to the trouble of trying to teach me to read, after which I was sent to Beauvais College at the age of eight and a half [the same age as Descartes, and in the same sixth class]. There I received all my schooling, as did all my brothers, without a single one of us ever being whipped.' A noteworthy fact, which must have been exceptional. 'I was put in the sixth class before I could read.' In this model family, in which the father used to teach his son Latin after supper, a boy of eight and a half had not yet learnt to read! But the sixth was in fact an elementary class, sometimes divided into two on account of the number of pupils who were put into it just to learn reading, writing and the rudiments of grammar, and in this case a seventh class was formed which was taught in the same room.

About Charles Perrault's schooling all we know is his age and class when he started school, and his age when he left, between seventeen and eighteen, at the end of his second year in the philosophy class. If we count

a year for each class, we see that he has at least one year too many and probably two, whereas there was one year missing from Descartes's cycle. Charles Perrault must have stayed an extra year in one or two classes, thus extending the average cycle by a year for each class. We shall see later that this was the general rule. Charles Perrault did not go beyond the second year in the philosophy class, for he did not intend to enter the Church. He wanted to read law, but it did not occur to him to go to a Law Faculty to study under one of its masters as Mesmes did at Toulouse in 1545 or Ormesson at Orléans about 1593: the times had changed. For three years he took private lessons in law in accordance with the custom of the times: the Law Faculties had declined, with the result that would-be jurists, lawyers and magistrates studied the *Institutes* at home with a private tutor, presenting themselves at the Faculties only to obtain their diplomas, for the examination had become merely a tiresome, ridiculous formality. In July 1651, writes Charles Perrault, 'I went to obtain my diplomas at Orléans with two friends, one of whom was to become vicar-general of Sens.' They arrived at ten o'clock at night and did not waste a minute; as soon as they arrived, they knocked at the door of the school: 'A valet who came to the window to talk to us, on being told what we wanted, asked us if we had our money ready.' This was enough to get the three doctors out of bed, and they arrived 'with their nightcaps under their mortar-boards'. 'I imagine that the sound of our money being counted out behind us while they were questioning us helped to make them consider our answers better than they were.' The next day, after going round the town looking at its famous monuments, like the statue of Joan of Arc, they went back to Paris: Charles Perrault, at the age of twenty-three, was a qualified advocate.

The coincidence between the decline of the higher Faculties and the growing prestige of the colleges cannot have been accidental. At a time when even specialist instruction was becoming less technical and people were moving away from the ideal of omniscience of the late Middle Ages and humanism, the college had become the only means of education, and the tendency was to prolong the schooling there rather than to supplement it, except with private lessons.

However, cases of rapid, precocious studies of the sixteenth-century type did not disappear completely. Bussy was only a few years older than Charles Perrault. 'When I was nine years old, my father sent us, my elder brother and me, with a tutor to the Jesuit college at Autun.'[1] Bussy does not say in what class he started school. By tutor we must understand a

1. He is supposed to have been born in 1618, but this date does not tally with the ages he quotes later.

rather older and somewhat poorer companion. 'A little later [at the time of the war on the Huguenots in Languedoc] ... my father took my elder brother away from the college, where he was making much progress, and made him an ensign in his Company': the boy must have been about twelve, the same age as Bonneval and Chevert when they joined the army. This is another case of a brief stay at school before the direct apprenticeship of camp life. The eldest son of a family was not given a better education than the rest; on the contrary, seeing that he was destined for the army, his schooling was cut short. 'One of my younger brothers, who was destined to become a Chevalier of Malta, was sent to join me. I quite liked my studies and my masters were very pleased with me. However, the fighting having moved from Languedoc to Piedmont, my elder brother died of the plague at Brigueras and by his death left me the eldest of the house.'

At this point the family had to move to Paris, 'as much to settle a lawsuit as for anything else'. 'My brother the Chevalier and I were, therefore, living with my father and mother in a lodging taken for the year in the Rue de la Harpe, whence we went to the Jesuit college of Clermont. I started in the second class when I was only eleven, and I was such a good classical scholar that at *the age of twelve* I was considered good enough to move up into the Philosophy class without going through the Rhetoric class.' He did only the logic year: 'At the end of my Logic year, my father, having been ordered to form his regiment again, gave me the command of the first company, and instead of letting me finish my Physics [the second year of philosophy which he had therefore already begun], sent me in 1634 to the siege of La Motte in Lorraine with that regiment.' He was thirteen years old, the same age as several of his brother-officers. But he had covered the whole scholastic cycle except for the rhetoric class, which he had skipped thanks to the lead he had gained in the second class. Later, pupils would no longer skip the rhetoric class, which would have become a very important, and sometimes the terminal, class.

With the Duc d'Enghien, the future Grand Condé, we have a normal though still very precocious cycle of studies.[2] But in his case a new post-scholastic institution, the academy, made its appearance, an institution which was to assume considerable importance for the seventeenth-century nobility. His position as a prince of the blood did not disqualify him for a college education, for only the King's children received all their education at home; boys from the greatest families in the land went to school, particularly to the Jesuit college of Clermont which, in the seventeenth cen-

2. From Cherot (1896).

tury, took the place of Navarre College, where the high nobility had hitherto received their schooling.

Condé, born in 1621, started studying Latin at the age of five with a tutor. At the age of eight he entered the Jesuit college at Bourges, but in the fourth class and a term behind his classmates, whom he caught up with easily. At the same age Descartes and Perrault were in the sixth class. His masters recognized his merits: 'A pupil in the second Grammar class [i.e. in the fourth class], it is wonderful to see with what diligence and assiduity he takes part in the exercises in construing, composition and diction. In the daily concertations [contests between the two halves of a class] it is he who inspires the rest.'

He covered the normal cycle at the rate of a class a year, which brought him to the rhetoric class at the age of eleven (the same age as Père Ange de Joyeuse in the sixteenth century), and to the physics class at thirteen: he spent six years at school and went through every class from the fourth to the second philosophy class.

In August 1635 he left the college: he was fourteen. Like Charles Perrault, he then studied law with a tutor. This young prince accepted the tuition provided in school, but he shunned the higher Faculties and substituted private lessons for them. At the same time as law, he took lessons in mathematics (a subject which was virtually untaught in school) from a master who was an army engineer, in order to prepare for his admission at the age of fifteen to Pluvinel's 'Royal Academy for the Young Nobility'.

The academy was a new institution, semi-scholastic and semi-military in character: an institution characteristic of the seventeenth century, particularly of the first two-thirds of that century. It fulfilled a need which had not existed before.

In the sixteenth century, after a complete or more often an abbreviated schooling, a young man went to a university only if he intended to make his career in law, the Church or medicine. And we know that the Faculties of Law later went into a decline. If he wanted to follow any other career, he went straight away, as an apprentice, into an army company, into a noble house, or into commerce. Apart from the college, which was growing in prestige, and a specialist university which was partially on the decline, there was nothing left but apprenticeship.

One of these traditions of apprenticeship, especially in noble families, sent the boys to stay with other families, particularly abroad: then the formula of the stay with friends was gradually superseded by that of the tour abroad with a tutor (as in the case of Bassompierre). People came to regard the tour abroad as a complementary education in subjects ignored

at school and in the Faculties. Certain of these arts or techniques had hitherto been taught at home and formed part of the traditional domestic education given to pages and squires: dancing (more important than it is today), music (the playing of instruments such as the lute was more wide-spread than that of the piano in the late nineteenth century), riding and various sports. But other subjects, among those studied abroad, began to acquire a more didactic and sometimes scientific character: first of all, modern languages – Italian and Spanish, great cultural languages, but also German, probably because mercenaries were recruited in the German-speaking countries and it was to the interest of a future officer to speak the language; then geography and contemporary history, indispensible subjects for the soldier as also for the ambitious courtier; and finally mathematics, or 'fortifications' as it was called, a necessary subject at a time when warfare was becoming increasingly scientific.

These tours abroad were very costly, and at a time when the nobility's income was tending to diminish they could not satisfy a growing need for a practical, non-Latin education. The academy satisfied this need for a post-scholastic education, between school and active life, for young noble-men, and above all (though not exclusively) for future officers, whose families could not finance a stay abroad.

This institution originated in Paris, in the second half of the sixteenth century. Nicolas de Beauvais-Nangis writes of his father: 'Antoine de Brichanteau, aged between eleven and twelve, was sent to Lisieux College in the year 1564 [the class is not specified], where he stayed until the troubles of the year 1567 and the Battle of Saint-Denis, when, being con-sidered strong and brave enough to bear arms, he was sent to the Paris Academy where he was trained for nearly a year.' Nicolas de Beauvais-Nangis himself finished his schooling at the age of fifteen. His father refused to let him go to the siege of Amiens; he wanted him to complete his education first. Nicolas had reached the age of the traditional tour abroad. 'At the beginning of 1598, my father kept me with him for a time in Paris, where I began to accustom myself to the sight of companies of troops, and the following April I started training in Paris [i.e. at an academy], where I stayed until the end of September.' 'My father had in-tended to send me to Italy, for at that time young men were sent there to be trained'; but the journey was too expensive and the stay at the academy took its place.

The most famous of these establishments was Pluvinel's academy, founded in 1594. A contemporary wrote of it in these terms: 'The whole of France is infinitely grateful to M. de Pluvinel who, with incredible generosity, has devoutly offered himself to the nobility to serve as a ladder

and stepping-stone to the loftiest and most glorious things.' The college was never confined to the nobility; it was open to all classes. The academy, however, was thought of as the province of the nobility, at a time when the nobles were becoming aware of their importance in military affairs and citing this importance as a justification of special privileges. The academy was the first of those institutes for young noblemen which Richelieu imagined and which the eighteenth century created. It provided the inspiration for Mme de Maintenon's ideas about the education of girls.

The contemporary account continues: 'He [Pluvinel] deprives us of the occasion of rushing off to Italy, where we go to buy at fantastic expense the mere shadow of good manners, and whence we return with the substance of vice.' One notes a new interest, unknown in the sixteenth century, in safeguarding adolescent morals, which were exposed to considerable danger on these journeys. At Pluvinel's academy the pupils were taught horsemanship (Pluvinel was the author of a treatise on horsemanship, illustrated by Crispin de Pas), fencing, mathematics, fortifications, and social accomplishments such as painting, dancing and lute-playing. And our author discovered another advantage in the academy which strikes us as rather curious and shows that the modern idea of a complete secondary education had not yet imposed itself on the upper classes as a necessity: 'Young lords can be admitted [to the academy] as early as ten or eleven, whereas they cannot and must not go to Italy until they are seventeen or eighteen.' This means that the young nobleman could make do with one or two of the lower classes at school and then go straight into the academy to be educated, whereas before he had been obliged either to continue futile scholastic studies until he was old enough to travel, or else to throw himself straight into camp life at about eleven. People were in fact reluctant to send children too soon in life either into the army or abroad. The academy made it possible to keep children under control after their schooling was over, by means of a discipline inspired by scholastic and military regulations. The period spent at the academy was an intermediary period between schoolboy life and adult life: the beginning of a recognition of adolescence.

The academy was not an exclusively French phenomenon. The continued existence of a higher education, at the universities of Oxford and Cambridge, where boys went from their grammar schools, would seem to have prevented the academy from developing in England. But educational historians such as Adamson (1919), think that the academy played an important role in Germany, giving rise to certain institutions of higher education whose modern character led to their being used as models for

the university reforms of the nineteenth century, in both England and France. In France, the academies did not have the same enduring influence, for all that they met no competition in the country's decadent higher education: once again it was the college which partially absorbed them, in the form of military preparatory schools in the eighteenth century, while at the same time more highly specialized schools for officers and engineers were laying the foundations of the École Polytechnique and the Staff College.

The academies occupied a very important place in French society in the seventeenth century. The Abbé Michel de Marolles owed it to himself not to leave them out of his description of Paris of 1677; he devoted a whole chapter to them, written in doggerel like the rest of the book, and entitled: 'Academies for horsemanship and other decent occupations for the young nobility'.

This note of moral concern is to be found in other contemporary texts, for example in Bary's work published in 1675: 'In the seminaries, one learns not only how to serve God but also how to govern morals [the author is comparing the first seminaries with the first academies]; in the academies, one learns not only how to handle a horse, but also how to curb one's passions.' The need for moral discipline had been the original reason for the founding of the colleges and had inspired their authoritarian regulations in the fifteenth and sixteenth centuries. Soon, especially with the Jesuits, moral education became one of the principal objects of school life, even more important than instruction. Now it was spreading in the seventeenth century to post-scholastic institutions such as the academies, to the young noblemen whom their parents no longer dared to turn loose without any preparation in the world of court and camp.

Among the academies were some of royal foundation: the schools for pages, shared out between the two Stables, the Hunt, the Chamber and the Chapel. The best known and the most popular with the nobility were the two Stables. The Great Stable consisted of a tutor, two assistant tutors, a preceptor, a chaplain, a bursar, and masters to teach fencing, riding, dancing, drill, writing (that 'writing to perfection' which is not to be confused with ordinary writing), mathematics and drawing.

Sorel tells the story of Dorilas. Dorilas covered the complete course of classical studies at school: 'I was still in those classes called the humanities when I decided that to "arrive" was the most human of occupations.' Dorilas lacked the precocity of the Grand Condé, who started logic at the age of twelve: when he was studying the humanities he must have been fourteen, and at that time a boy of that age could understand the full significance of Ovid's *Art of Love*, which was taught with the aid of a whip:

'They whipped us when we missed a syllable.' In the rhetoric class Dorilas learnt 'the art of persuading by means of eloquence', then, at the age of sixteen he 'went up into the philosophy class'; this was probably a more usual age than the very precocious cases we have met with in our biographical examples. 'When I had completed my course of philosophy at the age of seventeen, it was considered that I knew more than enough to be a soldier, like my father, who wanted me to follow the same profession.' He could in fact have extended his stay at school with a year of physics, but he 'knew more than enough'; people went on *saying*, in conversation and books, that a college education was no use to future soldiers, but often they *acted* as if this were no longer the case and allowed their children to go to all the classes, including the first philosophy class.

'I was taken away from college and sent to a boarding-school, a house where I learnt fencing, dancing, lute-playing and mathematics', and also languages. This was a modern education, and it is easy to understand why in Germany it should have resulted in the teaching in the vernacular of new ideas, foreign to the traditional arts. 'And every morning I went to a riding-school to learn horsemanship.' This boarding-school had a fencing-master, a music-master and so on, but it had no riding-school. Thus besides the great academies there were 'boarding-schools' which were less comprehensive, more modest and less expensive, like the one in this story.

This shows how essential it was considered in the seventeenth century for youths of good family to go through an academy or a 'house' of the same sort. Even Antoine Arnauld, despite an already pronounced taste for literature and theology, spent six months at Pluvinel's academy. When Mme de Sévigné wanted to emphasize a young man's chances of success, she wrote that he had 'just left the Academy': M. de Locmaria 'can set all the courtiers at defiance and confound them, upon my word. He has an income of sixty thousand livres, and has just left the Academy.' Nowadays we would say in France that he had just left the 'Sciences Po' and in England that he had just come down from Oxford or Cambridge.

In another letter Mme de Sévigné described a quarrel between the Prince d'Harcourt and La Feuillade, a silly quarrel between overgrown schoolboys: 'Thereupon the Prince threw a plate at his head; the other threw a knife at him; neither hit the target. They were parted and made to embrace. In the evening they spoke to each other at the Louvre as if nothing had happened.' And Mme de Sévigné added: 'If you have ever seen how academists who have *campos* behave, you will know what this quarrel was like.' The word 'academist' had become generally familiar. Mme de Sévigné and her correspondents also used the expression 'to have

campos', which would seem to have been borrowed from academy or army slang; similarly barrack-room words are nowadays used currently in middle-class conversation.

But let us go back to the career of the future Grand Condé. He stayed at Pluvinel's academy for sixteen months: 'I have begun tracing fortifications on paper ... I have finished studying proportional compasses and mensuration and started on fortifications. I am also studying the map of the world.' He left the academy at the age of sixteen to take up his post as Governor of Burgundy; at nineteen he married Richelieu's niece, who was only thirteen. He had covered the whole of the scholastic cycle from the fourth class up, including the two years in the philosophy class which he had complemented with private lessons in law and over a year at an academy. He was only eleven when he was in the first class: an exceptional example of precocity.

While the Edict of Nantes was in force, the Protestant academies were very similar to the Catholic colleges: the only difference was that sometimes – not always – philosophy was dropped in favour of theological instruction (intended for future pastors).[3] On the whole, the cycle of classes remained the same. Here are two examples of Protestant schooling. The first is taken from an entry in the Marquis d'Asson's journal, quoted by Waddington in a note in his addition of Rou's memoirs:

I began my studies before the age of eight under the eyes of my late father. A few years later, I accompanied my three elder brothers to Saumur; I was so young [he must have been between eight and ten] that it was thought fit to send our governess with me until bedtime so that the separation should be less of a wrench, and she went to bed with me as usual. I was soon ready for the second class [presumably the humanities class: it would seem that the Protestant academies had a different system of numbering], where I remained for three years under the learned M. Lefebvre. [We have already come across similar cases of a long stay in one class, which seems to have been a way of compensating for an over-precocious start.] Next I went up into the third [rhetoric] class. I finished my schooling extremely young [presumably between thirteen and fourteen. He did not study philosophy, but went to an academy for the nobility]: at the end of 1668, I went from the college to the Paris Academy to be trained.

The second Protestant example is that of Jean Rou (1638–1711), another remarkable case of precocity: 'I learnt to read so easily and quickly that at the age of four I was able to read a chapter of the Bible after supper ... This rapid progress resulted in my being sent to school

3. Philosophy was not dropped at the academies for the nobility mentioned earlier.

at the age of five, in the care of a maidservant who took me there and back every morning and evening.' The school was Harcourt College, where he was regarded as something of a phenomenon, for he had few schoolmates as young as he was, and it was more usual to be accompanied by a tutor, a sort of big schoolfellow, than by a maidservant. But Jean Rou, unlike his richer friends, never had a tutor. When he was a little older he supplemented the classes at Harcourt with private coaching which he shared with a few friends: he joined 'three or four young pupils' at the house of one of them, Lecoq, the son of a counsellor at the High Court, for lessons from a coach.

In 1652 he was sent to the Protestant college of Saumur. The principal, the pastor of the town, put him in the first class: fourteen years old and in the first class, he had lost the lead he had had to begin with; he was two years older than the Prince de Condé in the same class. What is more, at fourteen he was considered too young as yet to go into the philosophy class. 'I was at the end of the year when it was usual to go up into the philosophy class.' But his master made him spend yet another year in the first class, 'seeing that I was so young for studies which he considered beyond my understanding'. Yet a few years before, Descartes had gone into the philosophy class at that age. We can see here a depreciation of schoolboy precocity which foreshadows the modern attitude. After his philosophy studies, Jean Rou took his diplomas as bachelor and doctor of arts (at that time the two diplomas were taken together as two parts of the same examination), something which was no longer done unless one intended to enter a higher Faculty such as theology or medicine.

Thanks to a study by a Jesuit Father who obtained access to the Society's archives, we are familiar with the school careers of the Grand Condé's son and grandson who were both pupils of the Jesuits. His son, born in 1643, started Despautère – Latin grammar – at the age of seven. 'He quotes Cato [Pseudo-Cato, a fourteenth-century author taken up by the Middle Ages which attributed his maxims to the Elder Cato] and Latin maxims, and since reading *Galatée* [a manual of etiquette used in the Jesuit colleges] he notices all the offences against the proprieties which are committed.' Thus his tutor informs his father of his progress. 'He composes very prettily, and if you wish he will write to you occasionally in Latin: when I compare his terminology with Cicero's, I see that he already has a good understanding of Latin.'

There is nothing very surprising about this familiarity with Latin shown by a child of seven; at that time Latin was learnt like a modern language, in conversation, and French parents gave their child a Latin tutor just as not long ago they entrusted him to an English or a German nanny. This

was in the medieval tradition of oral culture: over a century before, in his advice to Queen Catherine on bringing up Mary Tudor, Vivès had suggested surrounding the little eight year old with companions of the same age who spoke Latin; to obtain the best results, it would have been better to start a year earlier, at the age of seven – Enghien's age. The same method was being used at the end of the sixteenth century in Calvin's Geneva, where Cordier was teaching. Cordier has left us this conversation between two pupils:

'How old is your brother?' 'Five years old.' 'Five years old? But he already speaks Latin!' 'Why does that surprise you? We always have a pedagogue at home who is learned and diligent. He teaches us to speak Latin all the time and we never say anything in French. Indeed we do not dare speak to our father except in Latin.' [The speaker is twelve years old.] 'Then you never speak French?' 'Only with my mother, and at certain times when she summons us to her presence.' 'What do you do with the family?' [By the family he means the whole group of friends, clients, servants, and so on]. 'We scarcely speak at all to the rest of the family, and then only incidentally, yet some of the servants speak to us in Latin.' [He is presumably referring not so much to servants as to what we would call 'companions'. But there were some valets who had accompanied their masters to school and could muster a little Latin without too much difficulty – which shows, incidentally, that people were not too particular about the quality of this Latin. But let us return to the conversation between our two boys.] 'But what about the chambermaids?' 'If it ever happens that we have to speak to them, then we speak French, as we do with our mother.' 'Oh, how lucky you are to be taught so well!'

Thus, however remarkable Condé's achievement in Latin may seem, it was not exceptional and its equivalent was to be found in other milieux than that of the princes of the blood, although the teaching of Latin as a living tongue by means of conversation must have started growing rarer; it would cease altogether at the end of the seventeenth century.

At the age of nine, young Condé entered Bordeaux College, starting in the fourth class (this was at the time of the Fronde), leaving almost immediately to follow his father into exile in Namur. In December 1653 he entered the Jesuit college in Namur and was placed in the third class. The third was the biggest class in the school: ninety-seven pupils out of a total of four to five hundred. At the end of the year, the young prince was placed seventh out of the ninety-seven pupils in his class.

From the third class, Condé went up into the humanities class in 1654, into the rhetoric class in 1655. The University of Louvain did not allow the Jesuits of Namur to teach philosophy in their college (another example of the ambiguous character of the philosophy class, which combined sub-

jects belonging to higher education with what was to become secondary education). However, the difficulty was overcome by ostensibly confining the philosophy course at Antwerp to the theologians of the Society, in other words to the future priests. The prince took this course too; he was thirteen years old. On the course he spent his logic and physics years, which he finished a little older than his father.

1652–3 9 years old, fourth class
1653–4 10 years old, third class
1654–5 11 years old, second class
1655–6 12 years old, first class
1656–7 13 years old, logic class
1657–8 14 years old, physics class

The regularity of the annual system of promotion is worthy of note.

His son, the Duc de Bouillon, was seven years old in 1675 when he was taken away from the women who had been looking after him and given to two Jesuit tutors 'in the interior of his home'. The Condé family was faithful to the Society of Jesus. At the age of eight he entered Clermont College, going into what might have been called the sixth class, seeing that it preceded the fifth, but which had no number: 'a room in which instruction was given to those children who were not fit to be put in a class'. Many had to be taught to read and write. Then he followed the cycle of classical studies at the rate of a class a year:

1676–7 8 years old, sixth class
1677–8 9 years old, fifth class
1678–9 10 years old, fourth class
1679–80 11 years old, third class
1680–1 12 years old, second class
1681–2 13 years old, first class
1682–3 14 years old, logic class
1683–4 15 years old, physics class

In the course of these three successive generations, each Condé finished his schooling a year later than his father. Condé entered the rhetoric class at eleven, his son at twelve, his grandson at thirteen. In this family which took its studies seriously and completed them at an early age, one sees that the pupils of each successive generation began and left school at an older age.

Henceforth the cycle of classes became more regular and approached the classic pattern of modern secondary education in France. For the eighteenth century, three examples will suffice: one aristocratic, one middle-

class and the last more popular and rural in character.

Cardinal de Bernis was born in 1715. In his memoirs, he describes his childhood in the rosiest colours, with that easy conscience which is typical of his time. 'The distinctive feature of my mind was reflection.' He lived in the country, where his father, a former captain, had retired because he had not been able to obtain a cavalry regiment. Between the ages of seven and ten, he used up five or six tutors his family had engaged for him: here we should note the development, compared with the seventeenth century, of education at home with a tutor. The first tutor was a medical student who soon left him 'to go and take degrees in the Faculty of Medicine in Paris'. He was followed by a seminarist who inflicted incredible penances on the boy: 'This pious eccentric was dismissed, and I passed successively under the domination of three or four other tutors who were either ignorant, brutal or licentious ... Without being more mischievous than other boys, I spent three years under the birch.' When he reached the age of ten he was sent to the Barnabites' college, at Bourg-Saint-Andéol in Vivarais, a little provincial college where he spent four years. At twelve he was tonsured (that was the usual age, when a boy was destined for the Church). At the same time his elder brother, who was destined for the army and was probably about fifteen, joined 'the King's pages [i.e. entered the Stable] to be trained', in accordance with the tradition of the academies, which were on the decline.

At the age of fourteen, Bernis reached the end of the grammar or humanities classes at Bourg-Saint-Andéol. Either the college had no rhetoric class or the Bernis family wanted to give the boy a more Parisian education; in any case, they sent him to Louis-le-Grand: 'I arrived at the Jesuit college in August 1729. I expected to enter the rhetoric class after the holidays; the prefect, having examined my capabilities, did not consider me worthy of entering the third class [the tuition given by the Barnabites of Vivarais must have seemed very inadequate to the Fathers of the Society]. My amour-propre was wounded by this judgement; I started studying so intensively, giving up hours of sleep, and reading and writing by moonlight, that after two months [presumably two months in the third class] I was allowed to be examined for the rhetoric class, and I was admitted to that class without any difficulty.' He adds: 'My amour-propre was responsible for another achievement on my part: I arrived in Paris with a southern accent; my schoolmates' ragging made me get rid of it in less than three months.'

He finished his year in the rhetoric class with a Latin discourse on the superiority of eloquence over philosophy. 'This discourse enjoyed a great success and caused a kind of schism between the rhetoricians and the

philosophers. A reply was made to my discourse. I asked permission to reply, but the Father Principal, fearing a worsening of this dispute, condemned me to silence. This quarrel finished with an exchange of blows. The philosophers were superior in strength, but not in numbers.' By this time, the first half of the eighteenth century, the class had become the organic educational unit, and the schoolboys were well aware of it.

Bernis does not say whether he studied philosophy for one or two years – probably two, because he was a cleric. He says only that on leaving school he sought entry to the Saint-Sulpice seminary, where his candidature was not accepted: the Church was becoming particular about the recruiting of priests, as a result of the increasing number of seminaries. Seminaries were coming to be regarded as the essential preparation for the ecclesiastical state.

Our second example of schooling in the eighteenth century is taken from the provincial middle class. Grosley was born at Troyes in 1718 into a family of lawyers: his father was an advocate, his mother the daughter of a municipal magistrate. As soon as he was out of infancy, his grandmother took charge of his education, but in practice it was the old family housekeeper who looked after him. 'At that time, as schoolmaster, tutor and preceptor I had an old housekeeper.' 'Although she could not read [she must have guessed, or rather remembered from the shape and order of the letters, the sense of familiar Bible stories], it was she who taught me to read from the Bible.'

Next, 'I went to learn the rudiments of Latin from an old schoolmaster': a former governor of the General Hospital of Paris who, on retiring to Troyes, had opened a little Latin school there. It seems that these Latin schools, few in number at the beginning of the seventeenth century, had subsequently multiplied. This preparation made it possible to skip the lowest classes in the colleges – classes which, moreover, sometimes did not exist. Thanks to this old schoolmaster's tuition, 'I entered college at the age of seven, starting in the fifth class.' The college in question was the Oratory at Troyes, which we know rather better than most, thanks to the preservation of its archives, and particularly its registers.

At the Oratory, Grosley followed the now regular cycle of a class a year as far as the rhetoric class. But he spent an extra year in two classes, first the rhetoric class, then the logic class (he does not mention the physics class). 'I had spent an extra year in the rhetoric class ... I was unsatisfactory in Logic' (on account of poor teaching). 'I spent another year in this class under Père Verdier, who enabled me to maintain my thesis at the end of the year.' This maintaining of a thesis at the end of one's philosophy studies – not to be confused with the examinations for the baccalaureate

and the doctorate in arts, which had become mere formalities, and infrequent formalities at that – represented the last survival of the medieval 'determination': the maintaining of the thesis consecrated the end of college studies for the better pupils.

Grosley's cycle was another extremely precocious cycle, for in 1729 he entered the rhetoric class at the same age as the Prince de Condé nearly a century earlier:

7 years old, fifth class
8 years old, fourth class
9 years old, third class
10 years old, second class
11 years old, rhetoric class
12 years old, rhetoric class repeated
13 years old, logic class
14 years old, logic class repeated

He left the Oratory at the age of fifteen after eight years of classical studies.

With Marmontel we enter a rural world, which the memorialist often covers with a varnish of sentimentality after the fashion of Greuze or Restif de la Bretonne: 'Oh, what a present Heaven gives us when it gives us kind parents!' – and an eighty-year-old grandmother 'sipping her wine beside the fire and remembering the good old days'.

Marmontel, born in 1723, was the son of a village tradesman. 'I had learnt to read in a little convent of nuns who were friendly with my mother ... A lady of gentle birth who for a long time had lived in retirement in this house of refuge, had had the kindness to take me in hand ... From there I went to a school kept by a priest from the city who, free of charge and from inclination, had dedicated himself to the instruction of children.' This was obviously a little Latin school of the sort which young Grosley went to in Troyes; but Marmontel presumably stayed there longer, for he did not go to college until he was eleven. His father had no Latin and could see no advantage in learning it. But his mother was 'eager that her eldest son at least should go to college': there is already something modern or 'nineteenth-century' about this case of a mother's influence at home and her role in the children's education and social progress, a province which had so far been exclusively paternal.

Marmontel's father gave in to his wife's insistence, and took his son on his horse's crupper to Mauriac. The boy was eleven years old when he started school, in the fourth class of the Jesuit college in the town; twelve

years old in the third and thirteen in the second; he reached the rhetoric class at fourteen. He then had to leave Mauriac College after some incident with his master, and after various adventures we find him as a 'master of studies', in other words a coach, at Clermont College in Paris, where he did his two years' philosophy; at seventeen he had finished his education.

The last in this series of biographies is a late eighteenth-century case taken from the provincial middle class which conveys the atmosphere of the last years of the ancien regime.

Jacques Lablée was born in a little town on the Loire, possibly Beaugency, between 1765 and 1772. His father, a sexagenarian married to a young woman of twenty-seven, ran a wine business. Jacques spent his first years with his brothers, in the care of a housekeeper who taught him to read from a Psalter: 'At the age of six, I was started on the study of Latin. Until then, church books were the only books I had read.' He spent six years in a little Latin school: this first stage of Latin tuition had become general in the eighteenth century.

At the age of twelve 'I was sent as a boarder to the seminary of M——, less than five miles from my native town.' In this seminary, not all the pupils were necessarily destined for holy orders. Here, in the years 1775 to 1780, we already have an example of the 'little seminary' which was to occupy an important place in the secondary education of the early nineteenth century and rival the colleges and *lycées* of the new educational system.

Lablée started in the fourth class at the seminary: coming from a Latin school, he was not afraid, he tells us, of the competition from his classmates. However he took a dislike to Latin, in which his masters 'wanted to initiate us to the exclusion of everything else'. There was a preference at that time for a more modern education. He even boasts of incompetence: 'Having reached the second class, I could not construe or translate my Latin authors except by laboriously consulting my dictionary.' (Does this mean that other pupils translated at sight?) He left the seminary at the end of the second class. 'I was fifteen years old when I studied rhetoric at the Oratory at Vendôme ... The next year I entered the seminary of O. [Orléans?] to study philosophy.' He was expelled for giving his master's favourite a thrashing and that was the end of his studies.

Because they are recorded in memoirs, the cases we have just been considering are, if not exceptional, at least rather out of the ordinary: the ordinary man does not write his memoirs. We are therefore dealing with examples of social successes, sometimes of a brilliant nature.

Taken in succession, starting in the sixteenth century, they enable us to follow the regularization of the school cycle. In the case of Thomas Platter,

the German-Swiss, in the early 1500s, the division into classes did not exist, and therefore neither did promotion from one class to the next. In sixteenth-century France the succession of classes existed but was not observed at all strictly. Boys passed quite naturally from the third to the first, or from the fourth to the first, or else started school late, like Bassompierre in the third class. The college had not yet entirely replaced the old traditions of apprenticeship.

In the seventeenth century, although these irregularities continued here and there, they became much rarer; the regular rhythm of a class a year became the general rule. A class was only very rarely skipped, and it often happened that a pupil spent an extra year in one of the higher classes, particularly the rhetoric class, because there was a tendency to prolong the period at school: the college with its classic cycle was beginning to take the place of the old forms of education by apprenticeship, at least in non-manual occupations. At the same time as the system of promotion from class to class was being regularized, a sort of hierarchy between the various academic institutions was established: from the little Latin schools to the lowest grammar classes in the small-town colleges, to the last grammar classes – the humanities and sometimes the rhetoric classes (in the big colleges, to the rhetoric class or the two years of philosophy) – with the sole reservation that the small-town colleges tried to keep their pupils and to provide a complete education like the rest.[4]

Finally, in the seventeenth century, with the academies, a post-scholastic education was created, at least for the young nobility. However, it did not survive in the eighteenth century. And since the Faculties of Law declined and were replaced by private lessons for would-be lawyers, the college remained the only general institution of collective education, the sole setting for a differentiated childhood and youth.

The ages of the pupils we have discussed vary a good deal over this period of two hundred years. However, the pupils are always precocious, not only from our modern point of view, but in comparison with the contemporary average, as we shall see shortly. We have come across pupils in the rhetoric class aged between ten and fourteen or fifteen: not a single one was over fifteen. Yet fifteen was the theoretical age given by English writers from the sixteenth to the eighteenth century for leaving grammar school and entering the university.

The biographical examples analysed above characterize certain aspects of childhood and youthful manners, and many of their features can be generalized. However, they give a false impression of the age structure of the colleges and their classes, and of the correspondence between ages and

4. Recounted by Père de Dainville in 1955.

classes. On this point at least – a point of capital importance – they need to be corrected by documents from another source providing statistics of a more average character: the registers in which the headmasters and masters of the colleges listed their pupils according to age and class. These registers, unfortunately, are fairly rare. Père de Dainville has published two in an important study, 'Effectifs des collèges et scolarités aux XVIIe et XVIIIe siècles': the registers for the 1618–20 period of the Jesuit college of Châlons and that for 1638 for the Oratorian college of Troyes (which Carré had already used in 1881). Finally the Manuscripts Department of the Bibliothèque Nationale has two registers for 1677 and 1692 from the Jesuit college of Caen, noted by Père de Rochmonteix in his monograph on the Henri IV College at La Flèche. These samples provide us with the material for four soundings which extend almost the whole length of the seventeenth century.

Let us examine first of all the demographic characteristics which remained constant in the seventeenth century. We shall be struck as soon as we look at these figures by the difference between the ages in these statistical samples and the ages of the biographical cases analysed above. All our young memorialists reached the rhetoric class between eleven and fourteen. Here the school population is situated at a higher age: there are no rhetoricians of eleven or twelve. There are only two of thirteen and three of fourteen; 91 per cent of the rhetoricians are over fourteen. In the light of this comparison, the precocity of our memorialists is seen to be an exceptional phenomenon. It is none the less significant for all that. It is as if precocity were a characteristic of brilliant careers, of social successes. It seems too to correspond to a sort of scholastic ideal of the late sixteenth century, since the age of our memorialists is the minimum age laid down by the *ratio studiorum* of the Jesuits of 1586: the rhetoric class at eleven like Père de Joyeuse of the Grand Condé.

In the second half of the seventeenth century the phenomenon of precocity seemed sufficiently remarkable, sufficiently characteristic of the most striking successes, to become a subject of study for the moralists. This was the case with the book by Baillet, *Les Enfants devenus célèbres par leurs études*, and that by Père Niceron, *Les Hommes illustres*. Baillet records a number of progresses similar to those we have listed. There was Melanchthon, who dedicated a comedy to Reuchlin at thirteen, 'qualified as a bachelor at fourteen and as a doctor at seventeen'. There was also Pierre de Lamoignon, born in 1555: 'His father provided him with a carriage for the journey to Italy ... he was only fifteen at the time' – and consequently eleven or twelve when he was in the rhetoric class. Justus Lipsius completed his studies at the Jesuit college at Cologne at the age of

Ages of the pupils at Caen College

1692 (end of year)	9	10	11	12	13	14	15	16	17	18	19	20	Total
5th class	2	9	19	24	17	15	12	5	1				104
4th class	1	3	11	20	35	24	19	15	2	3			133
3rd class		1	5	20	24	35	42	22	15	7			171
2nd class				1	3	10	18	21	15	3	1		72

Ages of the pupils at Caen College

1677 (end of year)	9	10	11	12	13	14	15	16	17	18	19	20
5th class	2	9	24	37	23	17	14	11	2			
4th class		1	6	12	23	15	40	22	2	4		
3rd class		1	3	8	15	34	37	25	28	6	2	1
2nd class					1	4	6	11	16	4	2	1
1st class					1		12	12	39	20	4	12

(+ 1 to 20 and 1 to 30)

Ages of the pupils at Châlons (1618–20)
(according to Père de Dainville)

| | Classes | | | | | |
	5th	4th	3rd	2nd	1st	Total
8 years old	4	4				8
9 years old	11	6	1			18
10 years old	28	18	1			47
11 years old	26	11	5			42
12 years old	29	12	2			43
13 years old	21	9	9	0	1	40
14 years old	26	15	8	3	2	54
15 years old	12	12	11	5	4	44
16 years old	5	15	8	6	2	36
17 years old	1	1	5	1	4	12
18 years old	2	5	6	2	2	17
19 years old		2	2	0	1	5
20 years old		3	5	4	0	12
21 years old		1	3	1	2	7
22 years old			1	1		2
23 years old			2			2
24 years old			1			1
	165	114	70	23	18	390

Ages of the pupils at Troyes (1638–9)
(according to Père de Dainville)

	Classes					
	5th	4th	3rd	2nd	1st	Total
9 years old	3					3
10 years old	7					7
11 years old	12	1	1			14
12 years old	28	4	2			34
13 years old	21	5	5			31
14 years old	19	15	6	3		43
15 years old	14	13	14	16		57
16 years old	4	15	14	16	4	53
17 years old	1	1	7	10	5	24
18 years old	3	2	11	16	10	42
19 years old	1	3	5	1	7	17
20 years old	0	2	0	3	1	6
21 years old	0	1	0	1	5	7
22 years old	1	1	1	0	3	6
23 years old	0					0
24 years old	1	1				2
	115	64	66	66	35	346

fourteen. Pieresc also left the Jesuits at fourteen after completing his philosophy studies; at fifteen he went to an academy 'to learn to fence, ride and dance'. Then there was the young rhetorician of thirteen or fourteen, a student at Toulouse, who wrote a general historical treatise. According to Père Niceron, Raymond Merille 'worked with such rapidity that he had completed his studies at the age of fifteen and embarked on the Law when he was sixteen'. François de Clugny, born in 1637, 'entered the rhetoric class at the age of thirteen and at fourteen studied philosophy at the Oratory'.

There is a phrase of Baillet's which conveys very well the idea people had of precocity at school in 1688: he refers to children who 'by twelve or thirteen had done with the ordinary college course by means of extraordinary activity'. Whether this was the result of talent, as in the case of Descartes, or of forcing, as with the Condés, precocity implied a superiority which opened the way to a great career. That is why, if it was rare among the average run of schoolboys, it was common among people who had 'arrived'. And this is easy to understand if we remember that originally – and often still in the late sixteenth century – many of the posts at court were not occupied by people who had completed a full course of studies but by people who had simply served an apprenticeship, sometimes com-

bined with a brief stay of one or two years at a college. There could not be any excessive difference of age at the start in a period when, particularly in careers connected with the army, old age and incapacity began very early, before forty, and when the duration of active life was very short indeed. Only pupils who had finished their studies at a very early age could compete with the 'apprentices'. Consequently if, as we shall see later on, there occurred a relative ageing of the school population, this ageing process affected the humbler classes most of all, while on the other hand the medieval habits of precocity were maintained longest in court circles.

Though they include few cases of precocity, our registers reveal an impressive number of old pupils. In the fourth class at Troyes, the over-eighteens represent 5 per cent of a total exceeding a hundred, conjuring up a strange sight for our modern eyes of a class in which young men between nineteen and twenty-four sat with children between eleven and thirteen! In the third class at Châlons, the proportion of over-eighteens reaches 20 per cent, including five aged twenty, three aged twenty-one, and two aged twenty-three. Similarly the ages of seventeen and eighteen were spread out over all the classes. At Caen in 1677 we find as many pupils of eighteen in the fourth class as in the second (but the fourth class is three times as large as the second); at Troyes, more pupils of eighteen in the fourth and the third than in the second and the first. On the other hand, the ages between ten and fifteen tend to be concentrated in the grammar classes. This high proportion of old pupils in nearly every class from the fifth up to the first is the basic anomaly which separates the colleges of the ancien regime from our typical present-day secondary school. Our modern sensibility is revolted by this mixing of students and schoolboys, of young boys and adolescents in the same class. This revulsion was foreign to the seventeenth century, and even to the first half of the eighteenth.

Who were these old pupils? The oldest, according to Père de Dainville, were usually people tardily taking up a vocation, young monks from near-by abbeys who came to learn Latin in order to embark on the study of theology. Nobody hesitated to mix this tardy evening-school clientele with the mass of children pursuing their normal school studies.

But these young men of twenty were not always those who were late in preparing for a vocation. The Chevalier de Méré is an example of a pupil who was old because his education was prolonged, which was probably not exceptional. It is known that the Chevalier de Méré imposed himself on court and town, at the beginning of Louis XV's reign, as the arbiter of good manners, conversation and etiquette. Though he could

not be described as a great success, he was not a complete failure either. He was born in 1607. He puts into the mouth of one of his characters a reference to his own youth, in which he condemns the disadvantages of an excessively long schooling: 'In the past I studied more than I would have wished, because I had a father who, not having studied [although he was a nobleman: an example of a direct apprenticeship in his station in life], ascribed his lack of success in various ventures to his ignorance of the humanities. This obliged him *to leave me at school until I was twenty-two,* and after I had left school I discovered from experience that apart from Latin, which I was glad to know, everything I had been taught was not only of no use to me but was positively harmful.' We need not pay any attention to this criticism of school education, criticism made by every seventeenth-century gentleman, and which did not prevent him from sending his children to college. Let us consider simply the indications of age given by the author. Méré entered the Jesuit college at Poitiers when he was about nine or ten. He left at the age of twenty-two after a stay of twelve years or so, starting in the sixth or the fifth class. This stay implies an average of nearly two years in every class, and we must assume that time and again he had to spend another year or another semester in the same class. We have come across several instances of this sort among the memorialists, and also in the case of Descartes. In these cases, spending another year in the same class was not always regarded as a sanction: and Méré tells us himself that he was considered a good pupil – 'At the age of seventeen I used to hear people saying: "There is an excellent young man. I should like my son to be like him."' Generally speaking, it was considered perfectly legitimate for the average duration of a college education to be over seven or eight years, depending on whether it started in the sixth or the fifth class, and including two years' philosophy. Baillet in his book, *Les Enfants devenus célèbres par leurs études,* gives this definition of French practice in this respect: 'This is what the system and practice of the University of Paris and the other French colleges have been until now: a course in the Humanities [in the widest sense, including grammar and rhetoric] and a course in Philosophy generally constitute the entire occupation of our young people for nine or ten years' – in other words, from one to three years longer than the duration of annual classes. Some of the twenty-year-old rhetoricians in our catalogue must have been pupils who were kept on at school at the request of parents who considered a long schooling the best education.

There must have been a third category of old pupils, in addition to that of the tardy vocation and that of the extended schooling. Among the twenty-year-old rhetoricians some had entered the lower grammar classes

when they were about fifteen or sixteen, and were not necessarily destined for the Church. They usually reached the rhetoric class when they were over twenty. At Caen, 7 per cent of the pupils in the fifth class were sixteen, the age when most pupils in the 1930s finished their schooling. We can guess which social class produced these adolescents who started school at such a late age. The sculptor Girardon's father was a brass-founder. This artisan wanted his son, who was born in 1625, to be an attorney, showing exactly the same sort of ambition as the modern railway worker or miner who wants his son to be a schoolmaster or an engineer. There is nothing anachronistic about this comparison: despite the lapse of time since the end of the seventeenth century, it has not changed either the desire to gain entry to a higher class by means of a post which confers middle-class or noble standing, or the means of this ascension, namely schooling. What has changed is the age limit of this schooling. Nowadays an ambitious father will try to get his son into a secondary school at the start. If he waits too long, he will be too late, for a boy who has passed the normal age is not allowed to enter the *lycée*. There is therefore a legal or traditional age limit in our contemporary society, beyond which admission to the lower classes in a secondary school is impossible.

The idea of an age limit was entirely unknown in the seventeenth and eighteenth centuries. It was at the age of sixteen that Girardon's father sent his son (born in 1625) to start school in the sixth class, at a time when the rudiments were still taught in the sixth and certain pupils learnt to read in that class. Probably young Girardon could already read and write, something he could have been taught from the Psalter by an old priest in a little French school, but we cannot be certain and it is not indispensible for us to assume this. We may quite reasonably suppose that he did not wait until he entered the sixth class at the age of sixteen to make himself useful: he probably helped his father or another artisan in the workshop and served his apprenticeship. Serving a manual apprenticeship until sixteen did not pledge his future, since at that age he could start his schooling again with the rudiments of grammar: an old medieval habit which we have come across in the case of Thomas Platter in the early sixteenth century. At that time there was much more elasticity than there is today in the organization of life, even though that life was shorter and the various ages were crowded closer together. If Girardon had stayed at school, he would have reached the rhetoric class when he was about twenty. Some of the pupils among the old ones in our registers must have been in this position. In fact he left school at the end of his year in the sixth class to apprentice himself to a carpenter; the two cases must have been common – that of pupils who continued their schooling, and that of late starters

like Girardon who spent only one or two years at school before starting or resuming an apprenticeship.

It is easy to understand why the living conditions of the time made it impossible for artisans and labourers to send their children to college early in life: they had to wait until the boy was old enough to manage by himself in the town, away from the family, with almost no resources except for a little food brought along now and then on market-day: at a tenderer age he would have had to be provided with better lodgings and given greater (and consequently costlier) attention. But public opinion did not oppose this delay in starting school.

Although they seem more common and widespread than the cases of precocious schooling, which are not recorded in our registers, the cases of tardy or extended schooling represent only a small proportion of the total school population. Let us now examine the ages nearest to the average cases.

Let us note first of all the variations in numbers from one class to another. Generally a drop in numbers is registered after the fifth class, and another after the third, due to the departure of pupils of passage such as Bonneval or Girardon. Sometimes there is a rise in the first class (Caen, 1677), caused by the arrival of pupils from other schools without higher classes. The oscillations due to departures would be even more pronounced if they were not offset by the entry into classes all the way up the school of pupils of all ages, for admission was not restricted as it is nowadays to the bottom class.

In these circumstances, it is easy to see why there was not one predominant age in each class, but several.

In the fifth class at Châlons in 1618 there is no age group representing more than 20 per cent of the total number of pupils in the class. Five groups going from ten to fourteen are close together:

10 years old 16 per cent
11 years old 15 per cent
12 years old 17 per cent
13 years old 12 per cent
14 years old 15 per cent

Apart from the spread of the ages, we can also note a drop between two successive age groups: the thirteen year olds in relation to the twelve year olds and the fourteen year olds. These characteristics are to be found everywhere: not only is there a considerable distance in every class between the extreme ages (eight and eighteen, nine and nineteen), but

the demographic kernel is made up of four or five more or less equal age groups. On the other hand, this astonishing heterogeneity in the population of each class is offset by the minute difference between the various classes: the same ages are to be found, with very slight variations, in all the classes. To consider again Châlons in 1618, the fourteen-year-old group constitutes 15 per cent of the fifth class, 13 per cent of the fourth, 11 per cent of the third, 4 per cent of the second. In each of these four classes there is an appreciable proportion of pupils of fourteen, fifteen and sixteen.

While the class had established itself in the sixteenth century as the structural unit of the college, as a basic element of differentiation between a pupil's years of study, the connection between age and class still remained very vague or loose.

Between the beginning of the seventeenth century and the beginning of the nineteenth century, the demographic structure of the school class changed completely, and we are now going to try to discover the significance of this evolution, even though it would be rash to make any dogmatic judgements on the basis of a documentation which is not only scanty but above all irregular and spasmodic. For the seventeenth century we used the registers of Châlons for 1618-20, of Troyes for 1638-9, and of Caen for 1677 and 1692. For the eighteenth century we shall be using a very incomplete document: the register of the pupils at Louis-le-Grand, which after the departure of the Jesuits had become a boarding-school and an institute for scholarship boys. Its drawback is that it does not always give both the pupil's age and the class in which he started school, when it is the coincidence of these two indications which interests us. This source has already been used by Dupont-Ferrier in his monograph on Louis-le-Grand.

The second document we are going to add to the series is much more precise: the register of the pupils at Sainte-Barbe in Paris, in the first years of the nineteenth century.[5] After a good many changes Sainte-Barbe had become a boarding-school which either sent its pupils to attend classes at a *lycée* or else gave them tuition on the premises, in what is called 'internal classes'. The Sainte-Barbe registers are kept in the Seine Archives. They consist of lists of pupils, divided into classes, with one paper for each pupil on which are entered his marks for the year, and copies of the letters in which the masters reported to the parents on their pupils' progress and behaviour. Unfortunately we do not have the pupils' ages for the first years of the century: nobody bothered to record them. Later, though, the

5. We wish to thank M. Fleury, now Director of the École des Hautes Études, for allowing us to consult these catalogues.

school authorities took care not to leave them out. I have chosen the school year 1816–17.

The following table and the corresponding graphs enable us to compare the proportions of the various ages in the classes scaled up to a total of one hundred.

One change can be seen straight away: the disappearance between the seventeenth century and the nineteenth century of the extremely precocious and the extremely tardy cases.

The indications of precocity diminish fairly soon and fairly quickly. The proportion of nine year olds in the fifth class, of ten year olds in the fourth, and of eleven year olds in the third drops sharply between Châlons in 1618 and Troyes in 1638. Then it remains roughly constant until the end of the seventeenth century. The ten year olds in the fifth class go from 16 per cent at Châlons to 6 per cent at Troyes, and they stay at 6 per cent and 8 per cent at Caen in 1677 and 1692. The eleven year olds in the fifth class represent about 15 per cent of the class throughout the seventeenth century. In the register of admissions to Louis-le-Grand for the years 1760 to 1770, there are very few cases of precocity: I have noted only one case, a child of thirteen and a half in the second class. Among the pupils starting school in the fifth class whose age is given, the youngest is thirteen years old. The drop in precocity which one suspected occurred in the course of the eighteenth century is confirmed by the figures for 1816–17 at Sainte-Barbe. The ten year olds in the fifth class, who still came to 8 per cent in 1692, disappear completely in 1816; the eleven year olds in the fifth go from 15 per cent in the seventeenth century to only 4 per cent in 1816.

It struck Baillet as 'strange' in 1688 that there should be children who had 'done with' their schooling by twelve or thirteen. Strange but rather admirable. On the other hand, at the beginning of the nineteenth century precocity was regarded with suspicion.

The masters at Sainte-Barbe took care to avoid promoting pupils who were too young for their classes. Thus of a pupil in the sixth class aged eleven years seven months, whose father wanted him to go up into the fifth, we find the masters writing: 'We consider that such a rapid rise would gravely prejudice his progress. Let us have a solid sixth rather than a mediocre fifth.' Another pupil, at thirteen and a half, was among the youngest in a third class in which 85 per cent of the boys were fourteen, fifteen and sixteen (as against only 1 per cent aged thirteen). The masters did not appreciate his childish high spirits in the midst of classmates who were two or three years older (and our modern experience tells us that at the age of thirteen a difference of two or three years counts a great deal):

'He rather likes the quarrels and little civil wars between pupils, interfering in matters which do not concern him and trying to turn private arguments into public disputes. He likes fighting and boxing: this is unworthy of a big boy.'

With regard to a pupil aged thirteen years ten months who had somehow got into the second class, the masters write: 'The extreme frivolity of this pupil ... the habit of chattering [do not mark him out for a class such as this] ... judging by his age, he should have been kept in the third class.' This pupil would spend another year in the second.

The masters hesitated to promote a pupil aged fourteen and a half from the third class to the second: 'The third is a sufficiently advanced class, especially as one comes closer to the end of the school year; judgement is called for, and the imagination begins to play its part. *The youth of this pupil means that his faculties cannot be sufficiently developed.*' Hence-

Ages of the pupils at Sainte-Barbe (1816–17)

	8th 2nd div.	8th 1st div.	7th	6th 2nd div.	6th 1st div.	5th	4th	3rd	2nd	1st	Total
20											
19									1	1	2
18							1		2	3	6
17								3	9	11	23
16						1	7	15	17	10	50
15					1	8	16	21	7	2	55
14			1	7	7 = 14	13	15	16	2		61
13	1	3	2	4	3 = 7	10	14	4	1		42
12	2	3	9	4	8 = 12	15	9				50
11	4	3	9	4	12 = 17	2	1				35
10	8	5	4								17
9	12	9	7		1						29
8	8	1	1								10
7	4										4
6	1										1
	40	24	33	19	32	49	62	60	39	27	385

forth, it would be recognized that there was a close connection between age, capacity and school class, and it would be considered inadvisable to modify this conection, especially in favour of children who were too young.

If the child prodigies disappeared in the course of the eighteenth century, the old laggards had a harder time of it. They were still accepted

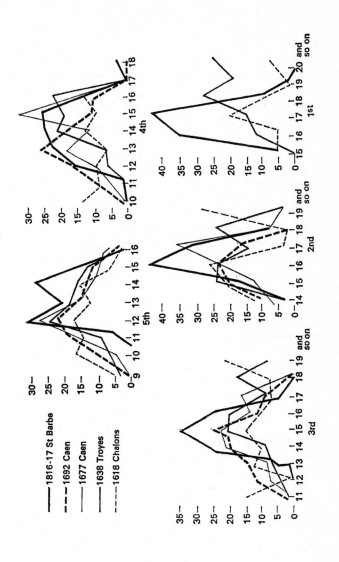

1816-17 St Barbe
1692 Caen
1677 Caen
1638 Troyes
1618 Chalons

without hesitation at a time when precocity was already regarded with suspicion. The category of pupils between nineteen and twenty-one remained, at least in the second class and the rhetoric class, throughout the ancien regime. True, their presence in the grammar classes was considered rather more exceptional: the proliferation of little Latin schools in out-of-the-way rural areas had helped to reduce the overcrowding of the lower classes of those colleges which provided a complete course of tuition. But these colleges recovered their contingent of twenty year olds in the second class or the rhetoric class. The second class at Caen in 1677 included 19 per cent who were over nineteen. In the registers of admissions to Louis-le-Grand in the second half of the eighteenth century, there is not a great difference to be recorded in this respect; high ages continue to be common: eighteen, twenty, twenty-three in the rhetoric class; eighteen, nineteen, twenty in the second class; eighteen, nineteen in the third class; seventeen in the fourth class. At the beginning of the nineteenth century, when people were giving considerable thought to the problems of education, in connection with the reorganization of secondary teaching and religious education, the specialists remembered the old collegians who had peopled the somewhat variegated classes of the ancien regime. Thus the Abbé Liautard, the founder of Stanislas, wrote in 1829 in a memoir on 'public education in France': 'A college is not an Academy. We must take care not to repeat the folly of the old University of Paris which, in order to compete more easily with the Jesuits [?], maintained at considerable expense pupils of twenty-five in the sixth class and forty year olds in the rhetoric class.'

The Abbé Liautard's irritation proves that at the beginning of the nineteenth century this mixing of the ages was no longer tolerated. The old laggards disappeared completely from the grammar classes at Sainte-Barbe. A few isolated cases, aged nineteen or twenty at the most, remained in the second and first classes. But that could also be put down to a modification of the curricula for the rhetoric class. At that time there was no longer any trace of a philosophy class at Sainte-Barbe, and it was in the rhetoric class that the older pupils supplemented Latin or French rhetoric with lessons in logic, at the same time as they were preparing for the entrance examination to either the Law School or the Polytechnic. Be that as it may, the masters at Sainte-Barbe had no patience with these bearded, loud-mouthed pupils, who brought into the college the free and easy ways of young men. This is what they thought of a humanist aged eighteen years three months: 'Whatever his age may be, his youth is premature. *His beard makes him look out of place on the college benches,* and his language, which is all too often indiscreet and licentious, shows

signs of worldly emancipation.' This pupil would leave school. We do not know the age of another humanist of 1807, but we find his masters writing of him: 'This pupil is rather old in his studies.' As a result there could be no question of allowing him to go up into the rhetoric class: 'I beg you, Monsieur,' his master wrote to his father, 'to let me know what station of life you mean him to occupy, what your wishes and intentions are ... His age does not allow him to waste time in study!' The heyday of the old college boys was over: that of the university student was soon to begin.

Let us now see how the age structure of the classes was modified. However imperfect and spasmodic our sources may be, a comparison of the curves of the percentages of age per class reveals certain interesting tendencies.

The first thing to strike us is the difference in speed between the seventeenth-century curves and those of 1816–17. Let us consider for a moment the seventeenth-century curves: we find them indicating phenomena we have already noted. They present two common characteristics: the general spread of the curve and the positioning of several maxima. It is in the fifth class that the spread is most pronounced: in the four seventeenth-century cases considered, five ages go beyond 10 per cent. This means that in the four seventeenth-century fifths, the bulk of the class is aged between ten and fifteen, the under-tens and the over-fifteens representing less than 10 per cent of the total. Except in 1618, where the curve remains very flat, the curves of the other classes are not spread out to the same extent: notably in the humanities of 1638 and 1677, where three ages – instead of five in the fifth – go beyond 10 per cent. One might conclude in favour of a certain demographic concentration in the higher classes if another phenomenon did not sometimes contradict this: the high proportion of older pupils aged between eighteen and twenty.

The admissions registers at Louis-le-Grand suggest that the spread of the ages was also maintained in the eighteenth century. Pupils are between thirteen and sixteen in the fifth and the fourth, between thirteen and eighteen in the third, between thirteen and nineteen in the second, and between fifteen and twenty-three in the rhetoric class.

In these very spread-out curves, the positions of the maxima are very revealing. Sometimes it happens that there is as it were no maximum: that is the extreme case in 1618 in the fifth, fourth and third classes.

When the maxima are very pronounced, several features become apparent: first of all, the coincidence between the maxima of the curves of different years and regions. Thus all the curves of the fifth class culminate at the age of twelve, while those of the third class culminate at the age of

fifteen, incidentally coming to a sharper point. This statistical maximum approaches the age which will become the average age of the class in the nineteenth century: it indicates a tendency of the future rather than a characteristic of the present, as happens more often than is generally supposed with so-called average cases.

It may also happen that the maxima of different curves do not coincide, like those of the fourth classes: the maxima of the fourth-class curves go from thirteen in 1692 to seventeen in 1638 (not counting the peculiarly flat curve of 1618 which has three maxima: ten, fourteen and eighteen). This means that from one time to another, or from one region to another, the largest fraction of a fourth class – more than 20 per cent of the class – can vary between thirteen and seventeen.

In the higher classes, in the third, second and first, another phenomenon appears: the splitting up of the maxima. True, it often happens that out of three successive ages, the one in the middle varies: the irregularity of admissions, due to economic conditions, and indifference to the connection between age and class, are sufficient to account for this undulation of the upper section of the curve. But here I am referring to a more distinctive phenomenon. We have already noticed that the curves of the third and the higher classes were more pointed than those of the lower classes. But this is true only of that part of the curves corresponding to the ages from thirteen or fourteen to seventeen or eighteen. Now another curve often continues the first one on its way down, producing a rise towards a second maximum of eighteen, nineteen or twenty. This second maximum corresponds to a new intake, different from that of the annual promotions, and quite considerable: the intake of tardy pupils, who had sometimes come from other Latin schools.

Let us turn now to the Sainte-Barbe curves for 1816–17; to what extent do they differ from those of the seventeenth century, whose characteristics, or so at least we suppose, remained roughly the same in the eighteenth century?

Generally speaking, it seems at first glance that the Sainte-Barbe curves are more pointed and go higher, in other words that the ages around the maximum represent a larger proportion of the total number of pupils. Thus in the fifth class, three ages go beyond 20 per cent as compared with a single age in the seventeenth century. In the third, second and first classes, two or even three ages go beyond 25 per cent whereas no age reached this level in the seventeenth century. The population extends over a smaller number of years and tends to concentrate around a characteristic age.

However, this rise and this regularization of the nineteenth-century

curves are not equally pronounced for every age. In the fifth and fourth classes, they still have a bell-like shape which retains something of the spread-out appearance of the ancien regime. In the fourth class, there are almost as many pupils of seventeen as of twelve. In the fifth class, four ages each represent over 15 per cent of the total. It is only from the third class upwards that the modern characteristics predominate. In the third class, more than 80 per cent of the pupils are fourteen, fifteen or sixteen; in the second class, sixteen and seventeen.

Thus, at the dawn of the nineteenth century, the correspondence between age and class reached its full rigour only in the higher classes. This would not be the case for long. But I do not think I am mistaken in suggesting that in the mid-twentieth century the situation is reversed: the pupils in the sixth class set off at a fairly homogeneous age, imposed by the competition between the candidates for admission to a secondary school, while failures in school examinations and in the baccalaureate produce set-backs and result in more pronounced age differences in the final classes.

However, it must be admitted that even in the lower classes the masters disliked this mixing of the ages, although they could not entirely eliminate it. In 1861 they announced that they intended to create a new section of the sixth class which would be reserved for the laggards, who had previously been mixed up with their younger classmates: 'We are going to form a *backward sixth* ... to give these pupils special tuition corresponding to their needs and capabilities ... a class composed almost entirely of children who are very backward in their studies although advanced in age.'

A final question faces us now. We have just seen that at the beginning of the nineteenth century the population of each class concentrated around a specific age. Does the characteristic age which was fixed at that time represent a rejuvenation or an ageing, either in comparison with the vague traditions of the ancien regime or in comparison with the stricter usage of the early twentieth century?

Generally speaking, the class curves for 1816 cut across the curves of the ancien regime in such a way as to leave the lowest and highest ages outside their scope. They tend to bring their maxima (which are very pointed) close to the flatter, gentler maxima of the ancien regime. It is as if the average ages of the ancien regime, which were not particularly characteristic at their time and which only a fairly abstract statistical analysis could determine, became the predominant specific ages at the beginning of the nineteenth century. However, this phenomenon of the coincidence of the old maxima and the new did not occur to an equal degree in the lower and higher classes.

We have noticed that in the lower classes in the seventeenth century the maxima were often split up and always hard to distinguish from a gentle curve. The 1816 curves are more pointed but are further down than those of the seventeenth century, and their maxima correspond to the lower maxima of the seventeenth century. Let us take the fifth classes as an example. The fourteen year olds in the fifth classes of the seventeenth century represent only 12 to 16 per cent of a younger population, which culminates at the age of twelve. In 1816, the twelve year olds are still at the top, seeing that they reach 30 per cent, but the fourteen year olds remain almost as numerous and reach 28 per cent. The same is true of the fourth class, with its 1816 maximum of fifteen. We must therefore recognize, in the first grammar classes, an increase in the average ages in comparison with the ancien regime.

This demographic composition gives us twelve to *fourteen* for the fifth class and thirteen to *fifteen* for the fourth class, with a maximum of fourteen and fifteen in each of the two classes. The fifteen year olds of the fifth class would normally enter the first class at eighteen, and all being well would become bachelors at nineteen and would get through their philosophy or their mathematics at twenty. Ages such as these must seem advanced to our contemporaries too, at least to those who, like the author of this book, finished their secondary schooling before 1940, for I believe that a new ageing process has since taken place, due this time to the competition which has transformed the baccalaureate examination, devalued though it is, into a sort of contest. But rivalry of this sort was as foreign to the ancien regime as it was to the nineteenth century and the early twentieth century – at least to this degree. Study of the ages in the lower classes thus enables us to conclude in favour of an ageing at the beginning of the nineteenth century in comparison with the seventeenth century and the late nineteenth–early twentieth century.

If we consider the Sainte-Barbe statistics, we find that this ageing process stops with the third class. In the curves from the third class to the first, the extremely pronounced maxima of 1816 coincide with the first maxima of the seventeenth century (the second maxima of the seventeenth century disappear with the category of the old pupils aged twenty or over, which they depict in graphic form). This situation gives us: fourteen-*fifteen*-sixteen in the third class, *sixteen* and seventeen in the second, and sixteen-*seventeen* in the first – ages very close to those of the nineteenth and twentieth centuries.

These data have a certain value. It is not certain that they were very representative of either the school population or of the mentality of the time; we must not forget that Sainte-Barbe was a boarding-school whose

numbers dropped sharply in the higher classes. On the other hand, a good many indications suggest that the ageing noticeable in the early school ages was often maintained. Even at Sainte-Barbe, the masters, in their reports to their pupils' parents, revealed a mental attitude in favour of a certain ageing. We know that they were definitely hostile to precocity. We have also seen that like all the pedagogues of their time they disliked the presence in their classes of grown men. On the other hand, they displayed a marked preference for pupils whom we would nowadays consider too backward. Of an eighteen year old in the second class we find them writing: 'Excellent at his studies, in which he is doing well.' And of his classmate of seventeen and a half we are told: 'It must be remembered that he was put in a class for which he was too young and too weak' – too young for the second class at seventeen and a half!

Here we have a sixteen year old in the fifth class. His masters consider that he has risen too fast: 'Always an interesting pupil ... His papa wanted his son to skip a class; we complied with his request [with a bad grace]. What happened? When he entered the fifth he lacked the necessary maturity to live up to this class.' This we find astonishing: today we would say either that he is incapable or that he must make up for lost time and rise quickly.

But the masters at Sainte-Barbe approved of pupils' spending another year in a class: they often recommended this, and if certain parents put up what was already a modern resistance to the idea, many anticipated the pedagogues' intentions: 'Congratulations on the decision to make him spend another year in the rhetoric class.' Pupils spent extra years in the higher classes above all, and this was even recommended. In 1807 (a year for which the Sainte-Barbe registers do not give any ages) it was recorded at Sainte-Barbe that 'the rhetoric class of the lycée is crowded with veterans [note the word 'veteran', transferred at this time from military to academic jargon].' Nowadays a critical view would be taken of the standard of a secondary-school class in which old pupils were in such a majority. The opposite opinion was held in 1807: 'This strengthens it [the rhetoric class] with experienced pupils.' But these 'veterans' of the lycée, not being boarders at Sainte-Barbe, do not appear in our statistics.

However, some of the veterans showed signs of weariness, and their worthy master had to admit that this weariness might be justified: 'The pupil shows a certain reluctance to spend a *third* year in the rhetoric class. We consider that this would in fact be a waste of precious time for him, since he has nothing more to learn in this part of the school.' The presence of these advanced – or retarded – pupils accounts for the trouble which conscription caused in the lycées and colleges, as national service would

today if students were not usually deferred. There was still a certain confusion between two notions which would henceforth be quite distinct: that of the schoolboy and that of the student. It is true that in the early nineteenth century the universities did not yet attract a large number of students, and post-scholastic education was almost as neglected as under the ancien regime. Only later, at the end of the nineteenth century, did preparation for the licentiate's degree or the doctorate of the Faculties of Law and Medicine, which had become the essential qualification for a career in the liberal professions, compel pupils to cut short the duration of their secondary studies.

Consequently, if the ages of the higher classes at Sainte-Barbe were not as advanced as those of the lower classes would lead us to expect, this cannot be put down to the masters' policy. On the contrary, the masters tended rather to let their pupils grow old at school, and the masters' mentality seems to have matched the spirit of their time.

Other documents show that people were aware that pupils' ages in the first third of the nineteenth century were more advanced, at least in comparison with the second half of the same century. Witness F. Bouquet's recollections of his childhood and of his schooldays at Rouen *lycée* about 1830: 'At that time *pupils started in the sixth class two or three years later than today*, before reaching their thirteenth year', in other words between twelve and thirteen. 'The complete course of study ended at about nineteen or twenty [which would correspond to the maxima of fifteen in the fourth class at Sainte-Barbe]. A bachelor aged under sixteen would have been a phenomenon which would not have occurred to anybody.' This ageing may account for the mutinies which became fairly common in the first half of the nineteenth century, coinciding moreover with a stiffening of discipline and an extension of the boarding system.

It therefore seems that the disappearance of the excessively precocious cases of the sixteenth and early seventeenth centuries, and of the excessively retarded cases (up to the end of the eighteenth century), corresponded to a concentration of the school populations around ages which were higher than both the average ages of the ancien regime and the typical ages of the late nineteenth and early twentieth centuries.

From these analyses, we can deduce some salient points.

The precocity of certain cases in the sixteenth and early seventeenth centuries struck us as a survival of the practice in medieval schools, but also of the general customs of apprenticeship, in which the ages were mixed and a premature skill caused no more surprise than the exceptional nature of certain gifts; we also noticed that the more brilliant careers, those of our memorialists, were characterized by a certain precocity, and

this precocity remained for some time an attribute of success. However, public opinion soon ceased to admire child prodigies, in the course of the eighteenth century at the latest. The dislike of precocity marks the first breach in the lack of differentiation between children's ages. The educational policy which eliminated children who were too young, however gifted they might be – by refusing to admit them, or more often by putting them in the lowest classes, or again by making them spend two years in the same class – reveals a new distinction between an extended infancy and school age. Until the mid-seventeenth century, people tended to stop infancy at the age of five or six, when a boy would leave his mother, his nanny or the servant-girls; at the age of seven he could go to college and even start in the fifth class. Later on, school age, or at least the age of entry into the three grammar classes, was postponed until the child was nine or ten. It was therefore the first ten years which were pushed clear of college life. The result was that an infancy lasting until nine or ten was separated from a period at school beginning at that age. The reason most commonly advanced to justify the postponement of admission to school was the weakness, 'imbecility' or incapacity of little children. It was rarely the danger incurred by their innocence, or at least this danger, when it was recognized, was not limited to infancy.

The dislike of precocity therefore marks the differentiation by the college of a first section: infancy extended to the age of ten.

But if infancy was segregated in this way, the old mixing of the ages continued in the seventeenth and eighteenth centuries for the rest of the school population, with children between ten and fourteen, adolescents between fifteen and eighteen, and young men between nineteen and twenty-five studying in the same classes. Up to the end of the eighteenth century, nobody thought of separating them. Even at the beginning of the nineteenth century, although the grown men, the 'bearded ones' of over twenty, were excluded for good, the presence of backward adolescents in college aroused no opposition, and the promiscuity of widely separated age groups did not shock people, provided that the youngest boys were not exposed to it. Indeed nobody felt the need to distinguish childhood beyond the age of twelve or thirteen from adolescence or youth. These two age categories still remained confused: only later in the nineteenth century would they be separated, thanks to the spread of further education in the middle classes. Under the First Empire, even conscription, which was easy for the middle classes to avoid, did not break up this long age-span in which our modern distinctions were not yet recognized.

It will be noticed that the tradition of not distinguishing between childhood and adolescence, a tradition which disappeared in the middle classes

in the course of the nineteenth century, still exists today in France in the lower classes where there is no secondary education. Most primary schools remain faithful to the old practice of simultaneous tuition. Once he has obtained his school-leaving certificate, if he does not go to a technical school or an apprenticeship centre, the young artisan goes straight into the working world which still ignores scholastic age distinctions. And there he will be able to pick his friends from a far wider age group than the very restricted span of the *lycée* class. Late childhood, adolescence and early maturity are not opposed as they are in middle-class society, conditioned by the habits of secondary and higher education.

This period of childhood and adolescence was distinguished thanks to the steady though tardy establishment of a connection between age and school class. For a long time, in the sixteenth and even in the seventeenth century, this connection remained very vague. The regularization of the annual cycle of promotions, the habit of making all the pupils go through the complete series of classes instead of only a few, and the requirements of a new system of teaching adapted to smaller, more homogeneous classes, resulted at the beginning of the nineteenth century in an increasingly close correspondence between age and class. The masters then got into the habit of making up their classes to fit in with their pupils' ages. The age groups which had hitherto been confused began to split up in so far as they corresponded to different classes, for since the end of the sixteenth century the class had been recognized as a structural unit. But for the college and its living cells, the middle class would not attach the importance it does to the slightest differences in age between its children, and would share in this respect the comparative indifference displayed by lower-class society.

Chapter 10
The Progress of Discipline

The statutes of the University of Aix at the beginning of the fifteenth century enable us to witness the initiation of a 'novice', or of what we would now call a freshman. The admission of a new student was an important occasion: in every 'nation' a promoter was appointed annually to organize it. The freshman had both to pay a tax and to offer a banquet to some of his companions and masters; the beadle, the promoter and the rector – who at that time was a student – also attended the banquet. If he tried to avoid this obligation he ran the risk of purging his noviciate *in studio*, in the schoolroom, 'with a book on his behind in accordance with custom and tradition', and no doubt with other torments which the document fails to mention.

After the meal the purge of the freshman took place which turned him into a full-blown student. In Germany, according to R. F. Seybolt (1921) and Rashdall (1895), the freshman was washed, confessed and dressed, in a sort of crossing-the-line ceremony. At Aix every guest, starting with the promoter armed with a frying-pan, gave not more than three blows *supra anum aut femora bejonarum*: the ladies present could obtain a mitigation of the penalty. The official document obviously tries to tone down the ragging which often must have been more brutal than this and accompanied by licentious scenes. Certain universities, such as that of Vienna, went so far as to forbid practices known for their violence and immorality: the statutes mention debts, extortions, wounds and blows inflicted on freshmen. Similarly the 1379 statutes of Narbonne College forbid the scholars to exact anything from the *noviter intrentibus* contrary to the honour or good of the college, or to indulge in 'vicious practices or other indecencies which they would be forbidden to reveal'. This ban almost certainly remained a dead letter: the vow of silence which the older pupils imposed on the newcomers is proof enough of the secret character of the initiation, and one is reminded of other customs of the same sort, like those of the Templars (assuming that there was a basis of truth in the confessions extorted from them at their trial).

The statutes of the corporation of law students at Avignon in 1441, published by Fournier in 1887, mention these initiatory customs, the

repugnance which the ecclesiastical authorities felt for them, and the students' association responsible for this initiation.

This association had a religious character: it was dedicated to St Sebastian, and it was on St Sebastian's Day that the priors and councillors were elected. It was not an old society, or rather it was obviously a new and reformed version of an association which, according to the religious authorities of Avignon, had deviated from its traditional mission. The preamble to the document remarks in fact on the laziness and lack of discipline among the members of the *studium generale* at Avignon; they are accused in particular of no longer praying for the dead, of believing that the *voluptates corporales* bring happiness, and, on the occasion of the admission of novices or purge of freshmen, of repeatedly indulging in 'forbidden acts of an unimaginable nature'. The new association would thus seem to have been an instrument of reform. However, at least as far as one can see, the statutes were not imposed by the authorities but were fixed freely and unanimously by all the members of the student body: here we may recognize the democratic methods of medieval societies and their insistence on unanimity as the sole guarantee of peace; this had been common practice in the confused society of the Middle Ages, and only a few traces of it remained in the fifteenth century.

Every year the students elected the prior and his councillors, who formed a sort of court of arbitration, and two promoters, whose essential function was to summon the society's members to students' funerals and to organize the admission of freshmen.

The corporation had both to maintain the peace among its members and supervise their behaviour. Nobody was to speak ill of his brother, but each was to try to correct by gentle methods anyone he knew had sinned. If he did not succeed he was to refer the matter secretly to the prior; in the last resort the black sheep would be expelled from the confraternity by a majority vote. The members' principal duties were to attend the funeral of any student who died at the university, to visit sick friends, to inquire on such occasions after the state of their soul, and to accompany the *corpus domini*.

Regulations drawn up by the prior laid down the conditions for a freshman wishing to enter the corporation: no novice would be admitted *ad purgationem suae infectionis* and allowed to take the venerable title of *studens* unless he presented himself with due humility and deference before the prior and his deputy and paid them six *grossi* for his admission to the confraternity. The rich, that is to say the noblemen or beneficed clergymen, were to pay more: cases of poverty would be examined by the prior. Then the freshman would be allowed to take his oath and would be

received: *volumus jocose et benigne.* What are we to understand by this joyous admission? The regulations contain a long paragraph which tries to persuade the members that the payment of dues takes the place of the traditional banquets which spelt ruination for body and soul. The cost of the useless banquet, *superflue cene,* would be paid to the confraternity for the honour of God and the patron saint. However, these arguments do not seem to have convinced the students. The prior admits, albeit with a bad grace, that they 'prefer the belly to the mind', but in that case he insists that he or his deputy should be present at the banquet to safeguard the society's morals and avoid *viciorum macula.* In particular he stipulates that the freshmen are not to bring along any courtesans, lest the society's members be turned into pimps.

We see here a tendency to substitute an admission fee in money or in kind for the banquets and ragging which used to accompany the freshman's purge. But nobody thought of reducing the importance of the actual principle of the initiation: the admission of the new students was one of the chief responsibilities of the promoters of the confraternity of St Sebastian. There are other college statutes which recognize the importance of the admission ceremony while at the same time condemning ragging and excessive fines. The 1311 statutes of Harcourt College stipulate: 'No newly arrived scholar shall give an admission banquet, either in his room or in the refectory.' The tradition of the mug of wine drunk in common was not abandoned, however: 'He may give each *socius* only one mug of wine, and that wine must be at the current price.' It is hard to believe that the celebration always stopped after the regulation mug of wine.

In the 1427 statutes of Seez College we read that for his joyous entry into the college, the student shall not be forced to pay more than twenty *sous* but shall instead pay 'according to his rank'. The oath and the rule of secrecy remain, but the secrecy here applies not to the events and gestures of the initiation ceremony but to the life of the community the pupil is going to enter. He takes an oath to observe the statutes and 'not to reveal to any outside person [*nulli extraneo*] the secrets of the college'. He becomes the *de novo receptus.* His oath is recorded in writing and signed. He then presents the community with two table-cloths, in which it is difficult not to see a symbol of the traditional banquet.

The documents we are quoting speak of drinking bouts and initiation rites at a time when enlightened ecclesiastical circles condemned them (the moralists and theologians have probably always condemned them, as being tainted with paganism and vice, but without success) and succeeded to some extent in curbing or suppressing them. However, the

eagerness they showed in forbidding them, or else, as at Avignon, their resigned tolerance, shows how attached the student population was to practices which dated far back into the past and still corresponded in the fourteenth and fifteenth centuries to a state of mind which is difficult to imagine today. It would in fact be a mistake to compare these admission rites to the ragging inflicted on freshmen in a modern university. They were something very different and profound, bound up with the very structure of society. A. Varagnac (1948) has shown the survival in country districts under the ancien regime and up to the triumph of the agricultural revolution in the eighteenth and nineteenth centuries of an organization of collective life in age groups: a very old organization which can be found in the Homeric world as also in the Negro societies of Africa. Entry into the adult world called for an initiation. Speaking more generally, to enter a society one had to undergo a sort of operation of a religious character, sometimes magical and always ritualistic, which changed the very being of the novice, naturalized him and thus joined him to his brothers with an inseparable bond. This was the case with the student-bodies and probably also with the trade guilds, and what remained of their customs in the eighteenth and nineteenth centuries must have dated back to the Middle Ages at least. This operation consisted first of a drinking bout, a *potacio* as it is called in the texts concerning the guilds quoted by E. Coornaert in 1948, and then of violent ragging, sometimes accompanied by sexual orgies. The ragging broke the former man, and by humiliating him placed him at the mercy of his conquerors; he was tamed and henceforth belonged irrevocably to the community which had mastered him in this fashion. At the same time he became his torturers' brother, thanks to the meal in common: henceforth the society to which he had been admitted was not a utilitarian association but a fraternity, a society of friends. This fraternity would be renewed by periodical communion rites, by collective meals and drinking bouts. For students, one of the principal opportunities for drinking was the 'determinance'. In his reformation of the University of Paris in the fifteenth century, Cardinal d'Estouteville shows the revulsion he feels, but does not dare to forbid such established customs, and confines himself to preaching moderation: 'The determinants must not offer banquets, unless it be with moderation and temperance, and only to *socii* and to their masters.' (Quoted by Théry, 1858.) Masters and pupils, often of roughly the same age, drank round the same table: they belonged to the same fraternity.

The theologians themselves showed no repugnance for these convivial habits. In the thirteenth century Robert de Courçon in his reformation of the university had not dared to ban their banquets: he merely stipulated

that they should be confined 'to some companions and friends, but few in number'.

Apart from great events such as the purge of a freshman or the 'determinance', there were a great many occasions, if not for a *convivio*, at least for a *potacio*. The importance attributed to the mug of wine drunk together can be seen from the constitutions of the colleges for scholarship boys. At Harcourt College, tradition required the *lectores* to treat their pupils to drinks and the 1311 statutes accepted this tradition: 'For the honour of the college we wish the pupils of the house to show deference to the *lectores* ... The latter, at the beginning and end of their classes, may, if they wish, offer their fellow pupils the mug of friendship [*potum amicabilem*], provided that no guest receives more than one mug.'

In many cases, the peccadilloes of everyday collective life in the colleges were sanctioned by a round of drinks: at Cornwall College in 1380, pupils who did not stop shouting, laughing or playing during mealtimes were fined 'a mug of ordinary [*mediocris*] wine which shall be drunk among friends'. At the Cistercian College in Paris, pupils who spoke in any language other than Latin had to buy a pint of wine, 'which shall be distributed *illico* [*sic*] to those companions who are present'. Similarly it was forbidden to wear long pointed shoes under pain of a pint of wine.

The associations of scholars which tried to cut down or to suppress the traditional banquets forced the *socii* to take their meals in common, forbidding them to eat separately in their rooms: the meal in common consecrated the friendship which was supposed to unite the members of the group.

The characteristics of these student-bodies recall those of the professional, economic or other associations studied by E. Coornaert in an excellent article on the medieval guilds (1948): the importance of the *compotacio*, of the oath of friendship and peace taken between the brothers, of attendance at members' funerals, and of the performance of religious duties. Our modern minds are puzzled because they refuse to accept the mixing of ways of life which are nowadays, carefully separated: the intimate way of life (family and friends), the private way of life (leisure and amusement), the religious way of life (devotional activities), or the corporate way of life (meetings of those who share the same profession with the object of learning it or exploiting it or defending it). Modern man is divided between a professional life and a family life which are often in competition with each other, and all the rest is regarded as of secondary importance: religious and cultural activities, and even more so rest and amusement; meetings with friends for a meal or drinks are considered as a mere relaxation, necessary to the organism like food which can be hurriedly

swallowed, but not to be counted as part of the serious business of living –
an extra, a luxury, which a man does not neglect, true, but whose impor-
tance he does not admit though he is not actually ashamed of it. But in the
Middle Ages all these social activities, which are today individualized and
repressed, occupied an essential position in collective life. It does not
matter to us that they had a religious origin in Mediterranean or Germanic
rites of an orgiastic nature. What matters is that at that time people could
not imagine a society that was not cemented by public recognition of a
friendship – maintained by the common meal and the *potacio,* and some-
times sealed with intoxication. This rite was valued not only because it
afforded sensual pleasure – men have never ceased to appreciate the
joys of a good binge among friends! – but because this pleasure was
transcended and became the perceptible, physical sign of a religious and
legal engagement, of a sworn contract on which the whole of collective
life rested, just as it rests today on our institutions of private and public
law. The modern way of life is the result of the divorce between elements
which had formerly been united: friendship, religion, profession. It is
also the result of the suppression of some of them, such as friendship and
religion, and of the development of another element to which the Middle
Ages attributed only secondary importance: the family.

The medieval student corporations bore no relation to our ideas on
the organization of human societies, especially for children and youths.
They were not authoritarian: no leader could impose a decision – a
decision was generally taken by the community as a whole, on a majority
vote, sometimes unanimously. They were not democratic or egalitarian
either, for they comprised certain privileges, differences between gradu-
ates, differences between old students and new. They were built on per-
sonal relationships, on friendship between the members, rather than on a
utilitarian aim. The idea of authority, or rather of the delegation of
authority, the modern idea of a disciplinary code for which agents of
authority are instructed to enforce respect, remained foreign to them.

However, we should be wrong to deduce from the absence of the
modern principle of hierarchy and authority that medieval pupils lived
in a state of anarchy. On the contrary, they belonged to these communities
which constituted the structure of the societies of their time. Thus in
place of the relationship of master and pupil, chief and subordinate, there
were bonds of a different nature, less judicial, closer to real life, but just
as strong and just as valid in the eyes of the public: the relationship of
old hand and greenhorn, *bacchant* and *bejaune.*

On this subject we have an extremely full and detailed document of
the early sixteenth century, which I have already quoted with regard to

pupils' ages: the biography of the Swiss, Thomas Platter. It may be objected that it deals with German manners, but if these were different at the time from French manners, this was simply because they were comparatively old-fashioned. In all probability, a hundred years earlier the differences were less pronounced, and Thomas Platter's description must be valid not only for Germany in the early sixteenth century but for a large part of the Western world in the fifteenth century. We have seen how at the age of nine Thomas Platter learnt to sing the *Salve* from a village priest. One of his first cousins, Paulus, who was a student at Ulm and Munich, then came to spend a few days with his family. Thomas had a good reputation: 'My friends spoke to him about me and suggested that he should take me to the German schools.' Paulus agreed, and thus was born the association between the greenhorn Thomas and the old hand Paulus. The former supported the latter, who in return protected him. 'We set off. I had to start begging. I gave Paulus my takings. People gave me money with a good grace.' Students at that time often lived by begging, the greenhorn begging for the old hand. The two companions went through Lucerne and arrived at Zürich, where Paulus was due to meet some friends with whom he was going to travel across Germany. 'During this time I kept on begging and earned almost enough to support Paulus, for when I went into a tavern [we must remember that at this time the tavern was a place of ill repute, frequented by thieves and prostitutes, but a young lad of nineteen could none the less do his turn there] people enjoyed hearing me talk the Valais dialect and willingly gave me something.' But there was also the risk of mortifying experiences: a ruffian who was staying in the same house at Zürich as the band of students 'offered me a six-kreutzer piece if I would allow him to whip me on my bare skin'. The game was worth the candle: 'I finally agreed. He promptly seized me, threw me across a chair and beat me horribly' ... and then took back his six kreutzers.

After loitering there for eight or nine weeks, the band of students set off for Misnia. 'There were eight or nine of us, to wit three greenhorns [*Schützen*] and the rest old hands. I was the youngest and smallest of the greenhorns. When I could no longer drag myself along, my cousin Paulus would walk along behind me, armed with a stick or a pike, and would beat my bare legs, for I had no breeches [he was therefore dressed in just a shirt and underpants, and perhaps not even underpants] and only a bad pair of shoes.' But he kept on walking all the same, whereas but for Paulus he would have fallen by the wayside; admittedly Paulus would then have lost his bread-winner. There were a few minor incidents: when Thomas heard his big companion saying how easy it was to catch geese

in Misnia, he tried his luck with the first goose he saw, and felled it with a stone, but only just managed to escape the vengeance of the peasants. 'Coming to the village, the peasants found our old hands at the inn and asked them for the price of the goose.' The two sides came to an agreement. 'When the old hands rejoined us [for the greenhorns were not allowed inside the inn], they laughingly asked what had happened. I apologized for doing something which I had thought was allowed by the customs of the country : they replied that I had been in too much of a hurry.' When they stopped for the night, the old hands slept together in an inn room, and the greenhorns in the stable.

By the time he came to write down these stories of vagabond life, Thomas Platter had become a schoolmaster and a respected humanist, and he tells them with ill-concealed pleasure. At Neuburg, 'those of us green-horns who could sing went round the town singing; I for my part did some begging.' In this fashion they arrived at Halle in Saxony : 'There we went to St Ulrich's school. But our old hands treated us so harshly that some of us plotted with my cousin Paulus to escape.' Here he is probably referring to the old hands at St Ulrich's who ragged the newcomers, young and old alike, little Thomas as well as big Paulus. The band left Halle and made for Dresden. At Dresden they went to school for a while : 'The school building was full of vermin which we could hear swarming about in the straw.' But it seems that the masters were not very good, and they set off again, this time for Breslau. They had a hard time on the road : nobody would take in the vagabond students and people set their dogs on them.

At Breslau there were seven schools, corresponding to the seven parishes of the town, and each parish was private territory : 'No student would dream of going outside his parish to sing in the street, for if he did the greenhorns would come running up shouting "*Ad idem, ad idem*", and there would be a terrible brawl.' It is said that at times there were several thousand students as Breslau who all lived on charity, and that some stayed at school for twenty or thirty years or even longer, thanks to the green-horns who fed them. 'In the evening I often made five or six journeys to bring the day's takings to my old hands, who stayed in the school.'

'In winter the greenhorns slept on the floor of the schoolroom, and the old hands in cells.' But all shared the same vermin : 'I could have wagered that I would be able to catch three insects at once on my chest any time I wished.' In summer, greenhorns and old hands slept out in the open, in the cemetery. If it rained they went back into the school. After a period at Breslau, the eight friends returned to Dresden. For the journey the band split up into two groups, one for catching geese and the other for picking

swedes and onions. 'The youngest of us were sent to Neumark, the nearest town, to beg for bread and salt. We had agreed to meet in the evening near the town gates where we intended to camp. But the inhabitants had no sooner seen the fire we had lit than they started firing at us. Luckily nobody was hit.'

In spite of everything, the band managed to reach Dresden. There the old hands came to an arrangement with the schoolmaster – who must have been of about the same age – to exploit the pupils. The master does not seem to have been in charge of the pupils, but one of them reports: 'At Dresden the schoolmaster and our old hands sent us goose-hunting one day . . . We caught two geese which the old hands and the schoolmaster ate at a farewell meal.' Platter does not tell us whether the greenhorns were allowed to eat the crumbs.

The band left Dresden and set off for Nürnberg and then Munich, where it settled down. 'Paulus and I lodged with a soap manufacturer . . . whom I helped with his soapmaking more than I studied . . . My cousin went to the school in Our Lady's parish, and so did I, but not so frequently, since I had to sing in the streets to earn enough for our keep.' This went on until the two cousins were thrown out because Paulus had been rather too familiar with the maidservant. Then, after five years of wandering around the schools of Germany, Paulus suddenly felt homesick: 'My old hand then took it into his head to go back to the country from which we had been absent for five years, and we returned to the Valais.' Thomas must have been about fifteen, and Paulus over twenty. They did not stay long in the village, but set off again, taking with them, like Thomas five years before, another young boy, one Hildebrand 'who was the son of a priest' and therefore born to be a scholar! All three, under Paulus's command, went to Ulm. Thomas had acquired considerable skill in begging, 'so that the old hands did not give me time to go to school, preferring to use me for their profit, with the result that I could not even read.' He and Hildebrand were supposed to give the old hands all their takings. But Hildebrand sometimes kept back some of his money to buy food: 'Our old hands would follow him in the street and catch him eating; or else they would force him to rinse his mouth and spit into a dish full of water; they could then see whether he had been eating. If they caught him out, they threw him on to a bed, put a cushion over his face to muffle his cries, and beat him cruelly until they were exhausted.'

Thus the older student was a leader, doing what he wished with the young ones who kept him alive and whom he exploited, though also protecting them, or rather maintaining them by force in a society which, however harsh it may have been, provided them with a setting and, by its

very existence, defended them against the solitary adventure. The formation of bands of boys in which the younger ones recognize the authority of the older ones despite their brutality, or perhaps because of it, still happens in our contemporary societies: it has been a particular object of study in the United States.[1] But in the medieval association of old hands and greenhorns there was something else: parents did not abandon a child of ten or so to the hazards of the road and foreign towns; they entrusted him to an older and therefore more experienced student, who was better equipped for a dangerous life. The authority of the child's father was then delegated to this older student. Consequently, however much he might abuse it, his authority was recognized not only by his subjects – or his victims – but also by public opinion. And public opinion would not tolerate the breaking of this bond of subjection between the greenhorn and the old hand, least of all if it was broken by the greenhorn. It seems in fact to have been the only form of subjection which enabled the child to avoid anarchy, vagabondage, moral and physical distress.

This can be seen from Thomas Platter's account of his two attempts at escape. The first failed. It took place at Breslau. A member of the Fugger family took an interest in the little beggar he saw wandering through the streets. He offered to take him in. Did Thomas accept straight away? No, for he was not free. He went to Paulus and asked him for permission to leave him for the Fugger house. Paulus refused to give him this permission. 'I have brought you abroad and I mean to take you back to your family,' he said, and such indeed must have been the sense of responsibility these hulking brutes felt for their young drudges.

The second attempt succeeded: Thomas was older – he must have been over fifteen – and obedience was becoming irksome to him. The scene was Munich. Thomas was no longer living with his old hand but with a kindly butcher's wife. One Sunday after vespers, Paulus stopped him in the street: 'Greenhorn,' he said 'you don't come to see me any more. Take care or you'll get a beating.' At his age, with his voice breaking and his talents as a street-singer on the wane, Thomas was no longer of much use to his old hand. But the latter was asserting his authority, which the greenhorn's departure had set at naught. Worried by this threat, Thomas decided to flee. He said nothing to his kindly landlady: 'I did not dare tell her about my intentions, *for she might have given me away.*' She would have given him away, despite the fact that she disapproved of Paulus's cruelty, because it would have probably struck her as immoral to break so brutally a bond which was recognized as legitimate and necessary. 'I therefore left Munich, feeling sad at heart, either at abandoning my cousin whom I had

1. This had been written before there was any talk of 'skinheads'.

accompanied in his numerous and distant peregrinations, but who had always been brutal towards me, or at leaving the butcher's wife who had been so kind to me.' For his part Paulus 'had often told my companions and me that if one of us escaped, he would catch him wherever he might go'. True enough, at Freisingen he was told that Paulus was on his track and had arrived in the town. 'Your old hand from Munich is here looking for you,' the greenhorns told him at the school. He fled to Ulm, where Paulus followed him: 'He had therefore pursued me a distance of eighteen miles.' At Zürich, where he took refuge, a messenger from Paulus came to see him: his fellow-countryman Hildebrand, the boy who used to be thrashed because he spent part of his taking on food. 'A few months had gone by [at Zürich] when Paulus sent his greenhorn Hildebrand from Munich to ask me to come back and to say that he forgave me: I refused and stayed at Zürich.' Paulus had stopped ordering him to return – and thus recognized his emancipation! Thomas would continue to lead the vagabond life of a student, but alone: if the opportunity offered itself, he would requisition the services of a few greenhorns.

Thus before the fifteenth century the student was not submitted to an extra-corporate disciplinary authority, to a scholastic hierarchy. But this did not mean that he was left to his own resources. Either he lived near a school at his own home, or else he lived with another family to whom he had been apprenticed with a contract stipulating that he should go to a school – a Latin school of course. He then entered those associations, corporations or confraternities, which by means of pious or joyous practices, by religious worship, drinking bouts or banquets, nourished the feeling of their community of life. Or else the young pupil followed the older student, sharing his life in good fortune and bad, and often, in return, being beaten and exploited. In either case the student belonged to a society or to a band of friends in which a sometimes brutal but none the less a real comradeship governed his daily life, much more than did the school and his master, and, because it was recognized by public opinion, had a moral value.

From the end of the Middle Ages, this system of comradeship aroused growing opposition in influential circles, and the system went on deteriorating steadily until it finally gave the impression of being disorderly and anarchical. In its absence, schoolboys and students were organized on new principles of authoritarian hierarchy. Admittedly this evolution was not peculiar to childhood: it extended to the whole of society, and the establishment of monarchical absolutism was one aspect of it. But at school it produced – or followed – a change parallel to the concept of childhood which is of particular interest to us.

We are now going to follow the progress of these new disciplinary principles.

They originally manifested themselves in a reluctance to tolerate the students' traditional customs of comradeship and self-government. Indeed we scarcely know these customs, especially at the end of the Middle Ages, except through texts which criticize and limit them when they cannot ban them. This disapproval appeared quite early on in Church circles: we find it in Robert de Courçon's thirteenth-century reformation of the University of Paris. These churchmen represented an outlook foreign to their times: a technical, technocratic attitude, a Cartesian spirit, a love of order, regularity, classification, hierarchy, organization. Their first success consisted in relegating to the domain of minor pastimes those communal customs which medieval man regarded as an essential part of his life. Even at the beginning of the seventeenth century, certain indications bore witness to their long survival, in spite of the hostility of the pedagogues and, generally speaking, of the authorities as a whole. The authorities of the town of La Flèche had to take into account the presence within their walls of a large student population attracted by the Jesuit college; special measures were taken (as they are today in garrison towns or prohibited areas), specifying a certain number of prohibitions – forbidding prostitutes to reside in the town, tavern-keepers to serve students, students to carry arms, etc. Among these prohibitions we find: 'The aforesaid students are forbidden to elect any duke, attorney, or leader of a nation.' Similarly in 1623 the High Court of Dijon forbade the students 'to form any assembly or monopoly among themselves, or to elect an abbot, prior or any other leader and supporter of debauchery'. It was the whole traditional corporate organization, even that of the 'nations' which was still allowed elsewhere, that was condemned here. At the same time, the reformation of the University of Paris by Henri IV finally abolished the traditional banquets and all forms of *compotacio*.

As early as the fifteenth century, at the same time as they fought against the student traditions of corporate solidarity, these reformers and enlightened organizers tried to spread a new concept of childhood and its education. Gerson and Cardinal d'Estouteville are of this state of mind. In Cardinal d'Estouteville's opinion, children belong to an *etas infirma* which requires 'greater discipline and stricter principles'. In his view the schoolmasters, the *principales*, are no longer the first among their comrades. They are distinct from the *infirmi* in their charge. Their duty does not consist solely in communicating knowledge, as elders instructing young companions: they must also and above all mould their pupils' minds, in-

culcate virtues, educate as well as instruct. This preocupation did not appear so explicitly in the earlier texts.

These pedagogues are responsible for their charges' souls: *monemus omnes et singulos pedagogos presentes et futuros ... ut sic intendant regimini suorum domesticorum puerorum et scolarium* It is a matter of conscience for them to choose their colleagues, the other masters and *submonitores*, judiciously: *viros bonos, graves et doctos*; to use their powers of punishment without culpable indulgence, for this is a matter of the salvation of souls, for which they are responsible before God: *ne eorum damnationem.*

Two new ideas appear at the same time: the notion of the weakness of childhood and the concept of the moral responsibility of the masters. The disciplinary system which they postulate could not take root in the old medieval school, where the master took no interest in his pupils' conduct out of class – or if he did, it was not in his capacity as a leader, but as an elder, in the context of the corporations or confraternities and their festivities. In the early thirteenth century, when a student was arrested in Paris, his master was informed and went to identify him, to remove him from the provost's jurisdiction and enable him to benefit from the university's privileges. However, in 1289, every student had to be registered on the *matricula* of his master.

Then, in the fourteenth century, it became necessary to belong to a 'nation' as well. The organization of these 'nations' was the first attempt at a systematic regimentation of the students. It resembled the spontaneous associations of students and had the same corporate structure; in all probability it was originally just a corporation of students from the same region: community of origin was keenly felt, and some college statutes stipulate that students from the same region must be separated, for fear of brawls between ethnic groups. The attorney of a nation was elected like the principal of an association of scholars. He gradually acquired a more authoritarian character, however. In the early fifteenth century he wielded disciplinary powers, at least in theory, over his nation. The reformation of 1452 ratified the attorneys' right of search and punishment in the colleges and pedagogicas of the University of Paris.

Despite all the efforts of the reformers, the corporate nature of the medieval nation did not lend itself to this concentration of power in the hands of its elected attorneys. The new discipline would be introduced rather by means of the already modern organization of the colleges and pedagogicas providing full tuition, where the principal and the masters were ceasing to be *primi inter pares* to become the repositories of a

superior authority. It was the authoritarian and hierarchical government of the colleges which, as from the fifteenth century, would make possible the establishment and development of an increasingly strict disciplinary system.

This system was distinguished by three principal characteristics: constant supervision, informing raised to the level of an institution and a principle of government, and the extended application of corporal punishment.

Already in 1315 the statutes of the grammar school of Navarre College laid down the principle that no *puer* (it was probably the child of about ten who was meant) should go out alone. If there was an urgent reason (a *lectio* or a sermon outside the college) and if neither of the two masters could accompany him, they were to give the boy a good companion, *bonum puerum socium*, of dependable character, to accompany him. And they were to take care to change this companion frequently, for fear that the two boys should plot some *turpefactum* together. The same preoccupation is to be found in Gerson's *Doctrina pro pueris ecclesiae parisiensis*, the regulations for a choir-school. One of the two masters must accompany and watch the children: 'Both at school and outside, wherever they may happen to go.'

This supervision was doubtless monastic in origin. In the fourteenth and fifteenth centuries, it must have been confined to the grammar schools, the youngest pupils: student freedom preserved the older ones from it. But in the sixteenth and seventeenth centuries it became one of the essential principles of education. The Jesuits laid great stress on the need for vigilance on the part of the masters, particularly in the regulations for their boarding-schools. At La Flèche, at the time fixed for the pupils to relieve themselves, 'one of the masters shall stand downstairs in the boarders' latrines and shall not retire until all the boarders have left.' No doubt the old principle of supervision had never before been so systematically applied, and the authors of the regulations felt it incumbent on them to justify it: 'Do not complain, gentlemen, if a great many masters and other people never let you out of their sight. This *eternal vigilance* is embarrassing but it is necessary.' However, it cannot have been very efficient in the huge day-schools of the sixteenth and seventeenth centuries, which sometimes numbered several hundred pupils. That is one of the reasons why the pedagogues of Port-Royal criticized the big colleges and preferred smaller schools, in which the masters, entrusted with fewer pupils, could watch them more closely. However, the little schools of Port-Royal were exceptions, and costly exceptions too, where the pupils' parents paid very high fees. As a general rule, a single master had to look after huge

classes. He could not exercise the constant supervision required of him, even in school, without enlisting the help of some of his own pupils. Whence the importance assumed in the modern college by informing, which had been unknown in the Middle Ages.

At Our Lady's School, Gerson made it the little grammarian's duty to report the schoolmate (*suum socium*) whom he caught speaking French (*Gallicum*), lying, swearing, cursing, offending against decency or modesty, dawdling in bed in the morning, missing the recitation of the canonical hours, or talking in church. If he failed to report his schoolmate, he would be punished as if he had committed the offences himself. Informing raised in this way to the level of a principle seemed the only way for the masters to control every moment of the lives of their pupils, who were henceforth regarded as incapable of behaving themselves: *infirmi*. The authorities soon stopped imposing the duty of watching and reporting on all and sundry, however. From the sixteenth century on, this duty was confined to certain pupils chosen by the masters to help them. Hitherto the pupils of a school had been more or less governed by comrades whom they had elected. It was still pupils who carried out the physical and moral duties in the college, but henceforth they held their authority from above, from the master whose delegates they were.

Their authority was sanctioned by their right to inform, failing the right to punish, which was confined to the masters. This was the monitor system.

At Montaigu this monitor was called the *excitator*. There was a single *excitator publicus*, chosen from the last arts class – a philosophy student who woke the boarders and toured the dormitories – and as many *excitatores particulares* as they were classes.

Elsewhere he was called the *custos* or the *asinus*. Thomas Platter was a *custos* at Myconius's school at Zürich 'It is the custom [in England] in the schools to appoint *custodes* or *asini* . . . to supervise the pupils.' (Brinsley, 1612.) At Eton in 1560, every form had its *custos*, similar to the *excitator particularis* at Montaigu. The masters also chose eighteen *praepositores* from among the bigger pupils: four had to find out who was absent from the single schoolroom; four supervised the dormitory, two the services in the chapel, one the movements in the hall; two were responsible for the *oppidani*, i.e. the paying boarders who were not scholars, and one for the housework and cleaning (Lyte, 1889).

At Geneva, in Cordier's college, they were called observers or nomenclators. And the good pupil, whom Cordier cites as a model in his dialogues, was supposed to help the observer by reporting the troublemakers: 'We dined in the room, sitting quietly and making no murmur or noise; I

gently reproved those whom I heard laughing foolishly or speaking in vain or frolicking; I told the observer about those who paid no attention to my warning so that he should take note of them ... The master walked up and down the middle of the room, holding a book and frequently telling the observer to take note of those who played the fool ... While we were finishing dinner, the last bell was rung, each of us picked up his books, and we went into the common room, the register of each class was read out according to custom, those who were present answered to their name, I answered too, and the absentees were recorded on the nomenclators' registers.' At the end of the week the observers gave the list of delinquents to the master who judged and punished.

In the eighteenth century, at the Jesuit college at Mauriac which Marmontel attended, the first in the class was the 'censor': his special task was supervising the class in the master's absence, during what would later be called preparation.

The principle of informing and the monitorial system were considered to be so effective that in the early eighteenth century St Jean-Baptiste de la Salle, despite his distrust of certain practices current in his time – corporal punishment for instance – adopted them without hesitation and without any qualms of conscience. In his rules for Christian schools, discipline is based on informing. 'As the master cannot see what is happening in the street outside the school, the Brother Director [who supervised the pupils' movements] shall order certain pupils to notice what happens in the following streets, especially those where there are a great many pupils, and to give a faithful report of what they have noticed. However, the pupils must notice without speaking, or they will be punished or given some penance to perform for having spoken.' Inside the little school, 'inspectors' are instructed to report what they have seen to the master 'in private and in a whisper'. The inspector in his turn is to be spied on by two 'supervisors' unknown to him: 'There shall be supervisors in every district and large street who shall observe what happens and promptly report it to the master.'

We are a long way here from the modern dislike of 'sneaking' which is shared by masters and pupils. And yet even then many pupils must have detested this duty which opposed them to their companions, though without their opinions troubling the pedagogues' conscience. In Cordier's dialogues a master calls out: 'Hey, Martin, go and bring me five public observers whom I appointed yesterday for this month [they were apparently changed every month].' The master then preaches this little sermon to them: 'However much the proud and ignorant may consider this duty [of observer] to be vile and abject, you may none the less be sure that your office is honourable and holy.'

Linked with the system of supervision and informing was an increasingly strict penal code, based on corporal punishment. In the associations and colleges of the Middle Ages, and as late as the fourteenth century (sometimes later still, but only rarely), the statutes laid down punishments for members who did not observe them or whose way of life left something to be desired. These punishments consisted of either a round of drinks or else a fine (which could also contribute to improve the meal). The statutes included a scale of charges. We have already seen cases where a mug of wine had to be bought for the culprit's companions. Cases of pecuniary punishments are common: at Seez in 1425 (a late date), the *juvenes* were forbidden to go out alone, except in certain cases, under pain of a fine of four deniers. At Navarre College, if a boy spent a night out he was fined two and a half sous. At Harcourt College in 1311, the pupils were forbidden to go drinking in a tavern under pain of a fine of six deniers. The severest punishment was expulsion.

However, in the course of the fifteenth and sixteenth centuries, a far-reaching evolution of manners was to substitute corporal punishment for fines, an evolution parallel to that which established an absolute authority of the college principal, and introduced informing, the monitorial system and the principle of constant supervision.

Corporal punishment could be imprisonment in a cell; there was a prison cell at Montaigu, but this was something of an exception. Generally speaking, it was a whipping: the birch became the mark of the schoolmaster, at least of the grammar-school master, the symbol of the subjection in which the master henceforth held his pupils and consequently of the subjection into which the child had fallen: *infirmus*. To the end of the fourteenth century, references to corporal punishment are extremely rare: and then there was nothing humiliating about corporal punishment because it accorded with the monastic austerities depicted on the moralizing Bibles or with those which the saints inflicted on themselves, as in the scene in the life of St Louis where the King is being scourged. From the fifteenth century on, the whip takes on a degrading, brutal character, and becomes increasingly common.

At first the birch was prescribed for the *parvuli*, the little grammarians. Gerson states that the master 'must threaten the childen with the birch' so that 'for their sins the children know that they will be beaten with the birch', but only with the birch and 'not with rulers or other instruments of chastisement likely to cause dangerous injury'. An early fifteenth-century miniature depicts a punishment being inflicted: the victim, a boy of twelve or thirteen, with his breeches undone just as far as is necessary, is lying across a schoolmate's back, with another pupil holding his legs

and the master raising the birch to strike. Certain statutes of the early six-
teenth century specify that the traditional fines are not applicable to the
parvuli – e.g. at Tours College, 1540: 'These pecuniary punishments do
not concern the *parvuli*; instead of these pecuniary punishments, we wish
them to be birched for the same offence, but with moderation and without
injuring them.' A century earlier, no doubt, nobody would have thought
of adding a qualification of this sort. Similarly the birch was substituted
for fines in the punishment of the poorer pupils, even those above the age
of the *parvuli*, whereas their richer companions continued to be punished
with fines. These poor pupils were sometimes the college servants, who
for a long time were recruited from among the less prosperous schoolboys :
for example, it was not until the seventeenth century that the porter at
Beauvais College stopped being picked from among the scholars and
became a regular servant. They could also be the personal servants of
richer schoolmates. According to Rashdall, the statutes of the University of
Vienna and of Queen's College, Oxford, limited the birch to the poor
pupils, though it is impossible to say whether this was because they were
regarded as insolvent or simply as inferior. The monks punished their lay
servants with the birch. In the late Middle Ages, feudal tradition sub-
mitted the villeins to corporal punishments still unknown in the public
courts, and as late as the seventeenth century the moralists made it the
duty of the master to chastise his servants : we know from Molière and La
Fontaine what this chastisement consisted of – Jack Stick. One has the
feeling that the same evolution introduced the birch into both the schools
and the penal code : under the ancien regime it became one of the punish-
ments to which the courts sentenced poor offenders.

In the course of the fifteenth century, the birch was used for the punish-
ment of acts of violence. At Montaigu in the early sixteenth century
venial offences were punished with fines or a diet of bread and water, but
anyone who laid violent hands on a thing or a person was scourged or
imprisoned in the cell, or even expelled. To begin with, pupils who were
neither *parvuli* nor poor were given corporal punishment only in cases of
violence.

But soon all these limitations disappeared. By the sixteenth century the
birch had taken the place of the traditional pecuniary punishments, which
had fallen into disuse, or which were revived simply for form's sake, out
of respect for the old texts. Corporal punishment had become the 'scholas-
tic punishment' par excellence : it was by this name that it was referred
to euphemistically. It was no longer practised only on the very young, the
poor, and those guilty of acts of violence. Henceforth it was applied to all
offences and all ages, even the most advanced. That is the essential point

of this evolution. As the English historian Rashdall has pointed out, the beginning of the fourteenth century found the undergraduate, who did not belong to a college, a free gentleman, while the end of the fifteenth century left him a mere schoolboy – not so much in Germany as in Paris and at Oxford. He was a schoolboy subjected to the same discipline as the little grammarian. Rashdall adds that it was the development of the colleges which brought about this revolution in university discipline, which reached its zenith in the sixteenth century. According to the same author, the 1509 statutes of Brasenose College, Oxford, were the first in England to reduce the arts student to the level of the little grammar-school boy; in the university colleges, tutors could order undergraduates to be whipped like grammar-school boys elsewhere. Caius's statutes at Cambridge fixed eighteen as the age at which corporal punishment was replaced by fines. Wolsey's statutes at Cardinal College took the age limit to twenty.

In France, from the beginning of the sixteenth century, the birch was applied with an enthusiasm which exceeded the provisions of the statutes. Such at least was the case under Standonc at Montaigu as Godet (1912) reports, where the statutes did not explicitly prescribe the *susceptio disciplinae* except as a punishment for acts of violence. But contemporaries tell us that Standonc 'had those he caught out whipped, and pupils guilty of serious offences were stripped in front of the whole community and beaten until they bled'.

Also in the sixteenth century, writers would often recall with some bitterness memories of their captive childhood. Montaigne's recollections are well known, and should be linked with what we know about Montaigu. About 1560, Thomas Tusser told how:

From Powles I went, to Aeton sent
To learne straightwayes the Latin phraise
Where fiftie three stripes given to mee at once I had.

Other English texts of the same period refer to school as a 'place of execution' (Watson, 1908), using almost the same expression as Montaigne. This brutality was not confined to schoolboys: l'Estoile tells how one day in 1583 'the King had up to two hundred pages and lackeys whipped at the Louvre in Paris [note the familiarity between the pages, who were courtiers' sons, and the valets] because they had imitated the procession of the penitents in the lower hall of the Louvre.'

In the seventeenth century this repressive ardour cooled down somewhat. But the birch (applied in public, at least at the Jesuit colleges, by a corrector – one of the older pupils appointed for this purpose, because the *ratio* did not allow the Fathers to punish offenders with their own hands)

remained the scholastic punishment, inflicted on one and all without regard to differences in age. The records of the time are full of examples of young people between sixteen and twenty who were sentenced to a whipping, and, generally speaking, we know only the cases of recalcitrant offenders. At Aix-en-Provence in 1646 a philosopher and a humanist were both given a whipping. At Orléans in 1672 a twenty-year-old rhetorician who stirred up his class against the master was given three strokes of the birch – a mild punishment. In 1634 at Dijon pupils in the logic class were given the same punishment. The Jesuits' *ratio* specifies the conditions in which punishment was to be meted out. The 1624 regulations of the Collège de Bourgogne, a school restricted to scholars 'already versed in grammar, and capable of being instructed in logic and philosophy', threaten them with 'deprivation of their allotment [the old fine] or with corporal punishment'. As late as the seventeenth century, Marmontel left the rhetoric class at Mauriac College to escape from the corrector (see his works published in 1827).

The history of discipline from the fourteenth to the seventeenth century enables us to make two important points.

First, a humiliating disciplinary system – whipping at the master's discretion and spying for the master's benefit – was substituted for a corporate form of association which remained the same for both young pupils and other adults. Admittedly this evolution was not peculiar to childhood, and in the fifteenth and sixteenth centuries corporal punishment became widespread at the same time as an authoritarian, hierarchical – in a word, absolutist – concept of society. Even so, there remained an essential difference between the discipline applied to children and that applied to adults, a difference which did not exist to the same degree in the Middle Ages. Among the adults, not all were subjected to corporal punishment: people of quality escaped it, and the way in which discipline was applied helped to distinguish the social classes. On the other hand all children and youths, whatever their rank, were subjected to the same disciplinary system and were liable to be birched. This does not mean that there were no class distinctions in the scholastic world. They existed there as elsewhere, and they were just as pronounced. But the degrading character of corporal punishment for high-born adults did not prevent them from applying it to their children. It even became a feature of the new attitude to childhood.

The second phenomenon revealed by our analysis is the extension of the use of the birch to pupils of all ages: confined at first to the youngest children, it was extended after the sixteenth century to the whole school population, which often approached and sometimes passed the age of

twenty. There was therefore a tendency to diminish the distinctions between childhood and adolescence, to push adolescence back towards childhood by subjecting it to an identical discipline. Inside the school world, the adolescent was separated from the adult and confused with the child, with whom he shared the humiliation of corporal punishment, the chastisement meted out to villeins.

Thus a childhood prolonged into an adolescence from which it was barely distinguished was characterized by deliberate humiliation. The whole of childhood, that of all classes of society, was subjected to the degrading discipline imposed on the villeins. The concept of the separate nature of childhood, of its difference from the world of adults, began with the elementary concept of its weakness, which brought it down to the level of the lowest social strata.

The insistence on humiliating childhood, to mark it out and improve it, diminished in the course of the eighteenth century, and the history of school discipline enables us to follow the evolution of the collective conscience in this respect. It is interesting to compare the ways in which the change occurred in England and France. The starting-point in the sixteenth and seventeenth centuries was the same: absolute power for the master, informing and corporal punishment. Starting in the eighteenth century, the situation would alter in different ways in the two countries, despite the similarity of the moral principles which determined its evolution.

In France, public opinion showed a dislike for the scholastic system of discipline, a dislike which led to the suppression of the system about 1763, when the authorities took advantage of the condemnation of the Jesuits to reorganize the school system.

The historian of the Brothers of Christian Doctrine, H. Rigault (1937), quotes the regulations for one of the first little schools (the model for those of St Jean-Baptiste de la Salle), at Moulins, at the beginning of the eighteenth century. The regulations give instructions on the administration of the birch: the child must be beaten harder if he screams. Why? His cries stir up the neighbourhood: 'The children begin to enjoy it and scream loudly in the hope that this will exempt them from the punishment, and this is why the people who live near the schools and those passing by in the street make a great fuss and imagine that those who are being chastised are suffering serious injury.' Rigault sees here an admission that 'already at the beginning of the eighteenth century, there were a good many opponents of this system of brutal repression'. St Jean-Baptiste de la Salle was one of them. He did not ban the birch, but he did not recommend it: 'The birch is used only out of bad temper or weakness. For the birch is a

servile punishment, which degrades the soul even when it corrects, if indeed it corrects, for its usual effect is to harden.' Thus the servile and degrading character of corporal punishment was no longer regarded as suitable for the weakness of childhood. The idea began to spread that childhood was not a servile age, and that it did not deserve to be methodically humiliated.

This revulsion, aroused here by the punishment of little schoolboys, became even more pronounced in regard to older pupils. Little by little it became customary not to whip rhetoricians any more. In 1748, at Schlestadt in Alsace, eight schoolboys violated the Jewish cemetery. At the mayor's request, the rector sentenced them to the *poena scholastica*. Rather than submit to it in public, in accordance with the customary public ritual, they left the college. A century earlier, the officers of the watch would have brought them back by force, but now the mayor felt sorry for them, appealed to the rector on their behalf and secured a mitigation of their punishment: the culprits would not be whipped. At about the same time, at Mauriac College, where Marmontel was a pupil, the prefect still sent his charges to the corrector for punishment; but certain masters no longer agreed with this practice. One laid down the principle that rhetoricians should not be whipped.

This was Rollin's view too. When, in 1762, after the suppression of the Jesuits, Louis-le-Grand was turned into a sort of model college, corporal punishment was abolished; the 1769 regulations give the reason for this change, the same reason that Jean-Baptiste de La Salle advanced: they 'degrade and do not correct'. Nearly everywhere in France, the traditional *poena scholastica* was abandoned, never to be revived. At Vendôme College in 1770, 'the master was dismissed for using the ferrule on the rhetoricians' (from Lablée, 1824).

At the same time the old practices of informing were dropped. Already the little schools at Port-Royal and Jansenist tradition avoided them. About 1700, the new college of Sainte-Barbe adopted Port-Royal's methods. It suppressed corporal punishment, the medieval principles of emulation adopted by the hated Jesuits, and the institution of the observer. What is more, at the weekly meeting of the masters at which they fixed punishments, a 'champion' of the pupils was present and defended his schoolmates. An entirely different spirit appears here. It imposed itself on Louis-le-Grand after 1763, and on the whole French educational system.

The abolition of the observers brought about a reformation of the teaching body. Without their monitors, the masters could not remain so few in number. If the schools in the Jansenist tradition dispensed with

monitors, it was because they adopted the costly formula of the little schools of Port-Royal: eight or ten children to one master, a luxury formula. In the colleges the teaching staff was increased and hierarchized: the *agrégation* examination was created in 1766 for this purpose, and at the bottom of the ladder the pupil monitors were replaced by assistant masters. This was the origin of the usher, sometimes called the 'master of conduct'.

Did this reformation of the disciplinary system simply correspond in the world of childhood to the progress of liberal ideas? That explanation would be both too simple and too general. For if the birch was dropped by the colleges, it was adopted by the army, where corporal punishment, copied from Frederick the Great's army but also from those of the Georges, became a systematic sanction. Probably the discipline in the first industrial workshops too was fairly grim, even without corporal punishment.

The relaxation of the old scholastic discipline corresponded to something else: to a new orientation of the concept of childhood, which was no longer associated with the idea of the weakness of childhood and no longer recognized the need for its humiliation. Henceforth it was a question of awakening in the child an adult sense of responsibility and dignity. The child was not so much opposed to the adult (although he was clearly distinguished from the adult in everyday life) as prepared for adult life. This preparation could not be carried out brutally and at one stroke. It called for careful, gradual conditioning. This was the new concept of education which would triumph in the nineteenth century.

In England this concept of education appeared much later. In its educational records, the eighteenth century in England appears as a period of violence and brutality. 'Flogging' became increasingly common. According to the historian of Winchester College, H. Cook, in the seventeenth century pupils were flogged only on Saturday, 'the bloody day'. Later they were flogged every day. George III, meeting a boy from Eton in the course of a walk near Windsor, asked him: 'Well, well, my boy, when were you flogged last, eh, eh?' It is said that Keates, the headmaster of Eton at the beginning of the nineteenth century, mixed up his lists one flogging day, and whipped the boys who turned up for Holy Communion. It should be added that these masters who were so free with their hands had some fearful ruffians to deal with, always on the verge of revolt. Stories of the time give an impression of reformatories where the most brutal punishments could not succeed in taming youths addicted to the foulest vices. There was a great deal of this punishment in the French colleges of the sixteenth century, but the reforms carried out by the Jesuits,

the Oratorians and the universities made possible the application of a discipline of violence and humiliation within very moderate limits during the seventeenth century. Nothing of the sort happened in England: *Tom Brown's Schooldays* gives one some idea of the conditions obtaining at Rugby in the early nineteenth century. A reformation was called for: it came at the end of the first third of the nineteenth century, and it was carried out by Thomas Arnold, the headmaster of Rugby.

This reformation was inspired by the same principles as the French reformation of the 1760s: the idea of awakening the man in the child. But the English schools did not adopt a single one of the French methods. The English schools preserved the old discipline – corporal punishment and the monitorial system, which had been abolished in France – but they managed to change its spirit completely. For example, if the birch was retained, it was no longer simply as a punishment but above all as an instrument of education, an opportunity for the boy being flogged to exercise self-control, the first duty of an English gentleman.

Similarly, the English educational reformers succeeded in dissociating the practices of informing from the monitorial system. Contrary to the opinion of certain English historians, anxious to stress the novelty of the reforms instituted in the 1830s, the monitors of the nineteenth century were no different from the *praepositores* of the sixteenth and seventeenth centuries. But they no longer had a duty to inform on their schoolmates – the practice could not be tolerated in a young gentleman. Curiously enough, the smaller schools, which were affected after the larger schools by the educational reformation, continued in Tom Brown's time to encourage informing, which had already disappeared at Rugby. But if they had stopped informing, the monitors continued to act as assistants to what was still a very small teaching body. It was felt in fact that this early experience of command could foster a sense of authority and its responsibilities in a future leader of men. However, how could he assert his authority over his schoolmates if he was deprived of the sanction which consisted in reporting them to the masters? This is why he was granted in compensation a right of direct punishment which former usage had never allowed him to have. Henceforth the monitor himself inflicted a flogging on any schoolmate he caught out, and the punishment was covered by the hierarchy.

There is no need to pursue this comparison any further. We can see that in England as in France, despite the different methods of the two countries, the changes in the scholastic discipline marked the appearance of a new attitude to childhood.

I tried to show a little earlier how the liberalism of the scholastic system

in the eighteenth century was the product of a new concept of childhood. One might imagine that this liberalism, the liberalism of a man like Rollin, in tune with the general ideas of the time, would have gone on spreading and growing. But in fact nothing of the sort happened, and by the early nineteenth century scholastic discipline had abandoned the liberal tradition obtaining at the end of the ancien regime and even during the revolutionary period, in order to adopt regimental methods and a barrack-room style which were to last a long time, almost to the end of the century. As is well known, Napoleon I felt strongly on the need to impose on secondary education the principles of exactness and subordination derived from military discipline: principles which, incidentally, were probably better observed under the Empire in the *lycées* than in the army! It was thought at the time that military discipline had special educational virtues, and this idea, after many vicissitudes, whose history Raoul Girardet has recorded, would reappear in France in the opinions of right-wing circles in the late nineteenth century, just as it was being abandoned by the official pedagogues. 'Without discipline,' Napoleon used to say, 'it is extremely difficult to organize with any precision the government and policing of the establishment.' The result was that habits were introduced into French school life which remained unknown in England, and which in France were not confined to the creations of the Napoleonic educational system. In spite of the dislike felt by the ecclesiastical hierarchy for this militarization, institutions of religious origin, such as the little seminaries, adopted certain of these habits: the use of the whistle, moving about in squares, lining up in columns, and sometimes solitary confinement, for nobody dared to revive the corporal punishments inflicted before 1763.

At Louis-le-Grand, the regimental character of the disciplinary system resisted every change of regime and opinion; protests from the pupils amounted at times to mutiny, until at last in 1890 new regulations abolished the prison-cell and the Napoleonic system which had lasted nearly a century. As Dupont-Ferrier, the historian of Louis-le-Grand, remarks, the school then reverted to the situation under Rollin in the eighteenth century.

The liberalism of the eighteenth century was therefore offset by a contrary influence, which obtained a partial triumph, and which imposed a semi-military condition on the school population.

This tendency cannot be attributed entirely to Napoleon. It went back in fact to a more distant source: during the whole of the second half of the eighteenth century, one can trace the rise of the military idea, at the same time as that of the liberal idea, inside school life. This was something entirely new: till then, the only institutions which had left their mark on

the school had been ecclesiastic, and even monastic. The military had been the last to submit to the complete and regular cycle of school classes, and in the seventeenth century the post-scholastic academies had had to be created for them to fill the gap left by the classical instruction of the colleges. But after the suppression of the Jesuits, part of the educational system, systematically reorganized, copied the methods of the military schools founded at the same period, and education as a whole took on something of a military character.

The Jesuit College at Tournon became a military school (like that at La Flèche) under the Oratorians. Here we can recognize a strange mixture of a Rollinesque liberalism and a Bonapartist militarism. The pupils were drilled in squads of twenty-four; offenders had to wear a sort of homespun fatigue dress and were kept in detention. Those pupils who, at the end of the year, were admitted to the École Militaire – an ancestor of the modern Saint-Cyr – were given a hat with a cockade and a uniform. Others were immediately posted to regiments. This tendency was not confined to public institutions with foundation revenue such as Tournon. For instance, at Rouen after 1762, some new private schools were opened whose pupils were dressed in a uniform which was no longer the clerical robe of the poor scholars of the seventeenth century, but an imitation of the uniform worn by army officers; they were taught less Latin too and more 'modern' subjects – history, geography and mathematics. The old masters deplored these changes. In the opinion of one of them, quoted by Beaurepaire, 'this sumptuous education amounts to nothing more than giving the children a sort of military uniform, putting them under arms, and drilling all these youngsters indiscriminately'.

Thus, long before the Napoleonic *lycée*, the French school, or at least that which corresponded to the present-day secondary school, took on a military character. This change doubtless corresponded to the position which the army was beginning to assume in society, which it was to lose in France at the Restoration, only to resume it after an interval of half a century under the Second Empire, and which it has never lost in central Europe. Officer status tended at this time to become confused with the concept of nobility: army uniform became the official dress of kings and princes, as E. G. Léonard has shown. In these circumstances it was natural that the education of boys of good family should take on a military character. Even in the English public schools, which managed to resist this change, new names were used to denote the hierarchy of the monitors – names such as captain and corporal: this was obviously a fundamental tendency of the sensibility of the time. There was something else too, more relevant to the ages of life. The new interest shown in the officer and

the soldier brought about a vague but definite correlation between early adolescence and the typical soldier. The conscript was no longer the rascally and often prematurely aged trooper of the seventeenth-century Dutch and Spanish paintings; he became the handsome young soldier depicted by Watteau.

The medieval school made no distinction between the child and the adult. The college at the beginning of modern times had merged adolescence and childhood in the same scholastic system. In the eighteenth century, the officer and the soldier were to introduce into sensibility the new notion of adolescence: a Chérubin in uniform, but a more virile Chérubin.

This notion of adolescence was to bring about a major transformation of education: the pedagogues henceforth attributed a moral value to uniform and discipline. The correlation of the adolescent and the soldier, in school, resulted in an emphasis on characteristics such as toughness and virility which had hitherto been neglected and which henceforth were valued for themselves. A new concept had appeared, though as yet in embryonic form, a concept distinct from that of childhood: the concept of adolescence.

Chapter 11
From Day-school to Boarding-school

Today we know only three categories of education: individual education by tutors (which was more common in the bourgeois nineteenth century), and two types of collective education, the day-school and the boarding-school.

One might imagine that individual tuition was bound to have been adopted by the society of the ancien regime, whose aristocratic make-up and isolated country residences would have favoured it. This was not the case. Not that the idea did not exist: on the contrary, it was to be found in pedagogical literature from the Renaissance to the eighteenth century, from Erasmus to Rousseau, in texts which constantly presented individual tuition as the best of educations. However, it sometimes happened that the authors of these theoretical discussions preferred small tutorial classes of ten pupils at the most to individual tuition. Small tutorial classes were held for a very short period in the little schools of Port-Royal and later at Sainte-Barbe.

In fact this literature, rich though it was, had no influence on either manner or institutions. Some modern historians, not realizing that no connection existed between this literature and actual practice, often attribute more importance to Erasmus, Rabelais or Port-Royal than to the Jesuits or the Oratorians! Under the ancien regime, until the mid-eighteenth century at least, education at home stopped before the age of ten, except for the King's sons, the only boys in France who did not go to college. Even princes of the blood such as the Condés went to college, which was the only educational institution open to all.

True, the word 'preceptor' belonged to common parlance, but in the sixteenth and seventeenth centuries it was not taken to mean a master who took the place of school and thus spared his pupil the promiscuity and discipline that went with school life. The word 'preceptor' was used in two senses.

The preceptor could be an older companion (the valet was of the same age, and was sometimes the pupil's foster-brother) chosen by rich parents to accompany their children to school where he shared their life and studies, and watched over them, protected them, helped them. He did not

take the place of school, but supplemented it and in particular offered protection against the physical or moral dangers which remained in school life as a result of the many survivals of medieval liberty. An engraving by Crispin de Pas of the early seventeenth century shows us the child, accompanied by his preceptor, taking leave of his family: they are about to set off, their double bags slung over their shoulders, leaving the family standing at the door; along the road they are going to take, other boys – with or without preceptors – are heading in a group towards the same goal.

'My father,' says H. de Mesmes, born in 1532, 'gave me as a preceptor J. Maludan, a disciple of Dorat's, a learned man chosen for the innocence of his life and of a suitable age to guide my youth until I was able to govern myself as he did ... He left his post only when I started my career ... *with him* and my younger brother ... I was sent to the Collège de Bourgogne.' Similarly, the future Maréchal de Bassompierre, born in 1589, was accompanied to Freiburg College by a preceptor, a dancing master and a writing-master – not counting the valets.

But the same name, 'preceptor', was given to a college master to whom children were entrusted as boarders. At the Collège des Grassins, according to Loménie de Brienne, born in 1636, 'my brother and I had as master, and *preceptor* as well, M. Le Haulx, the vice-principal of the college, who took special care of our education.' In his *Francion*, Sorel uses 'preceptor' as a synonym of 'master': 'Preceptors are people who come almost from the plough to the rostrum, servants who use a few hours of teaching which they owe their master to pursue their own studies ...'

As for the distinction between day-boys and boarders, that too was not the same as it is today. Generally speaking, it can be said that the boarding-school as we know it rarely existed: in the Jesuit colleges, the pupils whose life was most like that of our boarders were called *convictores*. The concept of the day-school was clearer and more widespread, because it corresponded to the most common practice. However, the terminology varied. In the Jesuit colleges *externi* denoted pupils outside the Society, those who were not *scholastici*; the day-boys or non-residents were called *auditores*. However, we know from Sorel that at Lisieux College the term 'day-boy' (*externe*) was already used as a synonym of the old term 'old fogy' (*galoche*): the same pupil is mentioned within a few lines as an *externe* and a *galoche*.

In fact, instead of the clearly defined categories of present-day education – boarder and day-boy – there existed a whole range of ways of life which I shall now try to distinguish and classify. It should then be possible

to see how the classic boarding-school system of the nineteenth century took the place of the earlier formulas.

The simplest, but probably also the rarest, case was that of the family living fairly close to a Latin school or a college. Vivès's dialogues show us the scene: the maidservant helping the child to get dressed, and the child going to say goodbye to his parents. He is given his lunch-basket: 'a piece of bread with some butter on it or some dried figs or raisins'. Then he sets off for school. Sometimes he is given some little errands to run; thus he stops to ask an old woman he meets: 'How much do you pay for your cherries?' She replies: 'We buy them at six deniers a pound – but why do you want to know?' And he answers: 'Because my sister told me to buy some this morning.' He dawdles on the embankment and plays at hopscotch and cards, with the result that he arrives late, when his schoolmates have already finished eating. 'Child,' says the master, 'by the time you arrive, everyone has already had supper.'

In Cordier's dialogues, we have this conversation between two boys: 'I had dinner at half past eight.' 'Why do you have dinner so early?' 'We nearly always have dinner at that hour in summer. How about you?' 'We never have dinner before half past ten, or even eleven.' 'Why not earlier?' 'We have to wait for my father to get back from the court.' 'But can't your mother give you dinner before your father returns?' 'Of course, but my father prefers me to wait for him.'

In another of Cordier's dialogues we have a pupil greeting his master: 'Good day to you, master.' 'And to you, dear little Stephanio. When did you get up this morning?' 'Just before four o'clock, master.' 'You get up too early. Who woke you up?' 'My brother.' 'Did you say your prayers?' 'As soon as my brother had combed my hair, I said my prayers.'

In the living conditions of the ancien regime, this category of pupils living at home could not represent more than a minority. The school population was not recruited only in the towns where the schools were to be found: it was largely drawn from the country, and many pupils, villagers or lords of the manor, villeins, clerics or nobles, lived too far away to return home at night and to make the journey to school and back on foot every day. Consequently a great many pupils lived away from home, either on the college premises, as boarders or servants, or in lodgings as day-boys.

Among those who lived on the college premises were some for whom the college had made provision right from the start: the scholars. They were called the *paupères* at Montaigu in the sixteenth century, and also at Louis-le-Grand in the seventeenth. But soon the foundation scholarships were put to a different use. Either wealthy families as a result of their

influence monopolized them (this happened in the English public schools, turning foundations for poor scholars into nurseries for young gentlemen), or else they were bought as offices, even by people who were not students, and notably by clerics who were thus able to enjoy the advantages of college life. In 1652 an inquiry conducted by the High Court into Autun College revealed that the scholars' association had become a middle-class boarding-house![1] Scholarships were sold for about two hundred livres each: 'Most of the scholars do not fulfil their obligations either in chapel or in schoolroom ... and spend years without attending a single class.' Many had completed their studies, or were supposed to have completed them. Newcomers paid an entry-fee to scholars relinquishing their scholarships: 'Master Paul, priest and scholar, has said that when he obtained his scholarship the person who had held it before him extorted sixty crowns from him, which were paid to the principal.' In these circumstances the scholars could not be regarded as pupils: this was particularly true of those colleges which did not provide a full course of tuition and whose pupils had (in principle) to attend the classes at another college which did. They gave the impression of being the principal's peers rather than his subordinates, in so far as they took part in the communal life of the establishment.

At Louis-le-Grand in the seventeenth century – when it was a Jesuit college – the terms of foundation were strictly observed and the *paupères* were given the same treatment as the boarders: that is to say, the same treatment as the richer pupils, the same statute thus covering the richest and the poorest. However, the *paupères* were distinguished from the other boarders by their dress, a dull grey cassock.

The scholars represented only an insignificant minority, whose importance lay only in the college statutes, which were originally drawn up for them alone. As we have seen, the colleges later recruited a much bigger population. It is this population that concerns us.

Among those who lived in the college buildings, apart from the scholars, was the bigger group of 'boarders', whom Pasquier defines as 'those who board with the master' or with the principal of the college. Cordier's texts show how envied they were: 'I am going to go into college,' says a pupil who therefore must be living out of school, coming in only for classes. 'What, to live in college?' 'Not to live there as a tenant and non-resident [two other ways of living in the college buildings which I shall analyse later] but as a companion of yours and a *boarder at the master's table*.' The master's wife looks after their clothes and their personal hygiene: 'Can't I go out?' 'What for?' 'To go home.' 'What! you want to go home

1. 'Visite au Collège d'Autun', 19 November 1652.

again?' (Home cannot have been far away, for a child to be able to go there so easily, yet far enough for him not to return every night but stay in college as a boarder). 'My mother told my brother and me to go home today so that the chambermaid could clean our clothes.' 'Why? Have you got lice on you?' 'Yes, a lot.' 'Why didn't you tell my wife?' 'We didn't dare.' 'As if she would have minded! She has a chambermaid whose principal function is to keep you clean, and well you know it. But you are pleased to have this excuse for going to see your mother. You shall stay at school. I shall have your clothes cleaned tomorrow.'

In 1549 Baduel, the rector and founder of Nîmes College, wrote to Séguier of Toulouse about his son: 'If you send me your son, I shall bring him up with my commensals or boarders.' He explained that consequently there was no need for a preceptor to accompany him: 'I do not know what companions [the preceptor was regarded as a companion rather than a master] or servants you are thinking of sending with him. A little boy is enough for everything to do with his personal service [the little valet, often a foster-brother]. The rest, that is to say his education and health, is our concern.' The master assumed full responsibility for him.

This category of boarder in the principal's house was still to be found in many old-established colleges in the seventeenth century. But in the colleges founded by new teaching orders such as the Jesuits or the Oratorians, the status of the boarders altered. It lost its character of a personal relationship between pupil and principal. The boarders were no longer the principal's but the college's, subject to a statute which laid down their time-table and their movements, quite apart from the restrictions imposed on all the pupils, including the day-boys. This system foreshadowed that of the modern boarding-school but was unusual at the time, being confined to a few privileged persons. The richer or better-born pupils were not satisfied with a bed in a dormitory: they were given a room of their own. This was the case with Condé. It was also the case with this relative of the Archbishop of Aix mentioned in the records of Aix College for 1731: 'His Grace the Archbishop asked for a room in college for the young Comte d'Agout, his sister's son, with a prefect [i.e. a preceptor chosen from among the college masters] and a valet. Master Cachard is to be the prefect. It was impossible not to give His Grace the first two rooms in the masters' gallery. But we had to have reasons as essential as those which we had to put ourselves to this inconvenience.'

In Geneva College, which Cordier describes, apart from the master's boarders there were the 'tenants' who hired rooms in college where they ate. Sometimes several tenants occupied one room; they attended the

classes, but were not subject to the discipline reserved for the master's boarders. 'The master caught us drinking on the sly,' says one of Cordier's pupils. 'Where?' asks another. 'In Fluviaus's room.' 'Why did you start drinking together?' 'Those two are not boarders at our table. They had brought some delicacies from their house which I wish they had lost on the way ... And seeing that I teach them sometimes [in these very big classes, certain pupils acted as unpaid tutors to their schoolmates], when I have the time to spare, they invited me last night after supper to this dinner today.'

Finally, besides the boarders and the tenants, the college buildings also housed those whom Étienne Pasquier calls the *cameristes*, 'who are boarded by their pedagogues', and Cordier the *domestic pupils*, lodged with the masters. 'Master,' says one of Cordier's pupils to the principal, 'there is nobody in the sixth class.' 'What's that! Where is Master Philip?' 'He is ill in bed.' 'How do you know? Did one of his *domestic pupils* come and tell you?'

The masters who lived in college had private boarders: this was the 'tutorial system' which the English public schools have kept to this day. We know from Sorel what the boarding-house of one of these masters was like. Francion's father wanted to send him to college: 'And since the colleges in our part of the country [Brittany] were not to his liking, in spite of my mother's complaints, having business in Paris, he took me there and put me to board with a master at Lisieux College whom someone had recommended to him' – a man called Le Heurteur. 'My master was an impossibly proud and impertinent young man. He insisted on being called Hortensius', in the Roman fashion. He lived with his valet in a house whose front door gave on to the college courtyard, while another door gave on to the street. He 'acted as master in a few classes'. Some of the college's inmates enjoyed the status of scholar, but this was not the case with Hortensius. His pupils, eight in number, lodged in rooms or 'chambers'. Hortensius kept back 'the greater part of our boarding allowance and fed us on scraps'. 'For our first two meals we were at the mercy of a spiteful valet who, so as not to give us our pittance, went out for a walk, on his master's instructions, just when they were ordered, so that that much should be saved and we should have to wait until dinner-time, when we could not complain . . .'

Like the principal's 'boarders', these 'domestic pupils' were subject to the college's discipline and its comparative claustration. 'At that time,' says Francion, 'I was more closely confined than a monk in his cloister, and had to present myself for divine service, a meal or a lesson at the sound of the bell, which governed everything.'

The boarders, tenants, *cameristes* or servants who lived in college, in its buildings and under its constant discipline, formed only a small part of the school population. The great majority lived neither at home nor in college: they were in lodgings. 'Apart from these [the boarders and *cameristes*],' says Pasquier, 'there are also pupils who live in town and go to hear the lessons of one master or another as the whim takes them . . . the young ones we call *martinets* and the others *galoches*.' We have seen that the term *galoche* is also used by Sorel as a synonym of day-boy: it was to fall into disuse in the course of the seventeenth century. Cordier calls these day-boys non-residents or *forains*. Sorel's Francion also speaks of 'one of my friends who is a *town pupil*', a pupil living in town.

This category, easily the biggest and the most characteristic of the school population as a whole, corresponded roughly to our modern day-boys, except for the fact that they lived in lodgings, and not at home. Some made do with a little room in which they lived by themselves: they may well have been the unhappiest of all. One of Cordier's boys complains of being unable to wake up in time: his landlord, a merchant and an old friend of his father's, had already gone out; the chambermaid was absent-minded; and his landlady, 'from early in the morning, when she gets up, is always busy with the children or thinking about household matters'. He is alone and friendless. 'I cannot study as I would like on account of the great multitude of merchants who come to this house and make a noise all day.' His room is 'so close to the stairs that a cat cannot go up and down without my hearing some noise'. What is more, 'there is a great warehouse where the merchandise is stored.' His father does not understand his complaints 'because he has never been to school and consequently cannot understand how people study'.

Generally speaking, pupils lodged together, either several to a room or in the same lodging-house. In 1605, Canon Jacques de Baune writes in his memoirs, 'there were seven hundred pupils at Tournon, most of them nobles, not only from near-by provinces, but from the most distant parts.' They were nearly all in lodgings: 'In the house where I lodged there were twenty of us' – twenty clerics, future prelates and canons, all very hard to please. 'Alexandre wanted me to give him some fish, and I had not had any.'

The system of living in lodgings lasted until the last years of the ancien regime and sometimes a little longer. In 1734 Marmontel arrived at Mauriac to enter the fourth class in the Jesuit college: 'In accordance with the custom of the college, I was lodged with a worthy artisan of the town'. There was a 'discipline exercised by the pupils on themselves'. 'The rooms brought together pupils from different classes, and among

them the authority of age and talent ... brought order and discipline to both studies and manners.' 'We worked together round the same table.'

The landlord provided lodging and heating, but only part of the food. On market-days, Cordier's school closed down to allow the pupils to go shopping and to collect the money which their parents would send them by means of people passing through the town. 'Are there many of you wanting to go out?' asks the master. 'Nearly all of us.' 'Why is that?' 'It is market-day today and consequently all of us want to buy something.' 'Go back to the market,' one pupil tells another. 'What, at this hour? There was such a crowd at the butcher's that I could scarcely get to his stall.' 'What sort of meat have you brought us for tomorrow?'

Similarly, Marmontel tells us: 'My father ... left me at Mauriac with my bundle and enough food for a week': a loaf of rye bread, a cheese, a piece of bacon, a dozen pears. It was the week's provision that the parents renewed every market-day; Marmontel adds that with these provisions 'our landlady did our cooking for us.' The schoolboys watched carefully over their little stock of food. Their landlord, who tried now and then to take a little for himself, had his trouble for nothing. The boys knew how much everything cost. One of these lodging-house keepers, in Larivey's comedy, *Les Écoliers*, says: 'Most of those schoolboys were so stingy that you could no more swindle them than you could shear an egg. I have had some in my house who would even lock up a piece of bread that was left over from their dinner and supper.'

As late as the beginning of the nineteenth century, in the Somme district where there remained a few Latin schools in the country, the boys used to arrive with a week's food in their *besaces* or double bags: they were known as the *besaciers*.

The only systems in force under the ancien regime were therefore either the 'tutorial system' or the day-school with board and lodging in a private lodging-house. The only thing which was like our modern boarding-school, the status of the *convicti* of the Jesuits or the Oratorians, remained exceptional; it was accepted by the college pedagogues only with the greatest reluctance, and in order to avoid displeasing an aristocratic clientele anxious to protect its progeny from the promiscuity of school life. The Jesuits never tried to increase the number of their boarders: the day-school system remained their ideal.

The social climate was unfavourable in any case to a complete incarceration: conditions of supply, transport and hygiene were all against the concentration of boarders in a single building and the overall maintenance of a large population. A great deal was made of the risks of

epidemics, and also of brawls and riots, for the pupils, of very different ages, were rough, violent and headstrong.

The authoritarian tendency and the strengthening of discipline reduced the schoolboy's liberty and produced a stricter control of his private life. But it is worth noting that this evolution did not start with the Jesuits' *convicti* and develop as an extension of that boarding-school system.

The modern boarding-school has a different origin: the steady transformation of the pedagogicas into private boarding-schools subject to a discipline similar to that of the colleges.

We have seen that most of the pupils at colleges were in private lodging-houses; a time came when these day-boys ceased to escape from the college's authority, which soon extended to their landlords. We have already noted an evolution in the sixteenth century towards absolute power for the schoolmaster. But this power could not be exercised efficiently if most schoolboys enjoyed unlimited freedom outside school and church. The principals and masters accordingly tried to reduce this freedom by keeping a check on the lodging-house keepers who put up their pupils in town. Moreover their right to do this was recognized by the civic and ecclesiastical authorities: a Cardinal, the reformer of the University of Paris, in the fifteenth century; and in the seventeenth century, the courts responsible for ensuring the good order of towns with colleges. It was in the interest of the lodging-house keepers themselves to accept this control which guaranteed the respectability of their houses and thus assured them of high-class lodgers. The principals and masters were led to favour certain lodging-house keepers, particularly priests who no longer merely provided board and lodging but also acted as tutors to their boarders and exacted from them, under the threat of the birch, respect for scholastic discipline.

In 1605 Canon Jacques de Baune boarded at Tournon with a 'pedagogue', as he calls his lodging-house keeper. 'For the lodging-house keeper who put us up we were twenty lazy, rascally pupils', addicted to 'childish tricks' and even to 'taking wing'. The students often slept out and sometimes plundered the pedagogue's wardrobe. His final resource was the birch: 'He who will not study in obedience to the word, will do so in obedience to the birch.' A pedagogue who wields the birch is no longer a mere lodging-house keeper.

At La Flèche in the early seventeenth century, it was recognized that the rector and the prefect of the Jesuit College had the right to inspect the pedagogicas, and they visited them personally. An edict issued by the seneschalsy lieutenant compels the 'lodging-house keepers and preceptors' (note the word 'preceptors') of the town to report their boarders'

names within three days of their arrival, not only to the presidial clerk – this would have been a police formality – but to the prefect of the college. The lodging-house keeper thus became the master of a private boarding-school, of a *pedagogica* as it was called in the early seventeenth century, who sent his pupils to the classes and religious services of the college, and the rest of the time kept an eye on their studies and their morals.

In Père de Rochemonteix's monograph on La Flèche College we find an account of one of these pedagogicas; the account tells the story of an Irishman, John Callaghan, known for his Jansenist activities thanks to the note on him in the Port-Royal necrology. Coming from Quimper College, he entered the second class at La Flèche. As he had no money, the Fathers paid him a small salary for his work as sweeper and 'corrector': 'eighteen livres in silver as wages, a cassock and a cloak for filling the afore-mentioned office of corrector, and his food with the other servants of the aforementioned college'. He continued his studies after leaving the philo-sophy class and attended classes in theology in 1630. He was still given bread and soup at the college. What is more, a priest who *took in boarders at a widow's house* 'also gave him food out of charity and put him at the right end of the table'. This text is interesting in that it reveals a certain degree of specialization: the owner of the house and the master of the pedagogica were not the same person. The priest had hired the widow's house in order to receive schoolboys in it, provide them with regular meals and supervise their studies. Some of these boys lodged in the same house: 'A certain Moreau, a schoolboy, who lodged in the same house, lent him [Callaghan] half his bed.' Others lodged elsewhere, two of them at a butcher's, but took their meals with the priest and attended his lessons. This priest, for all that he was not a master at a college, was regarded as a professional teacher. It was a career. From being the master of a boarding-school at La Flèche, he became in 1633 master of the novices at an abbey at Le Mans. On his departure he suggested to Callaghan 'that he should leave him his schoolboys to give him the means of subsistence'.

Here we can see one of the origins of the boarding-schools or institutes which developed in the eighteenth century: boarding-schools which sent their pupils to the classes of a college. The schoolboy was no longer the *martinet* or the *galoche* of the fifteenth and sixteenth centuries. Nor was he the rare rich *convictus* of the Jesuit college. He became the boarder (or sometimes the half-boarder, when he was not rich enough to pay for full board and lodging, and lived in a garret in the house of some artisan or merchant) of a pedagogica which provided discipline and coaching. This type of boarding-school was a college annex open to all ages.

Claude Joly (1678) tells us that there was, at least in seventeenth-century Paris, another type of private boarding-school reserved for younger boys. Claude Joly was the canon cantor (choirmaster) at Notre-Dame, and by virtue of this office he was 'patron, judge and director of the grammar schools or little schools of the city and suburbs of Paris'. He therefore had to defend the rights of the chapter and cantorship against all who threatened them: the university, the parish priests, the master-scribes, the religious orders. His treatise is at once an indictment and a speech for the defence. The university, that is to say the Faculty of Arts or its colleges, had in fact accused the cantor of infringing their monopoly. Claude Joly admits the truth of the accusation: 'The cantors of the Church in Paris, having been asked some sixty years ago (about 1610) by certain private persons who were married and who had hired well-ventilated houses with gardens in the suburbs of Paris, to give them permission to lodge children in those houses in order to teach them, gladly granted their requests.' 'The district masters [masters of the 'little schools'[2] which depended on the cantor] could not take in boarders, not because they lacked the rights but because they lacked the means [their houses were too small]; and that is why they considered that an establishment of this sort would be convenient for many people of quality with young children who were delicate and still needed a woman's care, for which reason the parents could not send them to the university colleges although they were afraid that their children would be spoilt by living at home with valets.' 'The baptismal innocence of these little children, *who are almost all of an age in these schools,* would be safer here than with the bigger schoolboys of the University colleges, however careful and vigilant the principals and masters may be.'

These boarding-schools were called 'licensed schools', because they had been licensed by the cantor, or else 'little colleges', because the Faculty of Arts regarded them as rival establishments and demanded their suppression. They owed their existence to the parents' desire to have their children aged between ten and thirteen lodged in the country, under closer supervision than that provided in the colleges where the numbers were too large. 'As Paris has grown by almost a third in the past fifty years, the number of licensed schools has also rightly been increased.'

There were therefore two sorts of boarding-school: the pedagogicas which sent their pupils to classes in the colleges, and the licensed schools which taught the younger children themselves, up to the fourth class. It so happened that in the course of the eighteenth century these two types

2. For the 'little schools' see Chapter 12.

of establishment came together and complemented one another. Private 'institutions', outside the university, came into existence and took in boarders of all ages. They provided elementary education up to the fourth class; after the fourth class, they sent their pupils to classes at a college providing a full course of tuition, giving additional coaching themselves. Thus the community of the Gillotins, which rented some of the buildings of Sainte-Barbe College, numbered – just before it was broken up for its Jansenist leanings in 1730 – one hundred and sixty pupils, all boarders, who went to the classes held at Le Plessis College. These one hundred and sixty pupils were in the charge of twenty-five masters, an exceptionally high figure for the time, and one which can be explained by the adoption at Sainte-Barbe of the system of small tutorial classes instituted at Port-Royal.

These establishments were called 'Pension' or 'Institution', followed by the founder's name – for example, the Institution Savouré, founded in 1729 by two masters at Sainte-Barbe: its boarders went to the classes at Dormans-Beauvais College and later to those at Lisieux College, under the supervision of a 'master of behaviour'. This practice has continued to the present day.

These private boarding-schools existed all over France. At Vendôme in 1775, Jacques Lablée, then a fifteen-year-old rhetorician at the Oratory, was 'boarded with Monsieur Favin ... a good fellow with too easygoing a character and over-fond of wine ... There were sixty of us boarders. Like other pupils belonging to various boarding-schools, we went to the classes in college.'

These private boarding-schools grew in number, it seems, after the expulsion of the Jesuits. Masters took advantage of the uncertain situation resulting from the closing of the colleges or the change in their administration to open boarding-schools: these boarding-schools no longer simply followed and supplemented the classes of the colleges, but provided a complete course of tuition, of a more modern character, intended to prepare pupils for entry into the new military schools. Thus in the late eighteenth century there was a relatively extensive boarding-school system. However, it had arisen on the fringe of the great traditional schools. By and large, one can say that there were two types of complementary institutions: the colleges where pupils simply attended classes and the private boarding-schools which as a rule did not hold classes. These two types corresponded to two contrary concepts of education, the college to the spirit of the Renaissance, which did not trouble itself with the question of lodging, and the private boarding-school to a new spirit which attributed a moral value to the boarding-school system.

In the early nineteenth century, the internment of the child and the young man far from the world and his own family was considered one of the ideal forms of education, together with the individual tuition made famous by Rousseau's *Émile*. Individual tuition and the boarding-school became part of French life together. The paradox is only apparent: both types of education were designed to satisfy the same conviction of the moral necessity for a more suitable setting for childhood. For a long time Jesuits and Jansenists alike had recommended constant supervision of pupils, but they had been unable to apply this principle or to impose it on a public opinion still attached to old habits of liberty, if not of anarchy. On the other hand, from the end of the eighteenth century on, the moral and educational value of seclusion had been generally recognized. Thus we find Rollin (1728) writing: 'It is an eminently wise rule, established in several colleges, not to let the boarders out on Sundays and holidays.' When Louis-le-Grand was reorganized as a model college after the suppression of the Jesuits, the day-boy system was abolished, for it was considered, to quote Dupont-Ferrier, 'the vehicle of insubordination'.

The correspondence between the masters at Sainte-Barbe and the pupils' parents gives us some idea of the preference shown for the boarding-school system in the early years of the nineteenth century. In 1807 one family wanted to keep its son at home, although he was in the eighth class at Sainte-Barbe. The master expressed his disapproval: 'We would point out to the family that he is setting a bad example to his schoolmates by abusing his facilities as a day-boy.' It would be better, the master suggested, if he followed the example of another boy in the eighth class, for whom, he wrote enthusiastically, 'his family has decided to make the necessary sacrifices in order that he may become a boarder'. For that boy will now be able to 'gain considerable advantage from this complete seclusion and our special attention'.

Parents were also recommended to extend this 'complete seclusion' to the holidays. In the sixteenth and seventeenth centuries, families used to mobilize all their members for the work that had to be done in the summer, and particularly the wine-harvest; in Cordier's dialogues there is a pupil who recounts his recollections of the wine-harvest. Possibly the origin of school holidays is in fact to be seen in this periodical mobilization. The custom, which took no account of fatigue and aimed at ensuring maximum efficiency, benefited the bigger pupils, who obtained longer holidays than the younger boys. But in 1800 the college no longer had the same connections with country life that the primary school retained far into the nineteenth century and even beyond. Holidays meant an interruption of school work and a period of idleness, and they soon became

objects of suspicion in the pedagogues' eyes.[4] The masters at Sainte-Barbe set out to cut them down. In 1816 they wrote to the father of a child of nine: 'M. Bonaire knows that long holidays are unsuitable at that age.' To the father of a pupil in the third class: 'Holidays strike me as dangerous in the first year at college; they are not traditional at this college or in the pupils' interests.'

The statistics for Louis-le-Grand published by Dupont-Ferrier show very clearly how the boarding-school system developed during the first half of the nineteenth century:

	1817–18	1837–8	1861–2	1888–9	1908
	per cent	per cent	per cent	per cent	per cent
Boarders in *lycées*	65	49·5	58	24	18
Boarders in *pensions*	19·5	40	[?] 24	[?] 18	13
Day-boys	15·5	10·5	14	35	69

Up to 1870, boarders in lycées, or in *pensions* which sent their pupils to classes in lycées, represented over 80 per cent of the total number of pupils. The day-boys were reduced to a small minority, between 10 and 15 per cent, in other words the exact opposite of the situation in the colleges of the ancien regime. This was the situation which inspired Taine to write these bitter lines: 'In order to receive a secondary education, more than half the boys in France have to endure seclusion in ecclesiastical or lay boarding-schools, seclusion under military or monastic discipline.' This extension of the boarding-school system in the late eighteenth century and early nineteenth century was in fact a general phenomenon, to be found in Frederick the Great's Prussia as in the England of the public schools. The English public schools became exclusively boarding-schools, and this circumstance distinguished them from the grammar schools, which were attended by day-boys from the surrounding district, as were the French colleges.

In France, the boarding-school system went into a decline in the second half of the nineteenth century. The number of boarders sent from *pensions* to attend lycée classes dropped to almost insignificant proportions. The number of boarders at lycées also dropped. The change can be clearly distinguished in the statistics for Louis-le-Grand shown above. The number of boarders dropped from 82 per cent in 1861 to 31 per cent in 1908. The number of day-boys rose from 14 per cent in 1861 to 69 per cent in

4. Another change: twentieth-century pedagogues no longer share this suspicious view of holidays, which have become a corporate privilege.

1908, in other words to over two-thirds of the total. And it should be re-membered that the proportion of boarders was bound to be higher at Louis-le-Grand than elsewhere, on account of the considerable number of boys from the provinces in the classes preparing for entry into the Grandes Écoles. The reason was that in France the boarding-school system was no longer credited with the moral and humane influence which eighteenth-century pedagogues had attributed to it. It was resorted to only when it was necessary for reasons of distance, family difficulties, or preparation for advanced education. It was accepted, but it was no longer chosen. The richer families retained a certain nostalgia for the boarding-school for some time, favouring not so much the state *lycée* as the private school, often a religious school. They remained in fact attached to the eighteenth- and nineteenth-century concept of the supervision of childhood: children, in their opinion, should live apart from adults, under a special discipline. But this was an out-dated phenomenon which soon disappeared: in France, boarding-schools of the English public school type failed to take root. This dislike of the boarding-school system did not in any way imply a return to the moral conditions of the sixteenth- and seventeenth-century day-school. The French family would no longer agree to be separated from its children, even in the interests of their education. The child would stay at home longer than before.

We have come then to the end of this particular development. We started with a situation in which the boarding-school was unknown, and schoolboys lived in lodgings, free of all authority, whether paternal or academic: hardly anything in their way of life distinguished them from unmarried adults. Soon masters and parents decided that this freedom was excessive. An authoritarian and hierarchical discipline was established in the college; and after that it was decided that it should extend further and reach the schoolboy where he spent most of his time. The result was a boarding-school system outside the college, at first fairly lax in character. Henceforth a child's schooling was expected to provide more than pre-paration for adult life: the moulding of a type of individual (the gentle-man in the English public schools), something in fact which had previously been expected not so much from school as from the society from which the child and the young man had not been excluded. This particular con-cern, which was to be found in the Napoleonic *lycées* and the little French seminaries no less than in the English public schools, was unknown to the pedagogues of the sixteenth and seventeenth centuries. The latter taught a culture that was at once humanistic and Christian, and made no attempt to impose upon their pupils the features of an ideal social type. The *honnête homme* of the seventeenth century was not a scholastic creation.

On the contrary, every seventeenth-century writer, story-teller or moralist depicted him as the opposite of a college pedant. One became an *honnête homme* in spite of one's schooling – at least that was the usual boast! Consequently the pedagogues felt no need to push discipline beyond the minimum necessary to quell the traditional turbulence of schoolboys and students. Still less did they regard claustration as an end in itself. Even in the seventeenth-century pedagogicas for boarders, under the supervision of the prefects and principals of colleges, there remained a great deal of the free and easy attitude of the preceding centuries.

The development of the boarding-school system after the end of the eighteenth century bears witness to a different concept of childhood and its place in society. Henceforth there would be an attempt to separate childhood from the other ages of society: it would be considered important – at least in the middle class – to shut childhood off in a world apart, the world of the boarding-school. The school was substituted for society in which all the ages were mingled together; it was called upon to mould children on the pattern of an ideal human type.

The change which occurred in the school population at the end of the nineteenth century in favour of the day-boys did not interrupt this tendency to set children apart, but it turned it in the direction of family life. The family was substituted for the school as the predominant moral setting (and this just as the school was beginning to play an increasingly important part in professional education). The central concern of the individual family was its own children. This was the triumph of demographic Malthusianism. If economic or social circumstances bring about a relaxation of family control, childhood and youth may escape from the isolation in which they are enclosed by a tradition going back at least to the eighteenth century; that is probably what is happening today, with childhood losing some of its special characteristics in favour of a new age group: adolescence.

Chapter 12
The 'Little Schools'

Until the seventeenth century, there was no term for elementary education in everyday French. The term *petite école*, corresponding to 'little school' or 'petty school' in English, did not appear until the seventeenth century. The cantor Joly, writing his defence of schoolmasters in 1678, maintained that the expression was recent, going back to the sixteenth century at the earliest, and also incorrect, 'contrary to the old form'. According to Joly, the correct term was 'grammar school'. But we know that the grammar school also tended to be confused with the college, and Joly took advantage of the vagueness of this terminology to contrast what would become the 'little schools' (i.e. primary education) with the university and the lower classes in college (i.e. secondary education).

In the Middle Ages and until the sixteenth century at least, all there was in fact was a Latin school, the grammar school, the 'school for the instruction of youth' (de Charmasse, 1871–8). However, these Latin schools were not all of the same nature. Some would blossom out into colleges and universities, while others – the great majority – would remain at an elementary level. Many in the fifteenth century consisted of two masters, one of whom taught singing and the rudiments of grammar while the other taught the liberal arts. Some consisted of a single master who taught both singing and the rudiments. We can imagine what these little Latin schools were like, thanks to 'The Prioress's Tale' by Chaucer: 'The little school for Christians was held at the far end of the street; and a crowd of children of Christian birth used to come here who from year to year learnt at school what was usually taught there, namely to sing and to read as children do in their tender years.' That is to say, the children learnt to read from the Psalter or a book of hours, and before learning to read (it is not certain that they even learnt to read well) they learnt the liturgical prayers by heart, by repeating them in unison (as is still done in rabbinical or Koran schools). 'Now,' Chaucer continues, 'among these children there was a widow's son, who was seven years old and usually came to school every day.' 'This little child, sitting with his little book in front of him, was learning his ABC when he suddenly heard the singing of the *Alma Redemptoris* which other children were reading from their

antiphonaries.' One can picture the scene: some of the children learning to spell, the others learning to sing. The child 'made so bold as to come nearer and nearer [to those who were singing] and listened to the words, and to the notes as well, until he knew the first verse by heart. He did not know what the Latin meant, for he was very young.' He asked an older schoolmate to translate it for him, but without success. 'I cannot explain it to you,' the other replied, 'I am learning singing but I have little grammar.' Nowadays we would say, 'little Latin'.

We can therefore regard these schools not as primary schools, since they were intended mainly for choirboys, but as the beginnings of the Latin school or grammar school. However, the cathedral chapters, which held the monopoly of school teaching, gave permission from the fourteenth century on for singing and the rudiments to be taught outside their own schools – which were grammar schools of a more complete character. It was recognized that the teachers in these other schools should stop at the Donat. Thus at Chartres in 1325: 'Roger, Rector of the schools of Saint-Jean-en-Vallée, was warned at a capitular meeting, by virtue of the privileges of the Church in Chartres, that he was forbidden to instruct children, in his house or elsewhere, except only in the great schools of Chartres [in majoribus scolis], which lie within the jurisdiction of the Chancellor of Chartres, in books or book-learning which go beyond the Donat.' After repeating his offence, he was excommunicated, and he paid a fine and 'promised that in the future, in scolis suis, he would not teach children after the day they began to know their Donat or their parts of speech, sed eos ducet ad majores scolas carnutenses'. In any case, it was not long before the restrictions imposed by the cathedral chapters were flouted and these little schools developed in such a way as to form other Latin schools similar to grammar schools: it was the city magistrate of Chartres who, in agreement with the bishop and against the wishes of the chancellor, decided in 1564 to merge all these schools into a single college. However, some of these private schools scarcely went any further than the Donat and seem to have been nothing more than little Latin schools.

In 1451 the priest of a parish in Rouen was prosecuted by the cathedral chapter which challenged his right to teach the Donat, a right restricted to the masters of the capitular school.

Thus in the sixteenth century nothing but Latin schools existed; but these schools were not all at the same level of development. This situation lasted until the end of the ancien regime. We have a document of 1678 giving the 'state of the colleges in the department of Lower Guienne' which P. Delattre published in 1940. Only a few colleges covered the com-

plete cycle of studies: Bordeaux, Périgueux, Agen, Condom, Dax. Others held classes only in philosophy and theology (the Jacobin school at Saintes), or else in the rudiments, grammar, the humanities, but not rhetoric (Saint-Macaire), or finally in the rudiments and first two classes in grammar (the Doctrinarians of Cadillac, the Benedictines of La Réole, and the Carmelites of Langon). Père de Dainville has shown how these schools of unequal development formed as it were geographical constellations and gravitated round a college providing the full course of tuition. Thus in our historical perspective, the school whose pupils learned to read Latin and sing the Psalter does not appear as the prototype of the modern primary school, but rather as the basic cell of a network of Latin schools which taught first the rudiments, then the rudiments and grammar, then grammar and the humanities, and finally the complete cycle up to rhetoric, and then up to ethics and logic. It is none the less true that as early as the fifteenth century there were some elementary Latin schools which, if they had not taken on additional classes, must have merged with the little schools which came into being towards the end of the sixteenth century.

We know that in the second half of the seventeenth century there were all over France 'little schools' in which we can undoubtedly see the origins of the modern primary school. In Paris, the canon cantor of Notre-Dame was 'patron, judge and director of the little schools of the town, city, university and suburbs of Paris'. He gave (or sold) 'licences to hold school' to masters and mistresses, with the proviso (which was rarely observed) that 'the masters shall not receive girls in their schools, nor the mistresses boys in theirs.'

Just as the masters of the Paris colleges were under the jurisdiction of the university, the schoolmasters were under the jurisdiction of the cantor of Notre-Dame, who held audience every Thursday. The cantor's edicts defended the common interests of the schoolmasters, avoided competition by fixing the number of schools in each district in proportion to the density of population and by fixing the time-tables of the classes. In country districts the master was elected by the village community, whose choice had to be approved by the bishop and in the eighteenth century by the administrator of the province. 'Most of the schools we have been able to trace [the oldest ones],' observes the Abbé Allain, 'belong to the last quarter of the sixteenth century. They are nearly all contemporaneous with the councils which were held in various provinces to put into effect the decrees of the Council of Trent.' The same was true of England, where the Elizabethan laws provided for a master to teach the 'pettyes' of each village.

A new method of tuition and a new type of school personnel had been established by the last years of the sixteenth century.

What did this tuition consist of? We know the answer from a whole scholastic literature which, as from the mid-seventeenth century, laid down curricula and teaching methods. This literature bears witness to the interest shown in the question and to the lack of precedents.

Take for instance *L'Escole paroissiale, ou la manière de bien instruire les enfants dans les petites escoles par un prestre d'une paroisse de Paris*, published in 1654 and reissued in an abridged form in 1685.[1] This handbook, written in French (the statutes of the colleges and the university were couched in Latin), deals with discipline as well as material conditions and curricula: one has an impression of established traditions which the reforms of St Jean-Baptiste de La Salle at the end of the century would improve without changing their nature.

In 1705 in fact there appeared *La Conduite des Écoles chrétiennes*, instructions for the Brothers' schools, which still carried weight in the late nineteenth century. The few chapters dealing with the tuition in the little schools reveal its various origins. First of all there is the influence of the Latin school, at its most elementary level: before Jean-Baptiste de la Salle, nobody thought of teaching children to read French straight away. According to the 1654–85 instructions, the child learnt to read and spell in Latin – Church Latin – and the prayers of the liturgy: the *Magnificat*, the *Nunc dimittis*, the *Salve Regina*, 'the responses in Mass, the Offices of Our Lady, the Holy Cross and the Holy Ghost, some of the penitential psalms, the Office for the Dead, 'vespers for the whole week', and the hymns of the diocese. And the author insists on the necessity of starting with Latin: 'Before going on to French reading', the pupils are to 'read Latin in all sorts of books'. There was therefore no difference between this tuition and that given in Chaucer's school, or in the sixth class of the colleges. The idea was still that of a choirboy's education. It was not until St Jean-Baptiste de La Salle came along that France abandoned this tradition which confused book-learning and the Latin language, whether liturgical or humanistic, and instituted tuition in French. Even so, *La Conduite des Écoles chrétiennes* still provided for classes devoted to reading in Latin after the French reading lessons.

For a long time singing remained as important as Latin, and for the same reason: it enabled the pupils to make the necessary liturgical responses. Consequently the rudiments master was often referred to as the master of music, as at Gerson's cathedral school in Paris and Colet's in

1. Shorter version of 1685: *Instruction Méethodique pour l'Escole Paroissiale, Dressée en Faveur des Petites Escoles.*

London, where there were two masters, one for singing who also taught the rudiments, and the other for grammar. In England the little schools were also called 'song schools'.

Besides singing and the rudiments – subjects taken from the old Latin school but now 'vulgarized' – the curriculum of the little school included the study of etiquette. We shall be examining elsewhere in greater detail the historical significance of the etiquette books.[2] Here let us simply say that they were manuals of good manners: how to behave in society and at table, 'all the duties of children to God and their parents, the proprieties and good manners, both Christian and worldly'. *L'Escole paroissiale* stipulates that after the Latin lesson the 'French reading' shall be done from manuals of etiquette. These manuals were not unknown in the Latin colleges. One edition of *Galatée* was intended for the pupils of the Jesuit college at Pont-à-Mousson. But etiquette, like history and geography or music and dancing, was regarded as a subject outside the curriculum taught in class. In the little schools, on the contrary, etiquette occupied an important place, and Jean-Baptiste de la Salle went to the trouble of giving his pupils a *civilité chrétienne,* or Christian manual of etiquette, which put all the previous manuals out of fashion and went through an incredible number of editions in the eighteenth and nineteenth centuries. In his *Conduite des Écoles,* Jean-Baptiste de la Salle wrote: 'When the pupils are all able to read French perfectly and are in the third standard in Latin [there were grades or standards in reading, writing and Latin], they shall be taught to write, and they are to be taught to read from the book of *civilité chrétienne.* This book contains all the duties children owe God and their parents and the rules of good behaviour both Christian and social. It is printed in Gothic characters, which are more difficult to read than French characters.' Certain manuals were also printed in several columns, each column being composed in different characters: gothic, roman, italic and manuscript. The manual of etiquette was therefore at once a reading book, an 'example' of handwriting and a handbook of good manners.

The manual of etiquette, foreign though it was to the medieval scholastic tradition, also had a distant ancestry: tuition in the proprieties, oral to begin with, later written, and sometimes versified, was almost the only tuition given to the non-cleric, the future knight, in his apprenticeship in life and good manners. We shall in fact see that, next to scholastic tuition, there was in the Middle Ages an apprenticeship, a period in which the child left his home and was sent to another house, where he had to learn the manners (or the trade) of the head of the family. The Latin school, restricted to clerics, did not monopolize all the forms of cultural communi-

2. See Chapter 15.

cation. There was a lay culture, a view of life, with its rules, its morality,
its refinements or 'courtesies', which was acquired by example and through
the cohabitation of children and adults: an apprenticeship. In this courtly
lay environment the literature of good manners was born: hints which
were first oral, then written down, and finally printed, and which were
passed around for the benefit of the young pages and squires of the house-
hold (see Watson, 1908; Furnivall, 1868). When the Latin school
spread to middle-class and noble circles, it was tempted to make use of
the manual of etiquette. But the pedagogues never, either in Montaigne's
time or in that of the Chevalier de Méré, abandoned their conviction
that college tuition was 'pedantic' and not meant for good manners, which
ought to be learnt elsewhere, at home or in the academies, if not in society:
the only exception was perhaps the Jesuits – whence one of the reasons
for their success. Etiquette was neglected in the universities and colleges;
on the other hand it moved from the sphere of domestic and family
apprenticeship to the curriculum of the little schools, where it became
one of the most important subjects. Domestic and family apprentice-
ship is thus seen to have been the second source of the primary curricu-
lum.

According to *L'Escole paroissiale*, when the pupil has learnt 'to read
well from the manual of etiquette', he is to become a 'scribe' and learn
how to write. But at this point the author seems a little embarrassed. By
writing, people at that time meant, as we do today, a means of com-
municating thought; but it was also regarded as a technique or an 'art'.
This art was not supposed to be taught in school: it was the monopoly of
the guild of master-scribes. The author of *L'Escole paroissiale* recognizes
this. He admits that his pupils will not be able to perfect their writing at
school but will have to address themselves *afterwards* to the master-
scribes, the 'famous writing-masters'. All the same, he argues, they must
be taught to write usefully: after the first 'examples', they must practise
copying out 'forms of receipt, bonds, farming leases ... so as to school
them in the affairs of the age'. This utilitarian point of view did not fail
to mark them out as rivals of the master-scribes. It bore no resemblance
to the more disinterested, loftier preoccupations of the Latin school. At
the Latin school, no stress was laid upon the quality of the pupils' writing.
It was understood of course, that one had to be able to write – though it
may be that this obligation had not been considered so pressing for very
long: in the Middle Ages there was nothing extraordinary about a lay
culture nurtured on reading aloud, recitation and music, in which writing
was uncommon and largely restricted to clerics. And even clerics – before
the invention of printing and doubtless also on account of the rarity and

high cost of paper – resorted to memory more often than we would nowadays: it was necessary to learn things by heart, and writing seemed a suspicious means of avoiding this effort. The theology student was not allowed to have a Bible during his first year, and the master was forbidden to use notes during his class. That way one could be certain that he knew his subject. Admittedly the use of writing spread quickly with the development of printing and the manufacturing of paper on a large scale, making possible more industrial work. In the iconography of the sixteenth century, the schoolboy is often depicted with an inkpot in his hand. However, even when it had become normal and indispensable, writing did not immediately play an important role in Latin studies at school. As late as 1596, Coote in *The English Schoolmaster* complained of grammar-school pupils who wrote badly. Teaching remained predominantly oral (hence the importance of the monitors who went over lessons with the class). However, it became customary to take notes during classes and sermons, and writing tended to become a form of shorthand. In England in the mid-seventeenth century there were indeed some shorthand manuals, such as Everardt (1658). It was a corrupt form of handwriting, which itself comprised several varieties: round, slanting, and so on.

In the little schools writing was no longer regarded simply as an instrument of literary or legal knowledge; it was already a profession, or the basis of a profession. This semi-technical education was introduced with the greatest care, for the schoolmasters were afraid of opposition from the master-scribes and had uneasy consciences. The pupils began by learning to write in different characters. We have seen that the manuals of etiquette were often composed in several characters: the usual characters employed in printing – gothic, roman and italic – and also 'handwritten letters' which in typographic jargon were also known as 'etiquette letters' or *caractères de civilité*. The complete and perfect knowledge of all the various scripts was anything but general. *La Conduite des Écoles chrétiennes* considers it necessary to expect it of all the masters. 'Every master of the writing-class must be able to read all sorts of handwritten documents.' The Brothers encouraged their pupils to study all the different varieties of handwriting; 'When the pupils are in the fourth standard of round writing or are beginning the third standard of slanting writing, they are to be taught how to read handwritten papers or parchments called registers.' It can be seen that writing was not distinguished from reading scripts, even rare or difficult scripts. Similarly the reading of scripts was not confused with the reading of the printed characters in current use. Starting with the easiest scripts, pupils were to be taught to

read handwriting of increasing difficulty 'until they are able to read the most difficult scripts it is possible to encounter'.

However, Jean-Baptiste de la Salle is bolder and more adventurous than his predecessors in the teaching of handwriting. *L'Éscole paroissiale* had provided for an initiation only. To perfect their writing, pupils were referred to the master-scribes, the 'famous writing-masters', in the hope of mollifying the latter. Yet Jean-Baptiste de la Salle does not hesitate to teach the complete curriculum of the scribes in his schools.

We have seen that the examples of writing given to the schoolboys to copy were business forms: receipts, bonds and so on. It was proposed to 'school them in the affairs of the age'. Thus writing was always linked with arithmetic, known in France as *le jet* because of the *jetons* or counters without which it was impossible to calculate correctly. The art of the *jet* was essential to 'the practices and affairs of the age', if only because it enabled one to find one's bearings in a complicated monetary system: with the aid of *jetons*, says *L'Escole paroissiale*, the pupils are to be taught to grasp the relationship between livres, sols and deniers. In *La Conduite des Écoles chrétiennes*, arithmetic is introduced as a means of solving everyday financial problems: 'To do a sum well, he will begin with deniers.'

Such are the three elements which formed the curriculum of the little schools in French towns in the seventeenth century: reading and singing, etiquette, writing and arithmetic. To varying degrees they were also to be found in the little schools in the country, which grew in number during the seventeenth century. Thus at Castillon, near Bordeaux, in 1759, 'the community gathered together in due order', listened to its attorney declare the school vacant and decided that it was necessary 'to obtain immediately a schoolmaster who would be able to teach reading, writing, arithmetic and book-keeping'. There was a candidate for the post: a certain Laroche, 'a sworn master-scribe of Bordeaux'. The aldermen and jurats (the notables of the community) satisfied themselves as to his orthodoxy and morals and, 'having seen his writing and questioned him about the rules of arithmetic and about book-keeping', decided that he was a suitable person to fill the post, 'subject to the approval of His Grace the Archbishop and His Lordship the Administrator'. On the other hand, in a village in the Lower Pyrenees in 1689, a candidate for a similar post was rejected because he was incapable of deciphering the village charters. Similarly in 1737 the inhabitants of Macau in Médoc asked the Archbishop of Bordeaux to dismiss the local schoolmaster: 'Every day people present themselves who are infinitely more capable than he is of teaching writing, arithmetic and the reading of bonds.'

Thus the village schoolmaster had to be both a book-keeper and a paleographer. Just as today the village schoolmaster in France is also the clerk to the parish council, at that time he was the notary to the community and sometimes even attorney and lieutenant of justice, in other words half police-officer and half justice of the peace.

The schoolmaster also acted as choirmaster in the village church: this was the singing element of the little school. He was honoured during Mass: the 1685 Assembly of the Clergy had decided that 'schoolmasters dressed in their surplices should be incensed in church and should be honoured before the laymen and even the lords of parishes.' As late as 1847, when the inhabitants of a village in the Oise gathered together to choose their schoolmaster from ten candidates, the first test was in singing, and the inspector reported to the rector: 'The ladies of the village made their choice at once, crying: "It's thattun we want!" "Thattun" may not have the most education, but he has the loudest voice . . . and that, Monsieur le Recteur, is how the matter is usually arranged.' (In Estienne, 1933.)

And nearly everywhere, at school as well as at home, children were taught to read from a manual of etiquette, in the eighteenth century usually Jean-Baptiste de la Salle's.

Thus the three constituent factors of the little school were to be found in the country schools. We know where singing and reading came from (the Latin school), and etiquette too (the education provided at home). But what about writing and arithmetic?

In the middle of the seventeenth century, tuition in writing and arithmetic was provided, outside the little schools or the Latin schools, by the public scribes or scriveners. They were not under the jurisdiction and control of chapter or university, and in Paris their guild was under the authority of the Châtelet, like all the other trade guilds. They appear to us today as craftsmen. They were not teachers, but primarily copyists, accountants and valuers. They called themselves 'experts in the verification of deeds, contracts, notes of hand and other such documents'. They were commonly known as 'verifiers': verifiers of deeds (because they could read all kinds of handwriting) and of accounts (because they could count and calculate). At Rouen, they bore the title of 'masters and guardians of the noble art and science of writing and arithmetic, expert verifiers in the city and suburbs of Rouen'.

Their 'science of writing' corresponded to what we ask of typewriting: the transcribing of texts in the most legible manner possible. We must try to appreciate how important copying was before the invention of the typewriter: clerks not only had to be able to write like everyone else, but

also to 'write to perfection'. Calligraphy was an art, an art inherited from the old manuscript copyists of the era before the invention of printing. It demanded considerable manual skill, as Jean Rou has testified. About 1643 he was a precocious pupil at Harcourt College. He tells us in his memoirs: 'I had so supple a hand and fingers so agile that if it had not been decided to make a scholar of me, I should have been trained to become nothing less than a perfect master-scribe.' Writing was the subject of manuals such as the late sixteenth-century English work: *Swift writing, true writing, fair writing: the Pen's excellency or the Secretary's delight*. The scribe used different scripts for different purposes, just as the printer uses different characters; one had to have recourse to the scribe, even if one could write oneself, when it was a question of drawing up a document which had to be unambiguous and whose material presentation had to follow certain rules. The 'science of writing' also corresponded to the skill of an expert paleographer today, for it comprised the deciphering of manuscripts which had become illegible, either as the result of a change in script or because of the use of symbols and abbreviations which had fallen into disuse. This work was not the gratuitous work of a historian: many ancient documents – charters, contracts, etc. – were still legally binding and still governed public and private relationships. They often ceased to be intelligible, sometimes because of the language, but above all on account of the writing. The master-scribe who could draw up present-day documents was also able to read and 'verify' those of the past. This function would be rendered obsolete by the extension of the printed paper (*Le Moniteur* and *Le Journal officiel* started publication in the late eighteenth century) and by the politico-judicial upheaval of the 1789 Revolution, which rescinded the old documents: the country started again from scratch, in a script which was intelligible to the general populace.

Finally, the scribes were also accountants. They were conversant with 'book-keeping by double entry and foreign exchange' and also with all the systems of weight and measures whose variety made the establishing of equivalents a delicate matter. They undertook to 'verify accounts and calculations' just as they 'verified scripts'. It was not given to everyone to be able to do sums. Mme de Sévigné for one was delighted to find at Les Rochers a priest who was skilled in the use of *jetons* and therefore a good accountant: 'I had a great surprise this morning in the abbé's study. We discovered, *with the aid of his counters which are very good and accurate*, that I had made a profit of 530,000 livres.' The master-scribe was also expected to instruct others in his art. Clerks able to 'write to perfection' and calculate with the aid of counters were needed in the offices of lawyers, merchants and administrators. Nor were these skills confined to minor

posts. A young noble intending to make his career in the army or at court could take lessons in writing as in languages or dancing or the non-scholastic arts: the future Maréchal de Bassompierre arrived at school in 1591 with a retinue which included, apart from his preceptor and his dancing-master, a writing-master. About 1600, Charles Hoole, in his book *The Petty School*, recorded that one grammar school used to 'entertain an honest and skilful penman, that he may constantly come and continue with them about a month or six weeks together every year, in which time commonly everyone may learn to write legibly'. This recourse to an outside specialist sometimes caused irritation, and Brinsley maintained that if a good manual were used, 'the schools may be freed from having any need of the scriveners, which go about the country, at least, which go under the names of scriveners, and take upon them to teach to write; and do oft-times very much hurt in the places where they come.' These intinerant scribes had a bad reputation.

In the towns, the master-scribes, organized into recognized corporations, kept respectable schools of writing and arithmetic: they had to hang 'signs in front of their houses which shall list the names of the sciences which they profess'. They stood up for their rights against all rivals. Among the latter were the schoolmasters, that is to say, in Paris, those under the jurisdiction of the cantor of Notre-Dame. In 1661 an edict of the High Court forbade the schoolmasters 'to put more than three lines in the examples which they gave to their pupils'. The principle was that they could teach writing but not calligraphy. We have seen that Jean-Baptiste de La Salle had not bothered about this subtle distinction and made no bones about teaching his pupils the writing styles which were the official monopoly of the scribes: but in Paris the scribes brought an action against him and won their case.

On another front, some 'so-called mathematicians' were also competing with them. The High Court recognized their monopoly and forbade 'the display of any sign under the title of mathematician'.

The division of labour between schoolmasters and scribes was a difficult problem, which the magistrates to whom it was submitted found impossible to solve. Thus an edict of the High Court issued in 1661 states that 'the scribes may have printed books or texts to teach spelling, but they must not on any account teach reading'. But as Claude Joly points out in his defence of the little schools, 'any Scribe teaching his pupils to read from these texts and printed books can say that he is teaching them spelling and not reading.' The best solution would have been for the schoolmasters to teach reading but not writing, and the master-scribes writing but not reading, with a common but contested zone between them for

spelling, which incidentally was in its early, unfixed stage. It can be seen that reading and writing, which are now considered to be complementary, were for a long time regarded as independent subjects to be taught separately, one being associated with literary and religious culture, the other with the manual arts and commercial practice.

The school of the writing-master would therefore seem to have been a technical school teaching a craft which still owed something to manual skill. These schools had two interesting features: they taught girls as well as boys, and they were attended by adolescents as well as little children.

A curious engraving[3] of the early eighteenth century shows a writing lesson in progress: some big fellows are present, and some of them are wearing swords, which would suggest that this form of tuition was not despised by families who either belonged or aspired to the nobility. It is in any case certainly no infants' class. The number of youths seems greater and the ages more mixed than in even the heterogeneous lower classes of the colleges.

If we are to believe the censorious canon Claude Joly, this diversity was not without its dangers for the virtue of any girls who should join the class. He wanted the scribes to be forbidden to teach girls, and he expatiated on 'the danger of putting girls with *big boys*, as those who go to the Master Scribes usually are'. The scribes' reply to Joly's suggested prohibitions was: 'It is necessary for girls to be able to read, and there are some who are capable of learning to write to perfection and who should not be deprived of that advantage.' To which Joly retorted like Molière's Chrysale: 'It is not necessary for girls to be able to write to perfection, but it is necessary for them to be in a safe place above suspicion.'

Yet the utility of writing and arithmetic was not disputed by the Dijon sergeant who in 1606 paid forty sous a month to 'Saint-Germain Schoolmaster, for teaching writing and arithmetic for three months' to his daughter; or by a certain Lemonier, 'proprietor of the Lion de France' at Dijon in 1648, who got a priest to give his daughter lessons in arithmetic. Hitherto there had been no schooling for girls: they stayed at home with the women of the house or else in a convent, without receiving any but religious instruction. However, in the first half of the seventeenth century, people began to feel some concern about their education, and religious orders such as the Ursulines devoted themselves to it. The scribes proposed to give them a real technical education, either because they were thought to have a gift for writing, or in order that they should learn how to keep accounts, a useful art whether in home life or in the running of a

3. Engraving classed under *Écrivains* in the *Métiers* series, Cabinet des Estampes, Bibliothèque Nationale.

business: seventeenth-century usage allotted women an important role in the administration of the estate and the supervision of certain incomes (notably income in kind: poultry, eggs, etc.). One can understand why thoughtful fathers such as that sergeant and that hotel-keeper of Dijon should have wanted their daughters to learn how to use a pen and counters.

But let us note here above all else the *almost adult nature* of the instruction given by the master-scribes. In fact it was linked to an education different from that of the Latin schools and anterior to that of the little French schools: the manual education given by craftsmen to their apprentices. The scribes' schools were a particular instance of a practice current in other crafts, at least in England and Germany.

English educational literature of the late sixteenth and early seventeenth centuries sometimes refers to these workshop schools. In 1596 Edmund Coote published *The English Schoolmaster*, a manual of seventy-nine pages in English, not Latin, which was remarkable in that it was not addressed to professional pedagogues, nor even to educated readers. It went through twenty-six editions between 1596 and 1656. It comprises thirty-nine pages on the alphabet and the art of spelling; eighteen pages on the catechism, prayers and Psalms; five pages on chronology; two pages of examples of writing; two pages of arithmetic; some twenty pages of vocabulary, with explanations of the difficult words and phrases. It is destined for self-teachers of all ages – 'the unskilful of what age so ever' – who after reading it 'may easily both understand any hard English words, which they shall in Scriptures, sermons or elsewhere hear or read; and also be made to use the same aptly themselves'. It is also supposed to allow craftsmen of little or no education to keep school. Coote declares that his book is addressed to 'such men and women of trade as tailors, weavers, shopkeepers, seamsters, and such others as have undertaken the charge of teaching others'. And he describes in a few words these humble workshop schools: 'Thou mayest sit on thy shop-board, at thy books or thy needle, and never hinder any work to hear thy scholars, after thou hast once made this little book familiar to thee.' Thus we can see that, without leaving his work, an artisan would sometimes gather some apprentices around him – or even some adult companions in the same craft – and teach them a few elements of reading, writing and doubtless draughtsmanship, for draughtsmanship was even more important than reading or writing for certain crafts: joinery and carpentry for instance. This impromptu schoolmaster could earn a little extra money in this way, and at the same time satisfy a need for rudimentary instruction. He might even be tempted to devote all his time to his school. It was for a school of this sort that at Basle in 1516 Holbein painted a sign showing on one side an evening class

– the master and his adult pupils – and on the other side a class for children, with the master and his boys on the left, the mistress and her girls on the right.[4] The inscription on this sign reads: 'He who wishes to learn to read and write German by the quickest method, and who does not know a single letter, is informed that here he will be able to learn all that he needs to know of writing and reading. And if anyone is so foolish that he does not manage to learn it, I shall have taught him *gratis* and for nothing and he shall not owe me anything. Whoever you may be, burgesses, artisans, labourers, women or girls, and whatever your needs, he who comes here will be faithfully instructed for a reasonable fee. On the other hand, children, little boys and little girls, will pay every term as is customary.'

As in the case of Coote's readers, children, whether boys or girls, formed only part of the clientele of these masters: 'of what age so ever', said Coote, and Holbein: 'burgesses, artisans, labourers, women or girls'. Many were adolescents or adults who plied their trade during the day and came in the evening to ask the master to teach them to read, write or draw. Gérard Dou has depicted a school of this sort: the schoolroom is lighted by candles, and some big children of twelve or more, both boys and girls, are gathered round the master's table; in the foreground, on the left, a young man is drawing, while a girl is holding the candle for him and pointing to something – probably they are studying draughtsmanship together. Here, with draughtsmanship, we have an element of technical education added to the ABC. In the commercial towns, draughtsmanship was replaced by arithmetic, for the keeping of accounts, and this tuition, from the fourteenth century on, was quite distinct from the Latin school. At Bologna there were the usual grammar masters, but besides this Latin instruction in the arts there were some *scholae puerorum* which, doubtless using the vernacular, provided practical instruction for merchants' sons in which an important place was given to arithmetic; in official documents the master called himself *magister de abaco* (and not *de artibus* or *grammaticae*). It is known that at Florence in 1338 grammar and logic were taught in four Latin schools, and algebra and the *abacus* in six schools. The same phenomenon was to be found in German towns such as Hamburg and Brunswick, and in France in the schools run by the master-scribes. And we must probably look to this education for adults, education of a professional and technical character, for the principal origin of the little schools. The other elements – singing and the Psalter taken from the Latin schools, and etiquette from the houses of the nobility – were added later, probably not before the beginning of the seventeenth century. Moreover, with the occa-

4. In the Basle Museum.

sional exception of big cities like Paris where the cantor was inclined to be pretentious and insist on university degrees, the masters of the little schools were often recruited from the scribes. Thus at Castillon in 1759 a sworn master-scribe from Bordeaux was appointed. It is easy to see why: the schoolmaster was also the village attorney, and he had to be able to read charters and old manuscripts and draw up official reports.

However, the essential feature of the little schools of the seventeenth century, which distinguished them from the workshop schools of the sixteenth century and from those of the master-scribes, was not so much their curricula as the pupils' ages. The pupils were no longer adolescents or adults: they were children between the ages of seven and twelve. In 1833 an inspector made this observation, which was also valid for the earlier years of the nineteenth century and the whole of the eighteenth: 'Children cannot be sent to school before the age of seven or eight ... At the age of eleven or twelve, they are sent to work.'

The principle of education for adults continued to be maintained in France for some time elsewhere than in the scribes' schools. Thus in the late seventeenth century the parish priest of Saint-Sulpice, M. de la Chetardye, set out to found a Sunday school for the poor: 'Skilled in finding ways of contributing to the education of the poor, he conceived the idea of founding a Sunday school for young people whom the necessity of earning their living kept busy all the week, leaving them only Sunday and holidays on which to go to school.' Called the Christian Academy, this school was handed over in 1699 to St Jean-Baptiste de la Salle and his new congregation. In addition to reading, writing and arithmetic, the pupils were taught geometry, drawing and architecture. The big boys were not supposed to be older than twenty. But this academy went into a decline and gave rise to few imitations. Adult education, widespread in the fifteenth and sixteenth centuries, disappeared in the seventeenth century, and its place was taken by an education confined to children. The phenomenon of the specialization of the ages and the particularization of childhood can be seen here much more clearly than in the age structure of the Latin college. Henceforth an age group ranging from five-to-seven to ten-to-eleven would be marked out from the rest of childhood.

How did the transition take place from the technical instruction for adults of Coote, Holbein and the master-scribes to that of the little schools of the seventeenth and eighteenth centuries? Under two influences: one, a general influence, which set apart the younger ages and tended to isolate the elementary stage of education; the other an influence linked with the great religious current of the Reformation and aimed at providing a suitable background for poor children.

From the mid-seventeenth century to the present day, the average age of the college boy has steadily decreased. And as greater homogeneity was demanded of each class, the beginners' class had to be split up several times and lower classes created, going further and further back, down to the kindergarten and the nursery school of modern times. In their plan, the *ratio studiorum* of 1599, the Jesuits wanted to start with the fifth class and have only three grammar classes. Like other education writers of the time, they disliked the idea of teaching the rudiments. In the same spirit, Brinsley wrote in 1627 in his *Ludus Litterarius* that it struck him as absurd that the grammar schools should be troubled with a class learning the ABC, and that it was humiliating for the masters to teach such things to 'such little petties'.

But the longed-for separation of the rudimentary classes and the grammar classes never became effective. In most of their colleges the Jesuits had to put up with a sixth class in which the ABC and the rudiments were taught. In the late seventeenth century, extra sixths were created in the colleges and even gave rise to weaker classes, which were already called sevenths and eighths: these were the bottom classes of the present-day secondary school. At La Flèche, for example, there were at this time a seventh class and a sort of eighth which was referred to as 'a room in which those who are not fit to enter a class are given instruction'. The cantor Joly complained of this proliferation of the lower college classes, in which he saw an encroachment by the university on the rights of the local schoolmaster. He deplored the 'seventh and eighth classes which have been formed in certain colleges in which the children are taught to read'.

Apart from these lower classes, *pensions* outside the town were reserved for 'children of tender years who were delicate and needed to remain with womenfolk'. There were the 'little colleges of licence-holders' authorized by the cantor, who acted as a sort of director of primary education in Paris. In Paris itself, beginners who risked being swamped by the huge numbers in the colleges, especially in their lower classes, employed the services of private coaching establishments. Joly calls these schools 'hedge-schools', that is to say clandestine schools unauthorized by either the university or the cantor: their masters 'coach pupils who go to the college classes'. This type of education would enjoy considerable success in the eighteenth century, in what we recognize as those *pensions* which also took in boarders and which we studied in the chapter on boarding-schools. Besides the boarders, who were often older boys, the *pensions* gave instruction to young day-boys. There is an interesting document which shows that these *pensions* were very well patronized in the late eighteenth century: the dossiers of the candidates for the military schools in 1790.

These schools were intended for impoverished nobles. The candidate's family had to fill up a printed form which, apart from the usual details, included the following questions: 'Can the child read or write? ... What is his present occupation? ... Is he being brought up in the Paternal House, in a *pension* or a college?'[5] The candidates were nearly all nine or ten. Here are a few cases. An eleven-year-old: 'He is a half-boarder at Tours, learning the rudiments of Latin, and has never left the paternal house as yet.' A nine-year-old: 'He is studying at Beauge College. He was educated in *pensions*.' Another nine-year-old: 'He is being brought up in the paternal house and is sent every day to take lessons at a neighbouring *pension*.' An eleven-year-old: 'He is studying in a *pension* at Rethel where he has been since March 15th. His father and mother cannot keep him in this *pension*.' A nine-year-old: 'Was brought up in the paternal house and for the past eighteen months has been in a private *pension*.'

In the sixteenth century, nobody had yet had the idea of taking the beginners out of the first grammar classes; when they were grouped together in a sixth class, it was a lumber-room class in which no attempt was made to measure their efforts. This was no longer true after the end of the sixteenth century. With the lower classes in the colleges, and with the private *pensions*, an elementary stage came into existence. It was regarded as a preparatory stage. The same was true also of the little schools which were trying, at least in the towns, to replace the lower classes in the colleges. According to Claude Joly, the little schools prepared their pupils for entry into the fifth, or, preferably in his view, the fourth class in the colleges: they were *anterior to* and not *concurrent with* the college, and incidentally had failed to eliminate the other establishments competing with them. We are still a long way here from the nineteenth-century concept of a primary stage from which pupils did not necessarily graduate to the secondary school. But we are even further from the more contemporary idea of an education that is unique and general to begin with, and is varied later on in accordance with the pupils' vocations and aptitudes.

Let us now consider the second influence which affected the origins and development of the little schools. In the late sixteenth century a new idea appeared in England and France, an idea which had originated in the religious feeling common to both the Reformation and the Counter-Reformation. In the art as well as the literature of Western Europe in that picaresque age, 'down-and-outs' occupied an important place, indicative of their numbers or rather of the extent to which people were aware of their existence. Their picturesque appearance appealed to many, but

5. Military school, register of pupils, in Archives Nationales.

others set out to combat their poverty, laziness and immorality by means of administrative and police measures such as the English Poor Laws, by means of edicts as ineffective as they were frequent against vagabondage, and finally – and this is what concerns us here – by means of the education of poor children. In those circles most affected by the new piety in France and England it was felt that the children in question should be given the religious instruction hitherto reserved in practice for the choir-boys of the Latin school, and at the same time taught reading and writing, which were now regarded as necessary for the exercise of any trade, even a manual job. In this way it was hoped to make pious, serious workers out of what had been depraved adventurers. A curriculum was soon evolved, providing for tuition in the vernacular based on the catechism, the ABC and the abacus, and intended for children who could not follow the Latin cycle. In England, the founder of one school explained: 'We have a great number of poor people in our parish who are not able to keep their children at grammar. But we are desirous to have them taught the principles of Christian Religion and to write, read and cast accounts, *and so put them forth to prentice.*' Some founders even tried to make the Latin schools a little more utilitarian, at least for the 'pettyes'. Thus in 1612, we find one such founder urging his master and ushers to try to teach arithmetic to their pupils, especially to those who showed greater aptitude for trade than for study. This preoccupation gave rise to schools in which the classical humanities were more or less abandoned in favour of the 'modern' curriculum, and to an active campaign to bring education to the lower classes and stamp out immorality and poverty: thus in the late seventeenth century the Society for Promoting Christian Knowledge founded a great many charity schools in which poor children were given 'knowledge and practice of the Christian religion, as professed and taught in the Church of England' and 'some other things which are useful in their station in life' – namely reading and writing, in some cases arithmetic, and a manual trade, spinning or cobbling.

In France, despite the difference in religion, the same thing happened in the same spirit. In 1543 the city council of Rouen decided on the subject of the poor that 'in order to train children from childhood in morality and reading and writing [these things went together], so that by this means they shall be prepared for service at an earlier age and in a more agreeable manner', they should 'take in beggar-children, both boys and girls, from the age of five, to give them instruction in decency and morality and reading and writing'. Throughout the eighteenth century, 'charity schools' or 'charitable schools for the poor' were built all over France. At Moulins and Lyons, Charles Dermia, born in 1637, gave the regulations for his

schools a military character: 'Readers, attention! ... Writers, get ready, take your pens, show them, start writing.' At Autun, a similar faith inspired three priests who explained their motives in these words: 'Every day we see idlers and vagabonds in the streets, who, not knowing how to do anything but eat and drink and bring poor children into the world, produce these swarms of beggars which are so much trouble to us ... Christian schools would put an end to this state of affairs.'

In Paris, at the height of the period of pious humanism, priests took to founding free schools for the poor in their parishes – greatly to the indignation of Claude Joly, because they did not come under his jurisdiction: 'The priests of Paris say that it is a right attached to their office and that it is even their duty to give instruction to their parishioners, children as well as fathers, and that consequently they can keep school ... It goes without saying that the charity of the worthy priests with regard to their schools costs them nothing at all.' People gave money generously for the schools. In some of these schools, the children also learnt a trade. In 1680, in the Saint-Sulpice schools, a hosier was employed to teach knitting to two hundred pupils. The girls, though neglected for a long time in this respect, were not forgotten. In 1646, Louise Bellange brought together forty poor girls of the parish of Saint-Eustache. New religious orders devoted their energies to this end: thus the Ursulines 'make it their profession to keep public schools for day-girls as well as for boarders'. In 1685 Père Barré founded the Institute of the Infant Jesus, which served as a model for the teaching orders, and especially for the most famous of them all, the Brothers of the Christian Schools. Then again, St Jean-Baptiste de la Salle gave his support to the charitable priests of Paris who aroused the indignation of the cantor of Notre-Dame, providing the schools of the parish of Saint-Sulpice with masters from his community. With him, primary education was endowed with principles which hardly changed at all until the mid-nineteenth century.

In the country, the bishops urged their parish priests to pursue this course – witness the Bishop of Châlons's synodical instructions of 1662: 'Take a sum of money every year from the building fund to help to have a schoolmaster in places where there is none on account of the poverty of the inhabitants. If you can yourself make some contribution to the schoolmaster's keep, give preference to that charity rather than to others which are neither so necessary nor so urgent. In a word, neglect nothing that depends on your zeal to secure the installation of a schoolmaster in your parish, this being the best and most dependable method of ensuring that youth is always well instructed in its faith and brought up in the fear of God, on which the reformation of our parishes depends.' Henceforth and

for a long time to come, religious education would be linked with utilitarian lay instruction, not for reasons of opportunism or propaganda but because professional lay education was recognized as having a high moral value.

In the preceding analyses, we began by distinguishing a tendency to set apart children between five and eleven, to separate them from their elders and group them in special classes – the seventh and the eighth, the nucleus of a system of elementary education; we then followed the current of religious apostleship which resulted in the foundation of charity schools for the poor. One might deduce from this that primary education, in so far as it existed in the modern sense in the seventeenth century, was the result of these two influences and was limited to charity schools for poor children. Such was no doubt the original aim of the religious reformers down to St Jean-Baptiste de la Salle.

One is accordingly tempted to attribute to this charitable origin the lower-class character which primary education has retained from the late eighteenth century to the present day: far from being one step in a hierarchy in which all children climbed at least the first steps together, it strikes us as a specifically lower-class education, as opposed to secondary education, the monopoly of the middle class. But the charity schools did not give rise to an education reserved for the lower classes. Claude Joly offers us proof of this. He would have tolerated the existence of charity schools at a pinch if they had been confined to little beggar-children. But his objection was that this was no longer the case at the end of the seventeenth century. According to him, the charity schools were no sooner founded than they attracted a well-to-do clientele of craftsmen, merchants and burgesses, to the loss of the traditional schools. The cantor had the right to visit all schools, even those outside his jurisdiction, and his promoter was something of a primary-school inspector. In the charity schools the promoter 'did not find the filth and the rags of the poor beggar-children of whom the priests say that they are composed'. There was no real poverty without rags at a time when the authority conferred by wealth necessarily asserted itself in dress.

No filth and no rags: greatly to his indignation, the promoter, 'visiting a girls' school in the Faubourg Saint-Germain in June 1675, found only cleanliness there, and having complained of this to the Mistress, was given no reply save that she did not know how poor they were'. In another school he found 'over two hundred girls ... most of them well dressed, neither dirty nor in rags: which is why all the girls' schools in the surrounding districts [which were not free and were under the cantor's jurisdiction] are at present deserted. It is proverbial that when something is

done free, everybody wants it, rich and poor alike.' Thus the charity
schools – where the teaching must have been done by masters of a religious
brotherhood, who inspired greater confidence than the lay-masters of the
district schools – attracted children from well-to-do homes as well as poor
children. We can also see from this that the district schools also hankered
after a middle-class or lower-middle-class clientele which the priests or the
religious orders were taking away from them and which Abraham Bosse
has depicted in his engravings.

The accusations of unfair competition levelled at the Brothers of St
Jean-Baptiste de la Salle by the district schoolmasters and the master-
scribes tell exactly the same story. The syndic of the master-scribes com-
plain in a factum of 7 June 1704, that the Brothers 'take in not only the
poor of the parishes in which they are established, but also the children of
worthy burgesses, merchants and craftsmen'. And they add, in a sentence
which reveals a great deal about the manners of the time: 'They distin-
guish the latter [the burgesses] by putting them in separate places and
seats.' This segregation of rich and poor at school offends our modern
sensibility. But the spatial proximity which it implies and the familiarity
inevitable within the same room if not on the same benches are also
repugnant to us. And here we have the great difference between the two
societies, that of the seventeenth century and that of the twentieth or at
least the nineteenth century: the difference between a society in which
people were carefully ranked but were mixed up in a common space, and
a society which is egalitarian but in which the classes are kept apart in
separate spaces.

We know that the college, the ancestor of the present-day secondary
school, also drew some of its pupils from the lower classes. Originally the
colleges were intended for scholarship boys; in fact the scholarships later
became privileges which were sold like offices. It was therefore not always
by means of scholarships that the poor gained admission to the Latin
school, but rather because of free instruction and the day-school system.
The day-school system enabled a pupil to live in lodgings, often in the
humblest conditions, in the house of an artisan who was often paid in
kind. He lived all week on the food which relatives or neighbours brought
him on market-day. In that way a child could be kept at school for far
less than it would cost a boarder at a modern *lycée*.

In principle the university colleges were not free. The master received
the traditional fees direct from his pupils, and he had other sources of in-
come: either a foundation scholarship if he was a senior scholar, or the
payments made by the pupils whom he lodged in his home. However,
the fees which pupils attending classes were called upon to pay, always

modest, were not even exacted with any strictness. Charles Sorel writes:
'In the ordinary colleges [as opposed to the Jesuit colleges] where the
pupils of good family pay their fees every month to the master, there are
almost as many day-boys who come without paying and who none the less
attend the master's lessons without anyone denying these poor boys the
advantage they may derive from them; it would be just as cruel to com-
plain of these things as for a man walking along the street at night with a
lighted torch to want to prevent the passers-by from enjoying the same
light.' The tendency was towards free education. It was already given by
the Jesuits. The University of Paris officially instituted it in 1719. The
Oratorians retained the principle of a small tuition fee.

One of the characters in Larivey's play, *Les Écoliers* (1601), declares
that if among these students (for he takes in students as lodgers) there are
some 'good young men', many are 'the children of poor artisans, who have
come from the dregs of the lower classes, with nothing of the scholar about
them save the name, and worse than sharpers'. The college registers some-
times give the father's occupation: at Le Mans in 1668, eleven pupils out
of forty-one in the physics class were the sons of artisans. Père de Dainville
has published the statistical results of an examination of the register of
the Jesuit college at Châlons-sur-Marne, for the years between 1618 and
1736. The proportion of artisans and labourers varied according to circum-
stances between 20 per cent and 35 per cent (mainly artisans); 'between
48 per cent and 62 per cent of the pupils in the college were drawn from
the lower class or the lower-middle class.' And we should note that this
was a big college: higher proportions probably existed in the Latin
schools, which were limited to grammar classes.

The recruitment from the lower class often corresponded to social ambi-
tions on the part of the parents: thus a brass-founder, Girardon, sent his
son, the future sculptor, to college in the hope of making an attorney of
him. A large proportion of these lower-class pupils – though it is im-
possible to gauge the proportion exactly – later became minor police or
treasury officials and founded middle-class families: their existence there-
fore implies a greater social mobility than is generally supposed. However,
many pupils spent only a few years in the lower classes of the colleges.
According to a text of 1789, 'the experience of a considerable number of
years proves that most provincial colleges would be obliged to abolish
their second, rhetoric and philosophy classes if they were not attended by
students destined for the Church or the Bar. Nearly all the other children
have scarcely covered half their studies before they abandon them for
good.' Some abandoned them for the army or commerce, but others for
manual trades. The register of the Oratorian college at Troyes gives the

reasons for some departures in the middle of the school course: several have joined the army, but one has become a joiner, another has 'gone back to his father's kitchen', while a third has 'left school to become a cobbler'. Young Girardon disappointed his father by apprenticing himself to a wood-carver. When Marmontel entered Mauriac College, his father envisaged a stay of only a few years, and he was reluctant to let him stay at school after the rhetoric class: 'That is enough of studying and Latin . . . I have a post for him with a rich merchant, and the counter shall be his school.' At the same time Guyton de Moreau wrote: 'It is customary for nearly all the artisans in the town to send their children to college, just for a few years and with the intention of taking them away again after a certain time . . . *Most of those who go to college leave before completing their studies in order to take up their father's trade.*' One can imagine the medley of ranks, and consequently of clothes and manners, to be found in these classes. But, as in the little schools, the children of good family were separated from the rank and file: in the Jesuit colleges, the young nobles sent their *famuli* or valets on ahead to keep the special seats which were reserved for them. In the same way, at the beginning of this century, society ladies would send their servants to church to keep the best seats for them at the fashionable Sunday Masses.

An edict of 1626 reveals the existence of similar customs in the colleges of the University of Paris: the colleges separated the boarders from the day-boys, the laymen from the clerics (*domesticos ab externis, a laicis sacerdotes*), but also the sons of good family from the poor students who acted as college servants (*famulos ab ingenuis*).

The little schools developed in the course of the seventeenth century at the same time as the sixth, seventh and eighth classes in the colleges. Their growth bears witness to the special interest shown henceforth in the younger schoolchildren, who had been somewhat neglected. But at this time neither colleges nor schools drew their pupils exclusively from one social class.

These colleges full of lower-class pupils were to disappear; they were unable to survive a radical transformation of manners. A new spirit appeared in the course of the eighteenth century, which created the situation obtaining in the nineteenth century; it was the same spirit which inspired the Enlightenment. It denied access to secondary education to the children of the lower classes. Henceforth it was considered that education should be confined to the rich, for, if it were extended to the poor, it would turn them against manual labour and make social misfits of them. The whole of society would suffer from the lack of an adequate labour force and from the presence of an excessive number of unproductive citizens. This

opinion was the expression in an economist's terms of an instinctive dis-like of the mixing of the social classes at school. It was the exact opposite of the opinion held by the seventeenth-century reformers, who saw in education the only possible means of installing a sense of morality into the down-and-outs, of turning them into servants and workers, and hence of providing the country with a good labour force. But it was already the theme of social conservatism in the nineteenth century and colonial con-servatism in the twentieth, which sees the school as the means taken by modern revolutionary ideas to reach the lower classes and undermine the authority of established fortunes. The time of this retrogression, the eighteenth century, is particularly indicative of a profound structural change.

Here is the opinion of a technologist, the author of a treatise on high-ways and bridges: 'It has become fashionable not to engage any servant who cannot read, write and count.' Apparently people preferred educated servants, like those of Marivaux or Beaumarchais! 'With all the labourers' children becoming monks, clerks [invoicing clerks in the offices of mer-chants, lawyers, magistrates or administrators] or lackeys, it is not sur-prising that there are none left for marriage or agriculture.' (Quoted by Brunetière, 1879.)

In 1763, after the departure of the Jesuits, the public felt concerned as to who was going to take their place, and there was a great deal of dis-cussion of educational questions. All this discussion gave rise to a mass of literature on the reform of education. The notorious La Chalotais expounded the ideas of the philosophers in his *Essais d'éducation nationale ou plan d'études pour la jeunesse*. In his opinion there were too many schools: 'Surely there are too many scribes [master-scribes who ran schools], too many academies, too many colleges. In the past it was diffi-cult to become a scholar because of the dearth of books; nowadays the multitude of books prevents one from becoming a scholar ... There have never been so many students in a country where everyone complains of depopulation [in fact the population, far from going down, was increas-ing]. Even the lower classes want to study; labourers and artisans send their children to the colleges in the little towns where it costs very little to live, and when they have muddled their way through studies which have taught them to despise their father's trade [this was not always the case], they take refuge in the cloister, in the ecclesiastical state [becoming the "unproductive citizens" which the liberal conservatives of the nine-teenth century would see, not in the monks any more, but in the civil servants], or they become officers of the law' [this was obviously the com-monest way of climbing the social ladder]. The Latin school in his

opinion, ought to be closed to peasants, workers and servants, like secondary education later on. But La Chalotais went further and would not even allow them into the little schools: 'The Brothers of Christian Doctrine, also known as the Ignorantines, came along to finish everything off. They teach reading and writing to people who should have learnt nothing but how to draw and how to handle a plane and a file, but who now no longer want to [note the association between draughtsmanship and manual skill, which we remarked on earlier in connection with the workshop schools of the late sixteenth century]. They are the rivals and successors of the Jesuits. The public good requires that the knowledge of the lower classes extend no further than their occupations.' Voltaire congratulated La Chalotais: 'Thank you for condemning the education of labourers. I who farm the land need agricultural workers and not tonsured clerics.' 'The lower classes should be guided, not educated: they are not worthy to be educated.' 'I consider it essential that there should be ignorant beggars on earth.' We find Verlac writing in 1759 in the same spirit: 'Cottages, hamlets, market towns and villages echo with this cry during the two months of holidays: "Send your children to college."' 'How are we to stop this flood of education which is submerging so many cottages, depopulating so many villages, producing so many charlatans, intriguers, envious, angry and unhappy people of all sorts, and introducing confusion into every class and condition?' Here we can recognize the essential themes of social conservatism – the need for ignorance and illiteracy to confine the lower classes to manual labour, and the opposition between education and manual work – themes associated here with the anti-clericalism of the Enlightenment. But these recriminations proved powerless in the face of the progress of education, although it is true that school attendance dropped during the first half of the nineteenth century.

At the same time there also appeared the modern idea of adapting a child's studies to his future trade or profession. Cardinal de Bernis wrote in his memoirs: 'Why are children, who are not all of the same station in life, nor destined for the same jobs, subjected to the same education? Would it not be better to teach arithmetic to a merchant's son, for instance, than to teach him to write Greek and Latin verse? [It would be another two hundred years before these ideas, frequently expressed at the time, began to be taken into consideration in France, with the educational reforms of the Fourth Republic: classical studies continue to dominate secondary education.] I should like everyone to be educated according to his station, and in relation to the function he is due to perform in society. I can see only three subjects of instruction which should be common to all men: religion, by means of which one hopes to attain

salvation; the study of the laws, by means of which one defends one's own property and that of others; and finally medicine [we should say hygiene], by means of which one hopes to preserve one's health.'

People began to think that the cycle of Latin studies retarded a young man too much and put him in a position of inferiority *vis-à-vis* his rivals when they had begun at an earlier age to serve an apprenticeship in their profession or station in life. Jacques Lablée finished his philosophy class at the age of seventeen. He writes: 'Going home, I had to think of making a career for myself.' His father had left the army to manage a wine business. 'Those children who do not go to college are the luckiest. They are in a better position than the rest to decide their lot; they enter a lawyer's office or a business house at an early age, and they have a job which soon becomes lucrative or leads them to a settled position.' The oldest college students, he goes on, either arrive too late and find every position filled, or else have 'no taste for long, difficult and obscure apprenticeships in classes of men where all the talk is of money and the means of making it.' Sensible observations, perhaps, but they have never discouraged French parents from giving their children a classical education, once this education had become the mark of middle-class status.

The current of opinion which condemned the admission of the lower classes to education in general and to the Latin school in particular, resulted in a social specialization of types of instruction from which the primary and secondary stages of present-day education are derived. In the early nineteenth century the lower classes were expelled from the Latin colleges by the development of the boarding-school system – which was restricted to the richer pupils – and by the steady disappearance of the little country colleges, which for very low fees took in *besaciers*, children from the surrounding countryside who lived in lodgings on food brought to them on market-days. These pupils could not hope to go to the big colleges in the great urban areas, where life was more expensive, where the medieval tradition of lodging students had disappeared and where the school authorities no longer tolerated day-boys who were free from both parental control and academic supervision. Having rid itself of its lower-class pupils, the college would become exclusively middle-class.

In England, a parallel evolution gave rise to the so-called public schools. Originally there was no distinction between the public schools and the other grammar schools or endowed schools. The latter were day-schools with only a few places for boarders who were scholarship boys; they drew their pupils from the town and neighbourhood and from an extensive social field, as was the case in France. Towards the end of the eighteenth century, the gentry showed a certain reluctance to send its

sons to the nearest grammar school, which was also attended by children from poorer homes. It was then that some of these grammar schools decided to specialize in the education of young gentlemen and became boarding-schools whose recruitment ceased to be regional in character and extended to the whole country: the public schools. The old grammar schools which remained faithful to the ancient day-school traditions, deprived of their rich, aristocratic clientele, gradually dropped the teaching of Latin and either disappeared completely or became indistinguishable from the little elementary schools. The prestige of the public school grew steadily; the new middle class, born in the Industrial Revolution, sent its sons to it to learn the manners of a modern gentleman, as codified by reforming pedagogues such as Arnold at Rugby (1828–42). The public schools moulded English society in the nineteenth century and gave it its aristocratic character: contemporaries appreciated their function as a dam to hold back the flood-waters of democracy, and the Duke of Wellington, alarmed at the progress being made by the lower classes, founded a public school of his own to help defend the English gentleman. The nineteenth-century gentleman, so different even in his physical make-up from the Englishman of the eighteenth or early nineteenth century, as also from Mr Pickwick, was a product of the public schools.

This aristocratic specialization was peculiar to England: no French college (even the Jesuit colleges) could be compared to the English public schools. Experiments such as the Dominican college of Saint-Elme at Arcachon, or the Protestant school of Les Roches, were too limited in their scope and sometimes failed completely. However, if the evolutionary mechanism differed in France and England, the phenomenon remained basically the same: a change from day-schools with a regional recruitment to boarding-schools with a more extensive and sometimes national recruitment, from a varied social make-up to a limited aristocratic or middle-class recruitment. The result was that what had been a virtually unrestricted secondary education became a class monopoly, the symbol of a social stratum and the means of its selection.

Conversely, the little schools were reserved for the lower classes, which were henceforth debarred from the secondary schools. In 1820 we find a primary inspector recommending the adoption of the methods of 'mutual education' because, among other reasons, this would satisfy the objections of respectable families to mixing their offspring with lower-class children: 'By adopting this method, a single master can easily look after two rooms at once, particularly two adjoining rooms, and this would raise the only obstacle which prevents many parents from sending their children to a school where they would be mixed up with paupers.' We are a long way

from Joly's point of view, expressed a little over a century before; the coexistence of the social classes in a single space, which had been quite natural in the seventeenth century, was no longer tolerated.

In this chapter we have studied two phenomena: first, in the seventeenth century, the demographic specialization of the ages from five-to-seven to ten-to-eleven, both in the little schools and in the lower classes of the colleges; then, in the eighteenth century, the specialization of two types of education, one for the lower classes, the other for the middle classes and the aristocracy. On the one hand the children were separated from their elders, on the other hand the rich were separated from the poor. There exists, in my opinion, a connection between these two phenomena. They were the manifestations of a general tendency towards distinguishing and separating: a tendency which was not unconnected with the Cartesian revolution of clear ideas.

Chapter 13
The Roughness of Schoolchildren

In 1881 the historian Carré expressed astonishment on studying the records of the Oratorian colleges at Troyes in the seventeenth century: 'The reports on some of the pupils are deplorable, and I doubt whether a pupil at a modern *lycée* could merit reports of that sort.' The remark would certainly be true of the young adults, but not as true as it would be of the children. The difference in manners between the two societies, that of the seventeenth century and our own, can best be seen in the children and young people, who for a very long time retained archaic, medieval characteristics which were already partly effaced in the adult world. We have studied the progress in school and other academic institutions of a modern concept of childhood: we have seen how a minority wedded to ideas of order, clarity and authority tried to introduce into society by means of education a new way of life opposed to the anarchical impulsiveness of the old manners. This minority exerted pressure from the outside on the world of childhood, but the latter held out for a long time and remained until the end of the seventeenth century in France, until the beginning of the nineteenth century in England, a sort of islet of archaism. It was later to become the focus of the modernization of society.

Schoolchildren used to be armed. The Jesuits' *ratio studiorum* provided for their disarmament on entering the college, weapons being placed in safe custody in return for a receipt, and handed back to the pupil when he went out. In 1680, the disciplinary regulations of the Collège de Bourgogne repeated this rule: 'Neither firearms nor swords are to be retained in pupils' rooms and those who possess such weapons must hand them over to the Principal, who will keep them in a place chosen for that purpose.' It is hard to imagine a rule of that sort in our present-day colleges or *lycées*! The youngest children, from the age of five, could already wear a sword, which was not simply for ornament or prestige: L'Estoile tells how 'on Shrove Monday this month [in 1588] the King sent the civil and criminal lieutenant, his public attorney at

the Chastelet, and the commissioners [examining commissioners, at once examining magistrates and police superintendents] with some sergeants to the University of Paris to disarm the students who during the Saint-Germain fair had gone there armed to behave insolently.' And much later, in 1709, the records of the Oratorian college at Troyes mention a pupil who was threatening to run his master through: *gladio minatus est praeceptori*. The judicial authorities of towns with colleges were forever forbidding the pupils to wear swords: witness this edict of 20 March 1675, issued by the High Court of Dijon: 'Since the majority of the young people of the city, although destined for the robe [but we knew now that there was really less difference between gentlemen of the robe and gentlemen of the sword than historians had thought: they came from the same families] and *still at school* [in the rhetoric or logic classes], and several other persons unfit to wear a sword, none the less wore one wherever they went, and since this licence was harmful, not only on account of the scandal it caused the public, but also on account of the quarrels and brawls which often resulted from it ...' (Mutteau, 1882) For a long time the High Court at Dijon went on repeating the same prohibition, even as late as 1753, as if the regulation had not become out of date, if not effective.

Even when he had deposited his sword in the armoury, before going into the college, the schoolboy could still be a dangerous character: in 1661, at Beaune, an Oratorian Father was soundly beaten by his pupils and the High Court of Dijon had to extend to other offensive weapons the ban already applied to the sword, forbidding 'all students to carry sticks, stakes and other offensive weapons *in the classrooms* of the house of the aforementioned Priests of the Oratory'.

The masters often had to cope with real armed revolts, and mutinies were common and violent. Take for instance the one staged by the pupils of the Jesuit college of La Flèche one carnival day in 1646. It will be seen that this was a far more serious affair than the minor demonstrations of young schoolboys or even older students nowadays.

The carnival at that time was a festival of youth in which the whole population took part: it was accompanied by great gaiety and great disorderliness. The authorities charged with maintaining order were broadminded in their attitude, like the authorities in Moslem countries at the end of Ramadan. However, the magistrate of La Flèche had taken the precaution of forbidding the election of a king, abbot or prior of youth: the traditional master of ceremonies and organizer of the carnival celebrations. The atmosphere was all the more electric that year in that some of the older pupils of the college had had to suffer the

humiliating *poena scholastica*, a public flogging by the corrector. They considered that they had been dishonoured and were plotting revenge. The school records of the time are full of stories of pupils who had been punished and who took their revenge by beating up their masters, who had to send for the police. At La Flèche, on the evening of Shrove Tuesday, the day-boys, who had sided with their schoolmates, introduced one of their number into the college disguised as a woman. But neither the Fathers nor the Brothers were taken off their guard: these monks knew what they were up against and defended themselves energetically. The Brothers managed to capture one of the mutineers who had drawn his sword and locked him up. The brawl then changed in character and turned into a riot: 'This made the others angrier than before. They went to the armourers and provided themselves with weapons.' Here we recognize the state of nerves which is still characteristic of Arab crowds, and which can easily turn a trivial incident into an orgy of killing and looting; we ourselves find it increasingly difficult to imagine this state of mind.

The students were armed: those involved were day-boys at the college who lived in the pedagogicas and lodgings approved by the principal: the oldest among them were those of the philosophy classes. 'They spent the night under arms and laid siege to all the doors of the college by which it could be handed over [in the morning] to justice.' One can imagine the excitement of this Shrove Tuesday vigil. In the morning they forced their way into the college: 'When morning came, they entered the college under arms, repeating their threats that they would have their companion back willy-nilly, and that they would capture a Jesuit or a boarder by way of reprisal.' In spite of this invasion, the Fathers and their obedient pupils got ready to follow the usual routine of a peaceful day: 'The rebels ... stood in the avenues, armed with swords, sticks, black-jacks, and stones, driving back the pupils who came out when the bell rang to go to the classrooms.' The affair threatened to take an ugly turn if the Fathers refused to lose face and release their prisoner. They too had their stock of weapons, and they armed their servants, not only with sticks, but also with halberds and above all with muskets: they had the superiority of fire-power on their side. The Jesuits' servants then attempted a sortie which nearly won them a bloodless victory: the sight of the muskets inspired a healthy mistrust. Unfortunately one of the mutineers held his ground: 'Instead of retreating like the other rebels in the troop, he advanced on the servant who was holding the musket with its muzzle pointing upwards [there may well have been only one musket!], and hurling himself on the man

and his weapon, tried to force him to surrender it ... As ill-luck would have it, the bolt of the musket was released in this struggle and the musket went off, the bullet going through the master's cassock [a master had intervened in the fight] which was caught between the barrel of the musket and the student's belly, passing between the skin and the flesh of the belly without entering a vital organ, and finally striking the thighbone.'

These school mutinies did not always turn into armed riots: they sometimes took the form of strikes and picketing. In 1633 the court, 'informed that the logic students of the college of this city of Dijon have withdrawn without the permission of the rectors and masters, and are forcibly and violently preventing their companions from entering the aforementioned college', ordered them to return to school and instructed the mayor to help the masters to punish the rebels. In 1672, at Orléans, a twenty-year-old rhetorician stirred up his classmates against their master.

The pupils of the Protestant academies were no more law-abiding: in 1649, at Die, the logicians barricaded themselves inside the college, prevented the masters and the pupils of the other classes from entering, fired pistol-shots, fouled the rostra in the first and third classrooms, threw the benches in the second classroom out of the window, tore up the books, and finally climbed out of the windows of the fourth classroom, scandalizing the public. Sometimes indeed they would attack passers-by with their swords, when they did not make do with the traditional fireworks.

In France the great school mutinies would stop at the end of the seventeenth century. One has the impression that a disciplinary system already over a century old succeeded then, but only then, in curbing the turbulence of youth. The eighteenth century was a period of calm; there would be some demonstrations in the *lycées* in the first half of the nineteenth century, but for political reasons: the boys were demonstrating for or against Poland, against the Jesuits, and so on. This was a very different state of mind, akin to that of modern times. Henceforth, apart from the traditional festivities, only politics would produce disorders which generally remained within the limits of the student rag.

In England, on the other hand, the schools did not enjoy this period of remission in the eighteenth century. Mutinies, far from decreasing in number and finally disappearing, became increasingly frequent and violent in the late eighteenth and early nineteenth centuries. There was indiscipline and rebellion everywhere. At Winchester, in the late eighteenth century, the boys occupied the school for two days and hoisted

the red flag. In 1818 two companies of troops with fixed bayonets had to be called in to suppress a rising of the pupils. At Rugby, the pupils set fire to their books and desks and withdrew to an island which had to be taken by assault by the army. There were similar incidents at Eton. In 1768 the *praepostors* or monitors – the good pupils – of the sixth form seceded and left the school. In 1783 there was a revolt against the headmaster, with rooms pillaged and windows broken. In 1818 the school authorities brought forward the time when the gate was locked, to prevent the boys from going hunting: the latter, after pelting their master with rotten eggs, knocked down part of the wall, and the troublemakers had to be taken by force. Mutiny had become one of the typical and picturesque aspects of the idea contemporaries had of school life. King George III, meeting some Eton boys at Windsor, and joking with them about the two main features of their life, floggings and mutinies, asked: 'Have you had any mutinies lately, eh, eh?'

In England, the last important mutiny occurred at Marlborough as late as 1851. At Eton there were none after 1832, when the last one ended with the flogging of eighty boys: order was then restored.

In France, during the first half of the seventeenth century, one of the forms that violence took was the duel. The preceptors sometimes set their charges an example in this respect. Thus the future Maréchal de Bassompierre, who in 1591 entered the third class at the college of Freiburg-im-Breisgau together with his brother, writes in his memoirs : 'We spent only five months there because Grouet, our preceptor, killed La Motte, who used to teach us dancing.' The annals of Aix College for 1634 record: 'Some of our pupils having been so unruly as to fight and quarrel, even challenging one another to duels, it was decided to put a stop to this, especially as after school they would sometimes start fighting in front of the college, scandalizing the neighbours, the passers-by and other pupils.' These brawls after school must have been frequent occurrences: Père de Dainville quotes 'quarrels outside and fights with stones and other weapons which take place [at Avignon] between the children who go to the Jesuit schools in that town and those who go to the master-scribes and other masters and pedagogues: fights which distract them from their studies and in which they risk being wounded unto death'.

In 1572, in the same town, in the course of a brawl between school-boys from Saint-Nicholas and some workmen, a schoolboy was, according to P. Archard (1869), killed with a stone. In 1513, on Corpus Christi Day, the schoolboys of Saint-Nicolas had laid claim to their place in

the procession with the aid of sticks and swords. The captain, mad with anger, tried to arrest them and pursued them right into the chapel where they had taken refuge. One of them, to strengthen a right of sanctuary in which he had no great confidence, had taken the chalice and held it in his hand. The captain cuffed him but did not dare to snatch the chalice from him.

'Then,' state the Aix annals, 'there was a great fight between the Philosophy class and the Humanities class, and the Rector informed President du Chaine' – who had a few of the boys imprisoned before handing them over to the college corrector. In 1646: 'One of our pupils [at Aix], a nobleman from Sisteron and a metaphysician, was killed in a duel without having the opportunity to show any sign of contrition. There were four of them who fought, two of whom were not students. It was at nine o'clock in the morning, and they had spent the night together in the Carthusians' barn, in order to be able to fight more conveniently afterwards. A few months before, another pupil in the third class had been killed in the same way by a surgeon and had died just as un-Christian a death.' A pupil in the third class, not one of the older boys, Louis Legendre, born in 1655, tells us in his memoirs that one of his brothers died 'from a sword-thrust when he tried to separate two students who were fighting'. These duels were common occurrences. At Aix the rector, alarmed at their frequency, 'went to the classrooms of the philosophy, rhetoric, humanities and third classes, after summoning there a great many of the little boys of the fourth and fifth [whose tender years afforded them no protection against this contagion of violence], and there he pointed out to them the evil in duelling and forbade them to indulge in duelling under pain of severe penalties'.

In France these private battles, very common at the time of the League and the Fronde, grew less frequent and practically disappeared during the second half of the seventeenth century, as did the collective battles and the mutinies: one has the impression that the turbulent, unruly population of the schools had finally been tamed. But in England the school records of the eighteenth century still mention cases of violence half-way between ragging and duelling: a pupil called Cottel was expelled *laesionem enormem Philippo Lys crudeliter et saepessime* – in other words for 'bullying'. These fights changed in the early nineteenth century into wrestling or boxing matches, respected by the masters, before the reform of the public schools: Thomas Hughes shows us some of these in *Tom Brown's Schooldays*.

During the same period, violence was also prevalent among adults: Richelieu too banned duelling, which was decimating his nobility. Vil-

lages and trade guilds fought each other like gangs of boys after school.
The spirit of violence spread to the whole of society, to all its ranks,
noble and villein alike, and to all its ages, children, youths or adults.
The only ones to escape its influence were the little group of church-
men, statesmen and moralists who, apart from the great currents of con-
temporary manners, were painstakingly building the social structure of
the world to come.

This spirit of violence went with considerable licence with regard to
wine and women. In the Middle Ages, schoolboys drank heavily, and
college statutes recognized the mug of wine as a forfeit for minor
offences and accepted it as a symbol of initiation and brotherhood. They
codified a custom, trying to regulate it in order to avoid its abuse, since
they did not dare to suppress it. In the sixteenth century, drinking was
officially prohibited in school, at least in France and Geneva: according
to Cordier, if pupils drank hard in their rooms, it was 'secretly', and if
the culprits were caught they knew what to expect. It is interesting to
note the progress made by the authorities: first they regulated drink-
ing, then they flatly prohibited it. But a deeply rooted habit could not be
changed immediately for all that; the boys simply did their drinking out
of school, in the neighbouring taverns. In Schottenius's dialogues, set in
Cologne in 1524-5, we have a schoolboy saying to another: 'Come with
me; I know where the drinking students hide.' 'I suppose you often go
with them,' says his companion. 'Now and then,' comes the reply, 'when
I have some money.' At Pont-à-Mousson, a drunken rhetorician killed
one of his schoolmates. In the records of the Oratorian college at Troyes,
at the beginning of the eighteenth century: *vino dediti cauponam olent*,
or again, *bibere doctiores quam studere*. If French students became
more sober in the eighteenth century, thanks to a more efficient disci-
plinary system, their English counterparts, at least in the university
colleges, were still upholding the medieval traditions of Pantagruelian
tippling in the early nineteenth century. Ruskin, at his first supper-
party at Christ Church, held his own only by pouring the punch down
his waistcoat, after which he helped to carry four of his companions
head-first back to their rooms.

In the sixteenth and early seventeenth centuries public opinion re-
garded the student as a libertine and the terror of fathers and husbands,
a sort of adventurer after the fashion of Villon, with all the risks that
that implied: 'A hundred scholars', Montaigne tells us, 'have caught the
pox before getting to their Aristotle lesson.' And boys read Aristotle
young! In Larivey's comedy, *Les Écoliers*, the lodging-house keeper

or 'host', Nicolas, for all that he knows his lodgers only too well, declares with a hint of envy: 'As for me, if I were a woman, I would rather go with a student than with the most splendid courtiers in France. A student, ah! he's the pearl of mankind. What sweet words, what gracious manners, what high spirits!' Anyone would think he was referring to the students of Murger's *Vie de Bohème* or Flaubert's *Éducation sentimentale*; but the lodgers of Nicolas were ordinary schoolboys, big schoolboys perhaps, but nothing in their everyday life entirely distinguished them from the smaller boys. In 1460 at Dijon a labourer's son, who was studying at the Dijon school and was aged about seventeen, was lodged in the house of a vineyard owner 'who provided him with nothing but bed and soup' (the boy supplemented this hot soup with his own personal provisions). He did not waste time, and his association with his host's 'chambermaid', a girl of fourteen who helped him to force the lock of the nearest hotel, obviously went deeper than mere friendship. Here, one hundred and fifty years later, is the complaint of another of Larivey's characters, the father of an inconveniently beautiful daughter: 'It seems to me that Paris has been put in such a plight by these libertines and fairground hunters [the students] that chickens have to be kept cooped up, and even then they are none too safe.' And yet the time was past when the authorities waited for the third repetition of the offence before expelling the scholar who had introduced a woman into his college or pedagogica, according to certain statutes noted by Rashdall. The 1379 statutes of Narbonne College forbade the pupils to invite any woman, however respectable, to lunch or dinner in the school, under pain of a fine of five sous. Was that expensive?

In their colleges the Jesuits demanded the strictest morality: Père Lainez exhorted his pupils to 'abstain from the pleasures of the flesh'. Francion does not attempt to disguise the fact that he had to wait until he left school before losing his innocence with an ugly old woman he had met at an inn. Between their classes and their pedagogicas or authorized lodgings, pupils had few opportunities to meet women: this was the beginning of the sexual claustration which would henceforth characterize college life and which the statutes of the medieval foundations had never been able to impose completely. It was understood in the seventeenth century that women were received only in the chapel, and provision was made for a room reserved for this kind of visitor who could not go any further: the parlour. At the Collège de Bourgogne, according to the disciplinary regulations of 1680, 'women shall not enter the college rooms, except for the mothers of gentlemen who may ask to see them. Conversation may be had with other women, when abso-

lutely necessary, in the chapel, pending the installation of a room for this purpose.'

Henceforth woman was the intruder, ridiculed by a masculine community which desired her and excluded her at the same time. This scene, described by Sorel, has something modern about it, and one might imagine oneself in the courtyard of a twentieth-century boys' school into which a girl had wandered by mistake: 'Our schoolmates hissed and whistled at the girls and women they saw entering the courtyard of our college.' But this strict morality encountered a resistance to which the college records bear witness, as if it were in advance of its time. At Troyes, as early as the end of the first half of the seventeenth century, we find these observations: *Sunt suspectis aut pravissimis moribus – pravitatem illius si noveris, vis poteris lacrimos continere – faex scholae – vitiorum omnium colluvies et sentina.* And at Caen in 1677: *Ejectus ob impudentia* (admittedly at the age of eighteen). *Impudentia et arrogantia famosus.*[1]

This is why, in the seventeenth century, towns with big colleges were subject to special police supervision. Thus at La Flèche in 1625 prostitution was more strictly controlled than it was elsewhere: 'Neither women nor girls of evil and scandalous reputation' could approach – in principle at least – within seven miles of the town. Tavern-keepers, gambling-den proprietors and hotel-keepers were forbidden to put students up or to take them in as lodgers; the tavern was still a place of ill repute, frequented by women of easy virtue, soldiers, vagabonds, sharpers – and students too, despite all prohibitions. In 1602 Crispin de Pas published a series of engravings depicting school life. Here we see not only the departure for school, scenes inside the college, the library, various sports such as ball-games, or tennis, the social graces represented by a dancing lesson, but a merry gathering in a place which looks like a cross between a tavern and a brothel, where men and youths are drinking with women to the sound of music. It seems possible that the regulations of the civil authorities at La Flèche were not very strictly observed.

Finally these college towns had a curfew: at nine o'clock at night all the inhabitants had to lock their doors. Similarly at Tournon, in the same period (1612), it was forbidden to go out after eight o'clock. In this way it was hoped to prevent schoolboys who lodged in the town from sleeping out. These measures were no longer necessary at Mauriac in the late eighteenth century, when Marmontel went to school there. School life had become much quieter, already closer to that of French schoolboys in the nineteenth century, clearly separated by a stricter discipline from the students who enjoyed the same complete freedom as adults. In England,

1. Bibliothèque Nationale, MSS Fonds, Latin, nos. 10990, 10991.

on the contrary, the old freedom of morals continued in the public schools throughout the eighteenth century until the reforms of the years 1830–50. In England in 1760 it was possible to write, as Montaigne did in France two centuries earlier, that a public-schoolboy 'had practised more vices by the age of sixteen than anyone else would have heard of by sixty'. (Samuel Foote, quoted by Archer, 1921).

Schoolboys, as we have already said, lived more often than not on food brought to the local market every week by relatives or neighbours. But they also lived by begging. In sixteenth-century Germany there is abundant evidence on this point. The little band of students, greenhorns and old hands, to which Thomas Platter belonged, and which led a vagabond life from one town to the next, lived either by thieving and scrounging on the roads and in the country, or by the begging of the greenhorns who went singing in the streets and taverns: 'When I went into a tavern, people enjoyed hearing me talk the Valais dialect, and gladly gave me something.' At Neuburg 'those of us greenhorns who could sing went singing round the town; for my part I did some begging.' 'In the evening I often made five or six journeys to bring our old hands who stayed in school my takings for the day.' 'Sometimes, in the summer, we would go and beg for some beer in the beer-houses after supper.' Thomas, it should be added, was a very skilful beggar.

Begging by children was tolerated, even approved by public opinion. The bands of scholars exploited this state of mind to the full, training the youngest boys for begging, while the oldest specialized in stealing and scrounging. There were eight companions, with Thomas Platter, on the Dresden Road: they split up into several groups, one for hunting geese, another for picking swedes and onions in the fields and gardens. 'As for the youngest of us, we were sent to Neumark, the nearest town, to beg for bread and salt.' They had no luck that day, for the inhabitants fired at them over the town walls as soon as they lit their camp-fires. Schoolboys whose voices were beginning to break no longer had any success. At about the age of nineteen, Thomas Platter tried to earn his living by singing in the streets of Zürich: 'People pushed me aside: I had the deep voice of an old hand.'

The practice of begging in childhood was so generally accepted, at least in sixteenth-century Germany, that Mosellanus describes it in his pedology. This is a collection of conversations between Leipzig schoolboys. Begging occupies an honourable place in their lives. 'As soon as Mass is over,' says Laurent, 'I shall run so fast to the rich people's door that I shall be, if not among the first, at least among the second and third

to be given alms.' 'You will be hard put to it to beat me,' says his friend. 'We shall see.' These alms, an indispensable part of the scholar's income, also had a traditional character and were associated with customs dating back to ancient times. I quote Mosellanus once more: 'Tomorrow is St Martin's Day.' 'Well, what of it?' 'We scholars reap a rich harvest that day. First of all, people give us more to eat than usual, and then it is customary for the poor to go from door to door to be given alms. I hope to collect enough to get me through the winter without too much hardship.' And again: 'Who's coming into the country with me? We'll go begging for eggs in accordance with the old custom.' His friend refuses, partly out of shame and partly because he does not think the game is worth the candle: 'Is there anything more degrading than hanging around farms for the sake of nine or ten eggs?' 'But how am I to appease my hunger?' 'Here in town you can at least husband your time.'

Another German dialogue of the same period as Schottenius's describes the same customs at Cologne. 'What are you doing with that stick?' 'Tomorrow we are going to go begging from door to door.' 'Begging for what?' 'A little piece of pork or a little loaf of rye bread.' 'Where does that custom come from?' 'I remember seeing a statue of St Blaise in church, holding a pig's head stuck on the end of a stick.' The historian of these dialogues, Massebiau, adds that in his day, in 1878, St Blaise was the patron saint of children and cattle in Germany. On his feast day, the priest used to bless bread and salt. Even in our own time, children in the United States go from door to door one October day, asking for little presents and sweets: a relic of customs which once corresponded to the alimentary needs of children living at some distance from their homes. One may incidentally wonder if begging by children was not tolerated longer in Germany than anywhere else. In 1877 the young Wagner was in the second class at the Kreuzschule in Dresden: he was fourteen years old. He wanted to go to see his mother in Dresden; as he had no money, he set off on foot, asking travellers he met on the way for alms. Yet he cannot have looked like a wretched little beggar-boy. In later times it is unlikely that he would have been allowed to get very far. Nowadays he would be a hitch-hiker.

In England the traditions of the public school preserve the memory of these begging customs. At Eton, on the day of the reception and initiation of the new boys or 'freshmen', the pupils used to go out in groups along the neighbouring roads: they would stop the passers-by and force them to give them some money in return for a little salt – the salt used to sprinkle over the freshmen. The English historian of Eton, H. Lyte (1889), sees here something half-way between robbery and mendicity.

In France, on the other hand, even in the sixteenth-century texts, there is no mention of begging at all. We have already drawn attention to the silence of French documents on the subject of student japes; mendicity would seem to have been linked with japes and rags in student manners. The disciplinary system of the colleges and pedagogicas in France must have limited, if not suppressed, vagabond customs which were more deeply rooted in other countries. Yet the population of the Paris schools was still extremely free and easy in the sixteenth century. The humanist Buchanan describes a classroom in the early sixteenth century in these terms: 'While the master shouts himself hoarse, these lazy children sit dozing and thinking of their pleasures. One boy who is absent has paid one of his companions to answer in his place. Another has lost his breeches, while yet another is looking at his foot which is poking through a hole in his shoe.' The educational reformers of the sixteenth and seventeenth centuries punished pupils who neglected their appearance: they must have been more successful than the founders of colleges in the late Middle Ages, who required their scholars to dress in a way which was no longer fashionable: no shoes with pointed toes, no short, tight-fitting clothes.

Respect in the colleges and even in the *pensions* or pedagogicas for a stricter system of discipline brought about the disappearance of the bohemian *martinet*. Provided with a better environment, the schoolboy behaved better. However, it was only with the greatest difficulty that the school authorities got rid of certain habits, the inveterate legacy of an easygoing past: thus pupils who were tired of a certain course, or more often who wanted to escape a punishment, used to change masters without obtaining the permission of either their family or the university. For a long time this was regarded as a right they possessed. Then it was seen as a sign of indiscipline on the part of the pupils, an invitation to an unpleasant rivalry between the masters, and from then on war was waged on this floating population. The 1598 reformation of the University of Paris would seem to have got the better of it.

But it would take a long time before greater regularity in school attendance could be achieved. Boys found it an easy matter to play truant from Mathurin Cordier's school, as is shown by this fragment of dialogue between two friends, one of whom is absconding: 'When are you coming back to school?' 'I don't know.' 'Why aren't you telling your father?' 'Do you think I care about him?' The records for the seventeenth century still reveal a goodly number of premature departures without permission. At Caen in 1677, fifty-one pupils in the humanities class left school in the middle of the year, without waiting for it to end; some because they refused to be punished (*ejectus medio anno quod*

debitas paenas non subire voluerit), others because their families had sent for them, being unable to support them any more; others simply on an impulse: *abiit, seu effugit ne paenas absentiae daret*, for punishments were inflicted for these unauthorized absences, which must have been frequent. *Saepe obfuit, pigerrimus et malus. Sine causa 15 ante finem diebus agens a domi – 15 ante finem diebus obfuit sine causa cum esset in urbe. Obiit proprio motu* (at the age of fifteen).

By the eighteenth century the schoolboy had been more or less tamed, despite certain habits of independence which lasted as long as the day-school system or the custom of living in lodgings, and which disappeared only in the nineteenth century with the spread of the boarding-school system or the extension of the child's stay at home.

The modern reader will have been surprised by the unseemliness of these manners: they strike us as incompatible with our ideas of childhood and early adolescence, and we barely tolerate them in adults in the lower classes, as the sign of a mental age the wrong side of maturity. In the sixteenth and seventeenth centuries, people situated schoolboys in the same picaresque world as soldiers, valets and beggars. Worthy citizens with landed property mistrusted all equally. A canon of Dijon, speaking of the gilded youth of the town (which included the son of the President of the High Court) and of its departure in 1592 'to go to the Universities of the Law at Toulouse', called it *vermin*: 'We are well rid of that vermin' – as if he were speaking of a gang of thugs. One of the characters in Larivey's comedy likens certain schoolboys to the outsiders who live on the fringe of civilized society: 'I do not regard them as schoolboys, but as *free men*, living without law and without appetite' – and 'free men' meant something like tramps or *truands*. The very word *truand*, which in modern French slang denotes an adult, comes from the scholastic Latin *trutanus* ('vagabond'), a word applied chiefly to vagabond scholars, the plague of school society in the past. It still retains this meaning in English, where the word 'truant' normally refers to a child who stays away from school. Here we can see links whose importance we can only guess at, between scholastic terminology and popular slang.

It needed the pressure of the pedagogues to separate the schoolboy from the bohemian adult, both of whom were the heirs of a time when elegance of speech and dress was limited not even to the cleric but to the courtly adult. A new moral concept was to distinguish the child, or at least the schoolboy, and set him apart: the concept of the well-bred child. It scarcely existed in the sixteenth century; it was formed in the seventeenth century. We know that it was the product of the reforming opinions

of an elite of thinkers and moralists who occupied high positions in Church or State. The well-bred child would be preserved from the roughness and immorality which would become the special characteristics of the lower classes. In France this well-bred child would be the little bourgeois. In England he would be the gentleman, a social type unknown before the nineteenth century, and which a threatened aristocracy would create, thanks to the public schools, to defend itself against the progress of democracy. The old medieval unruliness was abandoned first of all by children, last of all by the lower classes: today it remains the mark of the hooligan, of the last heir of the old vagabonds, beggars and outlaws.

Summary
School and the Duration of Childhood

We have studied the beginnings and development of two views of child-hood. According to the first, which was widely held, children were creatures to be 'coddled' and childhood was held to last hardly beyond infancy; the second, which expressed the realization of the innocence and the weakness of childhood, and consequently of the duty of adults to safeguard the former and strengthen the latter, was confined for a long time to a small minority of lawyers, priests and moralists. But for their influence, the child would have remained simply the *poupart* or *bambino*, the sweet, funny little creature with whom people played affectionately but with liberty, if not indeed with licence, and without any thought of morality or education. Once he had passed the age of five or seven, the child was immediately absorbed into the world of adults: this concept of a brief childhood lasted for a long time in the lower classes. The moralists and pedagogues of the seventeenth century, heirs of a tradition going back to Gerson, to the fifteenth-century reformers of the University of Paris, to the founders of colleges in the late Middle Ages, succeeded in imposing their considered concept of a long childhood thanks to the success of the educational institutions and practices which they guided and supervised. We find the same men, obsessed with educational questions, at the origins of both the modern concept of childhood and the modern concept of schooling.

Childhood was extended beyond the years when the little man still walked on a 'leading-string' or spoke his 'jargon', when an intermediary stage, hitherto rare and henceforth more and more common, was intro-duced between the period of the robe with a collar and the period of the recognized adult: the stage of the school, of the college. The age groups in our societies are organized around institutions; thus adolescence, never clearly defined under the ancien regime, was distinguished in the nine-teenth century and indeed already in the late eighteenth century by conscription and later by military service. The schoolboy or scholar or student – the terms were used interchangeably until the nineteenth century – of the sixteenth, seventeenth and eighteenth centuries was to a long childhood what the conscript of the nineteenth and twentieth centuries was to adolescence.

However, this demographic function of the school was not immediately recognized as a necessity. On the contrary, for a long time the school remained indifferent to the separation and distinction of the ages, because it did not regard the education of children as its essential aim. Nothing predisposed the medieval Latin school for this function of moral and social education. The medieval school was not intended for children: it was a sort of technical school for the instruction of clerics, 'young or old' as Michault's *Doctrinal* put it. Thus it welcomed equally and indifferently children, youths, adults, the precocious and the backward, at the foot of the magisterial rostrum.

Until the eighteenth century at least, a great deal of this mentality remained in school life and manners. We have seen how tardy was the division into separate and regular classes, and how the various ages remained mixed up within each class, with children between ten and thirteen sitting next to adolescents between fifteen and twenty. In common parlance, to say that someone was of school age did not necessarily mean that that person was a child, for school age could also be taken to mean the limit beyond which a pupil had small hope of success. That is how we must interpret the advice given by Theresa Panza to her husband Sancho as he set off on an expedition with Don Quixote: 'Do not forget me or your children. Remember that our Sanchico is already fifteen and that it is time for him to go to school if it is agreed that his uncle the priest is going to make a churchman of him.' People went to school when they could, very early or very late. This way of looking at things continued throughout the seventeenth century, in spite of contrary influences. Sufficient traces of it would remain in the eighteenth century for the oldest pedagogues, after the Revolution, to remember it and to recall, in order to condemn it, the practice under the ancien regime of keeping old pupils on at school. It would not disappear for good until the nineteenth century.

This indifference shown by the school to the education of children was not characteristic simply of old-fashioned conservatives. It is important to note that the humanists of the Renaissance shared it with their enemies, the traditional schoolmen. Like the pedagogues of the Middle Ages, they confused education with culture, spreading education over the whole span of human life, without giving a special value to childhood or youth. As a result they exerted only a slight influence on the structure of the school, and their role has been grossly exaggerated by literary historians. The real innovators were the scholastic reformers of the fifteenth century, Cardinal d'Estouteville, Gerson, the organizers of the colleges and pedagogicas, and finally and above all the Jesuits, the Oratorians and the Jansenists in the seventeenth century. With them we see the appearance

of an awareness of the special nature of childhood, knowledge of child psychology, and the desire to devise a method suited to that psychology.

The college under the ancien regime thus retained characteristics of its ancestor, the Latin cathedral school, for a very long time; many years passed before it became an institution specially intended for children.

Not everybody, by any means, went to a college or even to a little school. Among those who never went to a college, or who spent only one or two years there, the old habits of precocity remained as in the Middle Ages. The concept of a very short childhood held good.

In the seventeenth century, schooling did not necessarily go with good birth. Many young nobles ignored the college, avoided the academy, and went straight into active service in the army. In her famous account of Turenne's death in 1675 Mme de Sévigné mentions the presence beside the Maréchal of his fourteen-year-old nephew. At the end of Louis XIV's reign there were fourteen-year-old lieutenants in the army. Chevert joined the army at the age of eleven.

This precocity was also to be found in the ranks. Mme de Sévigné, who as E. G. Léonard pointed out in 1958, was decidedly interested in military matters, tells this anecdote: 'Despréaux has been with Gourville to see M. le Prince. M. le Prince sent him to look at his army. "Well, what do you think of it?" asked M. le Prince. "Your Royal Highness," said Despréaux, "I think it will be very good when it reaches its majority. Because the oldest soldier in it isn't eighteen." '

Common to both officers and men in the seventeenth century, this precocity would continue for a long time in the rank and file; it disappeared in the eighteenth century among the officers, who entered the army only after a more or less complete schooling, sometimes prolonged by training in special military schools.

If schooling in the seventeenth century was not yet the monopoly of one class, it remained the monopoly of one sex. Women were excluded. The result was that in their lives the habits of precocity and a brief childhood remained unchanged from the Middle Ages to the seventeenth century. 'Since the age of twelve, thanks to God whose life is eternal, I have taken a husband five times at the church porch.' Thus one of Chaucer's women in the fourteenth century. But at the end of the sixteenth century we find Catherine Marion marrying Antoine Arnauld at the age of thirteen. And she was sufficiently mistress of the house to give 'a slap to her first chambermaid, a girl of twenty, for not resisting a caress which someone gave her'. The person who wrote these lines, Catherine Lemaître, had herself been married at the age of fourteen. There was talk of marrying off her other sister, Anne, at the age of twelve, and only the little girl's

religious vocation put a stop to this project. The suitor was in no hurry and was fond of the family for, so Catherine Lemaître tells us, 'not only did he delay marrying until she [Anne] had made her profession, but he even put off his marriage until he had seen the entry into religion of the youngest of the family, the little girl who, when his marriage to my sister Anne was being discussed, was a child of six'. At the most an engagement of four to six years. Moreover, by the age of ten, girls were already little women: a precocity due in part to an upbringing which taught girls to behave very early in life like grown-ups. 'At the age of ten, that little girl's mind was so developed that she ran the whole house for Mme Arnauld, who deliberately made her do this to train her in the work of a wife and mother, since that was to be her station in life.'

Apart from this domestic apprenticeship, girls were given virtually no education. In families where the boys went to college, they learned nothing. Fénelon complains of this ignorance as a general phenomenon. He admits that considerable trouble is taken over boys: 'The greatest experts have taken pains to lay down rules in this respect. How many masters and colleges there are! How much money is spent on the printing of books, on scientific research, on methods of teaching foreign languages, on choosing professors ... and this shows the high opinion people have of the education of boys.' But the girls! 'It is considered perfectly permissible to abandon girls willy-nilly to the guidance of ignorant or indiscreet mothers.' The result was that women could scarcely read and write: 'Teach a girl to read and write correctly. It is shameful but common to see women of wit and manners unable to pronounce what they read: either they hesitate or they read in a sing-song voice ... They are even more at fault in their spelling, and in shaping and joining letters of the alphabet when writing.' They were virtually illiterate. People got into the habit of entrusting girls to convents which were not intended for education, and where they performed pious exercises and were given exclusively religious instruction.

At the end of the century Mme de Maintenon's Saint-Cyr would provide a model institution of a modern type for girls, who entered it between the ages of seven and twelve and left when they were about twenty. Complaints about the little co-educational schools and the teaching of the Ursulines indicate a general tendency in favour of feminine education, but it would operate with a time-lag of about two centuries.

From the fifteenth century on, and especially in the sixteenth and seventeenth centuries, despite the persistence of the medieval attitude of

indifference to age, the college tended to devote itself essentially to the education of youth, drawing its inspiration from the psychological principles which were found, and which we recognize today, in Cordier, in the Jesuits' *ratio*, and in the abundant pedagogical literature of Port-Royal. The need for discipline was recognized: a steady, organic discipline, very different from the violence of an authority regarded with scant respect. The lawyers knew that the unruly society under their jurisdiction called for a strong hand, but school discipline was born of a very different spirit and tradition. It originated in ecclesiastical or religious discipline; it was not so much an instrument of coercion as an instrument of moral and spiritual improvement, and it was adopted not only for its efficiency, because it was the necessary condition of work in common, but also because of its intrinsic moral and ascetic value. The pedagogues would adapt it to a system of supervising children which, at least in theory, was constantly in operation, night and day alike.

The essential difference between the medieval school and the modern college lies in the introduction of discipline. Discipline was gradually extended from the colleges to the private *pensions* where the schoolboys lodged, and sometimes to the town itself, though generally without any success in practice. The masters tended to subject the schoolboy to an ever stricter control in which parents, from the end of the seventeenth century on, increasingly came to see the best conditions for a good education. The authorities were led to increase the hitherto restricted numbers of boarders, and the ideal institution of the nineteenth century would be a boarding-school, whether *lycée*, little seminary, religious college or *école normale*. In spite of the survival of certain archaic features, discipline would give the college under the ancien regime a modern character foreshadowing the present-day secondary school. This discipline not only took the form of better supervision inside school, but it tended to force parents to respect the complete school cycle. Schooling would admittedly become a matter for children and youths – that is to say it would no longer encroach as in the Middle Ages or the Renaissance on adult life – but it would be comparatively long (though not as long as in the Middle Ages). People would no longer be content with spending a year or two at school as was often still the practice in the early seventeenth century, both for impoverished or hurried nobles and for humble folk anxious to give their children a smattering of Latin. The school cycle at the end of the eighteenth century was fairly similar to that in the nineteenth century: four or five years at least. The child would be subjected for the duration of his schooling to an increasingly strict and effective discipline, and this discipline separated the child who suffered it from the

liberty enjoyed by the adult. Thus childhood was extended by almost the entire duration of the school cycle.

On the one hand there was the school population, on the other there were those who, in accordance with immemorial custom, went straight into adult life as soon as they could walk and talk. This division did not correspond to social conditions. True, the nucleus of the school population consisted of future burgesses, lawyers and churchmen. But, as we have seen, there were nobles who never went to school, and artisans and peasants who did. Girls of good family were no better educated than girls of the lower classes, and they could be worse educated, for girls of the people sometimes learnt to 'write to perfection' as a trade. The school population, at a time when the college gave almost all the types of instruction which we nowadays label primary, secondary and higher, did not correspond nearly as closely as it does today to the contour of the social classes. The movement of educational apostleship in the late seventeenth century, which resulted in the foundation of the Brothers of the Christian Schools, was not confined to the poor. The poor schools were invaded by children of the lower-middle class, as the lower classes in the colleges were by little artisans and peasants.

Things could have developed in such a way that the French educational system would have been based on a single school: after all, until the eighteenth century, the ancien regime knew only one school. School attendance would have extended socially and geographically; the length of the school cycle, on the other hand, would have varied according to the vocation; only lawyers and churchmen would have completed the full course, including two or three years of philosophy corresponding to the modern university course; the rest, artisans or soldiers, would have stopped at an earlier stage. That was in fact the situation about the middle of the seventeenth century: the colleges and Latin schools spread a circular network around a big college providing a full course of tuition, and the density of this network diminished towards the periphery. It consisted of a host of schools which contained only the lower classes of the school cycle. This may seem surprising when one considers the rigidity and diversity of the social hierarchy under the ancien regime: educational practice differed less according to rank than according to function. Consequently the basic attitudes, like many features of everyday life, did not differ much more.

This state of affairs did not last, and after the eighteenth century the single school was replaced by a dual educational system in which each branch corresponds not to an age group, but to a social class: the *lycée* or

the college for the middle class (secondary education) and the school for the lower class (primary education). Secondary education is a long business. Primary education remained a short affair for a very long time, and in both France and England it needed the social revolutions which followed the two World Wars to prolong it. Perhaps one of the reasons for this social specialization is in fact to be found in the technical requirements of a long education, once it was firmly established as part of modern life; it was no longer possible to tolerate the coexistence of pupils who were not determined right from the start to go on to the very end, to accept all the rules of the game – for the rules of an enclosed community, whether it is a school or a religious body, demand the same total abandonment as gambling. Once the long cycle had been established, there was no longer any room for those who, on account of their station in life, their parents' profession, or their financial circumstances, could neither follow it through, nor intend to follow it through, to the end.

But there was another cause of this evolution: the action of those men of authority, reason and learning, whom we have already found at the origin of all the great changes in manners between the Middle Ages and modern times. It was they, as we have pointed out, who realized the special nature of childhood, and the moral and social importance of the systematic education of children in special institutions devised for that purpose. Very soon some of them were disturbed at the extent of their success – a sociological success of which they were not always aware. Richelieu, who wanted to found a model academy in the utopian city he intended to build at Richelieu, and Colbert after him, expressed fears of an overabundance of intellectuals and a shortage of manual labour: an old theme which generations of middle-class conservatives have handed down to our own day. In the seventeenth century, these precursors, despite their eminent reputations, talked to deaf ears: they could do nothing to halt the progress of the colleges, or their spread into the country. But in the eighteenth century their prejudice was adopted by those 'enlightened' people who in many respects appear as their successors; these men of the Enlightenment, thanks to their numbers and their connections, could influence public opinion to an extent which no group of jurists, clerics or intellectuals could have dreamt of before. Some of them, such as Condorcet, remained faithful to the idea of universal education open to all. But most of them proposed – as soon as the Jesuits had been expelled – to confine to a single social class the privilege of the long classical education, and to condemn the lower classes to an inferior, exclusively practical, type of instruction.

We know too that the concept of childhood found its most modern

expression in these same circles of enlightened bourgeois who admired Greuze and read *Émile* and *Pamela*. But the old ways of life have survived almost until the present day in the lower classes, which have not been subjected for so long a period to the influence of the school. We may even ask ourselves whether, in this respect, there was not a retrogression during the first half of the nineteenth century, under the influence of the demand for child labour in the textile industry. Child labour retained this characteristic of medieval society: the precocity of the entry into adult life. The whole complexion of life was changed by the differences in the educational treatment of the middle-class and the lower-class child.

There is accordingly a remarkable synchronism between the modern age group and the social group: both originated at the same time, in the late eighteenth century, and in the same milieu – the middle class.

Part Three
The Family

Chapter 14
Pictures of the Family

It may seem debatable whether one can speak of a profane iconography in the Middle Ages before the fourteenth century, seeing that the distinction between sacred and profane was so slight. However, among the profane contributions is one theme whose frequency and popularity are highly significant: the theme of trades and crafts (*métiers*). The archaeologists have shown us that the Gauls in the Roman era were fond of depicting scenes of their working life on their mortuary bas-reliefs. This liking for the subject of trades and crafts is to be found nowhere else. The archaeologists have been struck by the rarity, if not the complete absence, of such scenes in the mortuary iconography of Roman Africa. The theme consequently dates back far into the past. It continued and even developed in the Middle Ages. To use an anachronistic expression, one may say, broadly speaking, but without deforming the truth, that the 'profane' iconography of the Middle Ages consists above all of this subject of crafts. It is significant that it was their craft or trade which for a long time struck people as their foremost activity; this was a point of view that was linked with the mortuary cult of the Gallo-Roman epoch, and with the social and learned concept of the world in the Middle Ages, in the cathedral calendars. No doubt this seems perfectly natural to modern historians. But have they asked themselves how many people today would prefer to forget their trade and would choose to leave some other image of themselves? People have tried in vain to inject a little lyricism into the functional aspects of contemporary life; the result is a sort of academic art without any roots in everyday life. The man of today would not choose his trade, even if he liked it, to propose as a subject for artists, even if the latter could accept it. The importance accorded to the trade or craft in medieval iconography is a sign of the sentimental value that was put on it. It is as if a man's private life were first of all and above all his trade.

One of the most popular representations of trades and crafts linked them with that other theme, the seasons, whose importance we have had occasion to recognize in connection with the 'ages of life'.[1] We know that

1. See Chapter 4.

the Middle Ages in the West were fond of linking by means of symbols ideas whose secret connections, hidden behind external appearances, they wished to emphasize. They linked the various crafts to the seasons, as they did the ages of life or the elements. This is the significance of the calendars in stone and glass, the calendars of the cathedrals and the books of hours.

The traditional iconography of the twelve months of the year was established in the twelfth century, very much as we can find it at Saint-Denis, in Paris, at Senlis, at Chartres, at Amiens, at Reims, etc. – works and days; on the one hand, the great tasks of the countryman: hay, corn, wine and the vineyards, and pigs; on the other, the period of rest, that of the winter and the spring. It is the peasants who are shown working, but the pictures of leisure moments vary between peasant and noble. January (Twelfth Night) belongs to the noble, seen sitting at a groaning board. February belongs to the villein who is shown coming in from gathering wood and hurriedly sitting down by the fire. May is either a peasant resting in the midst of flowers or a young noble setting off for the chase and getting his falcon ready. In any case it is an evocation of youth taking part in the Maytime festivities. In these scenes the man is always alone, except that sometimes a young valet (as at Saint-Denis) is shown standing behind his master who is eating at table. The person depicted is always a man, never a woman ...

We see this iconography evolving in the books of hours until the sixteenth century, revealing significant tendencies as it develops.

First of all we see woman appear, the lady of courtly love or the mistress of the house. In the Hours of the Duc de Berry, in the month of February, the peasant is no longer, as on the walls of Senlis, Paris or Amiens, the only person warming himself. Three women of the house are already sitting round the fire, while the peasant is still shivering outside in the snow-covered yard. Elsewhere the scene shows a winter evening at home: the man, sitting in front of the hearth, is warming his hands and feet, but beside him his wife is quietly working at her spinnng-wheel (Charles d'Angoulême). In April appears the theme of the court of love: the lady and her lover in a walled garden (Charles d'Angoulême). She is also shown accompanying the knights in the chase. But even the noble lady does not remain the idle and somewhat imaginary heroine of the April gardens or the horsewoman of the Maytime festivities: she also superintends the work in the April garden (Turin). The peasant woman recurs more frequently. She works in the fields with the men (Berry, Angoulême). She takes drinks to the harvesters as they rest on a hot summer's day (Hennessy, Grimani). Her husband brings her back in a

wheelbarrow with the wine-flask she has brought him. The knights and ladies are no longer isolated in the noble pleasures of April or May. Just as the lady of the Turin Book of Hours busied herself with her garden, the nobles mingle with the peasants and wine-harvesters (as in the cherry-picking scene in the Turin Hours). The further one goes in time, especially in the sixteenth century, the more often one finds the lord's family among the peasants, supervising their work and joining in their games. There are a great many sixteenth-century tapestries showing these rustic scenes in which the masters and their children are picking grapes or supervising the corn-harvest. The man is no longer alone, and the couple is no longer simply the imaginary couple of courtly love. Wife and family join in the man's work and live beside him, indoors or out in the fields. These are not, strictly speaking, family scenes: the children are still missing in the fifteenth century. But the artist feels the need to depict the collaboration of the married couple, of the men and women of the house, in the day's work, with a hitherto unknown attention to homely details.

At the same time the street appears in the calendars. The street was already a familiar theme in medieval iconography: it takes on a particularly expressive animation in the admirable views of the bridges of Paris in the thirteenth-century manuscript of the life of St Denis. As in modern Arab towns, the street was the setting for commercial and professional activity, as also for gossiping, conversation, entertainments and games. Outside private life, which for a long time was ignored by artists, everything happened in the street. However, the calendar scenes, being of rustic inspiration, neglected it for a long time. In the fifteenth century, the street took its place in the calendars. True, the months of November and December in the Turin Hours are illustrated by the traditional sacrifice of the pig. But here it is taking place in the street, and the neighbours have come to their doors to watch. Elsewhere (the calendar of the Hours of Adélaïde de Savoie) we are at the market: some little street-arabs are cutting the purse-strings of busy, absent-minded housewives: here we recognize the theme of the little pickpockets which was to recur all the way through picaresque genre-painting in the seventeenth century. Another scene in the same calendar shows the return from the market: a woman has stopped to talk to her neighbour who is looking out of the window; some men are sitting resting on a bench, protected by a screen, and watching the boys of the village wrestling and playing tennis. This medieval street, like the Arab street today, was not opposed to the intimacy of private life; it was an extension of that private life, the familiar setting of work and social relations. The artists, in their comparatively tardy attempts at depicting private life, would begin by capturing it in the

street, before pursuing it into the house. It may well be that this private life took place as much in the street as in the house, if not more.

Together with the street, games invaded the calendar scenes: knightly games such as tournaments (Turin, Hennessy), games common to all, and festival pastimes such as dancing round the maypole. The calendar of the Hours of Adélaïde de Savoie consists chiefly of a description of a wide variety of games, parlour games, games of skill, traditional games: the bean-game on Twelfth Night, dancing on May Day, wrestling, hockey, football, water-jousting, snowballing. In other manuscripts we are shown a cross-bow contest (Hennessy), a musical boating party (Hennessy), and swimming (Grimani). We know that in those days games were not simply pastimes but a form of participation in the community or the group: games were played between members of a family, between neighbours, between age groups, between parishes.[2]

Finally, as from the sixteenth century, a new character came on the scene in the calendars: the child. He was already frequently depicted in the iconography of the sixteenth century, especially in the *Miracles de Notre-Dame*. But he had remained absent from the calendars, as if that ancient form of iconography had been reluctant to accept this latecomer. In the fields, there are no children to be seen with the women. Only a few are shown waiting at table during the January banquets. They can also be caught sight of at the market in the Hours of Adélaïde de Savoie; in the same manuscript they are depicted snowballing one another, heckling the preacher in church and being thrown out. In the last Flemish manuscripts of the sixteenth century, they are having their fling: one can sense the artist's liking for them. The calendars of Hennessy's and Grimani's Hours have imitated fairly closely the snow-covered village in the Très Riches Heures du Duc de Berry, in the January scene which I have described above, with the peasant hurrying home to join his womenfolk by the fire. However, they have added another figure: the child. And the child is in the same position as the Manneken-Pis, which had become a common subject in the iconography of the time: the child piddling through the open door. This theme of the Manneken-Pis was to be found everywhere – witness the picture of St John the Baptist in the Musée des Augustins at Toulouse (a picture which used to hang in the chapel of the High Court of the town), or a certain *putto* of Titian's.[3]

In these Hours of Hennessy and Grimani, the children are shown skating and aping the grown-ups' tournaments (one of the children is supposed to be the young Charles the Fifth). In the Munich Hours they

2. See Chapter 4.
3. One of the *putti* in the 'Bachannalia' at the Prado, Madrid.

are having a snowball fight. In the *Hortulus animae*, they are playing at courts of love and also at tournaments – riding a barrel instead of a horse – and skating.

These successive pictures of the months of the year therefore introduced new characters: the woman, the neighbours and friends, and finally the child. And the child was associated with a hitherto unknown desire for homeliness, for familiar if not yet precisely 'family' life.

In the course of the sixteenth century, this iconography of the months underwent a final transformation of great significance for our subject: it took on a family character. This it did by merging with the symbolism of another traditional allegory: the ages of life. There were several ways of representing the ages of life, but two of them took the lead: one, the more popular of the two, survived in the form of engravings and showed the ages on the steps of a pyramid rising from birth to maturity, and then going down to old age and death. The great painters scorned to copy this naive composition. On the other hand they frequently adopted the representation of the three ages of life in the form of a child, some adolescents – often a couple – and an old man. A Titian painting exemplifies this type: it shows two sleeping *putti*, and in the foreground a naked man and a full-dressed peasant girl playing the flute, and in the background a bent old man who sits with a death's-head in his hands.[4] The same subject would be treated by Van Dyck in the seventeenth century in 'The Four Ages of Life'. In these compositions, the three or four ages of life are depicted separately, in accordance with the iconographic tradition. Nobody thought of bringing them together within a single family whose different generations would symbolize the ages of life. The artists, and the public opinion which they expressed, remained faithful to an individualistic concept of the ages: the same individual was depicted at the various stages of his destiny.

However, in the course of the sixteenth century, a new idea had appeared which symbolized the duration of life by the hierarchy of the family. We have already had occasion (in Chapter 1) to quote *Le Grand Propriétaire de toutes choses*, the old medieval text translated into French and printed in 1556. The sixth book deals with the ages. It is illustrated by a woodcut depicting neither the steps of the ages nor the three or four ages shown separately, but simply a family gathering. The father is sitting with a little child on his knees. His wife is standing on his right; one of his sons is standing on his left, and another is kneeling to take something his father is giving to him. This is at once a family portrait, of a kind of which thousands were painted in this period in the Netherlands,

4. The Bridgewater Gallery, London.

Italy, England, France and Germany, and a family subject such as painters and engravers would produce in large numbers in the seventeenth century. This theme was destined to achieve the most extraordinary popularity.

It was not entirely unknown in the late Middle Ages. It is treated in a remarkable fashion on a capital, known as the marriage capital, in the loggias of the ducal palace in Venice. Venturi dates it about 1424; Toesca puts it at the end of the fourteenth century, which seems more probable in view of the style and dress, but more surprising in view of the precocity of the subject. The eight sides of this capital tell a story illustrating the fragility of life – a familiar theme in the fourteenth and fifteenth centuries, but here in the context of a family, which is something new. First we have the engagement. Then the young woman is dressed in a formal dress on which little metal discs have been sewn: ornaments perhaps, or possibly coins, for coins played a part in the marital and baptismal customs. The third face shows the wedding ceremony at the moment when one of the two holds a crown over the other's head – a rite which has survived in the Oriental liturgy. Then the couple are entitled to kiss. On the fourth face, they are lying naked in the marriage bed. A child is born whom the father and mother hold between them, wrapped in swaddling-clothes. Their own clothes look simpler than at the time of their engagement and wedding: they have become serious people, who dress severely or in an old-fashioned style. The seventh face brings together the whole family, who pose for their portrait. Each parent is holding the child by the shoulder and a hand. This is already the family portrait such as that in *Le Grand Propriétaire*. But with the eighth face, the story takes a dramatic turn: the family is in mourning, for the child has died; he is stretched out on his bed with his hands folded. The mother is wiping away her tears with one hand and touching the child's arm with the other; the father is praying. Other capitals near this one are adorned with naked *putti* playing with fruit, birds and balls: more commonplace themes, but themes which enable us to place the marriage capital in its iconographic context.

The story of the marriage begins as the story of a family but ends with a different theme, that of premature death.

At the Musée Saint-Raimond at Toulouse, one can see the fragments of a calendar which the costumes enable us to place in the second half of the sixteenth century. In the picture for July we see the family gathered together as in the contemporary engraving of *Le Grand Propriétaire*, with one additional detail which is not without importance: the presence of the servants beside the parents. The father and mother are in the middle. The father is holding his son by the hand and the mother her daughter.

The valet is standing on the men's side, the maidservant on the women's, for the sexes are separated as in the portraits of donors – the men, fathers and sons, on one side, the women, mothers and daughters, on the other.

August remains the month of the harvest, but the painter has chosen to depict not the actual harvesting but the delivery of the harvest to the master, who has some money in his hand and is about to give it to the peasants. This scene is connected with an iconography which was very common in the sixteenth century, especially in the tapestries of the period, where country gentlemen are shown supervising their peasants or joining in their games.

October: the family meal. The parents and their children are at table. The smallest child is perched on a high chair which brings him up to the level of the table: a chair specially made for children of his age, of a type still to be found today. A boy with a napkin is serving the meal: possibly a valet, possibly a relative given the task of waiting at table, a task which he would not in any way consider humiliating.

November: the father is old and ill, so ill that the doctor has been called in. The doctor, with a commonplace gesture which belongs to a traditional iconography, is examining the urinal.

December: the whole family is gathered together in the bedroom around the bed in which the father is dying. The last sacraments have been brought to him. His wife is kneeling at the foot of the bed. Behind her, a young woman on her knees is weeping. A young man is standing with a taper in his hand. In the background we can see a little child: no doubt the grandson, the next generation which will continue the family.

Thus this calendar likens the succession of the months of the year to that of the ages of life, but it depicts the ages of life in the form of the story of a family: the youth of its founders, their maturity with their children, old age, sickness, and a death which is both the good death, the death of the good man, another traditional theme, and also that of the patriarch in the midst of his family.

The story on this calendar begins like that of the family on the marriage capital in the Palace of the Doges. But it is not the son, the beloved child, that death takes too soon. Things follow a more natural course: it is the father who dies at the end of a full life, surrounded by a united family and doubtless leaving them a well-managed estate. The calendar illustrates a new concept: the concept of the family.

The appearance of the theme of the family in the iconography of the months was not an isolated incident. A massive evolution was to carry the whole iconography of the sixteenth and seventeenth centuries in this direction.

To begin with, scenes depicted by artists were set either in an indeterminate space, or in public places such as churches, or in the open air. In Gothic art, freed from Romano-Byzantine symbolism, open-air scenes become more common and more significant as a result of the invention of perspective and the fashion for landscape painting: a lady receives her knight in a walled garden; the chase passes through fields and forests; ladies meet to bathe in a garden pool; armies manoeuvre; knights meet in tournaments; the army is encamped round the tent in which the King is resting; armies lay siege to cities; princes enter and leave fortified towns to the acclamations of the people and burgesses. We go over bridges into these towns, passing stalls at which goldsmiths are working. We see wafer-vendors passing by, and heavily laden boats sailing downstream. We see games being played, still in the open air. We accompany tumblers or pilgrims along the road. The profane iconography of the Middle Ages is an open-air iconography. When, in the thirteenth or fourteenth century, the artists set out to illustrate particular anecdotes and incidents, they hesitate, and their naivety turns into clumsiness: they never achieve anything like the virtuosity of the anecdotal painters of the fifteenth and sixteenth centuries.

Before the fifteenth century, interior scenes are therefore extremely rare. But from that century on, they become increasingly common. The gospel-writer, hitherto placed in a timeless setting, becomes a scribe at his desk, with a quill and an erasing-knife in his hand. At first he is placed in front of an ordinary ornamental curtain, but finally he is shown in a room where there are shelves lined with books: we have come from the gospel-writer to the author in his room, to Froissart writing a dedication in a book. In the illustrations to the text of Terence in the Palace of the Doges, there are women working and spinning in their rooms with their maidservants, or lying in bed, not always by themselves. We are shown kitchens and inn rooms. Love scenes and conversations are henceforth set in the enclosed space of a room.

The theme of childbirth makes its appearance, the birth of the Virgin providing the pretext. Maidservants, old women and midwives are shown bustling round St Anne's bed. The theme of death appears too: death in the bedchamber, with the dying man fighting for his life.

The growing practice of depicting rooms corresponds to a new emotional tendency henceforth directed towards the intimacy of private life. Exterior scenes do not disappear – they develop into the landscape – but interior scenes become more common and more original, and they typify genre painting during the whole of its existence. Private life, thrust into the background in the Middle Ages, invades iconography,

particularly in Western painting and engraving in the sixteenth and above all in the seventeenth century: Dutch and Flemish painting and French engraving show the extraordinary strength of this hitherto inconsistent or neglected concept.

This copious illustration of private life can be divided into two categories: that of drinking and whoring on the fringe of society, in the shady world of the down-and-outs, in taverns and bivouacs, with gypsies and vagabonds – a category which does not concern us here – and its other face, that of family life. If we look through collections of prints and paintings of the sixteenth and seventeenth centuries, we cannot help being struck by the positive flood of pictures of families. This movement is at its height in painting in the first half of the seventeenth century in France, but during the whole century and beyond in Holland. In France it continues during the second half of the seventeenth century in engravings, gouaches and painted fans, reappears in the eighteenth century in painting, and lasts through the nineteenth century until the great aesthetic revolution which banishes the subject painting from art.

There is no counting the number of group-paintings in the sixteenth and seventeenth centuries. Some are portraits of guilds and corporations. But most of them show a family gathered together. We can see these family portraits beginning in the course of the fifteenth century, with donors who have themselves depicted on the ground floor of some religious scene, as a sign of their piety. They are discreet at first, and alone. Soon, however, they bring along the whole of their family, the living and the dead: wives and children who have died are given a place in the picture. On the one side are the man and his sons, on the other the wife or wives, each with the daughters of her bed.

The storey occupied by the donors spreads at the same time as it fills with people, to the detriment of the religious scene which soon becomes an illustration and almost an hors-d'oeuvre. More often than not it is reduced to the patron saints of the parents, the male saint on the men's side, the female saint on the women's. It is worth noting the importance assumed by the devotion to patron saints, who appear as protectors of the family: here we can see a sign of a private devotion of a family character, like the cult of the guardian angel, although this latter devotion is of a more personal character more closely linked with childhood.

This phase of the portrait of donors and their families can be illustrated with countless examples from the sixteenth century: for instance, the stained-glass windows of the Montmorency family at Montfort-L'Amaury, Montmorency and Écouen, or the pictures hung as *ex-votos* on the pillars and walls of German churches (several are still in position in the churches

of Nürnberg). Many other paintings, often naive and clumsy, are now in the regimental museums of Germany and German-speaking Switzerland. Holbein's pictures of families are faithful to this style.[5] It seems that the Germans remained attached longer than other nations to this form of religious family portrait intended for churches; it strikes us as a cheaper form of the donor's stained-glass window, an older type of gift; and it points the way to the more anecdotal and picturesque *ex-votos* of the eighteenth and early nineteenth centuries, which depict, not the family gathering of the living and the dead, but the miraculous event which has saved an individual or a member of a family from ship-wreck, accident or illness. The family portrait is also a sort of *ex-voto*.

English mortuary sculpture in the Elizabethan era offers another example of the family portrait intended as a form of devotion. But it should be added that this sculpture is an isolated phenomenon and is neither as frequent nor as commonplace in France, Germany or Italy. Many English tombs of the sixteenth and seventeenth centuries show the whole family in bas-relief or in the round, gathered around the deceased: the insistence on including all the children, living and dead, is extremely striking. Several of these tombs are still to be found in Westminster Abbey: for instance, that of Sir Richard Pecksall, who died in 1571 and is represented between his two wives, with four little figures – his daughters – sculpted on the base of the monument. On either side of the recumbent statue of Margaret Stuart, who died in 1578, are her sons and daughters. Over the tomb of another recumbent figure, that of Winifred, Marchioness of Winchester, who died in 1586, her husband watches; he is represented on a reduced scale, on his knees, with a tiny child's tomb beside him. Sir John and Lady Puckering, who died in 1596, are shown lying side by side, surrounded by their eight daughters. The Norrises (1601) are kneeling in the midst of their six sons. In 1634 the Duchess of Buckingham had a tomb erected for her husband, assassinated in 1628; husband and wife are represented as recumbent figures in the midst of their children.

At Holkham, there are twenty-one little figures on the tomb of John Coke (1639), lined up as in the portraits of donors, with those who are dead holding a cross in their hands. On the tomb of Cope d'Ayley at Hambledon (1633); the four boys and three girls are standing in front of their kneeling parents; one boy and one girl are holding death's-heads.

These German and English monuments prolong what are still medieval aspects of the family portrait. But in the sixteenth century the family portrait rid itself of its religious function. It was as if the ground floor in

5. Basle Museum.

the donors' pictures had invaded the entire canvas, banishing the religious picture, so that it either disappeared completely or lingered on in token form as a little pious picture hanging on the wall at the back of the painting. The *ex-voto* tradition is still present in a picture by Titian painted about 1560: the male members of the Cornaro family – an old man, a middle-aged man with a grey beard, a young man with a black beard (the beard, its shape and colour are indications of age) – and six children, of whom the youngest is playing with a dog, are grouped around an altar. At the Victoria and Albert Museum is a 1628 triptych showing a little boy and a little girl on the centre volet, and the parents on the two other volets. These pictures are no longer intended for churches: they are meant to adorn private homes, and this secularization of the portrait is undoubtedly a most important phenomenon – the family contemplates itself in the home of one of its members. The need is felt to fix the present condition of that family, sometimes also recalling the memory of the dead by means of a picture or an inscription on the wall.

These family portraits are extremely common, and no useful purpose would be served by recording them all. They are to be found in Flanders as well as in Italy, with Titian, Pordenone and Veronese; in France with Le Nain, Lebrun and Tournier; in England and Holland with Van Dyck. From the sixteenth to the early eighteenth century they must have been as common as individual portraits. It has often been said that the portrait reveals the progress of individualism. Perhaps it does; but above all else it renders the immense progress made by the concept of the family.

To begin with, the members of the family are arranged rather stiffly, as in the donors' pictures or in the engravings of the ages of life in *Le Grand Propriétaire* or the miniature in the Musée Saint-Raimond. Even when they are rather more lifelike, they pose in a solemn attitude intended to underline the bond joining them together. In a painting by P. Pourbus[6] the husband is resting his left hand on his wife's shoulder; at their feet, one of the two children is repeating the same gesture on his little sister's shoulder. Sebastian Leers has himself painted holding his wife by the hand.[7] In another painting by Titian three bearded men are standing around a child – who provides the only bright note in the midst of their black costumes – and one of them is pointing at the child, who is in the centre of the composition. However, many of these portraits make little or no attempt to give life to their characters: the members of the family are juxtaposed, and sometimes linked together by gestures expressing their reciprocal feelings, but they do not join in any common action. This is

6. 'Le portrait dans l'art flamand', Exhibition, Paris, 1952.
7. Titian, 'Sebastian Leers, his wife and son'.

the case with the Pordenone family in the Borghese gallery – the father, the mother and seven children[8] – and again with the Pembroke family as painted by Van Dyck: the Earl and Countess are seated, the other figures standing; on the right is a couple, probably one of the married children with husband or wife; on the left, two very stylish adolescents (stylishness is a sign of male adolescence: it disappears with age and gravity), a schoolboy with his book tucked under his arm, and two younger boys.

About the middle of the sixteenth century, artists began to depict the family around a table laden with fruit: the Van Berchaun family painted by Floris in 1561, or the Anselme family painted by Martin de Voos in 1577. Or the family may have stopped eating in order to make music : we know that this is no painter's trick, and that meals often ended with a concert or were interrupted by a song. The family posing for the artist, with varying degrees of affectation, remained in French art until the early eighteenth century at least, with Tournier and Largillière. But under the influence of the Dutch in particular, the family portrait was often treated as a subject painting: the concert after the meal is one of the favourite themes of Dutch painters. Henceforth the family was depicted as in a snapshot, at a moment in its everyday life: the men gathered round the fire, the women taking a cauldron off the fire, a girl feeding her little brother.[9] Henceforth it is difficult to tell a family portrait from a subject painting depicting family life.

During the first half of the seventeenth century, the old medieval allegories are also treated as illustrations of family life without regard for iconographic tradition. We have already seen what happened in the case of the calendars. The other classical allegories were altered in the same way. In the seventeenth century, the ages of life become pretexts for pictures of family life. In an Abraham Bosse engraving of the four ages of man, childhood is suggested by what we should call a nursery : a baby in a cradle, watched over by an attentive sister, a child in a robe who is kept on his feet by a sort of play-pen on wheels (a very common device between the fifteenth and eighteenth centuries), a little girl with her doll, a boy with a paper windmill, and two bigger boys – one of whom has thrown his hat and cloak on the floor – getting ready to fight. Manhood is illustrated by a meal which has brought the whole family together around the table, a scene similar to that in a great many portraits and which was often repeated in both French engraving and Dutch painting. This is the spirit of the engraving of the ages in *Le Grand Propriétaire* of

8. See note 6, p. 337.
9. e.g. P. Aertsen, mid-sixteenth century.

the mid-sixteenth century, and of the miniature in the Musée Saint-Raimond at Toulouse.

Manhood is always family life. Humbelot-Huart has not gathered the family round the dining-table but in the office of the father, a rich merchant whose premises are piled with bales of merchandise. The father is doing his accounts, pen in hand, with the help of his son who is standing behind him; at his side his wife is attending to their little daughter; a young servant, who has probably been to their country house, is coming in with a basket of foodstuffs.[10] In the late seventeenth century an engraving by F. Guérard takes up the same theme. The father – a younger man than in the Humbelot-Huart engraving – is pointing out of the window at the port, the wharf and the ships, the source of his fortune. Inside the room, near the table on which he does his accounts and on which his purse, some counters and an abacus are to be seen, his wife is rocking a baby in swaddling-clothes and watching another child in a robe. The caption gives the tone and stresses the spirit of this iconography: 'Happy is he who obeys the laws of Heaven and devotes the best years of his life to serving God, his family and his King.' Here the family is put on the same level as God and the King. This attitude does not surprise us in the twentieth century, but it was new at the time and its expression cannot but astonish us. Humbelot treats the same theme in another picture, where he depicts a young woman showing her breast to a child who has climbed up behind her: we must remember that in the seventeenth century children were weaned very late. Or else, this time in another Guérard engraving, we see the mistress of the house, with her keys and her children, giving orders to a maid-servant.[11]

The other allegories are also depicted by family scenes. The sense of smell, in an early seventeenth-century Dutch treatment of the five senses, is represented by the henceforth commonplace scene of the mother wiping the naked child's bottom.[12]

Abraham Bosse also symbolizes one of the four elements by a picture of family life: in a garden, a nanny is holding a child in a robe; the child's parents, gazing at him tenderly from the door of the house, are playfully tossing fruit to him – the fruits of the earth.

Even the Beatitudes give rise to evocations of family life: with Bonnart-Sandrart the Fifth Beatitude has become a mother's forgiveness of her children, a forgiveness which she confirms by offering them

10. Cabinet des Estampes.
11. Cabinet des Estampes.
12. David Ryckaert (1586–1642), Geneva Museum.

sweets: this is already the sentimental family spirit of the nineteenth century.

Broadly speaking, the modern subject painting began with the illustration of traditional medieval allegories. But the distance is too great between the old theme and its new expression. We forget the allegory of the seasons and of winter when we look at Stella's picture of an evening by the fire, with the men having supper on the one side of the big room, and on the other, around the hearth, the women spinning and plaiting rushes, the children playing or being washed. Instead of winter, we have an evening by the fire; instead of manhood or the third age of life, we have a family gathering. An original iconography has been born. The concept of the family is its basic inspiration, an inspiration very different from that of the old allegories. It would be a simple matter to draw up a list of the subjects repeated *ad nauseam*: the mother watching over the child in the cradle or feeding it at her breast;[13] the woman washing the child; the mother picking the lice out of her child's hair (an extremely commonplace operation and moreover one which was not confined to children: Samuel Pepys submitted to it);[14] the child in the cradle, with his little brother or his little sister standing on tiptoe in order to see him; the child in the kitchen or the store-room with a valet or a maidservant; or the child going shopping. This last subject, a common one in Dutch painting, was also treated by French engravers – in the middle of the century by Abraham Bosse (at the pastrycook's), and at the end of the century by Le Camus (at the wine merchant's). A painting by Le Nain depicts a tired peasant who has fallen asleep. His wife is hushing the two children, showing them their father, who is resting and must not be awakened: this is already a Greuze, not in its painting or style of course, but in its sentimental inspiration. The action is centred on the child. In a picture by Peter de Hooch the family is gathered together for breakfast, and the father is sitting drinking. A little child of about two is standing on a chair; he is wearing the round, padded hat which was normally worn at that time at the age when a child was not too steady on his feet, to protect him if he fell. A women (the maidservant?) is holding him up with one hand and with the other is offering a glass of wine to another woman (the mother?) who is dipping a biscuit in it. She is going to give the sodden biscuit to the parrot to amuse the child, and the entertainment of the child in the midst of the family whose unity he

13. e.g. Fragonard, engraving, Exhibition, Berne, 1954; Berey, engraving, Cabinet des Estampes; Stella, 'L'hiver', engraving, Cabinet des Estampes; Crispin de Pas, Cabinet des Estampes.

14. Dassonville, engraving, Cabinet des Estampes.

thereby ensures is the painter's real subject, the meaning of his anecdote.

The concept of the family, which thus emerges in the sixteenth and seventeenth centuries, is inseparable from the concept of childhood. The interest taken in childhood, which we have analysed at the beginning of this book, is only one form, one particular expression of this more general concept – that of the family.

An analysis of iconography leads us to conclude that the concept of the family was unknown in the Middle Ages, that it originated in the fifteenth and sixteenth centuries, and that it reached its full expression in the seventeenth century. It is tempting to compare this hypothesis with the observations of the historians of medieval society.

The basic idea of the historians of law and society is that the ties of blood composed not one but two groups, distinct though concentric: the family or *mesnie* which can be compared with our modern conjugal family, and the line which extended its solidarity to all the descendants of a single ancestor. In their opinion, there was not so much a distinction as an opposition between the family and the line, the progress of the one resulting in a weakening of the other, at least in the nobility. The family or *mesnie*, though it never embraced a whole line, contained, among the members who lived together, several elements, and sometimes several households: these lived on an estate which they had been reluctant to divide, in accordance with a method of possession known as *frereche* or *fraternitas*. The *frereche* grouped around the parents those of their children who had no property of their own, together with nephews and bachelor cousins. This tendency to joint possession in the family, a tendency which scarcely ever lasted more than a couple of generations, gave rise to the traditional nineteenth-century theories on the great patriarchal family.

The modern conjugal family is thus considered to be the consequence of an evolution which, at the end of the Middle Ages, is supposed to have weakened the line and the tendency to joint possession.

In reality, the story of the relations between line and family is more complicated than that. It has been traced by Georges Duby (1953) in the Mâcon country, from the ninth century to the thirteenth century inclusive.

In the Frank state, writes Duby, 'the family in the tenth century was to all appearances a community reduced to its simplest expression, the conjugal cell, whose cohesion was sometimes prolonged for a little while after the death of the parents, in the *frereches*. But the ties were very loose. This is because they were useless: the peaceful organs of the old Frank state were still strong enough to allow a freeman to live an independent

life and to prefer, if he so wished, the company of his friends and neighbours to that of his relatives.'

However, lineal solidarity and joint possession developed as the result of the dissolution of the State: 'After the year 1000, the new division of powers obliged men to group themselves together more closely.' The tightening of the ties of blood which took place then satisfied a desire for protection, like those other forms of human relationship and subjection: the vassal homage, the seigniory, the village community. 'Too independent, and ill protected against certain dangers, the knights sought refuge in lineal solidarity.'

At the same time, in the eleventh and twelfth centuries in the Mâcon country, we can note an advance made by joint ownership. It was this period which saw the institution of joint ownership of the goods of husband and wife; in the tenth century, husband and wife had managed their own property, buying and selling separately without the other being able to interfere.

Joint ownership was also extended more often than not to the children, who were prevented from obtaining any advance on their inheritance: 'There was a prolonged integration into the family home, and under the ancestor's authority, of descendants destitute of all personal wealth and of all economic independence.' Joint ownership often continued after the death of the parents: 'It is necessary to try to imagine what a knight's house was like in those days, gathering together on a single domain, in a single "court", ten or twenty masters, two or three couples with the children, the brothers and the unmarried sisters, and the canon uncle who dropped in now and then and who was looking after the career of some nephew.' The *frereche* rarely lasted beyond the second generation, but even after the *divisio* of the estate, the line retained a collective right over the divided estate: the *laudatio parentum*, the lineal redemption.

This description applies above all to the knightly family, which could already be called the noble family. Duby assumes that the peasant family did not experience this tightening of the ties of blood to the same extent because the peasants had filled in a different way from the nobles the vacuum left by the dissolution of the Frank state: the seignior's tutelage had immediately taken the place of that of the public authorities, and the village community had soon provided the peasants with a framework of organization and defence superior to the family. The village community was to the peasants what the line was to the nobles.

In the course of the thirteenth century, the situation changed again. The new forms of monetary economy, the extension of personalty, the frequency of financial transactions, and at the same time the increase in

the authority of the prince (whether he was a Capetian king or the head of a large principality) and in public security, brought about a tightening of lineal solidarity and the abandonment of joint ownership. The conjugal family became independent once more. However, in the nobility, there was no return to the loose links of the tenth-century family. The father maintained and even increased the authority which he had been given in the eleventh and twelfth centuries by the need to maintain the integrity of the undivided estate. We know too that from the end of the Middle Ages on, the power of the wife steadily diminished. It was also in the thirteenth century, in the Mâcon country, that the law of primogeniture spread among the families of the nobility. It took the place of joint ownership, which became much rarer, as a means of safeguarding the inheritance and its integrity. The substitution of the law of primogeniture for joint ownership and the joint estate of husband and wife can be seen as a sign of the recognition of the importance both of paternal authority and of the place assumed in everyday life by the group of the father and children.

Duby concludes: 'In fact, the family is the first refuge in which the threatened individual takes shelter when the authority of the State weakens. But as soon as political institutions afford him adequate guarantees, he shakes off the constraint of the family and the ties of blood are loosened. The history of lineage is a succession of contractions and relaxations whose rhythm follows the modifications of the political order.'

The contrast between the family and the line is less marked in Duby's writing than in that of other legal historians. It is not so much a question of a progressive substitution of the family for the line – this would seem indeed to be a purely theoretical view – as of the loosening or tightening of the ties of blood, now extended to the whole line or to the members of the *frereche*, now restricted to the couple. One has the impression that only the line was capable of exciting the forces of feeling and imagination. That is why so many romances of chivalry treat of it. The restricted family community, on the other hand, had an obscure life which has escaped the attention of the historians. But this obscurity is understandable. In the domain of feeling, the family did not count as much as the line. One might say that the concept of the line was the only concept of a family character known to the Middle Ages. It was very different from the concept of the family such as we have seen it in the iconography of the sixteenth and seventeenth centuries. It extended to the ties of blood without regard to the emotions engendered by cohabitation and intimacy. The line was never gathered together within a small space, around a single courtyard. It was not to be compared with the Serbian Zadrouga.

The legal historians recognize that there are no traces of any great peaceful communities in France before the fifteenth century.

But from the fourteenth century on, we see the modern family taking shape. The process, the history of which is well known, has been clearly summarized by M. Petiot (1955): 'Starting in the fourteenth century, we see a slow and steady deterioration of the wife's position in the household. She loses the right to take the place of the husband in his absence or insanity ... Finally, in the sixteenth century, the married woman is placed under a disability so that any acts she performs without the authority of her husband or the law are null and void. This development strengthens the powers of the husband, who is finally established as a sort of domestic monarch.' 'Royal legislation from the sixteenth century on took care to strengthen the father's power with regard to the marriage of his children.' 'While lineal ties weakened, the husband's authority in the home became stronger, and his wife and children were more rigorously subject to it. This dual movement, in so far as it was the unconscious and spontaneous work of custom, undoubtedly reveals a change in social manners and conditions ...' Henceforth a value was attributed to the family which had previously been attributed to the line. It became the social cell, the basis of the State, the foundation of the monarchy. We shall now see what importance the Church attributed to it.

The medieval glorification of the line, its honour, and the solidarity between its members, was a specifically lay attitude which the Church distrusted or ignored. The pagan naturalism of the ties of blood may well have been repugnant to it. In France, where it accepted the heredity of the kings, it is significant that it made no mention of that heredity in the coronation liturgy.

Moreover the Middle Ages did not know the modern principle of the sanctification of lay life, or rather it recognized it only in exceptional cases: the holy king (but the king was consecrated), the good knight (but the knight had been initiated after what had become a religious ceremony). The sacrament of marriage could have ennobled the conjugal union and given it a spiritual value, as also to the family. In fact it simply made the union legitimate. For a long time marriage remained simply a contract. The ceremony, if we are to go by the sculptured representations of it, did not take place inside the church, but in front of the porch. Whatever the theological point of view, most priests, considering their flocks, must have shared the opinion of Chaucer's priest in 'The Parson's Tale' that marriage was a concession to the weakness of the flesh. It did not cleanse sexuality of its essential impurity. Admittedly the priests did not go to the lengths of condemning marriage and the family after the

fashion of the Cathars of the south of France, but they showed suspicion and distrust of anything to do with the flesh. It was not in lay life that man could attain to holiness; sexual union, when blessed by marriage, ceased to be a sin, but that was all. What is more, the other great sin of the laity, the sin of usury, threatened a man in his temporal activities. The only way by which the layman could make sure of salvation was to leave the world completely and enter religious life. In the quiet of the cloister, he could atone for the faults of his profane past.

It was not until the end of the sixteenth century, the time of St François de Sales's *Philothée*, or the seventeenth century, with the example of the gentlemen of Port-Royal – and more generally of all the laymen engaged in religious, theological, spiritual and mystical activities – that the Church recognized the possibility of sanctification outside the religious vocation, in the practice of one's profession.

For a natural institution so closely linked with the flesh as the family was, to become the object of a cult, this rehabilitation of the lay condition was necessary. The progress of the concept of the family and of the religious rehabilitation of the layman followed parallel paths. For the modern concept of the family, unlike the medieval concept of the line, became an object of common piety. The first sign of this piety, as yet very discreet, is to be seen in the practice begun by donors of religious pictures or stained-glass windows – the donors grouped their families around them. Piety may also be discerned in the later custom of associating the family with the cult of the patron saint. In the sixteenth century, it was a common practice to offer as an *ex-voto* a picture of the patron saints of husband and wife, surrounded by the parents themselves and their children. The cult of the patron saints became a family cult.

The influence of the concept of the family is also to be seen, especially in the seventeenth century, in the new way of depicting a marriage or a christening. At the end of the Middle Ages, the miniaturists used to depict the religious ceremony itself, as it took place at the church door. Take for instance the marriage of King Cosius and Queen Sabineda in the life of St Catherine, where the priest is shown folding his stole round the hands of the newly-married couple; or the marriage of Philip of Macedonia depicted by the same Guillaume Vrelant in the story of King Alexander, where behind the priest, on the tympanum of the church door, one can see a sculpted representation of a husband beating his wife! In the sixteenth and seventeenth centuries, the marriage ceremony was no longer depicted, except in the case of kings and princes. Instead, artists chose to treat the incidental, family aspects of the wedding, with relatives, friends and neighbours gathered round the bride and groom.

With Gérard David ('The Wedding at Cana' in the Louvre) we have the wedding feast. Elsewhere we have the wedding procession: thus Stella shows us the bride on her father's arm, followed by a group of children, on her way to the church outside which the groom is waiting. In a picture by Molinier the ceremony is over and the procession is leaving the church: on the left is the groom with his groomsmen, on the right is the bride wearing a wreath (but not yet in white: the colour of love was still red, as for the priest's vestments), in the midst of her bridesmaids, with a bagpipe playing and a little girl throwing coins in front of the bride.[15] Albums of engravings of clothes of the late sixteenth or the early seventeenth century often show the bride or bridegroom with bridesmaids or groomsmen: at that time the wedding-dress became more specific (though it was not yet the white uniform worn from the nineteenth century to the present day), at least in certain details. Care was taken to present these details as characteristic of the manners of a certain region. Finally, all the licentious little scenes of folklore entered iconography – e.g. the first night of the newly-married pair.

Similarly, when it came to depicting a christening, artists preferred the traditional gatherings at home: the guests having a drink on their return from the church, with a boy playing the flute, or neighbours calling on the young mother. Or else they depicted traditional customs which are harder to identify, as in the picture by Molenaer of a woman holding a child in the midst of great ribaldry, with all the ladies present covering their heads with their dresses.

It would be wrong to interpret this taste for social or traditional festivities, from which licentiousness was not absent any more than it was from the language of respectable people, as a sign of religious indifference: the stress was simply laid on the family, social character of the occasion rather than its sacramental character. In the northern countries where the family themes were extremely widespread, a highly significant painting by Steen, 'La Saint-Nicolas', shows us the new family interpretation of folklore or traditional piety. We have already had occasion to stress the importance, in life under the ancien regime, of the great collective festivities: we have shown the part played in them by children, mingling with adults; the whole of a heterogeneous society was gathered together on these occasions, and happy to be together. But the festival pictured by Steen is no longer one of those festivals of youth, in which the children behaved rather like slaves on the day of the Saturnalia, in which they played a part fixed by tradition in the company of adults. Here, on the contrary, the grown-ups have organized the occasion to

15. Geneva Museum.

entertain the children: it is the feast of St Nicholas, the ancestor of 'Santa Claus'. Steen catches the moment when the parents are helping the children to find the toys which they have hidden all over the house for them. Some of the children have already found their toys. Some little girls are holding dolls. Others are carrying buckets full of toys. There are some shoes lying about: perhaps it was already customary to hide toys in shoes, those shoes which children of the nineteenth and twentieth centuries, in some countries, put in front of the fire on Christmas Eve? This is no longer a great collective festival, but a quiet family celebration; and consequently this concentration on the family is continued by a concentration of the family around the children. Family feasts became children's feasts. Nowadays, Christmas has become the biggest, one might almost say the only, feast in the year, common to believers and unbelievers alike. It was not as important as this under the ancien regime, when it suffered from the competition of Twelfth Night, following shortly after it. But the extraordinary success enjoyed by Christmas in contemporary industrial societies, which feel an increasing dislike for the great collective festivals, is due to the family character which its association with the feast of St Nicholas has won it: Steen's painting shows us that in seventeenth-century Holland the feast of St Nicholas was already celebrated as the feast of 'Santa Claus' or 'Father Christmas' is celebrated in Western countries today, with the same modern feeling for childhood and the family, for childhood in the family.

A new theme illustrates in even more significant fashion the religious constituent of the concept of the family: the theme of grace. For a long time past, 'courtesy' had demanded that in the absence of a priest, a young boy should bless the table at the beginning of a meal. Some manuscript texts of the fifteenth century, published by F. J. Furnivall in a collection called *The Babees Book*, lay down very strict rules for behaviour at table – 'the conventions of the table', 'the way to behave at table' – and instruct the child to say grace without any hesitation if given authority to do so by a priest or lord. The manuals of etiquette of the sixteenth century allot the task of saying grace, not to any of the children at table, but to the youngest. Mathurin Cordier's manual establishes this rule, which is maintained in later, revised editions; thus a mid-eighteenth century edition still stipulates that the duty of blessing the table 'falls to the ecclesiastics, if there are any, or, in their absence, to the youngest of the company'. 'Once he has finished serving the meal,' we read in *La civilité nouvelle* of 1671, 'it is a true and excellent courtesy to bow to the company and then say grace.' And in *Les Règles de la bienséance et de la civilité chrétienne* of St Jean-Baptiste de La Salle:

'When there is a child present, he is often instructed to perform this function' (that of saying grace). Vivès in his dialogues describes a big meal: 'The master of the house, as was his right, allotted the places. The prayer was said by *a little child*, briefly, quaintly, and in verse.'

Thus it was no longer a young boy in the company but the smallest child in the house who was given the honour of saying grace. We can see here a sign of the added attention given to childhood in the sixteenth century, but what is really important is that the child should be associated with the principal family prayer, for a long time the only prayer recited in common by the whole family gathered together. In this respect extracts from manuals of etiquette are less revealing than iconography. From the end of the sixteenth century on, the saying of grace becomes one of the most common themes of the new iconography which we have tried to distinguish. Take the engraving by Mérian for example.[16] Is is a portrait of a family at table, faithful to what is already an old convention: the father and mother sitting in two armchairs, their five children around them. A maidservant is bringing in a dish, and an open door reveals the kitchen beyond. But the engraver has caught the moment when a little boy in a robe, resting his arms on his mother's knees, his hands folded in prayer, is saying grace: the rest of the family are listening to the prayer with their heads uncovered and their hands folded.

An engraving by Abraham Bosse shows the same scene in a Protestant family.[17] Antoine Le Nain in 'Bénédicité' depicts a woman and three children at table: one of the boys is standing saying grace. Lebrun treats the subject in the old-fashioned style, with a Holy Family. The table is laid; the father, a bearded man with a traveller's staff in his hand, is standing. The mother, who is seated, is looking affectionately at the child who, his hands folded, is reciting the prayer. This picture obtained wide circulation as a devotional image.[18]

It is only to be expected that we should find this theme in seventeenth-century Dutch painting. In a picture by Steen, the father is the only person seated: an old country custom, which had long since been dropped by the French middle class. The mother is serving him, and also the two children who are remaining standing: the smaller, aged between two and three, has folded his hands, and is saying grace. In a similar picture of Heemskerck, two old men, who are seated, and a younger man, who is standing, are all at table, as well as a woman who is sitting with her hands folded: next to her a little girl is repeating the

16. Merian, engraving, Cabinet des Estampes.
17. A. Bosse, engraving, Cabinet des Estampes.
18. Lebrun, 'Bénédicité', Louvre.

prayer which she is reading on her mother's lips. It is the same theme again that we meet in the eighteenth century, in Chardin's famous 'Bénédicité'.

Artists were fond of depicting the scene of a child saying grace because they recognized a new significance in this hitherto commonplace prayer. The iconographic theme evoked and associated in a synthesis three emotional forces: piety, the concept of childhood (the smallest child), and the concept of the family (the gathering at table). Grace had become the model for the family prayer. Formerly there had been no private religious worship. The etiquette manuals mention the morning prayer (in the colleges the boarders said it together after washing). They already say less about the evening prayer. They lay greater stress on the children's duties to their parents (the oldest rules of courtesy of the fifteenth century did not speak of children's duties to their parents but to their masters). 'Children', says Jean-Baptiste de la Salle, 'must not go to bed before bidding their father and mother goodnight.' Courtin's manual of etiquette of 1671 brings the child's evening to a close in this way: 'He shall recite his lessons, bid his parents and masters goodnight, relieve himself, and finally, having undressed, lie down in bed to sleep.

Worship conducted privately by each family developed to considerable proportions in Protestant circles: in France, especially after the revocation of the Edict of Nantes, it took the place of public worship to such an extent that after the restoration of liberty, the pastors of the late eighteenth century found it difficult to bring back to public worship people who had become accustomed to make do with family prayers. Hogarth's famous caricature shows that in the eighteenth century the evening prayer said in common – a prayer which gathered together around the father of the family his relatives and servants – had become conventional and commonplace. It seems probable that Catholic families followed an almost parallel course, that they too felt the need for a piety which was neither public nor entirely individual: a family piety.

We described just now Lebrun's 'Bénédicité', popularized by Sarrabat's engraving: it was immediately recognized that this scene of the saying of grace was also a picture of the Holy Family, showing the prayer and meal of the Virgin, St Joseph and the Infant Jesus. Lebrun's picture belongs to two series of pictures, both equally popular at the time because both glorified the same concept. As V. L. Tapié has pointed out (1957): 'It was without a shadow of doubt the very principle of the family which was linked with this homage to the Holy Family.' Every family was urged to regard the Holy Family as its model. Thus the traditional iconography altered under the same influence that increased paternal authority: St

Joseph no longer plays the minor role in it which was still his in the fifteenth and early sixteenth centuries. He appears in the foreground, as the head of the family, in another picture of the Holy Family at table, which was likewise given wide circulation by engraving. 'The Virgin, St Joseph and the Infant Jesus,' comments Émile Mâle, 'are having their evening meal: a candle on the table is creating a startling contrast between light and deep shadow, and lending the scene an appearance of mystery; St Joseph is giving a drink to the Infant Jesus, who with a napkin round his neck looks as good as gold.' Or there is the theme which Mâle calls 'The Holy Family on the road', in which the Infant Jesus is between Mary and Joseph.

St Joseph's authority is to be noted in many scenes: in a picture by a Neapolitan painter of the seventeenth century, Paccaco di Rosa, he is carrying the Infant Jesus in his arms and thus occupies the centre of the picture; this scene was a common subject for Murillo and Guido Reni as well. Sometimes Joseph is shown working in his carpenter's workshop, helped by Jesus.[19]

Head of the family at table during mealtimes, and in the workshop during working hours, St Joseph is still head of the family at that other dramatic moment in family life, the moment when death strikes him down. St Joseph, becoming the patron saint of the good death, keeps his wits about him: the picture of his death resembles that of the father's death so often used in illustrations of the good death; it belongs to the same iconography of the new family.

The other holy families inspire the same feeling. In the sixteenth century in particular, artists were fond of showing Christ's contemporaries as children all playing together. A German tapestry of great charm shows the three Marys surrounded by their children, who are frolicking about, bathing, and generally enjoying themselves. This group frequently recurs, notably in a fine wood-carving of the early seventeenth century at Notre-Dame La Grande at Poitiers.

The theme is obviously linked with the concept of childhood and the concept of the family. This link is heavily stressed in the baroque decoration of the Lady Chapel in the Franciscan church at Lucerne. This decoration is dated 1723. The ceiling is adorned with little angels, all very decently dressed, and each carrying one of the Virgin's symbols listed in her litanies (star of the sea, etc.). On the side walls, holy parents and children, all life-size, are holding hands; St John the Evangelist and Mary Salome, St James the Elder and Zebediah, and others.

Subjects from the Old Testament are also used to illustrate this

19. e.g. Rembrandt's 'Carpenter'.

devotion. The Venetian painter Carlo Loth treats the blessing of Joseph by Jacob like the scene, very common in the ages of life, of the old man waiting for death in the midst of his children. But it is Adam's family above all which has been treated on the pattern of a holy family. In 'The Family of Adam' by Veronese, Adam and Eve are standing in the court-yard of their house, surrounded by their animals and their children Cain and Abel. One of the children is feeding at his mother's breast; the other, who is smaller, is crawling about on the ground. Adam, hiding behind a tree so as not to disturb these antics, is looking on. He is seen from behind. It is doubtless true that one can discover a theological intention in this family of the 'first Adam', who heralds the coming of the 'second Adam', Christ. But this learned intention is hidden behind a scene which evokes the now consecrated joys of family life.[20]

We find the same theme in the convent of San Martino in Naples, on a ceiling of a later date, probably the early eighteenth century. Adam is digging (just as Joseph works wood), Eve is spinning (just as the Virgin sometimes sews), and their two children are with them.

Thus iconography enables us to follow the rise of a new concept: the concept of the family. The concept is new but not the family, although the latter doubtless did not play the primordial part in early times which Fustel de Coulanges and his contemporaries attributed to it. M. Jean-maire has noted what are still important relics in Greece of non-family structures such as age groups. The ethnologists have shown the impor-tance of age groups among the Africans, and of clan communities among the American natives. Are not we ourselves unconsciously impressed by the part the family has played in our society for several centuries, and are we not tempted to exaggerate its scope and even to attribute to it an almost absolute sort of historical authority? Yet there is no doubt that the family was constantly maintained and reinforced by influences at once Semitic (and not simply Biblical, in my opinion) and Roman. It may be that the family was weakened at the time of the Germanic invasions, yet it would be vain to deny the existence of a family life in the Middle Ages. But the family existed in silence: it did not awaken feelings strong enough to inspire poet or artist. We must recognize the importance of this silence: not much value was placed on the family. Similarly we must admit the significance of the iconographic blossoming which after the fifteenth and especially the sixteenth century followed this long period of obscurity: the birth and development of the concept of the family.

This powerful concept was formed around the conjugal family, that of the parents and children. This concept is closely linked to that of

20. Venice, Palace of the Doges.

childhood. It has less and less to do with problems such as the honour of
a line, the integrity of an inheritance, or the age and permanence of a
name: it springs simply from the unique relationship between the
parents and their children. In the seventeenth century people thought
that St Joseph resembled his adopted son, thus stressing the importance
of the family bond. Erasmus had already had the very modern idea that
children united the family and that their physical resemblance produced
this close union; his treatise on marriage was reissued in the eighteenth
century – that work in which he had written: 'One cannot admire too
greatly the astonishing pains taken by Nature in this respect; she depicts
two persons in a single face and a single body; the husband recognizes the
portrait of his wife in his children, and the wife that of her husband.
Sometimes one can also discover the likeness of a grandfather or a grand-
mother, a great-uncle or a great-aunt.' What counted most of all was the
emotion aroused by the child, the living image of his parents.

Chapter 15
From the Medieval Family
to the Modern Family

The preceding analysis of iconography has shown us the new importance assumed by the family in the sixteenth and seventeenth centuries. It is significant that in the same period important changes can be noted in the family's attitude to the child; as the attitude towards the child changed, so did the family itself.

An Italian text of the late fifteenth century gives us an extremely thought-provoking impression of the medieval family, at least in England. It is taken from an account of England by an Italian republished in 1897: 'The want of affection in the English is strongly manifested towards their children; for after having kept them at home till they arrive at the age of seven or nine years at the utmost [in the old French authors, seven is given as the age when the boys leave the care of the womenfolk to go to school or to enter the adult world], they put them out, both males and females, to hard service in the houses of other people, binding them generally for another seven or nine years [i.e. until they are between fourteen and eighteen]. And these are called apprentices, and during that time they perform all the most menial offices; and few are born who are exempted from this fate, for everyone, however rich he may be, sends away his children into the houses of others, whilst he, in return, receives those of strangers into his own.' The Italian considers this custom cruel, which suggests that it was unknown or had been forgotten in his country. He insinuates that the English took in other people's children because they thought that in that way they would obtain better service than they would from their own offspring. In fact the explanation which the English themselves gave to the Italian observer was probably the real one: 'In order that their children might learn better manners.'

This way of life was probably common in the West during the Middle Ages. Thus a twelfth-century Mâcon knight called Guigonet, whose family Georges Duby was able to describe from a study of his will, entrusted his two young sons to the eldest of his three brothers. At a later date, numerous articles of apprenticeship hiring children to masters prove how widespread was the custom of placing children in other families. It is sometimes specifically stated that the master must 'teach' the

child and 'show him the details of his merchandise' or that he must 'send him to school'. But these are exceptional cases. As a general rule, the principal duty of a child entrusted to a master is to 'serve him well and truly.' Looking at these contracts without first of all ridding ourselves of our modern habits of thought, we find it difficult to decide whether the child has been placed as an apprentice (in the modern meaning of the word), or as a boarder, or as a servant. We should be foolish to press the point: our distinctions are anachronistic, and a man of the Middle Ages would see nothing in them but slight variations on a basic idea – that of service. The only type of service which people could think of for a long time, domestic service, brought no degradation and aroused no repugnance. In the fifteenth century there was an entire literature in the vernacular, French or English, listing in a mnemonic verse form the rules for a good servant. One of these poems is entitled in French: 'Régime pour tous serviteurs'. The English equivalent is 'wayting servant' – which has remained in modern English with the word 'waiter'. True, this servant must know how to wait at table, make beds, accompany his master, and so on. But this domestic service goes with what we would nowadays call a secretary's duties: and it is not a permanent condition, but a period of apprenticeship, an intermediary stage.

Thus domestic service was confused with apprenticeship as a very general form of education. The child learnt by practice, and this practice did not stop at the frontiers of a profession, all the more so in that at that time and for a long time afterwards there were no frontiers between professional and private life; sharing professional life – an anachronistic expression in any case – meant sharing the private life with which it was confused. It was by means of domestic service that the master transmitted to a child, and not his child but another man's, the knowledge, practical experience, and human worth which he was supposed to possess.

All education was carried out by means of apprenticeship, and a much wider meaning was given to this idea than that which it took on later. Children were not kept at home: they were sent to another house, with or without a contract, to live there and start their life there, or to learn the good manners of a knight, or a trade, or even to go to school and learn Latin. In this apprenticeship we see a custom common to all classes of society. We have noted an ambiguity between the valet and the superior secretary-companion. A similar ambiguity existed between the child – or the very young man – and the servant. The English collections of didactic poems which taught manners to the servants were called 'babees books'. The word 'valet' meant a young boy, and Louis XIII as a child would say in an outburst of affection that he would like to be

'Papa's little valet'. The word *garçon* denoted both a very young man and a young servant in the language of sixteenth- and seventeenth-century France: the French have kept it to summon café waiters. Even when, in the fifteenth and sixteenth centuries, people began to establish distinctions within domestic service, between subordinate services and nobler offices, it still fell to the boys of good families – and not to the paid servants – to wait at table. To appear well-bred it was not enough, as it is today, to know how to behave at table: one also had to know how to wait at table. Until the eighteenth century, waiting at table occupied an important place in the manuals of etiquette and treatises on good manners: a whole chapter in Jean-Baptiste de La Salle's *Civilité chrétienne*, one of the most popular books of the eighteenth century. It was a survival from the time when all domestic services were performed indiscriminately by children whom we shall call apprentices and by paid help who were probably also very young. The distinction between these two categories was established very gradually. The servant was a child, a big child, whether he was occupying his position for a limited period in order to share in the family's life and thus initiate himself into adult life, or whether he had no hope of ever becoming a master.

There was no room for the school in this transmission by direct apprenticeship from one generation to another. In fact, the school, the Latin school, which was intended solely for clerics, gives the impression of being an isolated and special case. It would be a mistake to describe medieval education in terms of the school: this would be to make a rule of an exception. The general rule for everybody was apprenticeship. Even the clerics who were sent to school were often lodged, like the other apprentices, with a cleric, a priest, sometimes a prelate, whose servants they became. Service was as much part of a cleric's education as school. For the poorer students it was replaced by college scholarships: we have seen that these foundations were the origin of the colleges of the ancien regime.

There were cases where apprenticeship lost its empirical character and took a more pedagogical form. A curious example of technical tuition originating in a traditional apprenticeship is given in a book that describes schools of hunting at the court of Gaston Phoebus, where pupils were taught 'the manners and conditions necessary to him who wishes to learn to be a good hunter'. This fifteenth-century manuscript is illustrated by some very fine miniatures. One of them shows an actual class: the master, a nobleman so his dress indicates, has his right arm raised, his index finger levelled – a gesture punctuating a speech. In his left hand he is waving a stick, the indisputable sign of professorial authority, the instrument of

correction. Three pupils, boys who are not very tall, are reading the big scrolls which they are holding in their hands and which they have to learn by heart: this is a school like any other. In the background, some old huntsmen are looking on. A similar scene shows a lesson in horn-blowing: 'How to halloo and sound the horn'. These were things learnt by practice, like riding, fencing and courtly manners. It may be that certain forms of technical education – tuition in writing for instance – developed from an apprenticeship which had already been organized on a scholastic pattern.

However, these cases remained exceptional. Generally speaking, trans-mission from one generation to the next was ensured by the everyday participation of children in adult life. This explains the mingling of chil-dren and adults which we have seen so often in the course of this study, even in the classes of the colleges, where one would have expected to find a more homogeneous distribution of the ages. Everyday life constantly brought together children and adults in trade and craft, as in the case of the little apprentice mixing the painter's colours;[1] Stradan's engravings of trades and crafts show us children in the workshops with older com-panions. The same was true of the army. We know cases of soldiers of fourteen; but the little page holding the Duc de Lesdiguières's gauntlet,[2] and those carrying Adolf de Wignacourt's helmet in the Caravaggio in the Louvre, or General del Vastone's in the great Titian in the Prado, are not very old either: their heads do not come up to their masters' shoul-ders. In short, wherever people worked, and also wherever they amused themselves, even in taverns of ill repute, children were mingled with adults. In this way they learnt the art of living from everyday contact. The social groups corresponded to vertical partitions which brought together different age groups.

In these circumstances, the child soon escaped from his own family, even if he later returned to it when he had grown up. Thus the family at that time was unable to nourish a profound existential attitude between parents and children. This did not mean that the parents did not love their children, but they cared about them less for themselves, for the affection they felt for them, than for the contribution those children could make to the common task. The family was a moral and social, rather than a sentimental, reality. In the case of very poor families, it corresponded to nothing more than the material installation of the couple in the midst of a bigger environment – the village, the farm, the 'court-yard' or the 'house' of the lord and master where these poor people spent

1. Conrad Manuel, Berne Museum.
2. Grenoble Museum.

more time than in their own homes (and sometimes they did not even have a home of their own but rather led a vagabond life); among the prosperous, the family was identified with the prosperity of the estate, the honour of the name. The family scarcely had a sentimental existence at all among the poor; and where there was wealth and ambition, the sentimental concept of the family was inspired by that which the old lineal relationships had produced.

Starting in the fifteenth century, the reality and the idea of the family were to change: a slow and profound revolution, scarcely distinguished by either contemporary observers or later historians, and difficult to recognize. And yet the essential event is quite obvious: the extension of school education. We have seen how in the Middle Ages children's education was ensured by apprenticeship to adults, and that after the age of seven, children lived in families other than their own. Henceforth, on the contrary, education became increasingly a matter for the school. The school ceased to be confined to clerics and became the normal instrument of social initiation, of progress from childhood to manhood. This evolution corresponded to the pedagogues' desire for moral severity, to a concern to isolate youth from the corrupt world of adults, a determination to train it to resist adult temptations. But it also corresponded to a desire on the part of the parents to watch more closely over their children, to stay nearer to them, to avoid abandoning them even temporarily to the care of another family. The substitution of school for apprenticeship likewise reflects a rapprochement between parents and children, between the concept of the family and the concept of childhood, which had hitherto been distinct. The family centred itself on the child. The latter did not as yet live constantly with his parents: he left them for a distant school, although in the seventeenth century the advantages of a college education were disputed and many people held that education at home under a tutor was preferable. But the schoolboy's separation was not of the same character and did not last as long as that of the apprentice. The child was not as a general rule a boarder in college. He lived in a master's house or in a private lodging-house. Money and food were brought to him on market-days. The ties between the schoolboy and his family had tightened: according to Cordier's dialogues, the masters even had to intervene to prevent too many visits to the family, visits planned with the complicity of the mothers. Some schoolboys, from well-to-do homes, did not set off alone: they were accompanied by a preceptor, an older boy, or by a valet, often a foster-brother. The educational treatises of the seventeenth century laid great stress on the parents' duties in the choice of college and preceptor, and the supervision of the child's studies when he

returned home at night. The sentimental climate was now entirely different and closer to ours, as if the modern family originated at the same time as the school, or at least as the general habit of educating children at school.

In any case the separation which was rendered inevitable by the small number of colleges would not be tolerated for long by the parents. Nothing could be more significant than the effort made by the parents, helped by the city magistrates, to found more and more schools in order to bring them closer to the pupils' homes. In the early seventeenth century, as Père de Dainville has shown, a dense network of schools of various sizes was created. Around a college providing a full course of tuition and comprising the full range of classes, there was established a concentric system of a few humanities colleges (with no philosophy class) and a greater number of Latin schools (with just a few grammar classes). The Latin schools provided pupils for the higher classes in the bigger colleges. Certain contemporaries expressed alarm at this proliferation of schools. The multiplication of schools satisfied both the desire for a theoretical education to replace the old practical forms of apprenticeship and the desire of parents to keep their children near home as long as possible – a phenomenon which bears witness to a major transformation of the family: the latter fell back upon the child, and its life became identified with the increasingly sentimental relationship between parents and children. It will be no surprise to the reader to discover that this phenomenon occurred during the same period in which we have seen a family iconography emerge and develop around the couple and their children.

True, this extension of schooling, so important in its effects on the formation of the concept of the family, had no effect on a vast proportion of the child population, which continued to be brought up in accordance with the old practices of apprenticeship. Girls at first did not go to school. Apart from a few who were sent to 'little schools' or convents, most of them were brought up at home, a neighbour's or a relative's. The extension of schooling to girls would not become common until the eighteenth and early nineteenth centuries. Efforts such as those made by Mme de Maintenon and Fénelon would have an exemplary value.

In the case of the boys, schooling was extended first of all to the middle range of the hierarchy of classes: the great families of the nobility and the artisan class remained faithful to the old system of apprenticeship, providing pages for grandees and apprentices for artisans. In the working class, the apprenticeship system would continue down to our own times. The tours of Italy and Germany made by young nobles at the end of their studies also stemmed from the old tradition: they went to foreign courts

or houses to learn languages, good manners, noble sports. This custom fell into disuse in the seventeenth century, when it gave place to the academies: another example of the substitution for practical education of a more specialized and theoretical tuition.

The survival of the apprenticeship system at the two extremities of the social ladder did not prevent its decline; it was the school which triumphed by means of its increased numbers, its greater number of classes and its moral authority. Our modern civilization, built on a scholastic foundation, was now solidly established, and time would steadily consolidate it, by prolonging and extending school life.

The moral problems of the family now appeared in a very different light. This is shown very clearly in connection with the old custom which allowed one child in a family to be favoured at the expense of his brothers, generally the eldest son. It would appear that this custom was established in the thirteenth century, to avoid the dangerous division of an estate whose unity was no longer protected by the practices of joint ownership and lineal solidarity, and which was threatened by the greater mobility of wealth. The privilege of the child favoured by its primogeniture or by its parents' choice was the basis of family society from the end of the Middle Ages to the seventeenth century, but not during the eighteenth century. In fact, starting in the second half of the seventeenth century, moralists and educational theorists disputed the legitimacy of this practice; in their view, it was inequitable, it was repugnant to a new concept of equal rights to family affection, and it was accompanied by a profane use of ecclesiastical benefices. One chapter in Varet's treatise, *De l'Éducation des Enfants*, is about 'the equality which must be maintained among children'. 'There is another regrettable practice which has become common among the faithful and which is no less prejudicial to the fairness which parents owe their children, and that is the habit of thinking only of the establishment of those who by the order of their birth or by the qualities of their person please them most. [They 'pleased' them because they served the family's future better than the rest. This was the concept of a family as a society in which personal feeling played no part, as a 'house'.] People are afraid that if they share their property equally among all their children, they will not be able to add to the glory and lustre of the family as much as they would wish. The eldest son will not be able to hold and keep the posts and offices which they are trying to obtain for him, if his brothers and sisters enjoy the same advantages as he. They must therefore be rendered incapable of challenging this right of his. They must be sent into monasteries against their will and sacrificed early in life to the interests of the one who is destined for the world and

its vanity.' It is interesting that the indignation aroused by false vocations and the privileges granted to the eldest son is totally absent when marriage is involved: there is no question of disputing parental authority in this field.

The text quoted above expresses a definite opinion. But Coustel (1687) displays a certain embarrassment, and he sees fit to employ all sorts of verbal precautions in condemning an old, widespread practice which seemed to be tied up with the permanence of the family. He recognizes the right of parents to have certain preferences: 'It is not that parents are wrong to love those children most who are the most virtuous and who have more good qualities than the others. But I maintain that it may be dangerous to make too great a show of this distinction and this preference.'

The Abbé Goussault, in 1692, is more vehement: 'There is not only great vanity in giving the better part of one's estate to the eldest son of the family, to maintain him in splendour and eternalize his name; there is even injustice. What have the younger sons done to be treated like this?' 'There are some who, in order to establish certain sons beyond their means, sacrifice the others and shut them up in monasteries without consulting them on the matter and without seeing whether they have a vocation ... Fathers do not love their sons equally and introduce distinctions where Nature put none.' For all his indignation Goussault none the less admits, as a concession to the common opinion, that parents 'may have more love for certain of their children', but 'this love is a fire which they must keep hidden underneath the ashes'.

Here we see the beginning of a feeling which would result in equality before the law and which, as we know, had already become widespread in the late eighteenth century. The efforts made in the early nineteenth century to restore the privileges of the eldest son encountered invincible repugnance on the part of the public: very few fathers, even in the nobility, used the right which they enjoyed by law to favour one of their children. Fourcassié cites a letter from Villèle in which the latter deplores this failure of his policy and prophesies the end of the family. In reality this respect for equality among the children of a family bears witness to the gradual move from the family viewed as a 'house' to the modern sentimental view of the family. People now tended to attribute a new value to the affection between parents and children. The theorists of the early nineteenth century, Villèle among them, considered this sentimental foundation too fragile; they preferred the concept of a 'house', a real business company, in which private feelings had no place: they had also realized that the concept of childhood was at the bottom of this new

family spirit. That is why they tried to restore the law of primogeniture, thus overthrowing the entire tradition of the religious moralists of the ancien regime.

Here we will note that the concept of equality among children was able to develop in a new moral and emotional climate, thanks to a greater intimacy between parents and children.

These observations might usefully be related to a phenomenon whose novelty and moral significance were underlined by a lawsuit in 1677. Masters were allowed to marry at that time, but married masters were still forbidden to hold university offices. In 1677 a married master was elected dean of the Tribe of Paris. The defeated candidate, a clerk of the court called du Boulay, appealed against the election and the matter was referred to the Privy Council. Du Boulay's lawyer lists in a memoir the reasons for upholding the celibacy of the teaching profession. Masters, he explains, are in the habit of taking in boarders, and the virtue of these boys may be exposed to various dangers: 'Perils which result only too often from the familiarity which married masters are obliged to allow between the youths they are teaching and their wives, daughters and maidservants. They cannot prevent it, even less among the boarders they take in at home than among the day-boys. Let the Commissioners reflect, if they please, on the indecency involved in schoolboys seeing on the one hand the clothes of women and girls, and on the other hand their books and writing desks, and often all together; and in seeing women and girls combing their hair, dressing, adjusting their clothes, children in their cradles and swaddling-clothes, and all the other appurtenances of marriage.'

To this last argument the married master replies in these terms: 'The aforementioned du Boulay talks as if he had just come from the village where he was born ... For everybody knows that where there are women living there are rooms for them where they dress in complete privacy [privacy that was probably fairly recent, and confined to big towns] and other rooms for the schoolboys.' *As for children in the cradle, there are none to be seen in these Paris houses*: 'Everybody knows that children are put out to nurse in some neighbouring village so that there are as few cradles and swaddling-clothes to be seen in the house of a married master as in the aforementioned du Boulay's office.'

These texts seem to indicate that the custom of putting children out to nurse 'in some neighbouring village' was common in urban circles such as those of the masters, but that it was not very old, since one of the plaintiffs could pretend ignorance of it. This custom would seem to have developed during the seventeenth century, when it was denounced by

educational moralists who, long before Rousseau, urged mothers to feed their children themselves. But their opinion rested only on traditions going back to Quintilian. It could not hope to prevail over a practice which was doubtless based on experience and which was considered the best treatment for the time. One has only to consider the difficulties involved in feeding a baby if the mother's milk ran dry. Using cow's milk was the poor man's fate. The humanist Thomas Platter, in order to describe the abject poverty of his childhood in the early sixteenth century, can find nothing more expressive than the admission that he was brought up on cow's milk. The hygienic conditions obtaining on the farms which provided the milk made this repugnance understandable. Moreover it was far from easy to give it to a child: the peculiar receptacles which are on display in the Musée de la Faculté de Pharmacie in Paris, and which were used as feeding-bottles, must have called for considerable skill and patience. One can understand why mothers resorted to wet-nurses. But what wet-nurses? At first, they were probably servants recruited from the neighbourhood, and the foster-child stayed in the house with the other children. It seems that in the rich families of the sixteenth and the early seventeenth century, the babies were kept at home. Why then, especially in lower-middle class families such as those of the college masters, did people get into the habit of putting them out to nurse in the country? Probably this comparatively recent custom can be interpreted as a protective measure – I hesitate as yet to call it a hygienic precaution – to be linked with the other phenomena in which we have recognized a special solicitude for children.

In fact, despite the propaganda of the philosophers, well-to-do parents, of both the nobility and the middle class, went on putting their children out to nurse until the end of the nineteenth century, that is to say until the progress of hygiene and aseptic methods made it safe to use animal milk. However, a significant change took place in the meantime: the wet-nurse was moved instead of the child; she stayed in the house and the parents kept their little children. This was a phenomenon comparable to the substitution of the day-school for the boarding-school.

The story outlined here strikes one as that of the triumph of the modern family over other types of human relationship which hindered its development. The more man lived in the street or in communities dedicated to work, pleasure or prayer, the more these communities monopolized not only his time but his mind. If, on the other hand, his relations with fellow-workers, neighbours and relatives did not weigh so heavily on him, then the concept of family feeling took the place of the other concepts of loyalty and service and became predominant or even

exclusive. The progress of the concept of the family followed the progress of private life, of domesticity. For a long time the conditions of everyday life did not allow the essential withdrawal by the household from the outside world. One of the great obstacles was doubtless the departure of the children when they were sent away to serve their apprenticeship, and their replacement by little strangers. But the return of the children, after the institution of the school, and the emotional consequences of this tightening of the family bonds were still not enough to create the modern family and its strong inner life; the general sociability of old, which was incompatible with it, remained virtually intact. An equilibrium was established in the seventeenth century between the centrifugal or social forces and the centripetal or family forces which was not destined to survive the progress of domesticity.

We have seen in the preceding pages the rise of these centripetal forces. Let us now study the resistance of the centrifugal forces, the survival of a stubborn sociability.

The historians have already stressed the survival late into the seventeenth century of relationships which had previously been neglected. The monarchical centralization achieved by Richelieu and Louis XIV was more political than social. If it succeeded in crushing the political powers competing with the crown, it left the social influences intact. Seventeenth-century society in France was made up of graded clienteles in which the little men mixed with the greatest (see Adam, 1948). The formation of these groups called for a whole network of daily contacts, involving an unimaginable number of calls, conversations, meetings and exchanges. Material success, social conventions and collective amusements were not separate activities as they are today, any more than professional life, private life and social life were separate functions. The main thing was to maintain social relations with the whole of the group into which one had been born, and to better one's position by skilful use of this network of relations. To make a success of life was not to make a fortune, or at least that was of secondary importance; it was above all to win a more honourable standing in a society whose members all saw one another, heard one another and met one another nearly every day. When the French translator of Laurens Gracian (1645) suggested that the future 'Hero' should find an *emploi plausible*, he did not mean what we would now call a good job, but 'one which was performed in sight of everybody and to the satisfaction of all'. The art of succeeding was the art of being agreeable in society. That was how Balthazar Castiglione's courtier saw it in the sixteenth century: 'This is in my opinion the most fitting way of paying court for a nobleman living at a princely court, by which he may render

perfect service in all reasonable matters in order to acquire the favour of some and the praise of others.' A man's future depended entirely on his 'reputation'. 'It seems to me that there is another thing which adds to or detracts from a man's reputation, and that is his choice of the friends with whom he must maintain constant and close relations.'

A great place was given to friendship in the whole of the seventeenth-century literature; a friendship which was a social relationship carried further than most. Hence the importance of conversation, according to Castiglione: 'I should again be particularly glad to hear about the manner of living and conversing with men and women: something which strikes me as most important in view of the fact that at court most of one's time is spent doing that' – and not just at court. All the etiquette manuals of the seventeenth century insist on the importance of conversation, on the need to know the art of conversation, on one's bearing during conversations, etc. The recommendations in these manuals go into incredible detail. Conversation must observe the proprieties. Domestic, household or excessively personal subjects must be avoided. One must avoid the lying boast (this was the time of Corneille's *Menteur*). Or again, to quote *La civilité nouvelle* of 1671: 'You will remember that the first rule is never to bring up frivolous matters among great and learned persons, nor difficult subjects among persons who cannot understand them ... Do not talk to your company of melancholy things such as sores, infirmities, prisons, trials, war and death ... Do not recount your dreams ... Do not give your opinion unless it is asked for ... Do not attempt to correct the faults of others, especially as that is the duty of fathers, mothers and lords ... Do not speak before thinking what you intend to say.'

We must remember that this art of conversation was not a minor art like dancing or singing. Sorel commented on *Galatée*, the bedside book of the seventeenth century: 'In some nations, when people see a man commit some discourtesy, they say that he has not read *Galatée*.' *Galatée* makes it quite clear that knowing how to converse is a *virtue*: 'I shall begin ... with what I consider necessary to learn to be thought well-bred and agreeably tactful when conversing with others, something which however is a *virtue* or something very like a virtue.' *Galatée* was used in the Jesuit colleges. As for the Jansenists, Nicole would later express himself in similar terms in his essay 'De la civilité chrétienne': 'The love of others being so necessary to support us, we are naturally led to seek it out and win it for ourselves ... We love or we pretend to love others, in order to attract their affection. That is the basis of human courtesy, which is simply a sort of exchange of *amour-propre*, in which we try to attract the love of others by showing them affection ourselves.' Good manners are to

charity what pious gestures are to devotion. 'The closeness of their union [that of respectable people] does not depend simply on these spiritual ties but also on those other human cords which preserve it' – propriety and the art of living in society. If one lives in the world, one must 'arrange one's opportunities' and 'endear oneself to others'.

The insistence on good manners and sociability was not new; it went back to a very old concept of society in which communications were ensured less by school than by apprenticeship, and in which writing did not yet occupy an important place in everyday life. It is remarkable that this state of mind should have endured in a society in which the development of the school indicated the progress of a very different mentality. This ambiguity between traditional sociability and modern schooling was clearly perceived by contemporary observers, and particularly by the moralist pedagogues, several of whom lived in the vicinity of Port-Royal. Nearly all of them examined the question whether private education at home was better than public education at school. To tell the truth, the problem was not as topical as it appeared, for it had already been discussed by Quintilian; but the moralist pedagogues discussed the problem in the context of their own time and circumstances. In *L'Honneste garçon* M. de Grenaille puts the problem in these terms: 'For my part, I do not want to offend antiquity with modern opinions, nor criticize the organization of the Colleges, which so many wise men have praised ... I will however venture to say that the Colleges are rather inexpensive Academies for the public than necessary institutions for the nobility.' They 'make it possible for the poor as well as the rich to acquire those treasures of the mind which only persons of great wealth could possess in the past. There are many children who, being unable to afford to keep masters at home, consider themselves extremely fortunate to be maintained at public expense and to be given free of charge knowledge which previously had to be bought. But for those whom Fortune, like Nature, has blessed with all its favours, I consider that private tuition is better than public. This is by no means a new opinion, bold though it may seem.' Public education was despised because it was held that the schools were in the hands of pedants: this opinion was common in literature, at least after Montaigne, and also most certainly in public opinion. The great development of the school did nothing to diminish the contempt felt for the schoolmaster.

There were other reasons for disliking the school. School discipline was considered to be too strict. 'Just as [at home] children are not accorded dangerous freedom [because they never left the company of adults], they are not subjected to a constraint harmful to their self-confidence.' And

M. de Grenaille adds this comment which reveals a nostalgic regret for the time when children were not set apart from adults: 'They are not treated in the same way as others.' The school either risks corrupting the child by putting him in evil company, or else it retards his development by keeping him away from adults. M. de Grenaille disapproves strongly of the pro-longation of childhood: 'Even if a child is not scandalized by his school-mates, he will none the less learn a great deal of childish nonsense which he will later find it hard to forget, and it will be as difficult to cleanse him of the defilement of college life as to protect him from its vices.' Finally, the most serious shortcoming of the college is the segregation of children, which separates them from their natural social environment. 'He needs to learn early in life how to behave in society as well as in the study, and he cannot learn that in a place where people think more of living with the dead than with the living, that is to say with books than with men.' Here we have the real reason for all his criticism: the dislike for school felt by those who remained more or less faithful to the old education by apprenticeship, a type of education which plunged the child straight into society and left it to society to train him to play his part immediately.

This would still be the opinion, twenty years later, in 1661, of Maréchal de Caillière. 'It is not enough to be versed in the knowledge taught at school; there is another sort of knowledge which teaches us how to use it ... which speaks neither Greek nor Latin, but which shows us how to employ both. It is to be found in the Palaces ... in the homes of Princes and grandees, it hides in the alcoves of Ladies, it delights in the company of soldiers, and it does not despise merchants, labourers, or artisans. It has prudence as a guide, and its doctrines are conversation and experi-ence.' Conversation and familiarity with society have 'often made good men without any help from Letters. The world is a great book which teaches us something every moment, and conversations are living studies which are not a whit inferior to those of books ... Habitual conversation with two or three wits can be more useful to us than all the university pedants in the world ... They pour out more good sense in one hour than we could read in a library in three days. The movements and the expres-sion of the face have a charm which lends weight to what the tongue has to say.'

At the end of the century, the Abbé Bordelon (1694) was of the same opinion: 'Teach children more for the world than through the school.'

It can be seen that throughout the seventeenth century there was a current of opinion which was hostile to the school. We shall be able to understand this better if we remember what a recent phenomenon the

school was. The moralists, who had understood the importance of education, hitherto neglected and still scarcely appreciated by their contemporaries, had not fully realized the role which the school would play, and had already played, in the training of children.

Some, particularly those associated with Port-Royal, tried to reconcile the advantages of the school, which they recognized, and those of education at home. In his *Règles de l'éducation des enfants* (1687), Coustel submits the problem to close analysis, and weighs the pros and cons. If children are brought up at home, the parents watch more closely over their health (this too is a new preoccupation), and they 'learn good manners more easily' by mixing in society. 'They unconsciously instruct themselves in the duties of social life and in the behaviour of civilized people.' But there are certain disadvantages: 'It is difficult to maintain regular hours for study, because mealtimes on which they depend cannot be fixed because of business and because of calls which are received which often cannot be either foreseen or avoided.' The children also risk being excessively spoilt by their parents. Finally they are exposed to the 'complaisant flattery of the servants, and to the lewd talk and foolish remarks of foreign lackeys who cannot always be kept away from them'. Time and again we come across this problem of the dreaded promiscuity of the servants; even the school's worst enemies recognized that this was a powerful argument in its favour. Thus M. de Grenaille admits that parents are 'forced to send their children to college, preferring them to be in a classroom than in a kitchen'.

Coustel recognizes that in any case the question is of a theoretical character because, in his time, every boy was sent to college: 'The practice usually employed for the education of children is to put them in colleges.' These institutions have their advantages; children 'make useful friendships in them which often last until the end of their days'. They enjoy the benefits of emulation: 'The pupils acquire a praiseworthy boldness in speaking in public without going pale at the sight of others, and this is essential for those who are destined to hold high office.' 'Private education' increases shyness. It will be noticed that the advantages which the colleges are recognized as possessing have very little to do with tuition; they are social in character, 'civil' as they would have been called at the time.

But the colleges also have certain disadvantages. It is known that the classes were too big, sometimes containing over a hundred pupils. In Coustel's opinion 'the excessive number of pupils is as much an obstacle to their studies as it is to their morals.' What we know about crowded classes and the unruliness of schoolboys enables us to understand Cordier's anxiety. 'As soon as young children set foot in this sort of place, they

start losing that innocence, that simplicity and that modesty which hither-
to made them so pleasing to God and men alike.'

There was a solution to the problem which had already been proposed
by Erasmus: 'to put five or six children with a good man or two in a
private house'. We have seen that this formula was adopted by Port-
Royal in the famous 'little schools' – famous but ephemeral. It was also
adopted in the numerous private *pensions* which were founded in the late
seventeenth century and in the course of the eighteenth.

With a few exceptions, the moralist pedagogues are rather reticent on
the subject of the college. An historian who confined himself to their
testimony could legitimately conclude that public opinion was hostile to
scholastic forms of education, when in fact, as we have seen, there was
such a demand for college education that the classes were seriously over-
crowded. Theorists do not always give the truest picture of their times.

Yet this opposition was no aberration; it can be explained by the im-
portance which social apprenticeship still retained in spite of the progress
of scholastic education. In everyday life people were better able than
the educational theorists to reconcile schooling and 'civility'. The one
did not exclude the other.

The word 'civil' was roughly synonymous with our modern word
'social'. The word 'civility' would thus correspond to what we call 'good
manners', but in fact it meant much more. In the sixteenth and seven-
teenth centuries, civility was the practical knowledge which it was neces-
sary to have in order to live in society and which could not be acquired
at school: what we call etiquette. Under the older name of 'courtesy',
civility already existed when schools were confined to clerics.

The origins of the manuals of civility or manuals of etiquette which
were so common in the sixteenth and seventeenth centuries are some-
what complex. The sources fall into three very old categories. First of all
the 'treatises of courtesy'. Many of these were written in the fourteenth
and fifteenth centuries in French, English, Italian and even Latin. They
were intended for everybody, clerics as well as laymen, people who could
read Latin as well as people who could understand only the vernacular. In
Italian there was a manual called *Zinquanta cortesie da Tavola*. This
manual included such directions as: 'Wash your hands ... Do not sit
down until you are invited to do so ... He who waits at table must be
clean, and must not spit or do anything unclean in front of the guests.'
In French there was the book *Comment se tenir à table*; in Latin, *Stans
Puer ad Mensam*. For these were books for children or youths: in English
they were known as the 'babees books'. They taught how to speak cor-
rectly, how to greet people, how to kneel before one's master, how to say

grace before a meal, how to answer questions. 'Cut your finger-nails fairly frequently, and wash your hands before dinner. When you have taken a morsel of food out of your mouth, do not put it back on the plate ... Do not pick your teeth with the point of your knife ... Do not rub your hands on your arms ... Do not spit at table ... Do not roll up your cloth ... Keep your trencher straight in front of you ... Do not doze at table ... Do not belch ...' These practical recommendations were usually presented in the form of couplets. In the Middle Ages they were also addressed to women. *Le Roman de la Rose* is in part a treatise on courtesy: it recommends women to wear a sort of corset (without bones or metal) and gives them advice on their toilet, their intimate hygiene, and the care of the 'house of Venus' which had to be kept well shaven. The later manuals of etiquette did not mention women, as if their role in life had diminished at the end of the Middle Ages and the beginning of modern times.

The second source of the manuals of etiquette can be seen in the rules of morality contained in a collection of late Latin adages attributed in the Middle Ages to Cato the Elder, Cato's distichs. *Le Roman de la Rose* cites them as a reference: 'This is also Cato's opinion if you remember his book.' Cato's distichs were used for several centuries: they were still being reprinted in the eighteenth century. They tell the reader how to live decently, to guard his tongue, to distrust women (including his own wife), not to count on legacies, not to be afraid of death, not to worry if somebody in the company starts whispering (and not to imagine in such cases that he is being discussed), to teach his children a trade, to restrain his anger against his servants, to conceal his defects (for dissimulation is better than an evil reputation), not to practise soothsaying and magic, not to talk about or worry about his dreams, to choose his wife well, to avoid gluttony (especially when it was accompanied by the 'shameful desire of love'), not to make fun of old men, not to be a complaisant husband, etc. These recommendations combine what we should now consider commonplace morality, social conformity and crude common sense: what is done and what is not done in all spheres – in one's relations with one's wife, one's servants, one's friends, as also in conversation or behaviour at table – all this pell-mell and on the same level. But where we see the pressure of trivial social conventions in these writings, our ancestors recognized the commandments of life in common, the guardians of real values.

The third source of the manuals of etiquette consisted of the writings on the arts of pleasing or the arts of love: Ovid's *Ars Amoris*, André le Chapelain's *De Amore*, Francesco de Barberini's *Documenti d'Amore*, the love manuals of the sixteenth century. *Le Roman de la Rose* is a typical

example. It tells the reader to avoid jealousy, that the husband is not his wife's lord and master (this would change later), that the lover must become versed in the arts and sciences in order to please his mistress, that he must not scold her or try to read her letters or discover her secrets. And it teaches him to refrain from mean actions, not to indulge in slander, to greet people correctly and acknowledge their greetings, not to talk coarsely, to avoid arrogance, to be smart and clean, gay and merry and generous, and to bestow his affections in one quarter only. These are recipes for winning the affections of women and all the companions of a life in which one is never alone, but always in the midst of a large, exacting society.

Treatises on courtesy, rules of morality and arts of love were all intended to achieve the same result: to initiate the young man (and sometimes the lady) in social life, the only conceivable life outside the cloister, a life which was spent in human contacts and conversation, the serious activities as well as the games.

This complex and abundant medieval literature changed in the sixteenth century and became much simpler. The result was two genres, similar in nature but different in form: the 'civilities' or manuals of etiquette, and the 'courtiers' or treatises on the art of succeeding in life.

The first manual of etiquette was that by Erasmus, which founded the genre. All the later manuals, and there were a great many of them, were inspired by Erasmus or slavishly copied him. Perhaps the most notable names are those of Cordier, Antoine de Courtin and finally Jean-Baptiste de la Salle, whose *Règles de la bienséance et de la civilité chrétienne* was reprinted an infinite number of times in the eighteenth and even in the early nineteenth century.

The manual of etiquette was not a school book, but it satisfied a more strictly educational need than the old courtesy treatises or the sayings of the pseudo-Cato. Circumstances (the extension of schooling) dictated that, although these manuals were not intended for school use, and although they continued rules of behaviour which were both unsuitable to be taught in school and difficult to teach, they should be associated with the tuition of little children, with the first lessons in reading and writing. Children were taught to read and write from manuals of etiquette. They were accordingly printed in different characters – as many characters as existed in a complicated typographical range: not only roman, italic and gothic characters, but also the manuscript characters which were used only in the printing of this type of book and which were therefore called *caractères de civilité*. The fact that these manuals were intended for an educational purpose resulted in their being given a picturesque typo-

graphical appearance. Moreover the text was sometimes printed in several languages, in vertical columns, each column in a different type: French and Latin of course, but also Italian, Spanish and German (never English, a language which at that time had a limited audience and no cultural value). The manuals of etiquette in fact taught modern languages which were not taught in college.

But these books were not by any means intended solely for children. Antoine de Courtin's manual was addressed 'not only to persons with children but also to those who, although advanced in years, are none the less insufficiently versed in the courtesies and proprieties which have to be observed in society.' Thus in Grimoux's painting in the Musée des Augustins at Toulouse we have an adolescent girl reading a book in which we can clearly make out the *caractères de civilité*. The subjects dealt with in these manuals were not always intended for children: they often included adult matters, such as how to treat one's wife and servants, or how to grow old gracefully. They contained both advice to children on how to behave and moral recommendations which we would consider unintelligible to children. These manuals were considerably influenced by the habits of a period when there were no restrictions on the reading-matter made available to children, and when the latter were plunged straight into society; they had plenty of time to assimilate all this knowledge, since it was given to them at the start. They went straight into the adult world.

We have often had occasion to refer to the manuals of etiquette. One of them, *Galatée*, reached an extraordinarily wide public in the first half of the seventeenth century. The Jesuits had adopted it: an edition of 1617 was specially intended for the boarders of the Society of Jesus at La Flèche and the boarders of the same Society's college at Pont-à-Mousson. *Galatée*, 'originally composed in Italian by J. de la Case and since rendered into French, Latin, German and Spanish', is described as 'a treatise essential for the education of young people in all the manners and customs approved by people of honour and virtue, and suitable for those who take pleasure not only in the Latin tongue but also in the vernacular tongues which at present enjoy greater favour'. Like the other manuals, *Galatée* teaches its readers how to behave and converse in society. It tells the reader that 'to put one's hand on a part of one's body in public is anything but commendable', just as the *Stans puer ad mensam* of the fifteenth century condemned the habit of scratching in society. One should not dress or undress in public when performing one's natural functions, nor wash ostentatiously immediately afterwards, nor draw attention to excrement on the roads, nor get people to smell 'stinking

things'. One should avoid offending other people's senses by 'grinding one's teeth, whistling, gurgling, or rubbing stones or pieces of iron together' (another manual of etiquette urges people not to crack their finger-joints or to make too much noise when coughing or sneezing). One should avoid yawning, keeping one's mouth open or looking at one's handkerchief. We find here the old precepts on table manners, which kept all their importance until the end of the eighteenth century; the meal was still a social rite – which it has practically ceased to be today – in which everyone's role was minutely defined, and in which everyone had to take special care to behave properly: not to eat too quickly, not to put one's elbows on the table, not to pick one's teeth, not to 'spit as far as possible and if it is absolutely necessary, to spit in a discreet fashion'. The book explains how one should dress: 'A man must make every effort to approximate as closely as he can to the style of dress of the other citizens and allow himself to be guided by custom.' Any eccentricity, in this sphere as in any other, is a sign of *lèse-société*. One should always give in to the company's wishes, without ever imposing one's own. One should not ask for writing-paper or a chamberpot when a meal is ready and one's hands are washed. One should not be shy or familiar or melancholy. One should always behave in a dignified manner with the servants (certain proud creatures 'are constantly scolding their servants and rebuking them and keep their entire family in perpetual tribulation'), and in the street (where one's walk should be neither too quick nor too slow and where one should never stare at passers-by).

Editions of manuals of etiquette continued to appear from the sixteenth to the eighteenth century, all very similar one to the other. That by Jean-Baptiste de la Salle, *Règles de la bienséance et de la civilité chrétienne*, had as much success in the eighteenth century as those by Erasmus and Cordier or as *Galatée* in the sixteenth and seventeenth centuries. The fact that a pious pedagogue, the founder of an educational institute, burdened with cares and responsibilities, should have taken the trouble to draw up a treatise which deals, like the preceding manuals, with good behaviour, clothes, hair, table-manners, etc., shows the importance that was attributed to subjects which have now become trivial. Admittedly it was a matter of educating a boorish rural population, and the discipline of good manners was more necessary than in our present-day society where people are more subject to all sorts of public authorities and police controls: the State has taken the place of good manners in the training of the individual, since the institution of schools, street-traffic and military service. People of earlier times had the feeling that there were no unimportant things in social life. That is why there was nothing astonishing about Jean-Baptiste

de La Salle, the Canon of Reims, carefully repeating in his turn the traditional recommendations of the manuals of etiquette: 'Take special care to see that there is no vermin or smells; these precautions are most important with regard to children.' There is a long discourse on ways of spitting. 'It is shameful to seem to have dirty, filthy hands; this is only tolerable in the case of labourers or peasants.' 'When one needs to urinate, one should always retire to some secluded spot, and it is wrong [even for children] to perform other natural functions anywhere except in places where one cannot be seen.' 'It is unseemly to strike a blow with one's hand when playing with someone.' 'One should not shake one's legs, nor move them playfully, nor cross them.' The reader is also told how to dress: 'It is unseemly for a child to be dressed like a man, or for a young man's clothes to be more ornate than an old man's.' And of course there is the usual long chapter on 'the way to cut and serve meat', to lay the table, to serve the meal and to clear the table, tasks specially reserved for children and youths.

The enormous number of manuals of etiquette, new editions and adaptations, from Erasmus to Jean-Baptiste de La Salle and beyond, shows that the school had not yet monopolized all the functions of instruction. Great attention was still paid to those good manners which, a few centuries earlier, had been the essential features of apprenticeship. 'The sweet and orderly behaviour of children,' wrote an English pedagogue in the seventeenth century, 'added more credit to a school than due and constant teaching, because this speaketh to every one that the child is well taught though perhaps he learn but little, and good manners indeed are a main part of good education.' (See Watson, 1908.)

In the early seventeenth century people still talked about 'knowing *The Courtier*' (*Il Cortegiano* in the original Italian, *Le Courtisan* in French translation), just as they could say of a man that he had read his *Galatée*. Balthazar Castiglione's *The Courtier* created a genre (just as Erasmus created the prototype of the manuals of etiquette): the genre of the arts of pleasing and succeeding. These arts were the essential subject-matter of *The Courtier*, of books such as Laurens Gracian's *Héros*, translated from the Spanish, of Faret's *L'Honnête Homme*, and indeed of a whole literature, which Daniel Mornet has studied.

This subject can be reduced to two basic ideas: ambition and reputation. Ambition was considered a virtue. Nobody, it was felt, should be content with his lot; he should constantly think of bettering it. This eagerness to rise in the world was not seen as an appetite for pleasure and comfort but as an ideal calling for strict discipline and unflinching determination, an heroic ideal in which one can recognize the spirit of the

Renaissance. It was to last until the middle of the seventeenth century. It finds ingenuous expression in a passage in *L'Honneste garçon*. The author, M. de Grenaille, knows the importance of noble birth: 'I should like the *honneste garçon* to be born into some noble family . . . Is it not true that noblemen are endowed by nature with an air of majesty which commands respect even in their degradation? Children of the nobility seem to command even in subjection, whereas commoners who are sometimes placed in a position of authority seem to be receiving orders when they give them.' But another social concept is no less important in the author's eyes: nobility is a 'divine quality which upholds courage and virtue and not a vain honour' – and this quality is acquired by virtue or reputation, and it increases as the result of a 'generous ambition'. The *honneste garçon* will raise the titles of his house: 'If he is born a mere nobleman he will want to become a baron; if he is a marquess, he will try to become a count. In short, he will press the rights which Nature has given him as far as Fortune will allow.' 'Those who, coming from an honourable family, find themselves in only a very lowly or very mediocre position should strive to rise by means of skill and to conquer nature by means of industry.' 'There are more men of lowly birth who become great than great men who maintain themselves in the same position. This is because the latter sometimes neglect everything whereas the former neglect nothing.' And M. de Grenaille accords his admiration to these brave achievements: the *honneste garçon* should 'realize that his nobility will be more honourable if he acquires it by merit than if he had it by birth.' This is a curious text, which reveals the moral value attributed to ambition.

How was this 'elevation' to be achieved? There was only one way: fame and reputation. Intellectual or technical competence and moral worth were not envisaged; not that they were overlooked, but they were included in the approval which consecrated a man as 'famous' and 'likeable'. This approval, however, had to be constantly maintained by new exploits and new displays of skill: 'Greatness must be renewed, reputation reborn, and applause resuscitated.' Success could be obtained only by means of the favour of the great and the friendship of one's peers. To secure this favour and this friendship, a man had to be prepared to use even ill-gotten riches, to conceal his faults and to simulate qualities. Dissimulation was permissible: 'Oh, man whose passion works only to win fame, you who aspire to greatness, let every man know you but no man understand you. Thanks to this art, the mediocre will seem great, the great infinite, and the infinite more.'

'Virtue,' writes Faret, 'is so essentially the aim of all who wish to obtain

consideration at Court that although everyone there is sullied and disguised, each tries to give the impression that he possesses it in all its purity.' This was understandable: 'A man who chances to speak to the courtier only once in his life will go away pleased with him and will say things about him which he would never say if he had seen the depths of his soul.'

In order to 'acquire people's love', a man needed 'tact', 'a beautiful soul, a perfect life'. And here we come back to civility, to etiquette, to the art of living in society: 'Without it, the finest achievement is dead, the greatest perfection revolting.'

In the second half of the seventeenth century, the genres born of Erasmus's 'civility' and Castiglione's 'courtier' underwent some significant changes.

The Renaissance ideal of ambition and elevation disappeared at the same time as the courtier was replaced by the *honnête homme* and the court by society. It was no longer considered in good taste to aspire too obviously to fortune and prestige. A new ideal appeared, which the Chevalier Méré was to cultivate throughout his work: the search for the happy mean, a distinguished mediocrity. This concept did not reduce the weight of social influences, but it no longer attributed the same moral value to them. Good manners remained just as necessary, but they gradually lost their moral content and ceased to be a virtue. This was the scarcely perceptible beginning of an evolution which would gather speed in the eighteenth and nineteenth centuries: the coherent sociability of the ancien regime would be reduced to a more fragile and less opulent worldliness. However, during the second half of the seventeenth century, this evolution was only hinted at, and sociability, for all that it was less heroic and less exemplary, remained extremely dense and powerful.

The manuals of etiquette remained for a long time descriptions of good manners which were intended for children as well as for adults in so far as the members of either group had not yet learnt them. Like their distant models in the Middle Ages, they explained how a well-bred man should behave, and they recalled established practices which had not hitherto been written down but which had none the less been respected and sincere. In the second half of the seventeenth century, the manuals of etiquette retained their traditional appearance, but they gave more and more place to educational advice and to recommendations addressed simply to children, to the exclusion of adults, on such subjects as the behaviour of the schoolboy. In a manual published in 1761, there was a whole chapter on 'the way in which the child must behave at school'. This was a manual based on that written by Cordier, who was a schoolmaster, and on his

school dialogues. It taught that the child should take off his hat on entering the school, either to bow to the master or to greet his companions. He should not change his seat but remain in the place allotted to him by the master. 'Do not annoy your companions by pushing one and shoving another.' 'Do not be so uncouth and unobliging as to refuse to lend ink, quills or anything else to your companions if it should happen that they have forgotten to bring any.' 'Do not talk in school.' 'It is a sign of an evil nature to show pleasure when someone is being scolded or punished.' The manual of etiquette now paid greater attention to school life, adapted itself to it and prolonged it. This was a consequence of the development of the school, and of the growing awareness of the special nature of child-hood.

La civilité nouvelle of 1671 was already something like an educational manual for parents: this had not been the case with the traditional manuals of etiquette, which were simply records of established practice. It told how to set about punishing children, when to start teaching them their letters, and so on. 'The child should repeat at home what he has learnt at school or at college, or else he should learn at home what he will have to recite before his master.' In the evening, the parents should examine his conscience: 'If the child has lived like a man', he should be washed and caressed. If he has committed a few venial offences, the parents 'should correct him by making fun of him or by inflicting some mild punishment that is easy to bear'. 'If he has committed one of those actions verging on crime, such as blasphemy, theft or falsehood, or hurl-ing a foul insult at a maidservant or a valet, or being stubbornly or con-temptuously disobedient, he should be birched.' 'Next the child should bid his parents and masters good-night, and go to relieve himself.' 'Finally, after undressing, he should lie down in bed to sleep, without chatting and telling stories. He should lie down in such a way that he is comfort-ably and decently arranged and entirely covered; he should sleep neither on his back nor on his belly, but on his side [a piece of medieval medical advice], and he should not sleep without a shirt, both for reasons of pro-priety and in order to be able to find his clothes in any emergency which might arise.'

Even the enlarged scope of the traditional manuals was too narrow to satisfy the new educational preoccupations. There then appeared, par-ticularly in the Port-Royal entourage, practical treatises on education, presented in the form of advice to parents: Varet's in 1666, Coustel's in 1687, and so on. Although these works contained chapters on good man-ners (in conversation and at table) which read like extracts from tradi-tional manuals of etiquette, they were written in a different spirit. They

also dealt with the choice of a trade, and with the difficult problems of choosing a school, also with masters, books (romances 'poisoned the soul' and were to be forbidden), games and pedagogic methods: 'Adjust yourselves as far as you can to their weakness, stammering with them, so to speak, in order to help them to learn their little lessons.' Thus, apart from recommendations to parents, these manuals also contained advice for masters. They urged parents to behave well in front of their children, to set them a good example, to keep an eye on their friends, to 'give them some occupation in conformity with their own plans on the subject, so as not to condemn them to a shameful idleness' while avoiding 'going to any trouble to put their children at their ease'.

We are a long way here from the traditional manuals of etiquette, for here it is no longer a question of recording adult usage for the benefit of children or ignorant adults, but of instructing the family itself in its duties and responsibilities, and of advising it in its behaviour towards children. The difference between Erasmus's *Civilité* and the educational treatises by Coustel and Varet corresponds to the difference between the late fifteenth-century family, still attached to the medieval habits of apprenticeship in other people's houses, and the family of the second half of the seventeenth century, already organized round the children.

However, these modern features of family education did not diminish the success of the traditional manuals, for the concentration of the family around the children was not yet opposed to the old habits of sociability: and pedagogues themselves recognized that 'social intercourse' remained essential.

Since everything depended on social relations, one is bound to wonder where people met. They still often met outside, in the street. Not only by chance, because towns were comparatively small, but also because certain streets or squares were promenades where at certain hours one met one's friends, as one does today in Mediterranean towns. The teeming crowds of the Corso or the Piazza Major were to be found in squares which are now deserted or crossed by pedestrians who, even when they loiter, are unknown to one another. The present-day tourist finds it hard to recognize the Place Bellecour at Lyons in this description of it given by an Italian traveller of 1664, the Abbé Locatelli (1956): 'Men and women were walking about arm in arm, holding one another as one holds a child ... A woman gave her arm to two men, a man his arm to two women. Unaccustomed as we were to these manners [the good priest came from Bologna where people were more reserved than in Lyons], we thought we had entered a brothel ... I noticed how gay they all were, and at the entrance to the promenade, I saw them take each other by the arm, which

they held bent like the handle of a basket, and they walked about in this way.' The surprise felt by this seventeenth-century Bolognese at the sight of this laughing population walking about arm in arm is the same as that which we experience today when we mingle with an Italian crowd.

People met in the street; where did they forgather? In nineteenth-century France, and modern France too, the men often gather together in the café. Contemporary French society remains unintelligible unless one recognizes the importance of the café: it is the only meeting-place which is accessible at any time, as regular as a habit. The English equivalent is the 'public house' or pub. The society of the sixteenth and seventeenth centuries was a society without a café or pub: the tavern was a place of ill repute reserved for criminals, prostitutes, soldiers, students on the spree, down-and-outs, and adventurers of every sort – it was not frequented by decent people, whatever their station in life.[3] There were no other public places except private houses, or at least certain private houses: the big houses in either the town or country.

What do we mean by a big house? Something very different from the meaning we would give today to the same expression. A house today is said to be big in relation to the density of its population. A big house is always a house with few people in it. As soon as the population density rises, people say that they are beginning to feel cramped for room, and the house, comparatively speaking, is no longer as big as it was. In the seventeenth century, and also in the fifteenth and sixteenth centuries, a big house was always crowded, with more people in it than in little houses. This is an important point, which emerges from all the investigations into density of population made by demographic historians.

The population of Aix-en-Provence at the end of the seventeenth century has been studied by means of the capitation register of 1695. In the light of these analyses, a sharp contrast can be seen between the poor, densely populated districts and the rich, less populated districts: the former had little houses with few people in each house, the latter big houses crowded with people. Some houses contained three or fewer than three occupants, while others contained twenty-five people (two masters, six children, seventeen servants) or seventeen people (two masters, eight children, seven servants).

This contrast was not peculiar to the seventeenth century or to Provence. A recent article on Carpentras in the middle of the fifteenth century by Bautier gives the same impression. Twenty-three families of notabilities comprised one hundred and seventy-seven people, or 7·7

3. But Lagniet, in his *Proverbes* depicts a tavern in which a child does not seem out of place.

people to each house; 17·4 per cent of the population lived in houses containing more than eight people. One noble had twenty-five people in his house. The cathedral architect lived with fourteeen other people. It is a delicate matter to draw conclusions about the birth-rate from these figures. But they show clearly that the houses of the rich sheltered, apart from the family proper, a whole population of servants, employees, clerics, clerks, shopkeepers, apprentices and so on. That was the case from the fifteenth to the seventeenth century in the greater part of Western Europe. The houses in question were big houses, with several rooms on each floor and several windows overlooking the street, courtyard or garden. Taken by themselves they formed a veritable social group. Beside these big, crowded houses there were tiny houses containing only married couples and probably just a few of their children, the youngest. In the towns, these were houses such as are still to be found here and there in the old districts, houses with only one or two windows on each floor. According to Paul Masson, it seems that the house with two windows was considered at Marseilles to be an improvement on the house with one window: 'The apartments on each floor are composed of two rooms, one overlooking the street, the other overlooking a narrow space separating the backs of these houses from those of the next street.' Often the two windows lighted only one room. Thus there were only one or two rooms in these urban lodgings. In the country, the little houses had no more than that, and when there were two rooms, one of them was reserved for the animals. They were obviously shelters for sleeping and sometimes (not always) eating. These little houses fulfilled no social function. They could not even serve as homes for families. The housing crisis after the Second World War has taught us something of the effect of housing on the family. Admittedly people were not as sensitive about promiscuity under the ancien regime. But there has to be a certain amount of space or family life is impossible, and the concept of the family cannot take shape or develop. We may conclude that these poor, badly housed people felt a commonplace love for little children – that elementary form of the concept of childhood – but were ignorant of the more complex and more modern forms of the concept of the family. It is certain that the young must have left at a very early age these single rooms which we would call hovels, either to move into other hovels – two brothers together, or husband and wife – or to live as apprentices, servants or clerks in the big houses of the local notabilities.

In these big houses, neither palaces, nor yet mansions, we find the cultural setting of the concept of childhood and the family. Here we collected all the observations which have gone to the making of this book.

The first modern family is that of these notabilities. It is that family which is depicted in the abundant family iconography of the mid-seventeenth century, the engravings of Abraham Bosse, the portraits of Philippe de Champaigne, the scenes by the Dutch painters. It is for that family that the moralist pedagogues wrote their treatises, that more and more colleges were founded. For that family, that is to say for the whole group it formed, a group which comprised, apart from the conjugal family, not other relatives (this type of patriarchal family was clearly very rare) or at the very most bachelor brothers, but a houseful of servants, friends and protégés.

The big house fulfilled a public function. In that society without a café or a 'public house', it was the only place where friends, clients, relatives and protégés could meet and talk. To the servants, clerics and clerks who lived there permanently, one must add the constant flow of visitors. The latter apparently gave little thought to the hour and were never shown the door, for the seventeenth-century pedagogues considered that the frequency and the time of these visits made a regular time-table, especially for meals, quite impossible. They regarded this irregularity as sufficiently harmful for children's education to justify sending them to college, in spite of the moral dangers of school life. The constant coming and going of visitors distracted children from their work. In short, visits gave the impression of being a positive occupation, which governed the life of the household and even dictated its mealtimes.

These visits were not simply friendly or social: they were also professional; but little or no distinction was made between these categories. A lawyer's clients were also his friends and both were his debtors. There were no professional premises, either for the judge or the merchant or the banker or the business man. Everything was done in the same rooms where he lived with his family.

Now these rooms were no more equipped for domestic work than they were for professional purposes. They communicated with one another, and the richest houses had galleries on the floor where the family lived. On the other floors the rooms were smaller, but just as dependent on one another. None had a special function, except the kitchen, and even then the cooking was often done in the hearth of the biggest room. Kitchen facilities in the towns did not allow of many refinements, and when there were guests, dishes were bought ready-cooked from the nearest caterer. When Hortensius, Francion's master, wanted to entertain some friends, he told his servant: 'Go and ask my neighbour the tavern-keeper to send me some of his best wine together with a roast. Now, he said this because as it was already very late, and seeing that the latest to arrive had brought

a hurdy-gurdy, he realized that he would have to offer supper to all the people in his room.' Francion went out with the servant. At the tavern-keeper's, 'we found nothing to suit us and we just bought some wine. We decided to go to the cook-shop on the Petit Pont. The servant bought a capon, and as he also wanted a sirloin of beef, went into all the cook-shops to see if he could find a good one.'

People lived in general-purpose rooms. They ate in them, but not at special tables: the 'dining-table' did not exist, and at mealtimes people set up folding trestle-tables, covering them with a cloth, as can be seen from Abraham Bosse's engravings. In the middle of the fifteenth century the humanist architect Alberti, very much a *laudator temporis acti*, recalled the manners of his childhood: 'When we were young ... the wife would send her husband a little jug of wine and something to eat with his bread; she dined at home and the men in the workship.' He must not be taken literally, for this custom was still common in many artisan and peasant homes at the time he was writing. But he contrasted this simple custom with urban usage at the time: 'the table put up twice a day as for a solemn banquet'. In other words, it was a collapsible table, like so many pieces of furniture in the early seventeenth century.

In the same rooms where they ate, people slept, danced, worked and received visitors. Engravings show the bed next to a dumb-waiter loaded with silverware, or in the corner of a room in which people are eating. A picture by P. Codde (1636) shows a dance: at the far end of the room in which the mummers are dancing, one can make out a bed with the curtains around it drawn. For a long time the beds too were collapsible. It fell to the apprentices or pages to put them up when company was expected. The author of *Le Chastel de joyeuse destinée* congratulates the youths 'dressed in the livery of France' on their agility at setting up beds. As late as the early seventeenth century Heroard wrote in his diary on March 12th, 1606: 'Once he [the future Louis XIII] had dressed, he helped to undo his bed.' 14 March 1606: 'Taken to the Queen's apartments, he was lodged in the King's bedchamber [the King was away fighting] and helped to take his wooden bed round to the Queen: Mme de Montglat installed her bed there to sleep there.' On 8 September 1608, just before setting out for Saint-Germain, 'he amused himself by undoing his bed himself, impatient to leave.' Already, however, beds had become less mobile. Alberti, in his regrets for the good old days, wrote: 'I remember ... seeing our most notable citizens, when they went off to the country, taking their beds and their kitchen utensils with them, and bringing them back on their return. Now the furniture of a single room is bigger and more expensive than that of a whole house used to be on a

wedding-day.' This transformation of the collapsible bed into a permanent piece of furniture undoubtedly marks an advance in domesticity. The ornamental bed, surrounded by curtains, was promptly seized upon by artists to illustrate the themes of private life: the room in which husband and wife came together, in which mothers gave birth, in which old men died, and also in which the lonely meditated. But the room containing the bed was not a bedroom because of that. It remained a public place. Consequently the bed had to be fitted with curtains which could be opened or drawn at will, so as to defend its occupants' privacy. For one rarely slept alone, but either with one's husband or wife or else with other people of one's own sex.

Since the bed was independent of the room in which it stood, there could be several in the same room, often one in each corner. Bussy-Rabutin tells how one day, in the course of a campaign, a girl frightened by the troops asked him for protection and hospitality: 'I finally told my servants to give her one of the four beds in my room.'

It is easy to imagine the promiscuity which reigned in these rooms where nobody could be alone, which one had to cross to reach any of the communicating rooms, where several couples and several groups of boys or girls slept together (not to speak of the servants, of whom at least some must have slept beside their masters, setting up beds which were still collapsible in the room or just outside the door), in which people forgathered to have their meals, to receive their friends or clients, and sometimes to give alms to beggars. One can understand why, whenever a census was taken, the houses of notabilities were always more crowded than the little one-room or two-room apartments of ordinary folk. One has to regard these families, for all that they were giving birth to the modern concept of the family, not as refuges from the invasion of the world but as the centres of a populous society, the focal points of a crowded social life. Around them were established concentric circles of relations, increasingly loose towards the periphery: circles of relatives, friends, clients, protégés, debtors, etc.

At the heart of this complex network was the resident group of the children and the servants. The progress of the concept of childhood in the course of the sixteenth and seventeenth centuries and the moralists' mistrust of the servants had not yet succeeded in breaking up that group. It was as if it were the living, noisy heart of the big house. Countless engravings show us children with servants who themselves were often very young. For example Lagniet's illustrations of a book of proverbs – a little servant is shown playing with the child of the house who is only just starting to walk. The same familiarity must have existed in poorer

families between artisans and labourers and their young apprentices. There was not a great age difference between the children of a big house and the servants, who were usually engaged very young and some of whom were foster-brothers of members of the family. The Book of Common Prayer of 1549 made it the duty of heads of houses to supervise the religious instruction of all the children in their house, that is to say, of all the 'children, servants and 'prentices'. The servants and apprentices were placed on the same footing as the children of the family. They all played together at the same games. 'The abbé's lackey, playing like a little dog with sweet little Jacquine, threw her on the ground just now, breaking her arm and dislocating her wrist. The screams she gave were quite terrifying.' So wrote Mme de Sévigné, who seemed to find this all very amusing.

Sons of houses went on performing domestic functions in the seventeenth century which associated them with the servants' world, particularly waiting at table. They carved the meat, carried the countless dishes in the French-style service which has now gone out of fashion and which consisted of offering several dishes at once, and poured out the wine, carrying glasses or filling them. The manuals of etiquette devoted a long chapter to the subject of waiting at table, and genre pictures often showed children performing this service.[4] The idea of service had not yet been degraded. One nearly always 'belonged' to somebody. The handbooks of the type of *The Courtier* advised the *gentilhomme particulier* or minor noble to choose his master well and try to win his favour. Society still appeared as a network of 'dependencies'. Whence a certain difficulty in distinguishing between honourable services and mercenary services reserved for the menials: this difficulty still existed in the seventeenth century, although the servants were henceforth placed on the same footing as the despised manual workers. There still remained between masters and servants something which went beyond respect for a contract or exploitation by an employer: an existing bond which did not exclude brutality on the one hand and cunning on the other, but which resulted from an almost perpetual community of life. Witness the terms used by moralists to denote the duties of a father: 'The duties of a good father can be placed under three principal heads: his first duty is to *control his wife*, the second to *bring up his children*, the last to *govern his servants*.' 'Solomon gives us some very judicious advice on this point, which contains all a Master's duties to his servants. There are three things, he says, which they must not lack: bread, work and scoldings. Bread because it is their right; work because it is their lot; scoldings and punish-

4. E.g. Helmont, 'Child waiting at table'.

ment because they are our interest.' 'There would be very few servants who behaved badly, if they were fed properly and paid their wages regularly.' But wages were not paid as they are today. Listen to Coustel: prodigal parents 'place themselves in a position where they are unable to *reward their servants*, to satisfy their creditors, or to help the poor, as is their duty.' Or Bordelon: 'There are reciprocal duties between servants and masters. For their services and their submission, give them *compassion and financial reward*.' A servant was not paid, he was rewarded: a master's relationship with his servant was not based on justice but on patronage and pity, the same feeling that people had for children. This feeling has never found better expression than in Don Quixote's thoughts when he awakens and considers the sleeping Sancho: 'Sleep, you have no worries. You have committed the responsibility for your person to my shoulders; it is a burden which nature and tradition have imposed on those who have servants. The valet sleeps while the master sits up, wondering how to *feed him, improve him and do good to him*. Fear [of a bad harvest, etc.] does not affect the servant, but only the master, who must support during sterility and famine him who served him during fertility and abundance.' The familiarity which this personal relationship produced can be seen in Molière's comedies, in the language of the maid-servants and valets when they are speaking of their masters. In those rooms intended for no special purpose, where people ate, slept and received visitors, the servants never left their masters: in the *Caquet de l'Accouchée*, the dialogues between a woman who had just had a child and her visitors, the maidservant joined quite naturally in the conversation. This was not only true of the middle class, but of the nobility as well. 'Madame la Princesse [de Condé],' writes Mme de Sévigné, 'having conceived an affection some time ago for a footman of hers called Duval, the latter was foolish enough to show signs of impatience at the kindness which she also showed young Rabutin, who had been her page.' They started a fight in front of the princess. 'Rabutin drew his sword to punish him, *Duval drew his too*, and the princess, stepping between them to separate them, was slightly wounded in the breast.'

This familiarity was undoubtedly beginning to disappear from adult relationships, and the moralists most concerned to ensure good treatment for servants also advised the greatest reserve when dealing with them: 'Speak very little to your servants.' But the old familiarity remained between servants and children or youths. The latter had played since infancy with the little lackeys, some of whom were personally attached to them and sometimes served them at college; a genuine friendship could arise between them. Molière's valets and the valet in Corneille's *Menteur*

are well known. But a forgotten stage valet, the one in Larivey's *Les Écoliers*, expresses the feeling he has for his master with a more sincere emotion: 'I was brought up with him and I love him more than any other living person.'

The historians taught us long ago that the King was never left alone. But in fact, until the end of the seventeenth century, nobody was ever left alone. The density of social life made isolation virtually impossible, and people who managed to shut themselves up in a room for some time were regarded as exceptional characters: relations between peers, relations between people of the same class but dependent on one another, relations between masters and servants – these everyday relations never left a man by himself. This sociability had for a long time hindered the formation of the concept of the family, because of the lack of privacy. The development in the sixteenth and seventeenth centuries of a new emotional relationship, or at least a newly conceived relationship, between parents and children, did not destroy the old sociability. The consciousness of childhood and the family postulated zones of physical and moral intimacy which had not existed before. Yet, to begin with, it adapted itself to constant promiscuity. The combination of a traditional sociability and a new awareness of the family was to be found only in certain families, families of country or city notabilities, both nobles and commoners, peasants and artisans. The houses of these notabilities became centres of social life around which there gravitated a whole complex little world. This equilibrium between family and society was not destined to survive the evolution of manners and the new progress of domesticity.

In the eighteenth century, the family began to hold society at a distance, to push it back beyond a steadily extending zone of private life. The organization of the house altered in conformity with this new desire to keep the world at bay. It became the modern type of house, with rooms which were independent because they opened on to a corridor. While they still communicated with each other, people were no longer obliged to go through them all to pass from one to another. It has been said that comfort dates from this period; it was born at the same time as domesticity, privacy and isolation, and it was one of the manifestations of these phenomena. There were no longer beds all over the house. The beds were confined to the bedrooms, which were furnished on either side of the alcove with cupboards and nooks fitted out with new toilette and hygienic equipment. In France and Italy the word *chambre* began to be used in opposition to the word *salle* – they had hitherto been more or less synonymous; the *chambre* denoted the room in which one slept, the *salle* the room in which one received visitors and ate: the *salon* and the *salle à*

manger, the *caméra* and the *sala da pranza*. In England the word 'room' was kept for all these functions, but a prefix was added to give precision: the diningroom, the bedroom, etc.

This specialization of the rooms, in the middle class and nobility to begin with, was certainly one of the greatest changes in everyday life. It satisfied a new desire for isolation. In these more private dwellings, the servants no longer left the out-of-the-way quarters which were allotted to them – except in the houses of princes of the blood, where the old manners endured. Sébastien Mercier noted as a recent innovation the habit of ringing for the maidservant. Bells were arranged in such a way that they could summon servants from a distance, whereas they had previously been capable of arousing attention only in the room in which they were rung. Nothing could be more characteristic of the new desire to keep the servants at a distance and also to defend oneself against intruders. It was no longer good form in the late eighteenth century to call on a friend or acquaintance at any time of day and without warning. Either one had days when one was 'at home', or else 'people send each other cards by their servants'. 'The post also takes care of visits ... The letterbox delivers cards; nothing is easier, nobody is visible, everyone has the decency to close his door.'

The use of 'cards' and 'days' was not an isolated phenomenon. The old code of manners was an art of living in public and together. The new code of manners emphasized the need to respect the privacy of others. The moral stress had been moved. Sébastien Mercier was quick to observe this change: 'Present-day custom has cut short all ceremonies and only a provincial stands on ceremony now.' Meals were shortened too: 'They are much shorter, and it is not at table that people talk freely and tell amusing stories', but in the *salon*, the room to which people withdraw: the 'drawing-room'. 'People are no longer in a hurry to drink, no longer torment their guests in order to prove that they know how to entertain, no longer ask you to sing [the old concerts over dessert of the sixteenth and seventeenth centuries].' 'People have abandoned those foolish and ridiculous customs so familiar to our ancestors, unhappy proselytes of an embarrassing and annoying tradition *which they called correct*.' 'Not a moment's rest: people tried to outdo each other in politeness before the meal and during the meal with pedantic stubbornness, and the experts on etiquette applauded these puerile combats.' 'Of all those stupid old customs, that of blessing someone who sneezes is the only one that has lasted down to the present day.' 'We leave it to the cobbler and the tailor to give each other the sincere or hypocritical accolade which was still usual in polite society forty years ago.' 'Only the *petit bourgeois* now employs those

tiresome manners and futile attentions which he still imagines to be correct and which are intolerably irksome to people who are used to society life.'

The rearrangement of the house and the reform of manners left more room for private life; and this was taken up by a family reduced to parents and children, a family from which servants, clients and friends were excluded. General de Martange's letters to his wife between 1760 and 1780 (see Bréard, 1878) enable us to gauge the progress made by a concept of the family which had become identical with that of the nineteenth and early twentieth centuries. The family had invaded people's correspondence and doubtless their conversations and preoccupations too.

The old forms of address such as 'Madame' had disappeared. Martange addressed his wife as 'dear *maman*' or 'my dear love', 'my dear child', 'my dear little one'. The husband called his wife by the same name that his children gave her: *maman*. His correspondence with his wife was full of details about the children, their health and their behaviour. They were referred to by nickname: Minette and Coco. This increasingly widespread use of nicknames corresponded to a greater familiarity and also to a desire to address one another differently from strangers, and thus to emphasize by a sort of hermetic language the solidarity of parents and children and the distance separating them from other people.

When the father was away, he kept himself informed of all the little details of everyday life, which he took very seriously. He waited impatiently for letters: 'I beg you, my dear little one, to write just a few words.' 'Scold Mlle Minette for me for so far neglecting to write to me.' He spoke of the joy of seeing his family again very soon: 'I look forward to being with you once more in our poor little home, and I should like no responsibility better than that of arranging your room and making our stay pleasant and comfortable.' Here we already have the modern taste for domesticity, contrasting the house, the object of enthusiastic pottering, with the outside world.

In this correspondence, questions of health and hygiene occupied an important place. Hitherto people had worried about serious illnesses, but they had not shown this constant solicitude, they had not bothered about a cold, a minor ailment: physical life had not been regarded as so important. 'I should be so unhappy if I had no news about your health and that of my little girls.' 'Although what you tell me about the poor health which you and my poor little girls are enjoying is not as comforting as a father's heart might wish ...' 'I am not very happy about what you tell me about our little boy's pains and loss of appetite. I cannot recommend you too earnestly, dear child, to procure some Narbonne honey for both him and

Xavière, and to rub their gums with it when they are in pain.' This was the anxiety of parents over their children's teething troubles: it could have interested a few old women in Mme de Sévigné's time, but it had not hitherto been given the honours of a place in a staff officer's correspondence. 'My daughters' colds worry me ... But it seems to me that the weather finally took a turn for the better this morning.' Vaccination against smallpox was discussed then as inoculation against poliomyelitis is today. 'I leave it to you to see to Xavière's vaccination, and the sooner the better, because everybody is satisfied with the vaccination.' He advised his wife to drink 'Sedlitz water', 'the salts of the same name', and lemonade, and also to mix vinegar or brandy with her water, to guard against infection.

One of the girls had got married in Germany. In a letter to her 'dear sweet *maman*' of 14 January 1781, she explained her long silence: 'First of all the two youngest had whooping-cough for two months, so badly that every time they coughed they went purple in the face and the blood came bubbling out of their nostrils. After that illness, my little girl and Xavier caught the worst brain fever you could imagine.' The doctors had given up hope of saving Xavier: 'The poor child suffered all it is possible to suffer.' However, in the end he was saved: 'Thanks to the Supreme Being, all three have been returned to me.' Nobody would now dare to seek consolation for losing a child in the hope of having another, as parents could have admitted doing only a century before. The child was irreplaceable, his death irreparable. And the mother found happiness in the midst of her children, who no longer belonged to an intermediary region between existence and non-existence: 'The company of my little ones is my sole delight.' Here we see the connection between the progress of the concept of childhood and the progress of hygiene, between concern for the child and concern for his health, another form of the link between attitudes to life and attitudes to death.

Considerable attention was also paid to the children's education, the importance of which was fully recognized: 'Above all I urge you not to waste a minute that can be given to the children's education; double or treble their lessons every day, especially to teach them how to stand, walk and eat' (an echo of the old manuals of etiquette). The three children had a tutor: 'Let the three children profit by his tuition and let the two girls in particular learn how to stand and walk. If M. H. can give them grace, he can consider himself a clever master.'

Martange ran into financial difficulties. He dreaded the consequences: 'The sorrow of being unable to give them the education I would have wished has given me some bitter moments of reflection.' Whatever happened, the 'masters' fees' had to be paid. We are a long way here from the

laments of the moralists of the 1660s, who complained that schoolmasters were not paid because people did not realize the importance of their work. 'I should sell my last shirt, if I had nothing else, to see my children on the same level as all the others of their age and rank. They must not be brought into the world to humiliate us with their ignorance and behaviour. I think of nothing else, my dear, but of repairing my fortune to ensure their happiness, but if they wish to ensure mine, they must work hard and not waste time.' Martange was worried when his children were vaccinated, in case 'the time taken by vaccination is lost by their masters'. 'Use your stay in town to give them a little of that education which my [financial] misfortunes have to far prevented us from obtaining for them.'

Health and education: these would henceforth be the chief preoccupations of all parents. One cannot help being struck by the extremely modern tone of this correspondence. In spite of the two centuries which separate us, it is closer to us than to Mme de Sévigné, who lived only a century earlier. In Mme de Sévigné, apart from the maternal solicitude of a good grandmother, what appears above all, at odd moments in her life, is an amused interest in the caprices of childhood, what I have called the first attitude to childhood, the 'coddling' attitude. This attitude is almost entirely absent from Martange. He treats everything much more seriously. His is already the gravity of the nineteenth century, applied to both little things and big: Victorian gravity. In the seventeenth century, when he was not a subject of amusement, the child was the instrument of matrimonial and professional speculation designed to improve the family's position in society. This idea is relegated to the background in Martange: his interest in education seems much more disinterested. Here children as they really are, and the family as it really is, with its everyday joys and sorrows, have emerged from an elementary routine to reach the brightest zones of consciousness. This group of parents and children, happy in their solitude and indifferent to the rest of society, is no longer the seventeenth-century family, open to the obtrusive world of friends, clients and servants: it is the modern family.

One of the most striking characteristics of this family is the concern to maintain equality between the children. We have seen that the moralists of the second half of the seventeenth century gave timid support to this equality, chiefly because favouring the eldest son often drove the younger children into false religious vocations, but also because they were ahead of their times and foresaw the future conditions of family life. We have seen from their writings how conscious they were of going against public opinion. Henceforth, from the end of the eighteenth century on, inequality between the children of one family would be considered an intolerable

injustice. It was manners, and not the Civil Code or the Revolution which abolished the law of primogeniture. The families of France would reject it out of hand when the Ultras of the Restoration restored it, inspired by a new concept of the family which they incorrectly attributed to the ancien regime: 'Out of twenty well-to-do families,' Villèle wrote to Polignac on 31 October 1824, 'there is scarcely one which uses the power to favour the eldest or some other child. The bonds of subordination have been loosened everywhere to such an extent that in the family, the father considers himself obliged to humour his children.'

Between the end of the Middle Ages and the seventeenth century, the child had won a place beside his parents to which he could not lay claim at a time when it was customary to entrust him to strangers. This return of the children to the home was a great event: it gave the seventeenth-century family its principal characteristic, which distinguished it from the medieval family. The child became an indispensable element of everyday life, and his parents worried about his education, his career, his future. He was not yet the pivot of the whole system, but he had become a much more important character. Yet this seventeenth-century family was not the modern family: it was distinguished from the latter by the enormous mass of sociability which it retained. Where the family existed, that is to say in the big houses, it was a centre of social relations, the capital of a little complex and graduated society under the command of the pater-familias.

The modern family, on the contrary, cuts itself off from the world and opposes to society the isolated group of parents and children. All the energy of the group is expended on helping the children to rise in the world, individually and without any collective ambition: the children rather than the family.

This evolution from the medieval family to the seventeenth-century family and then to the modern family was limited for a long time to the nobles, the middle class, the richer artisans and the richer labourers. In the early nineteenth century, a large part of the population, the biggest and poorest section, was still living like the medieval families, with the children separated from their parents. The idea of the house or the home did not exist for them. The concept of the home is another aspect of the concept of the family. Between the eighteenth century and the present day, the concept of the family changed hardly at all. It remained as we saw it in the town and country middle classes of the eighteenth century. On the other hand, it extended more and more to other social strata. In England in the late eighteenth century, agricultural labourers tended to set up house on their own, instead of lodging with their employers, and the decline of ap-

prenticeship in industry made possible earlier marriages and larger families. Late marriage, the precariousness of work, the difficulty of finding lodgings, the mobility of journeyman labour and the continuation of the traditions of apprenticeship, were so many obstacles to the ideal way of middle-class family life, so many obstacles which the evolution of manners would gradually remove. Family life finally embraced nearly the whole of society, to such an extent that people have forgotten its aristocratic and middle-class origins.

Summary
The Family and Sociability

The historian who studies iconographic documents in the hope of discovering the tremor of life which he can feel in his own existence, is surprised at the scarcity, at least until the sixteenth century, of interior and family scenes. He has to hunt for them with a magnifying-glass and interpret them with the aid of hypotheses. On the other hand he promptly makes the acquaintance of the principal character in this iconography, a character as essential as the chorus in the classical theatre: the crowd – not the massive, anonymous crowd of our overpopulated cities, but the assembly of neighbours, women and children, numerous but not unknown to one another (a familiar throng rather similar to that which can be seen today in the *souks* of Arab towns or the *cours* of Mediterranean towns in the evening). It is as if everyone had come out instead of staying at home: there are scenes depicting streets and markets, games and crafts, soldiers and courtiers, churches and tortures. In the street, in the fields, outside, in public, in the midst of a collective society – that is where the artist chooses to set the events or people he wishes to depict.

The idea of isolating individual or family portraits gradually emerged. But the importance which we have given to these early attempts should not blind us to the fact that they were rare and timid to begin with. For a long time – until the seventeenth century, when the iconography of the family became extremely rich – the important thing was the representation of public life. This representation doubtless corresponds to a profound reality. Life in the past, until the seventeenth century, was lived in public. We have given a good many examples of the ascendancy of society. The traditional ceremonies which accompanied marriage and which were regarded as more important than the religious ceremonies (which for a long time were entirely lacking in solemnity) – the blessing of the marriage bed; the visit paid by the guests to the newly-married pair when they were already in bed; the rowdyism during the wedding night, and so on – afford further proof of society's rights over the privacy of the couple. What objection could there be when in fact privacy scarcely ever existed, when people lived on top of one another, masters and servants, children and adults, in houses open at all hours to the indiscretions of callers? The

density of society left no room for the family. Not that the family did not exist as a reality: it would be paradoxical to deny that it did. But it did not exist as a concept.

We have studied the birth and development of this concept of the family from the fifteenth century to the eighteenth. We have seen how, until the eighteenth century, it failed to destroy the old sociability; admittedly it was limited to the well-to-do classes, those of the notabilities, rural or urban, aristocratic or middle-class, artisans or merchants. Starting in the eighteenth century, it spread to all classes and imposed itself tyrannically on people's consciousness. The evolution of the last few centuries has often been presented as the triumph of individualism over social constraints, with the family counted among the latter. But where is the individualism in these modern lives, in which all the energy of the couple is directed to serving the interests of a deliberately restricted posterity? Was there not greater individualism in the gay indifference of the prolific fathers of the ancien regime? Admittedly the modern family no longer has the same material reality as under the ancien regime, when it was identified with an estate and a reputation. Except in cases whose importance is constantly diminishing, the problem of the transmission of property takes second place to that of the children's welfare, and that welfare is no longer necessarily seen in loyalty to a professional tradition. The family has become an exclusive society in which its members are happy to stay and which they enjoy evoking, as General de Martange did in his letters as early as the end of the eighteenth century. The whole evolution of our contemporary manners is unintelligible if one neglects this astonishing growth of the concept of the family. It is not individualism which has triumphed, but the family.

But this family has advanced in proportion as sociability has retreated. It is as if the modern family had sought to take the place of the old social relationships (as these gradually defaulted), in order to preserve mankind from an unbearable moral solitude. Starting in the eighteenth century, people began defending themselves against a society whose constant intercourse had hitherto been the source of education, reputation and wealth. Henceforth a fundamental movement would destroy the old connections between masters and servants, great and small, friends or clients. It was a movement which was sometimes retarded by the inertia of geographical or social isolation. It would be quicker in Paris than in other towns, quicker in the middle classes than in the lower classes. Everywhere it reinforced private life at the expense of neighbourly relationships, friendships, and traditional contacts. The history of modern manners can be reduced in part to this long effort to break away from

others, to escape from a society whose pressure had become unbearable. The house lost the public character which it had in certain cases in the seventeenth century, in favour of the club and the café, which in their turn have become less crowded. Professional and family life have stifled that other activity which once invaded the whole of life: the activity of social relations.

One is tempted to conclude that sociability and the concept of the family were incompatible, and could develop only at each other's expense.

adult. The age groups of Neolithic times, the Hellenistic *paideia*, pre-supposed a difference and a transition between the world of children and that of adults, a transition made by means of an initiation or an educa-tion. Medieval civilization failed to perceive this difference and therefore lacked this concept of transition.

The great event was therefore the revival, at the beginning of modern times, of an interest in education. This affected a certain number of churchmen, lawyers and scholars, few in number in the fifteenth century, but increasingly numerous and influential in the sixteenth and seventeenth centuries when they merged with the advocates of religious reform. For they were primarily moralists rather than humanists: the humanists remained attached to the idea of a general culture spread over the whole of life and showed scant interest in an education confined to children. These reformers, these moralists, whose influence on school and family we have observed in this study, fought passionately against the anarchy (or what henceforth struck them as the anarchy) of medieval society, where the Church, despite its repugnance, had long ago resigned itself to it and urged the faithful to seek salvation far from this pagan world, in some monastic retreat. A positive moralization of society was taking place: the moral aspect of religion was gradually triumphing in practice over the sacred or eschatological aspect. This was how these champions of a moral order were led to recognize the importance of education. We have noted their influence on the history of the school, and the transformation of the free school into the strictly disciplined college. Their writings extended from Gerson to Port-Royal, becoming increas-ingly frequent in the sixteenth and seventeenth centuries. The religious orders founded at that time, such as the Jesuits or the Oratorians, be-came teaching orders, and their teaching was no longer addressed to adults like that of the preachers or mendicants of the Middle Ages, but was essentially meant for children and young people. This literature, this propaganda, taught parents that they were spiritual guardians, that they were responsible before God for the souls, and indeed the bodies too, of their children.

Henceforth it was recognized that the child was not ready for life, and that he had to be subjected to a special treatment, a sort of quarantine, before he was allowed to join the adults.

This new concern about education would gradually install itself in the heart of society and transform it from top to bottom. The family ceased to be simply an institution for the transmission of a name and an estate – it assumed a moral and spiritual function, it moulded bodies and souls. The care expended on children inspired new feelings, a new emotional

Conclusion

He was free, infinitely free, so free that he was no longer conscious of pressing on the ground. He was free of that weight of human relationships which impedes movement, those tears, those farewells, those reproaches, those joys, all that a man caresses or tears every time he sketches out a gesture, those countless bonds which tie him to others and make him heavy.

Saint-Exupéry, *The Little Prince*

In the Middle Ages, at the beginning of modern times, and for a long time after that in the lower classes, children were mixed with adults as soon as they were considered capable of doing without their mothers or nannies, not long after a tardy weaning (in other words, at about the age of seven). They immediately went straight into the great community of men, sharing in the work and play of their companions, old and young alike. The movement of collective life carried along in a single torrent all ages and classes, leaving nobody any time for solitude and privacy. In these crowded, collective existences there was no room for a private sector. The family fulfilled a function; it ensured the transmission of life, property and names; but it did not penetrate very far into human sensibility. Myths such as courtly and precious love denigrated marriage, while realities such as the apprenticeship of children loosened the emotional bond between parents and children. Medieval civilization had forgotten the *paideia* of the ancients and knew nothing as yet of modern education. That is the main point: it had no idea of education. Nowadays our society depends, and knows that it depends, on the success of its educational system. It has a system of education, a concept of education, an awareness of its importance. New sciences such as psycho-analysis, pediatrics and psychology devote themselves to the problems of childhood, and their findings are transmitted to parents by way of a mass of popular literature. Our world is obsessed by the physical, moral and sexual problems of childhood.

This preoccupation was unknown to medieval civilization, because there was no problem for the Middle Ages: as soon as he had been weaned, or soon after, the child became the natural companion of the

attitude, to which the iconography of the seventeenth century gave brilliant and insistent expression: the modern concept of the family. Parents were no longer content with setting up only a few of their children and neglecting the others. The ethics of the time ordered them to give all their children, and not just the eldest – and in the late seventeenth century even the girls – a training for life. It was understood that this training would be provided by the school. Traditional apprenticeship was replaced by the school, an utterly transformed school, an instrument of strict discipline, protected by the law-courts and the police-courts. The extraordinary development of the school in the seventeenth century was a consequence of the new interest taken by parents in their children's education. The moralists taught them that it was their duty to send their children to school very early in life: 'Those parents,' states a text of 1602, 'who take an interest in their children's education [*liberos erudiendos*] are more worthy of respect than those who just bring them into the world. They give them not only life but a good and holy life. That is why those parents are right to send their children at the tenderest age to the market of true wisdom [in other words to college] where they will become the architects of their own fortune, the ornaments of their native land, their family and their friends.'[1]

Family and school together removed the child from adult society. The school shut up a childhood which had hitherto been free within an increasingly severe disciplinary system, which culminated in the eighteenth and nineteenth centuries in the total claustration of the boarding-school. The solicitude of family, Church, moralists and administrators deprived the child of the freedom he had hitherto enjoyed among adults. It inflicted on him the birch, the prison cell – in a word, the punishments usually reserved for convicts from the lowest strata of society. But this severity was the expression of a very different feeling from the old indifference: an obsessive love which was to dominate society from the eighteenth century on. It is easy to see why this invasion of the public's sensibility by childhood should have resulted in the now better-known phenomenon of Malthusianism or birth-control. The latter made its appearance in the eighteenth century just when the family had finished organizing itself around the child, and raised the wall of private life between the family and society.

The modern family satisfied a desire for privacy and also a craving for identity: the members of the family were united by feeling, habit and their way of life. They shrank from the promiscuity imposed by the old

1. *Academia Sive Speculum Vitae Scholasticae*, Arnheim, 1602.

sociability. It is easy to understand why this moral ascendancy of the family was originally a middle-class phenomenon: the nobility and the lower class, at the two extremities of the social ladder, retained the old idea of etiquette much longer and remained more indifferent to outside pressures. The lower classes retained almost down to the present day the liking for crowds. There is therefore a connection between the concept of the family and the concept of class. Several times in the course of this study we have seen them intersect. For centuries the same games were common to the different classes; but at the beginning of modern times a choice was made among them: some were reserved for people of quality, the others were abandoned to the children and the lower classes. The seventeenth-century charity schools, founded for the poor, attracted the children of the well-to-do just as much; but after the eighteenth century the middle-class families ceased to accept this mixing and withdrew their children from what was to become a primary-school system, to place them in the *pensions* and the lower classes of the colleges, over which they established a monopoly. Games and schools, originally common to the whole of society, henceforth formed part of a class system. It was all as if a rigid, polymorphous social body had broken up and had been replaced by a host of little societies, the families, and by a few massive groups, the classes; families and classes brought together individuals related to one another by their moral resemblance and by the identity of their way of life, whereas the old unique social body embraced the greatest possible variety of ages and classes. For these classes were all the more clearly distinguished and graded for being close together in space. Moral distances took the place of physical distances. The strictness of external signs of respect and of differences in dress counterbalanced the familiarity of communal life. The valet never left his master, whose friend and accomplice he was, in accordance with an emotional code to which we have lost the key today, once we have left adolescence behind; the haughtiness of the master matched the insolence of the servant and restored, for better or for worse, a hierarchy which excessive familiarity was perpetually calling in question.

People lived in a state of contrast; high birth or great wealth rubbed shoulders with poverty, vice with virtue, scandal with devotion. Despite its shrill contrasts, this medley of colours caused no surprise. A man or woman of quality felt no embarrassment at visiting in rich clothes the poor wretches in the prisons, the hospitals or the streets, nearly naked beneath their rags. The juxtaposition of these extremes no more embarrassed the rich than it humiliated the poor. Something of this moral atmosphere still exists today in southern Italy. But there came a time

when the middle class could no longer bear the pressure of the multitude or the contact of the lower class. It seceded: it withdrew from the vast polymorphous society to organize itself separately, in a homogeneous environment, among its families, in homes designed for privacy, in new districts kept free from all lower-class contamination. The juxtaposition of inequalities, hitherto something perfectly natural, became intolerable to it: the revulsion of the rich preceded the shame of the poor. The quest for privacy and the new desires for comfort which it aroused (for there is a close connection between comfort and privacy) emphasized even further the contrast between the material ways of life of the lower and middle classes. The old society concentrated the maximum number of ways of life into the minimum of space and accepted, if it did not impose, the bizarre juxtaposition of the most widely different classes. The new society, on the contrary, provided each way of life with a confined space in which it was understood that the dominant features should be respected, and that each person had to resemble a conventional model, an ideal type, and never depart from it under pain of excommunication.

The concept of the family, the concept of class, and perhaps elsewhere the concept of race, appear as manifestations of the same intolerance towards variety, the same insistence on uniformity.

References

Achard, P. (1869), 'Les chefs des plaisirs', *Annuaire Administratif du Department du Vanchise.*
Adam, A. (1948), *Histoire de la litterature française au 17th Siècle.*
Adamson, J. W. (1919), *A Short History of Education*, Cambridge University Press.
Adamson, J. W. (1920), *A Guide to the History of Education*, Cambridge University Press.
Adamson, J. W. (1930), *English Education*, Cambridge University Press.
d'Allemagne, H. (1906), *Recréations et Passe-Temps.*
Archer, R. L. (1921), *Secondary Education.*
Ariés, P. (1954), *Le Temps de l'histoire*, Libraire Plon.

Baillet, (1688), *Les Enfants devenus célèbres par leurs études.*
Bans, R. (1675), *Nouveau journal de conservation.*
de Bassompierre, Maréchal, *Journal*, S. H. F.
Baulier, R. H. (1959), 'Feux, population et structure sociale au milieu du 15th siècle', *Annales E. S.*
Beauvais-Nangis (1862), *Memoires*, Mommerque and Taillandier.
Bergues, H, et al. (1960), 'La prévention des naissances dans la famille, ses origines dans les temps modernes', Institute National d'Études Démographiques, no. 35.
Bond, F. (1909), *Westminster Abbey.*
Bordelon. (1694), *La Bene education.*
Bouguet, H. L. (1948), *Le Collège d'Harcourt-Saint-Louis.*
Bouquet, F. V. (1895), *Souvenirs du collège de Rouen, Par un éléve de pension, 1829–35.*
Bouquet, H. L. (1891), *Le Collège d'Harcourt-Saint-Louis.*
Bourchemin, P. D. (1882), *Les Académies protestantes.*
Bouzonnet-Stella, C. (1657), *Jeux de L'enfance.*
Braudel, F. (1959), 'Histoire et science sociale, la longue durée', *Annales*, pages 725–53.
Bréard (ed.) (1898), *Correspondence inédite du general de martauge.*
Bremond, H. (1921), *Histoire littéraire du sentiment réligieux.*
Brinsley. (1612), *Ludus Litteratrius.*

Brunetiere, C. (1879), *Revue des deux mondes.*
Buchanan, (1612), *Oeuvres complètes.*

Cadet, F. (1887), *L'Education à Port-Royal.*
Cailliève, J. *Le Courtisan predestiné.*
Callois, R. (1951), *Quatre essais de sociologie contemporaine.*
Camden Society (1897), *A Relation of the Island of England.*
Callière, Marechal de (1661), *La Fortune des gens de qualité.*
Carré, G. (1881), *Memoires de la Societé des sciences et arts de l'Aube.*
Carré, G. (1881), *Les Élèves de l'ancien collège de Troyes, memoires de la Societé Academique de l'Aube.*
Cervantes, M. (1605), *Don Quixote;* Penguin, 1972.
Charmasse, A. de (1871–8), *État de l'instruction publique dans l'Autun.*
Chaucer, G. (c. 1387), *The Canterbury Tales;* Penguin, 1972.
Cherot, H. (1896), *Trois éducations princières.*
Clerval, A. (1895), *Les Écoles de Chartres au moyen age.*
Cognet, A. (1951), *La Nêve Angelique et Saint François de Sales.*
Coguet, L. (1950), *La Reforme de Port-Royal.*
Colombier, Pere du (1951), *Style Henri IV et Louis XIII.*
Coote, (1596), *The English Schoolmaster.*
Cordier, M. (1586), *Colloques,* Paris.
Coustel, (1687), *Règles de l'éducation des enfants.*

Dainville, Père de (1940), *La Naissance de l'Humanisme Moderne.*
Dainville, Père de (1955) *Entre Nous.*
Della Casa, G. (1609), *Galatée.*
Destrée, J. (1895), *Les Heures de Nôtre-Dames dites de Hennessey.*
Didron, 'La vie humaine', *Annales Archeologique,* no. 15, p. 4.
Duby, G. (1953), *La Société aux XIe et XII siècles dans la Region Mâconnaise,* Random House.
Dupont-Ferrier, G. (1773), *La Vie Quotidienne d'un Collège Parisien, Clermont Louis-le-Grand.*
Duval, P. M. (1952), *La Vie Quotidienne en Gaule.*

Erasmus, D. (1511), *Christian Marriage.*
Êstienne, J. (1933), *Preface to Archives de la Somme.*
Everardt, J. (1658), *Epitome of Stenographie.*

Felibiean, *Histoire de Paris.*
Fenelon (1687), *De l'Éducation des Filles.*
le Fevre d'Ormesson, A., *Journal.*
Ferte, H. (1868), *Des grades universitaires dans l'ancien faculté des Arts.*

Fick, E. (ed.), (1895), *Vie de Thomas Platter*.

Fleury (1686), *Traité de choix et de la Méthode des Études*.

Fournier (1889), 'Une corporation d'étudiants en droit', *Nouvelle revue historique du droit Français et Étranger*.

Gaufrés, J. (1880), 'Claude Baduel et la reforme des études au 16th siecle', *Bull. Soc. H. du Protestantism Francais*, no. 25.

Gaufrés, J. (1887), 'Histoire du plan d'études protestantes', *Histoire du Protestantisme*, vol. 25.

Gerson, H. (1950), *Von Geertgen Tot F. Hals*.

Gerson, H. (1952), *De Nederlands Schilderkunst*, vol. 1, p. 145.

Gerson, H. (1706), *Doctrina Pro Pueris Ecclesia Prisiensis, Opera*.

Glanville, B. (ed.) (1556), *Le Grand propriétaire de toutes choses, Très Utiles et Profitable pour tenir le corps en santé* (trans. by Jean Corbichon).

Göbel, H. (1923), *Wandteppiche*.

Godet, M. (1912), *Montaigu*.

Godard, C. (1887), *L'Ancien Collège de Gray, 1557–1792*.

Gratien, B. (1646). *El Discreto*, Huesca.

de Grenaille (1642), *l'Honnette garcon*.

Goussalt, Abbe (1692), *Portrait d'une honnete femme*.

Halphen, L. (1931), 'Les universites au 13th siècle', *Revue Historique*.

Hautecoeur, L. (1945), *Les Peintres de la vie familiale*.

Hughes, T. (1857), *Tom Brown's Schooldays*.

Jarman, T. L. (1951), *Landmarks in the History of Education*.

Joly, C. (1678), *Traite historique des écoles episcopales et ecclesiastiques*.

Jourdain, C. (1862–6), *Histoire de l'université de Paris aux XVIIe et XVIIIe siècles*.

Jourdain, C. (1876), 'Le collège du Cardinal Lemoine', *Memoires de la Societé de l'Histoire de Paris*.

Jusserand, J-J. (1901), *Les Sports et jeux d'exercise dans l'ancien France*.

Lablée, J. (1824), Memoires d'un Homme de Letters.

Laborde, A. (1921), *Bibles Moralisées Illustrées*.

Langlois, C. V. (1908), *La Vie en France au moyen age*.

Lavallé, T. (1862), *Histoire de la Maison Royal de Saint-Cyr*.

de Lattre, P. (1940), *Les Éstablishments des Jesuites en France*.

Leclerc, M. (1894), *L'Education des classes moyennes et dingenates en Angleterre*.

Leclerc, M. (1587), *Les trente-six figures contenant tous les jeux*.

Leonard, E. G. (1958), *Les Problèmes de l'Armée*.

Lyte, H. C. M. (1889), *History of Eton College.*
Locatelli (1956), *The adventures of an Italian priest.*

Marle, V. (1932), *Iconographié d l'art profane.*
Marmontel, J. F. (1827), *Memoires d'un père.*
Marrou, H. I. (1948), *Histoire de l'éducation dans l'antiquité.*
Magendie, M. (1925), *La politesse mondaine au 17th Siècle.*
Massebieau, L. (1878), *Les colloques scolaires.*
Méchin, (1892), *Annales du collège Royal de Bourbon-Aix.*
Mercier, S. (1781), *Les tableux de paris.*
Michault, Père, (1931), *Doctrinal de temps present,* ed. T. Walton.
Michel, P. H. (1930), *La pensée de L. B. Alberti.*
Molière, (1673), *La Malade imaginaire.*
Mornet, D. (1940), *Histoire de la Littérature Classique.*
Morowski, J. (ed.) (1926), 'Grant kalendrier et compost des bergiers', 1500 edition, reprinted in *Les douze mois figurés, Archivum Romanium.*
Mèré, *Oeuvres,* ed. C. Boudhors.
Mutteau, C. (1882), *Les Écoles et Colleges en Province.*

Nicole (1733), 'De la civilite chretienne', *Essais de morale.*
Nilsson, *La religion populaire dans la grece antique.*

de Pas, C. (1602), *Academia Sive Speculum Vitae Scholasticae.*
Pascal, J. (1721), *Regelments pour les enfants,* Appendix to the constitutions of Port-Royal.
Pasquier, E. (1621), *Récherches de la France.*
Pétiot, P. (1955), 'La famille en France sous l'ancien regime', *La Sociologie comparée de la famille contemporains.*
Picard, G. C. (1954), *Les religions de l'Afrique Antique.*
Pisan, C. de (1886), *Oeuvres poetiques,* M. Roy.
Pont-à-Mousson (1617), *Bienséance de la Conversation entre les hommes.*
Prigent, R. (1954), 'Le renouveau des idées sur la famille', *Institute National d'Études Demographique.*

Quicherat (1860), *L'Histoire de Saint-Barbe.*

Rashdall, H. (1895), *The Universities of Europe in the Middle Ages,* reprinted 1936.
Rigault, H. (1937), *Histoire general de l'institution des frères des ècoles Chretiennes,* vol. 1.

da Ripa, Fra Bonevisco (c. 1292), *Zinquanta Corbesie da Tavoli.*
de Robillard de Beaurepaire, C. (1872), *Recherches sur l'instruction Publique dans le Diocese de Lyons.*
de Robillard de Beurepaire, C. (1872), *Recherches sur l'instruction publique dans le diocese de Rouen avant 1789.*
de Rochemonteix, C. (1889), *Le Collège Henri IV de La Flèche.*
de Rochemonteix, C. (1889), *Un Collège de Jesuites aux 17th-18th siecles.*
Rouches (1923), 'Largillière, peintre d'enfants', *Revue de L'art ancien et Moderne.*
Rouchier, *Bull. Soc. des sciences et Arts de l'Ardéche.*

la Salle, J-B. de (1713), *Les Règles de la Bienséance et de la Civilité Chretienne.*
Schimberg, A. (1913), *Éducation morale dans les colleges de Jesuites.*
Serena, A. (1912), *Culture umanistica a Trevisio.*
Schmidt-Degener, F. and Gelder, V. (1928) *Jan Steen.*
Seybolt, R. F. (ed.) (1921), *Manuale scholarium.*
Sévigné, Madame de (1671), *Lettres.*
Sorel, C. (1642), *Maison des jeux.*
Sorel, G. (1926), *Histoire Comique de Françion*, ed. E. Roy.
Storer, M. E. (1928), *La Mode des Coutes de Fées.*

Tapié, V. L. (1957), *Le Baroque*, Praeger.
Théry, A. F. (1858), *Histoire de l'education en france.*

Varet (1666), *De l'education des enfants.*
Varagnac, A. (1948), *civilizations traditionelles.*
Vives, J. L. (c. 1519), *Dialogues.*
de Vries, S. and Marpugo (1904), *Le Bréviaire Grimani.*
Venturi, A. (1914), 'La fonte di una composizione del guaninto', *Arte*, no. 17.

Waddington, F. (ed.) (1857), *Memoires de Jean Rou, 1638–1711.*
Warner, G. F. (1885), *Miracles de Notre Dame.*
Watson, F. (1908), *The English Grammar Schools to 1660.*

Zaccagnini, G. (1926), *La Vita dei Maestri e degli Scolari nella Studio di Bologna.*

Index